Werner Schmalenbach

Masterpieces of 20th-Century Art

from the
Kunstsammlung Nordrhein-Westfalen,
Düsseldorf

Prestel

This book was originally published in German in 1986, as *Bilder des 20. Jahrhunderts: Die Kunstsammlung Nordrhein-Westfalen, Düsseldorf*. The present English edition is an abridged version of the 2nd German edition of 1987.

The publication of this book was made possible by a grant from the Association of the Friends of the Kunstsammlung Nordrhein-Westfalen.

Translated from the German by John Ormrod

Cover: Robert Delaunay, *Window* (detail), 1912/13 (see Plate 17)

Prestel-Verlag, Mandlstrasse 26, D-8000 Munich 40, Federal Republic of Germany Tel. (89) 381 70 90, Telefax (89) 38 17 09 35

Distributed in continental Europe and Japan by Prestel-Verlag, Verlegerdienst München GmbH & Co KG, Gutenbergstrasse 1, D-8031 Gilching, Federal Republic of Germany, Tel. (8105) 21 10, Telefax (8105) 55 20

Distributed in the USA and Canada by te Neues Publishing Company, 15 East 76th Street, New York, NY 10021, USA, Tel. (212) 288 02 65, Telefax (212) 570 23 73

Distributed in the United Kingdom, Ireland and all other countries by Thames & Hudson Limited, 30-34 Bloomsbury Street, London WC1B 3QP, England, Tel. (71) 636 54 88, Telefax (71) 636 47 99

Design: Heinz Ross, Munich
Typeface: 'Sabon' by Monotype GmbH, series 6691 and 6692
(system: Monophoto Lasercomp M2/Miles 300)
Composition, printing and binding: Passavia GmbH, Passau
Off-set lithography: Brend'amour, Simhart GmbH & Co., Munich
Colour photography: Walter Klein, Düsseldorf

Printed in the Federal Republic of Germany

ISBN 3-7913-1338-X

Foreword

This book is devoted to the collection of a single museum: the Kunstsammlung Nordrhein-Westfalen in Düsseldorf. The pictures presented here were collected over a period of some twenty-five years. They are all from the twentieth century and are examples of what is usually termed 'modern' art: the art that began with the generation of artists who were young at the turn of the century, a generation that followed the Post-Impressionists, who, though highly influential at the time, are not generally held to belong to the Modern Movement. The collection begins with Fauvism, Cubism and Expressionism and ends, with the exception of one or two more recent works, with the art of the 1960s. This selection is based on the belief that the task of a museum is to collect art which is durable rather than merely contemporary, art which has had sufficient time to mature and to prove its historical worth. This is difficult to ascertain after a brief interval of twenty years or less; a certain element of uncertainty is unavoidable. Yet the museum has endeavoured to reduce this uncertainty to a minimum. When purchasing works of art, its prime concern is with their abiding value, since a museum collection is on permanent show, unlike temporary exhibitions, which reflect the day-to-day life of art, whether they are held in museums or elsewhere.

The relative newness of the collection means that gaps are inevitable. The visitor or reader who thinks in historical categories will quickly realize that there is a good deal missing: entire movements, such as Futurism, are unrepresented; there are no pictures by such major artists as Kasimir Malevich or Barnett Newman; there is no early Matisse, no Picasso from 1911/12, no triptych by Beckmann or Bacon. However, in art it makes more sense to look at the works themselves than at the gaps between them. As its title indicates, this book is not a history of twentieth-century art, in which such gaps would be unacceptable; instead, it deals with individual pictures. It has no pretensions to completeness. Nevertheless, via the commentaries on the pictures and the black-and-white illustrations, the book does offer an outline survey of the development of art from the turn of the century to the 1960s.

The emphasis is firmly on pictures. Hence, the present volume is essentially a picture-book with texts and accompanying visual material instead of a history of art or a guide to artistic styles. Its primary concern is not with movements, currents and groups, but with a collection of individual works which were acquired on account of their singular quality, rather than for purposes of historical documentation. A Cubist painting will invariably tell us something about Cubism, but it owes its place in this collection – and in this book – to its intrinsic artistic value: its historical significance as a

representative example of a particular artistic movement is not a prime consideration.

This has certain consequences for the structure of the book. Instead of being divided into chapters, it simply presents one picture after another. The most logical method of presentation would have been alphabetical, but this would have led to unacceptable visual clashes. The strategy which seemed most advisable was to arrange the pictures in an order which is historical but not strictly chronological. Although historical criteria played no part in the choice of the works, history offers a useful structural basis for a book of this kind. However, one remains somewhat reluctant to impose historical categories on the pictures: this is clearly apparent in the commentaries, whose principal task is to concentrate on the individual work. In the main, historical concepts of style are merely convenient labels, applied indiscriminately to artistic phenomena which defy classification, whose individuality renders such exercises in pigeon-holing futile. What is the use of such a label as 'Surrealism' in dealing with artists as disparate as Ernst, Dalí, Miró and Magritte? Many artists elude categorization altogether, either from the outset of their careers or gradually, as they develop. Here, the reader is largely deprived of the help afforded by neat chapter divisions; yet other assistance is offered in the shape of the commentaries on the individual pictures.

A further explanatory comment is necessary. Since the book focuses on the work of individual artists rather than on stylistic movements, some artists appear in the 'wrong' historical place: either too early or too late. This results from the way in which the succession of pictures creates the impression of a linear historical process, whereas the works in question are, in fact, often contemporaneous. In some cases, younger and older artists are grouped together where their artistic and historical positions coincide.

The Kunstsammlung Nordrhein-Westfalen was founded in 1961. Its collecting activities began in the autumn of 1962. The foundations had been laid for the collection in 1960, when the regional government of North Rhine-Westphalia acquired a total of eighty-eight paintings and drawings by Paul Klee; at this point there were no plans for establishing a museum. This volume includes only a small selection of the works from the Klee collection and from that devoted to the work of Julius Bissier which the museum began to assemble in 1968.

The fact that less than two hundred works were acquired over a period of some twenty-five years indicates the museum's insistence on giving precedence to artistic quality rather than quantity and historical comprehensiveness. As this book shows, the vexed question of what 'quality' means and how assessments of quality – judgments which are a matter of public concern – can be justified, is best answered by the pictures themselves, by the power with which they impress us. Artistic quality is a problem for philosophers and perhaps even for social psychologists, but in our practical dealings with art it is a concrete, everyday reality which cannot be argued away. If this were not the case, then neither the museum nor this book would have been possible.

A number of facts and figures remain to be mentioned. In 1965 sixty-three paintings went on public display for the first time in Schloss Jägerhof, a beautiful but small building at the edge of the Hofgarten in Düsseldorf. In 1968 the collection, which in the meantime numbered 183 works, including the Klees, was shown at the Düsseldorf Kunsthalle. In the same year the Kunsthaus, Zurich, showed all the new acquisitions plus parts of the Klee and Bissier collections. A similar show took place at the Tate Gallery in London in 1974, and a further exhibition, with a smaller number of works, was held at the Villa Hügel in Essen in 1979. Owing to the restricted space in Schloss Jägerhof only a small part of the collection could be put on permanent display. This situation was remedied in 1986, when the Kunstsammlung Nordrhein-Westfalen moved into a new building in the centre of Düsseldorf. It was only then that it became a fully functioning museum rather than a mere 'collection'.

The English edition of this book appears four years after the original German edition of 1986. Since then, major pictures by Henri Matisse (1904), Paul Klee (1929), Jean Dubuffet (1944), Emil Schumacher (1987), Antoni Tàpies (1988) and Georg Baselitz (1982, 1986) have been acquired, which are not included in this book.

WERNER SCHMALENBACH

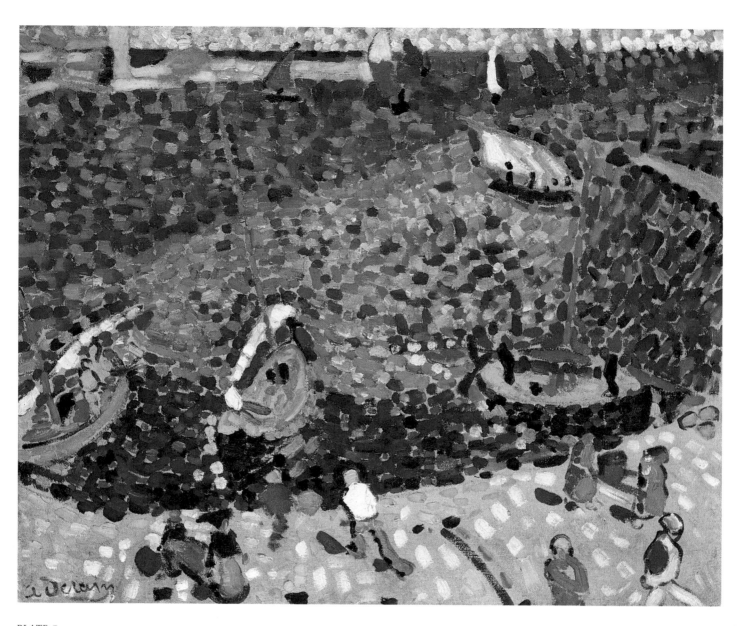

PLATE I
André Derain, *Boats at Collioure*, 1905
Oil on canvas, 60 x 73 cm

Fauvism and Cubism are the names of the two movements which ushered in the artistic revolution of the early twentieth century. Going beyond Impressionism, beyond the formal innovations of Paul Cézanne and the *fin de siècle* generation of Paul Gauguin, Vincent van Gogh, Henri de Toulouse-Lautrec, Georges Seurat and Edvard Munch, these two avant-garde movements, which have long since attained 'classic' status, led artists to turn away from the 'object' and to espouse a notion of the picture as an autonomous reality. In doing so, they emphasized, on the one hand, the idea of pure colour as an expressive value in its own right and, on the other, the expressive power of pure form. As modern art evolved, the expressiveness of colour tended to increase, while form strove for an ever-greater purity. The Fauves can be seen as the initiators of those forms of modern painting which are based on free expressive gesture, contrasting with the emphasis on constructive order which originated with Cubism. However, these two strands in the development of modern art are interwoven to an extent which makes it impossible to trace all subsequent schools and movements, including the Action Painting and geometrical abstraction of the 1950s and 1960s, to either a Fauvist or a Cubist model. The difficulty of doing this is compounded by the fact that contemporary art, and even the art of the inter-war years, is often concerned with issues which have little to do with colour or form. This is the case, for example, with Surrealism, Pop Art and many more recent artistic movements.

The Purity of Colours

The artists whose early derisive nickname 'Fauves' (wild beasts) subsequently became an accepted art-historical term are represented here by two landscapes, painted in 1905 and 1907 by André Derain and Georges Braque (Plates 1, 2). It is far from coincidental that both pictures were painted in the south of France, on the Mediterranean coast. Whereas the Impressionists – with the exception of Claude Monet, who paid occasional visits to Venice and the Côte d'Azur, and Auguste Renoir, who spent the latter part of his life in the South – had concentrated on Paris and its environs, the painters of the first Post-Impressionist generation had discovered the *Midi* as a source of artistic inspiration. Although the Impressionists, reacting against the dark tones of their predecessors, had been primarily interested in colour and light, they found that the sky and the diffuse light of the Ile-de-France and Normandy served their artistic purposes better than the brilliant sunshine of the South. The Impressionists broke light down into its prismatic components and covered the canvas with tiny particles of colour. They were not interested in stark contrasts: these became the province of the subsequent generation, which sought to maximize the expressive power of colour. With its strong light and bold colours, the South held a particular attraction for the Post-Impressionists: van Gogh moved to Provence, and Gauguin settled on a South Sea island. It is true that Cézanne also went to live in Provence, but his primary interest was in the Mediterranean clarity of the forms which he found there, rather than in the luminosity and power of the region's colours. Hence, the antithesis which later emerged between Fauvism and Cubism – between the emphasis on colour and that on form – is already apparent in the relationship between the Impressionists and Cézanne.

A generation later, after van Gogh, Gauguin and Seurat, when the Fauves began to proclaim their faith in pure and expressive colour, the south of France was a natural choice of artistic setting. The Fauves were particularly attracted to the Mediterranean coast. Henri Matisse and Maurice Vlaminck, Derain and Braque, celebrated their festival of colours in the region where the light was brightest and nature appeared most colourful.

DERAIN

Together with Matisse, the young André Derain (b. 1880) spent the summer of 1905 in the fishing village of Collioure. It was here that he painted his picture of the harbour, *Boats at Collioure* (Plate 1), whose brilliant, glowing colours are a form of manifesto, propagating the Fauvist idea of pure, autonomous colour. The work is clearly influenced by the style of Seurat and his Neo-Impressionist colleagues, who had systematized and formalized the techniques of Impressionism. However, the pointillist approach to colour, breaking it up into tiny particles (as in Seurat's *Fishing Fleet at Port-en-Bessin* [Fig. 1], which was painted in 1888, less than twenty years before *Boats at Collioure*), has given way to a technique which makes each blob of colour stand out as a solid, immovable element in the fixed architecture of the picture. It is scarcely surprising that Derain's contemporaries saw this wall of colour as wild, barbaric, *fauve*. However, unlike the far wilder creations of the German Expressionists, the picture did at least have a definite 'architectonic' structure; while breaking sharply with convention, its composition exhibited a high degree of rigour. The colours follow a strict pictorial order: for Derain, as for the Cubists a few years later, the authority of Cézanne was beyond question, and, when he repudiated Fauvism

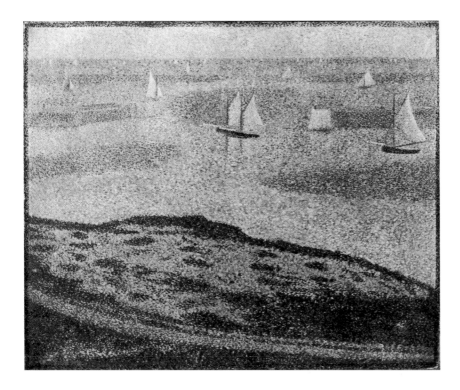

Fig. 1
Georges Seurat
Fishing Fleet at Port-en-Bessin, 1888

10

Fig. 2
Henri Matisse
The Red Beach, Collioure
1904

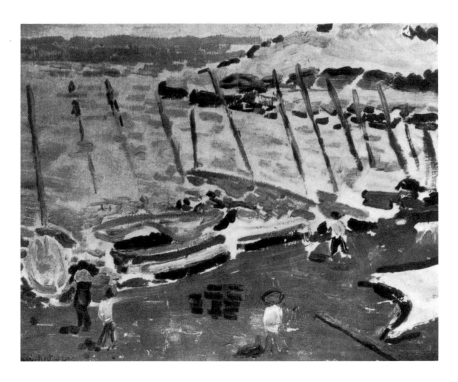

shortly afterwards, Derain naturally turned to Cézanne as his new stylistic mentor.

Boats at Collioure was influenced not only by Seurat's pointillist technique of painting, but also by the way in which, despite his atomization of colour, Seurat had challenged the Impressionists' indifference to form, reaffirming the importance of form and composition. This led, more by chance than design, to a renewal of emphasis on the shape of objects: a boat, for example, is no longer a mere fleeting impression of colour and light, but an object with precisely delineated contours. Although these contours are made up of minute particles of colour, they announce a return to line, which the Impressionists had rejected. This exerted a continuing influence on the work of the following generation: together with the rough pointillism of the pictorial structure, the exact demarcation of the coloured areas of the water in Derain's picture and the linear sharpness with which the tall masts of the boats cut through the surface of the water are strongly reminiscent of the work of Seurat and his friends.

Evidence of an interest in pointillism can also be detected in the Fauvist pictures of Matisse. A good example of this is his *The Red Beach, Collioure* (Fig. 2), painted in 1904, which shows a close affinity with the work of Derain. Although this picture is freer and less methodically organized than Derain's *Boats at Collioure*, there are obvious similarities between the two works. Here, too, the masts of the boats, placed in the central area of the painting, between the shore and the horizon, are a dominant formal motif, whose force is heightened by their parallelism; and, as in Derain's picture, the people in the diagonally demarcated foreground appear as freely mobile, coloured figures. No 'human' interest attaches to these figures: to this extent, Matisse and Derain are closer in spirit to Impressionism than to German Expressionism. Their expressive urge is directed towards colours rather than people.

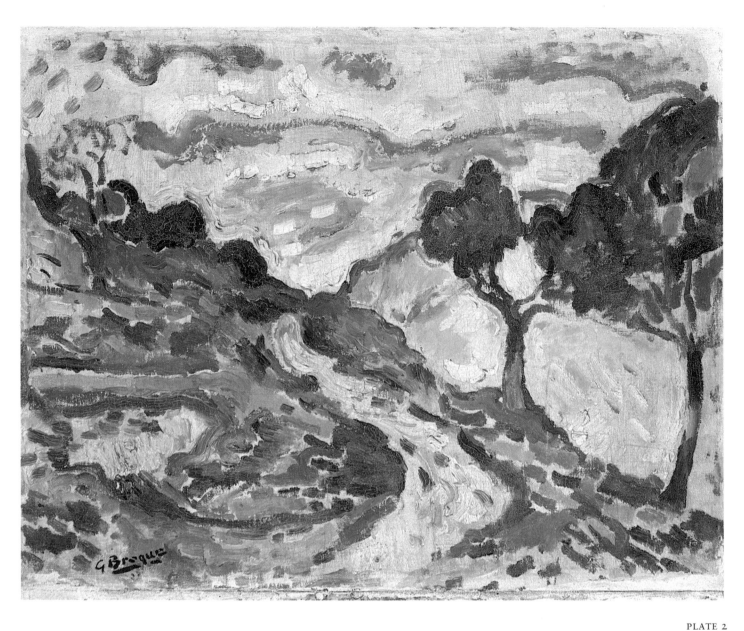

PLATE 2

Georges Braque
Landscape at La Ciotat, 1907
Oil on canvas, 38 x 46 cm

BRAQUE

The young Georges Braque was also fascinated by the Fauvist notion of the expressive autonomy of colour. However, his exquisite small-format *Landscape at La Ciotat* (Plate 2), painted in 1907, is more melodious, more lyrical and bucolic, less brazenly self-assured than Derain's view of the harbour at Collioure. Here, too, we find an emphasis on the immediacy of pure colour, but the nuances of colour are richer and more harmoniously balanced, and they follow the organic forms of the landscape in a more relaxed manner. Despite the residual pointillist influence, the dominant feature of the picture is linear movement: one even detects a faint hint of Art Nouveau, with its curves and elaborate arabesques. The same is true of Matisse's *Pastoral* (Fig. 3), where the lines of the figures and trees testify to the artist's deep respect for Gauguin and van Gogh, notwithstanding the distance between their work and his own.

Only a few months after Braque had painted *Landscape at La Ciotat*, his Fauvist period came to an end. It had lasted just under two

Fig. 3
Henri Matisse
Pastoral
1906

years. His encounter with Pablo Picasso's *Les Demoiselles d'Avignon* (1907), a picture of truly epoch-making significance, led him to embrace a different – indeed, entirely contrary – idea of painting, focusing not on colour, but on plain, almost monochrome form.

KIRCHNER

Ernst Ludwig Kirchner's *Girl under a Japanese Parasol* (Plate 3) documents the influence of Fauvism on the early work of the German Expressionists. The picture, whose central motif is the reclining figure of a nude girl, is dated 1906, but, like a second picture with the same title (Fig. 4), it was almost certainly painted in or around 1909. It is made up of pure, unbroken colours; the dominant yellows, blues, greens and reds form a series of vivid contrasts, generating a quite exceptional intensity. The brightly coloured parasol seems to spark off a kind of explosion, a pyrotechnic display in which the colours discharge their accumulated power. One is reminded of Derain, who, during his Fauvist period, declared that the artist's tubes of paint were like dynamite cartridges. The artists of the group *Die Brücke* (The Bridge) in Dresden particularly admired the work of Matisse, and there are obvious similarities between this picture and Matisse's *Nude with a White Scarf* (Fig. 5), especially in the painting of the girl's face, which is built up of patches and blocks of colour. It is probable that Kirchner visited the first German exhibition of Matisse's work, which was held at the beginning of 1909 in Berlin. During the first decade of the twentieth century almost all the major innovative German artists worshipped at the shrine of Matisse. The French artist was an object of interest not only to the members of *Die Brücke*, who were particularly attracted by his emphasis on the expressive value of colour, but also to the painters of the group *Der Blaue Reiter* (The Blue Rider) in Munich, led by

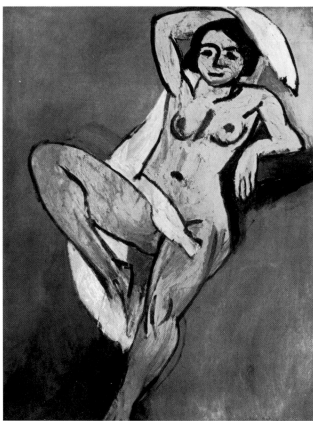

Vassily Kandinsky, whose primary concern was with form. Even Paul Klee, whose work contains few overt references to Matisse, reveals in his posthumously published writings that Matisse significantly influenced the development of his artistic thinking.

Fig. 4 Ernst Ludwig Kirchner
Girl under a Japanese Parasol, 1909

Fig. 5 Henri Matisse
Nude with a White Scarf, 1909

KANDINSKY

Kandinsky painted his *Composition IV* (Plate 4) in Munich in 1911, only a few years after Fauvism had reached its apogee. The picture is like a mighty fanfare of colours, heralding the arrival of a new era. In contrast to Kirchner's *Nude under a Japanese Parasol*, where the colour is partially liberated but retains a link with figure and object, the colour in Kandinsky's early masterpiece is almost completely divorced from the object, confidently proclaiming its status as an expressive medium in its own right. The picture stands at the threshold of what became known as abstract art. In view of both its historical significance and its exceptional intrinsic quality, it must be counted among the key works of twentieth-century art.

Here, too, there are traces of figurative detail: a mountain landscape, the truncated outline of a castle, the schematic forms of the riders battling on the left above a valley spanned by a rainbow, the phalanxes of black lances, and the three red-capped lancers in the foreground. However, all this is subordinate to colour, unfolding in pure, liberated glory, and to the free expressive play of line. 'Abstract' colour and line have moved to the forefront. Yet the term 'abstract', which is itself an abstraction, scarcely seems adequate to describe

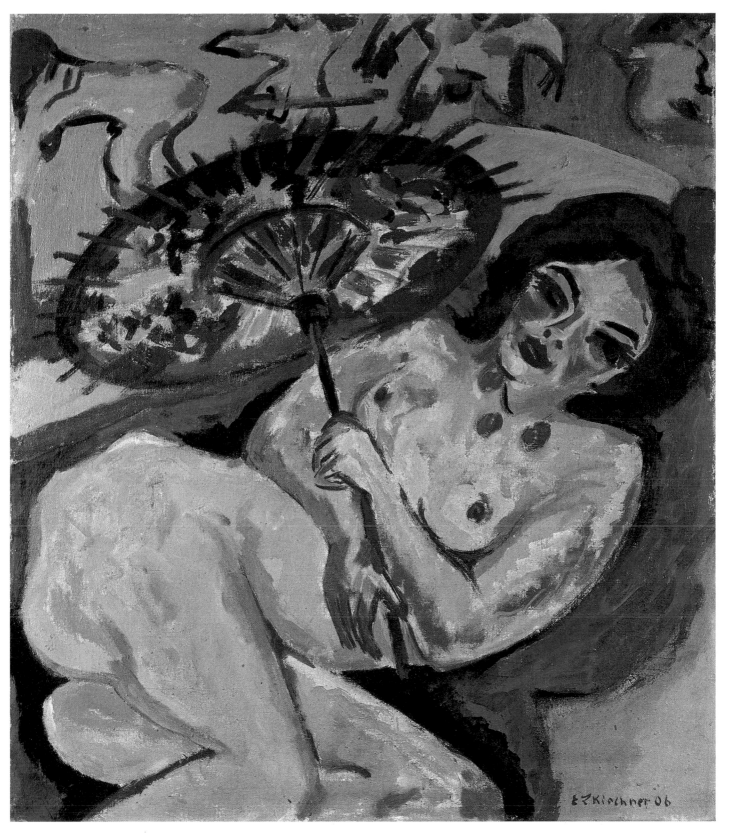

Fig. 6
Vassily Kandinsky
Battle, 1910

these colours and lines, charged as they are with living reality. The whole drama of the picture is acutely real: not because of the landscape and the events to which the work alludes, but because form has completely absorbed content. The form has a specifically expressive reality and, to this extent, it is more than merely 'abstract'. A mountain as such becomes meaningless: what counts is the intensity of the blue in which it is painted. A rainbow becomes a tri-tone harmony of colour. The drama lies in the clash of intersecting lines, rather than in the battle scene which they schematically depict. Abstract art was born not only of a new striving for form, but also of an urge to find new means of expression; at this point in its development it was closely allied with German Expressionism. In 1911, the year when *Composition IV* was painted, the first exhibition of the *Blaue Reiter* group was held in Munich, featuring works by Kandinsky, Franz Marc and August Macke.

Fig. 7
Vassily Kandinsky
Arabs II, 1911

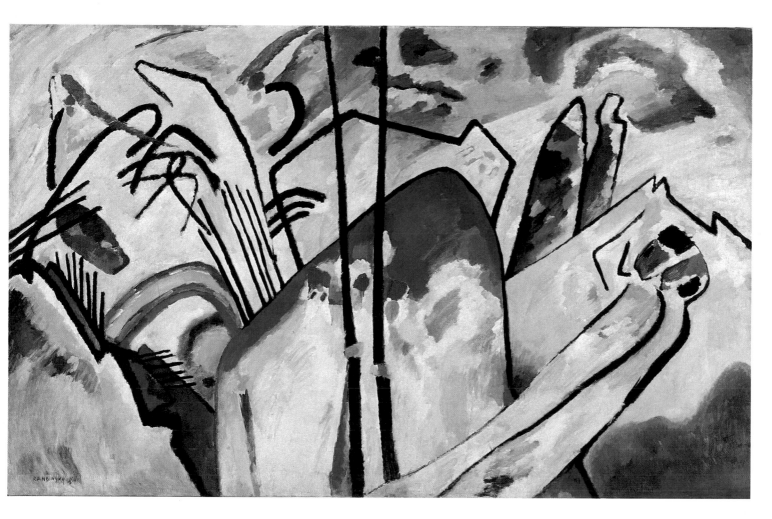

PLATE 4
Vassily Kandinsky, *Composition IV*, 1911
Oil on canvas, 159.5 x 250.5 cm

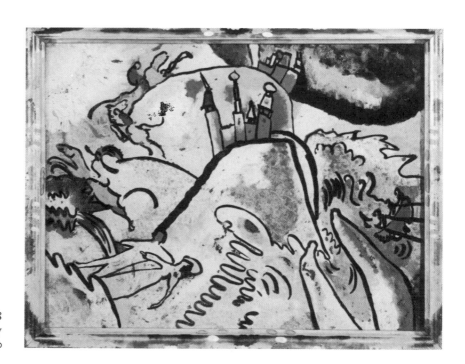

Fig. 8
Vassily Kandinsky
With Sun, 1910

The picture is part of a series of ten 'compositions' which Kandinsky painted between 1910 and 1939. He used the term 'composition', denoting a particular degree of perfection and symphonic orchestration, to distinguish these works from his other series of pictures, which he called 'impressions' and 'improvisations'. The 'compositions' are highly complex pictures in which the main and subsidiary motifs are closely interwoven and to whose execution Kandinsky devoted an especially large measure of formal deliberation and care. They were invariably preceded by a considerable number of drawings and colour studies. Four of the pencil and pen-and-ink drawings for *Composition IV* have survived (see Fig. 9, 10), together with a watercolour, which was probably done after the oil painting and was reproduced in the *Blaue Reiter* almanac in 1912. It is likely that the woodcut showing the same motif (Fig. 11) was also done after the painting. In addition, there is a picture painted in 1910 (Fig. 6) which anticipates the motifs found in the left-hand section of *Composition IV*.

In his autobiographical *Reminiscences,* published in 1913, Kandinsky subjected *Composition IV* to a rigorous analysis, in which he spoke of 'colour running over the boundaries of form' and the 'predominance of colour over form'. It would seem that he was endeavouring to formulate an alternative to Cubism, which had recently risen to prominence. Kandinsky's comments are somewhat misleading: what we in fact see in *Composition IV* is an even balance of colour and form, with the brilliantly coloured shapes offset by the black lines.

Regarding the content of the picture, Kandinsky offers only a few summary remarks, such as 'Principal contrast: between angular, sharp movement (battle) and light-cold sweet colours' and 'The juxtaposition of this bright-sweet-cold tone with angular movement (war) is the principal contrast in the picture.' *Composition IV* is a very far cry indeed from conventional depictions of battle scenes: what interests the painter is not the clash of arms, but the contrast of colours. Although figurative content has not yet been eliminated entirely, it is so attenuated that it takes a good deal of deciphering. Clues are provided by some of Kandinsky's other pictures from 1910/ 11. For example, the outlines of the lancers in *Arabs II* (Fig. 7) are

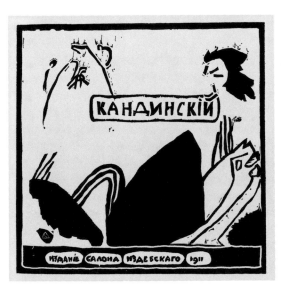

clearer than in *Composition IV*; their red caps confirm that the three red caps confirm that the three red patches which stand out in the centre of *Composition IV* are indeed the caps of three lancers, who are given no further distinguishing features. *With Sun* (Fig. 8), a painting on glass dating from 1910, features both a clearly recognizable castle on a hilltop and, on the left, a reclining couple which provides a clue to the identity of the pair of elongated figures in *Composition IV*. This reading of the motif is corroborated by Kandinsky himself, who speaks of 'the reclining figures'. Yet these figures reveal nothing of themselves to the viewer. The problems which one encounters in interpreting the content of the picture all point to the fact that the artist attaches far greater importance to the forms and colours themselves than to the reality to which they allude; understanding Kandinsky is not a matter of interpreting the signs in his pictures, but rather of accepting these signs on their own terms. The essential thing is not their content, but their expressive power.

The Avowal of Form

There is a sharp contrast between the exuberant use of colour seen in the work of the Fauves and the young Kandinsky, and the rigorous formal experiments of the Cubists. With a surprising degree of self-discipline, the Cubists resisted the temptations arising from the liberation of colour. Until 1907 Braque had moved in Fauve circles, and Picasso, too, had taken an interest in the free use of colour. But now both painters dispensed with the expressive value of colour and confined themselves to a limited, almost monochromatic range of colours, turning their full attention to the formal aspect of the picture. In 1907 Picasso painted *Les Demoiselles d'Avignon*, the work which initiated the decomposition of the object for the sake of form. The following year Braque painted his *L'Estaque* landscapes. Picasso spent the summer of 1909 in Horta de Ebro, where he painted a series of portraits of his mistress, Fernande Olivier (see Plate 6), together with a number of landscapes whose structure is rigorously Cubist. Here, the influence of Cézanne is unmistakable, both in the attitude to colour and in respect of Cézanne's famous dictum that three basic stereometric forms – the sphere, the cone and the cylinder – underlie the structure of the natural world. However, the essential distinguishing feature of Cubism was not the use of these forms, which were soon abandoned and replaced by non-stereometric, irregular ones; the real significance of the Cubist movement lies in the fact that the picture itself became more important than the objects depicted in it. Initially, Cubism was something of an embarrassment to critics and art historians, who were unsure what to make of it. According to one of the most popular contemporary interpretations, the Cubists' main interest was in simultaneity, in presenting several different views of, for example, a human face in one and the same picture. This explanation is manifestly inspired by the wish to read a 'realistic' motivation into something which the critic finds difficult to understand. It signally fails to grasp the Cubists' aim. They were not concerned with the human face, with nature, with the world of objects, but with the invention of a new pictorial language.

PICASSO

Until the winter of 1908/09 Picasso had painted pictures of the human figure which were highly expressive, albeit 'monochromatic', using various shades of brown. Compared with these works, *Woman with a Mandolin* (Plate 5), which was painted during that winter, appears wholly unexpressive: its tone is exceptionally mild and subdued. The subject-matter is one which readily lends itself to this kind of gentle, lyrical treatment. It is possible that Picasso deliberately chose an unspectacular motif so that the subject would not intrude on his attempts to develop a new formal language. Although there is a touch of lyricism in the use of colour, in the angle of the head and in the gentle curve of the right arm holding the instrument, Picasso's attention is focused primarily on the organization of the pictorial space, breaking up the spatial continuum into individual sections which collide abruptly with each other. The fragments of external reality – the woman's head and neck, her arm, the neck and body of the mandolin, the massive back of the chair – are joined together in an equally abrupt, discontinuous fashion. The artist's other main concern is with the colours, which form a structure of flat, interlinking patches and are richly nuanced, ranging from grey, via olive and green, to brown and enlivened by particularly charming reds and pinks. What makes the picture 'musical' is not its subject-matter, but its formal rhythm and the tonal values of its colours. Yet the subject does in a sense contribute to the overall effect by preparing the viewer to listen to the 'music' of the forms and colours. It would thus be wrong to dismiss the subject-matter as irrelevant: its significance is demonstrated by the fact that Picasso frequently returned to it in subsequent years. He painted several pictures of women playing the mandolin or the lute (see Fig. 12, 13). As a rule, however, he contented himself, especially during his Cubist period, with depicting the instrument by itself. There was no need to include the player: the evocation of rhythm and sound could be achieved by purely pictorial means.

Despite its artistic perfection, the picture of the mandolin-player contains a number of features indicating that it was a preliminary study. This is consonant with the fact that, at the time when the work was painted, Cubism was still very much at an experimental stage. One detects, for example, a certain impatience in the bunches of lines in the centre. The painting of the face, whose features are omitted in the interests of pure form, also shows how the artist was groping his way forward, searching for the right solution to the pictorial problem. It has been said that art is always abreast of its own aims, meaning that there is a measure of aesthetic validity to be found in even the most fleeting sketches and in pictures whose style is still evolving. With this picture and others like it, Picasso, who continued to derive inspiration from Cézanne, broke fresh ground and set the agenda for the new movement which was to become known as Cubism.

*

The early Cubism of the years 1909 und 1910 is generally known as 'analytical' Cubism, because its exponents still continued to analyse objects in terms of their stereometric content. However, this ap-

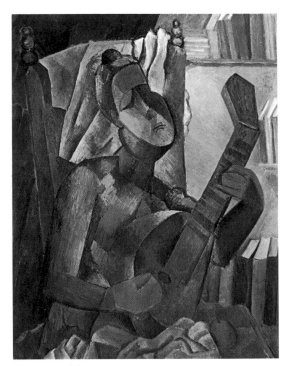

Fig. 12 Pablo Picasso
Woman with a Mandolin, 1909

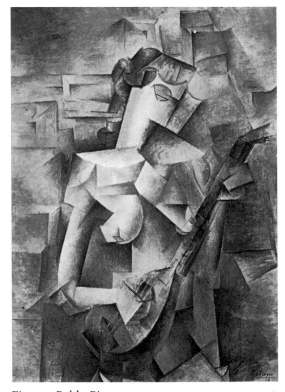

Fig. 13 Pablo Picasso
Young Girl with a Mandolin, 1910

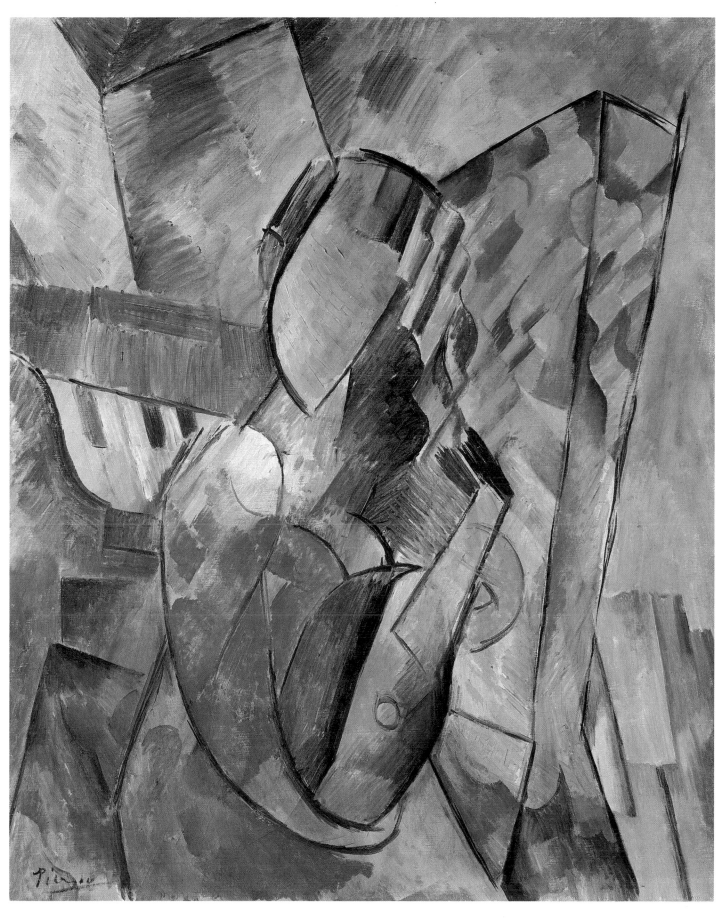

PLATE 5
Pablo Picasso, *Woman with a Mandolin*, 1908
Oil on canvas, 100 x 80 cm

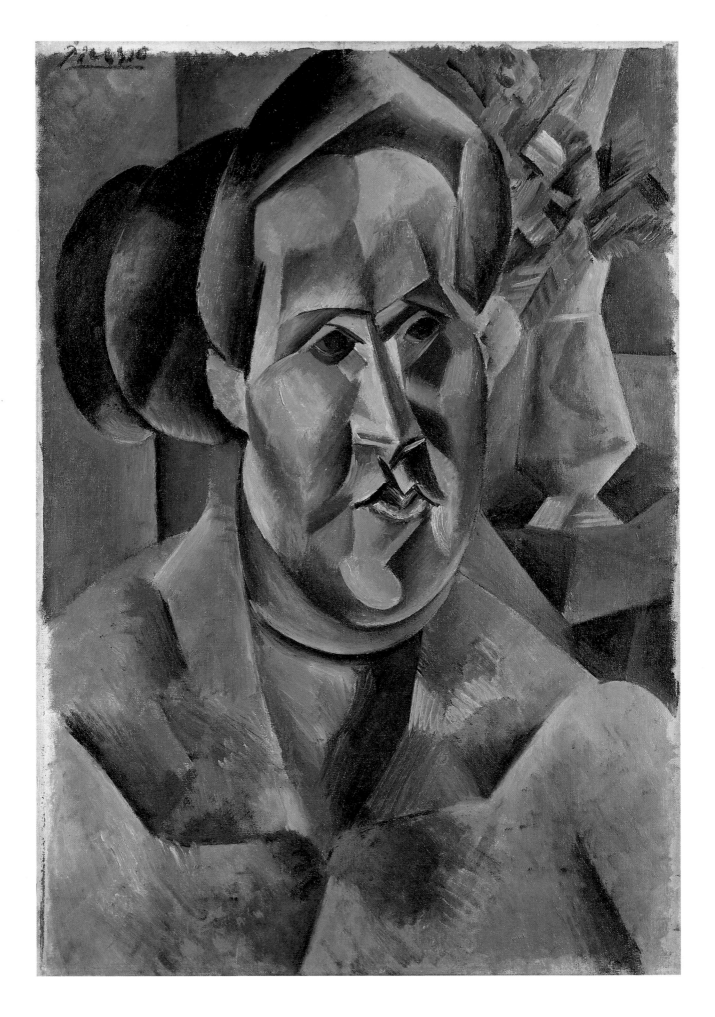

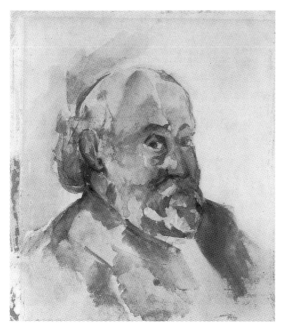

Fig. 14 Paul Cézanne, *Self-Portrait, c.* 1895

PLATE 6
Pablo Picasso
Portrait of Fernande, 1909
Oil on canvas, 61.8 x 42.8 cm

proach was rapidly superseded: from 1911 onwards, the free rhythm of forms took over the picture, subsuming all traces of the object. Analytical Cubism is represented here by *Portrait of Fernande* (Plate 6), which was painted in 1909. The human face and the vase retain their figurative integrity, but they are seen as conglomerations of cubic shapes which are not organically connected but collide abruptly. The anatomy of the picture has taken priority over the anatomy of the human face. A new unity has established itself, a unity which is no longer organic and functional, but rhythmical and painterly. Picasso and the Fauve generation abandoned the representation of nature as a continuum and replaced the laws of nature by the law of the picture. The way forward for this decisive innovation, which changed the face of art, had been shown by Cézanne. About 1895 Cézanne painted a watercolour self-portrait (Fig. 14) which clearly anticipates Picasso's *Portrait of Fernande*: there are detailed resemblances – in the painting of the eyes, for example – between the two pictures. Although Cézanne leaves the continuum of nature undisturbed, pictorial articulation has achieved a high degree of autonomy. Picasso takes this process of autonomization a stage further, producing an effect of crystalline hardness, but, at the same time, he continues to temper his new formal rigour with all the richness of a free painterly style.

The conflict between the picture, on the one hand, and nature and the object, on the other, is thus decided in favour of the picture. This has especially serious consequences for the portrait, which is normally defined by resemblance, by its likeness to the sitter. Picasso's aim was to paint a picture, rather than a portrait: what interested him was not the beauty of his mistress, but the beauty of the picture. To a large extent he therefore sacrificed resemblance, depriving the portrait of its real purpose. At a later stage in the development of Cubism he concealed the faces in a number of his portraits beneath a tissue of forms, rendering them wholly unrecognizable. However,

Fig. 15 Pablo Picasso
Study of a Head, 1909

Fig. 16 Pablo Picasso
Head of a Woman, 1909

23

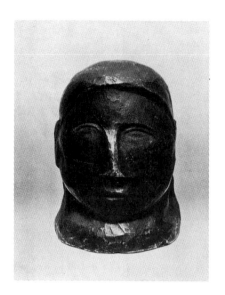 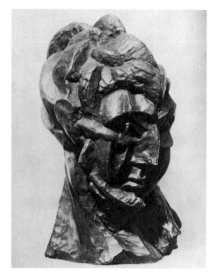

Fig. 17 Pablo Picasso
Head of a Woman, 1906/7

Fig. 18 Pablo Picasso
Head of a Woman, 1909

he was not prepared to do away with the object altogether, and the faces in his portraits even retain some of their individual features. The reason for this apparent inconsistency is that Picasso had a veritable passion for the visual and relied heavily on his subjects for inspiration: he was unable to dispense with the stimulus provided by the visible, tangible reality around him, before distorting and transforming it. For him, painting his mistress's portrait was an obvious thing to do; at the same time, though, it was equally necessary to go beyond mere portraiture and make something else out of the picture. 'You always have to start somewhere,' he remarked on one occasion. 'Afterwards you can remove all trace of reality.'

In addition to his many paintings and drawings of Fernande Olivier, Picasso also made two sculptures of her. The two busts, created in 1906/7 and 1909 (Fig. 17, 18), are exemplary documents of his early work, showing the direction in which his style was evolving. A number of the other images of Fernande stand in close proximity to the portrait discussed above. The drawings (see Fig. 15, 16) clearly demonstrate that Picasso was not interested in the physiognomy of his mistress for its own sake, but rather in the pictorial effects which he could achieve by breaking the face up into stereometric facets.

MODIGLIANI

Some two years after Picasso painted *Portrait of Fernande*, Amedeo Modigliani produced the oil sketch *Caryatid* (Plate 7). The rigorous formal construction of the figure would be inconceivable without the influence of Cubism. Yet the body is not fragmented in the typical Cubist manner; its form is merely simplified. In accordance with the tenets of the new artistic movement, the body is not a unified organic whole: the parts are put together one by one. Although the artist is not following a fixed dogma, he uses basic, schematic shapes: in the oval thighs, the triangular upper body, the spherical breasts, the egg-shaped head set roughly on the cylindrical neck, and the sharp angles of the raised arms. There is a marked emphasis on the horizontal and the vertical. However, in contrast to Cubist painting, formalization is

Fig. 19 Pablo Picasso, *Studies of Nudes*, 1907

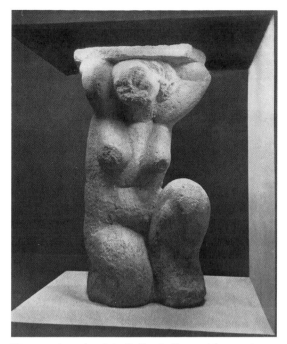

Fig. 20 Amedeo Modigliani, *Caryatid*, 1912/13

Amedeo Modigliani, *Caryatid*, 1911/12
Oil on canvas, 72.5 x 50 cm

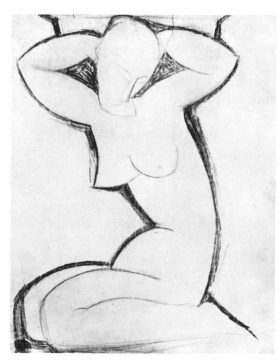

Fig. 21 Amedeo Modigliani, *Caryatid*, 1913/14

not used in a 'destructive' manner: the shape of the figure remains intact. Hence, although the picture was painted as late as 1911 or 1912, its style is clearly pre-Cubist.

The Cubists were greatly intrigued by the 'additive' principle of form as manifested in the sculpture of 'primitive' peoples and of early 'advanced' civilizations. During his pre-Cubist period Picasso, like many of his contemporaries, had found a new source of inspiration in African art (see Fig. 24). Modigliani and his circle also held African art in high esteem: Paul Guillaume, Modigliani's dealer, was an avid collector of 'negro' sculpture. Modigliani was influenced even more strongly by early Greek art, especially by the Cycladic idols, which at that time attracted the attention of a large number of artists. Yet the most important determining influence on his work was his

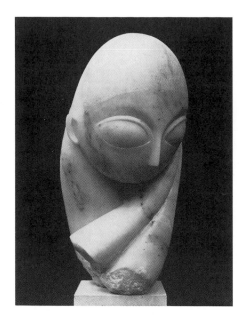

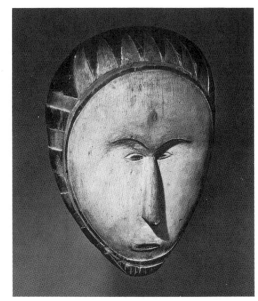

association with Constantin Brancusi, at whose suggestion he took up sculpture; for a time, the two artists even shared a studio. Over a period of several years Modigliani addressed the archaic, and to him essentially sculptural, theme of the caryatid in numerous sculptures, paintings, watercolours and drawings (see Fig. 20, 21). The close affinity between his work and that of Brancusi is clearly demonstrated by the formal resemblances between the latter's *Mademoiselle Pogany* (Fig. 22), which dates from 1913, and the head of Modigliani's caryatid. Picasso had explored the possibilities of the caryatid several years earlier, in 1907 (see Fig. 19).

<div align="center">*</div>

The influence of African art can also be detected in Modigliani's portrait of the writer Max Jacob (Plate 8). It is particularly apparent in the shape of the face and, above all, in the nose, which looks as if it has been carved with an axe. The picture, which was painted in 1916, is one of the artist's many portraits of writers, painters, sculptors and art dealers with whom he associated in Paris. It evokes the atmosphere of Montparnasse – the legendary world of the Café du Dôme, the Rotonde and the Select – with which Modigliani's name is indissolubly linked. It also documents the artist's unwillingness to follow the path trodden by the Cubists. His principal subject, to the near-exclusion of all others, was the portrait. In his treatment of this genre, which at the beginning of the twentieth century was already starting to show signs of exhaustion, Modigliani was the exact antipode of his near-contemporary Oskar Kokoschka, who outlived him by some fifty years. Whereas Kokoschka's portraits have an intense, almost hallucinatory quality (see Plate 36), Modigliani approached his subjects from a detached, Mediterranean perspective, paying less attention to psychological 'expression' than to external attitude, which he nevertheless shaped in accordance with his own stylistic will. This detachment is also reflected in the inclusion of the sitter's name in the portrait – a nonchalantly modernist gesture which would be unthinkable in the work of Kokoschka. It was from the Cubists that Modigliani took the idea of introducing writing into the picture, although Gauguin and van Gogh had also occasionally

Fig. 22 Constantin Brancusi
Mademoiselle Pogany, 1913

Fig. 23 Head of an idol, *c.* 2600 B.C.
Found on the island of Amorgos in the Cyclades

Fig. 24 Mask of the Fang tribe, Gabon.
Formerly owned by André Derain

26

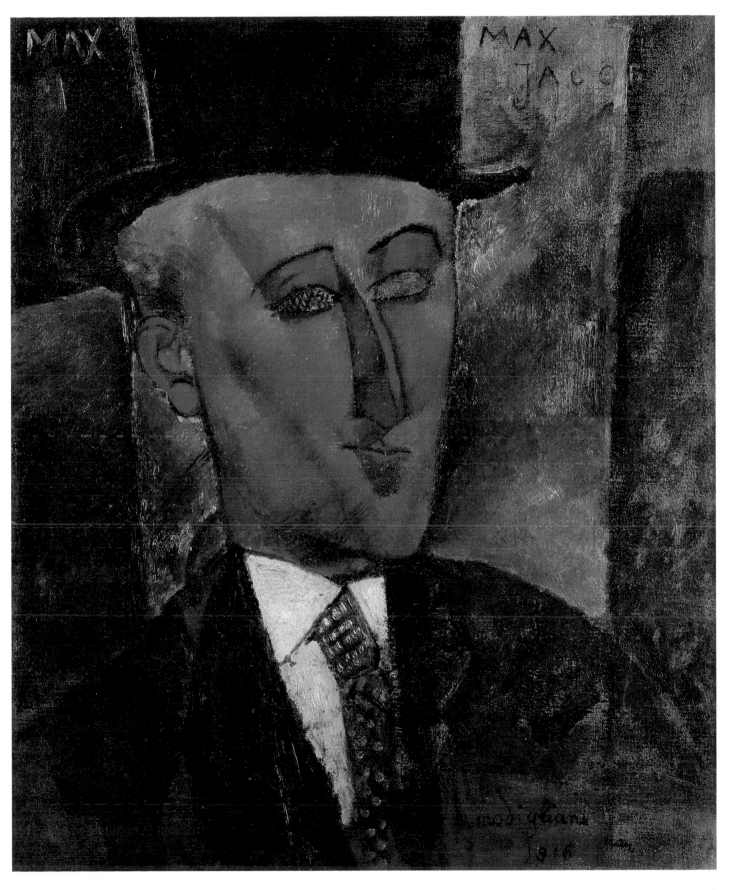

PLATE 8
Amedeo Modigliani
Portrait of Max Jacob, 1916
Oil on canvas, 73 x 60 cm

Fig. 25 Amedeo Modigliani
Max Jacob, 1915

Fig. 26 Amedeo Modigliani
Max Jacob, 1916

used this device. One detects, in addition, a veiled allusion to the pictures of street ballad-singers, which in the case of an Italian artist would be a quite likely source of influence, especially in view of the fact that Modigliani, like so many artists at the time, preferred subcultural amusements to the pleasures of bourgeois 'high' culture.

One of Modigliani's drawings (Fig. 26) bears a detailed resemblance to the portrait of Max Jacob: it even features the same strange cross-hatching in the right eye. We also encounter the cross-hatching, albeit in a somewhat different form, in a second portrait of the writer, which was painted at roughly the same time but which is a less stylized and altogether less finished work. Finally, there is a further portrait of Max Jacob (Fig. 25), from which only the top hat is missing: otherwise it is almost identical with the work discussed above.

*

Some two years before he painted the portrait of Max Jacob, Modigliani portrayed the Mexican painter Diego Rivera (Plate 9), who lived in Paris for several years and belonged to the same circle of artists and writers as Modigliani himself. As well as endless discussions on art, the friendship between the Italian painter and his Mexican colleague involved frequent alcoholic excesses. Rivera's contemporaries compared his physical appearance with that of an Arabian sheikh; his exceptional bulk and his Rabelaisian appetite for the pleasures of the flesh earned him the nicknames 'Gargantua' und 'Pantagruel'. The sculptor Jacques Lipchitz, who also sat for Modigliani, described Rivera as 'a wild Indian, passionately committed, humorous, aggressive, strong on expression and, despite his pensiveness, inordinately cheerful.' This is how he appears in Modigliani's portrait. The spherical head poised on the thick neck has a small, sensuous mouth; the expression on the face suggests intelligence, coupled with laziness and arrogance. In this picture the artist has dispensed with his customary form of stylization, as if he had found it impossible to mould a face of this kind into a narrow, elongated, angular shape of the usual 'Modigliani' type. Here, everything is round, full and sensuous. The colour is also atypical: with its blue-tinged dark tones, the picture reminds one more of Georges

PLATE 9
Amedeo Modigliani
Portrait of Diego Rivera, 1914
Oil on cardboard, 104×75 cm

Fig. 27 Amedeo Modigliani, *Diego Rivera*, 1915

28

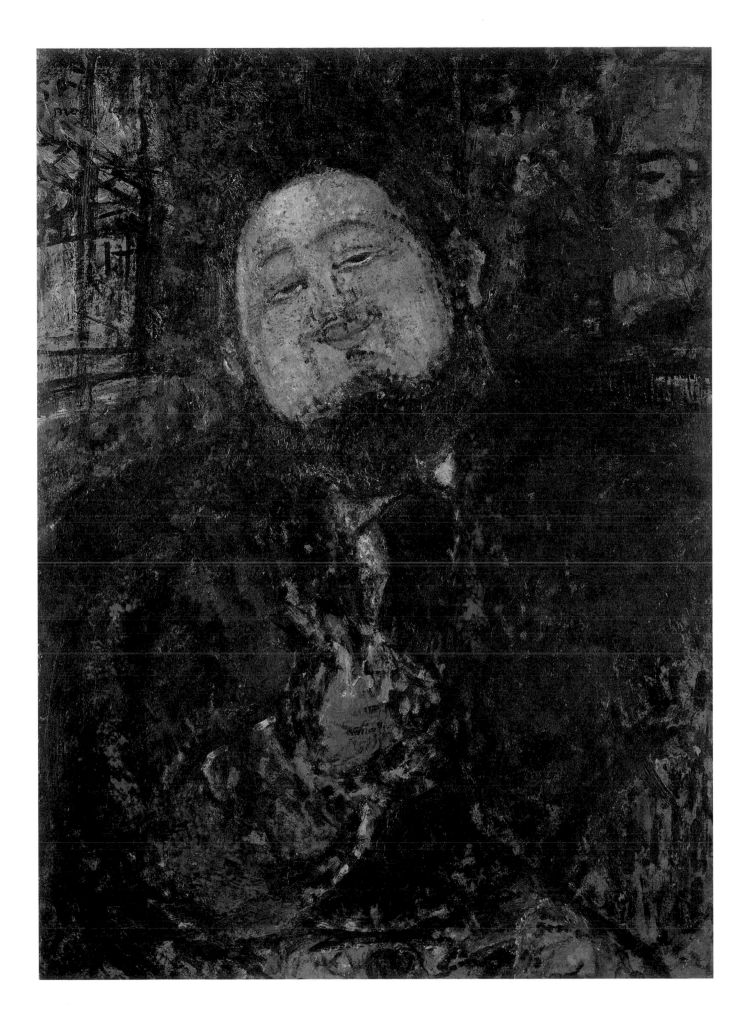

Rouault than of Modigliani. Here, as in several portraits which Modigliani painted at about the same time, one sees an almost Impressionist looseness in the handling of the paint. The sitter's face, looming up out of the surrounding darkness, is flecked with small dots of colour. His massive hand, which holds an almost invisible pipe, is painted in a manner which blurs its outlines, while at the same time emphasizing its voluminous presence.

In the top right-hand corner of the picture it is just possible to discern the sitter's name. It can be seen more clearly in one of the two drawings which preceded the painting (Fig. 27). The line in the drawings is loose and hovering, lacking the sharp precision which generally characterizes Modigliani's work.

Modigliani also did an oil study of Diego Rivera (Fig. 28). The pose is less provocatively arrogant, and the colours, too, are different from those in the finished portrait. Legend has it that Modigliani painted the portrait on the floor of his friend's studio. However, it is more probable that he chose to depict Rivera from a low viewpoint for artistic and psychological reasons, in order to emphasize the sitter's bulk and his swaggering sense of superiority. The device does not occur in any of Modigliani's other portraits. It is possible that he made the first of the two drawings on the floor and that this gave him the idea of painting the portrait as if he were looking up from below, an effect which greatly enhances its expressive force.

Fig. 28 Amedeo Modigliani, *Diego Rivera*, 1914

BRAQUE

During 1911 and 1912 Cubism underwent a fundamental change. The formal analysis of the object, as seen in Picasso's *Portrait of Fernande* (Plate 6), was replaced by the synthesis of liberated form: the picture itself became an autonomous object. At the same time, the construction of the picture took on an increasingly two-dimensional character, thereby emptying the term 'Cubism' of its original meaning – 'Cubism' was in any case no more than a convenient label, which the artists themselves did not use. From this point on, one rarely encounters stereometric, three-dimensional elements in the pictures: all one finds is a very general sense of space, without perspective, which in turn rapidly yields to two-dimensionality.

This historic moment in the development of modern art is exemplified by Georges Braque's *Still Life with Harp and Violin* (Plate 10), which was painted in 1912. Here, as in Kandinsky's *Composition IV* (Plate 4), the figurative content has been almost entirely dissolved, but, in Braque's case, the agent of this dissolution is not colour but form. The violin, the harp, the table and the brandy glass are mere citations in the multi-layered rhythm of linear forms, as are the letters 'EMPS', which refer to the newspaper *Le Temps*. Braque has achieved a large measure of formal autonomy. A move towards the geometrical is apparent in both the pyramid-like form and the precise but nevertheless 'painted' lines which chant out the rhythm. Yet Braque avoids imposing a horizontal/vertical structure on the whole. The limited range of colours – brown, ochre and grey – is typical of

PLATE 10
Georges Braque
*Still Life with Harp
and Violin*, 1912
Oil on canvas, 116 x 81 cm

Fig. 29 Georges Braque, *Pedestal Table*, 1911

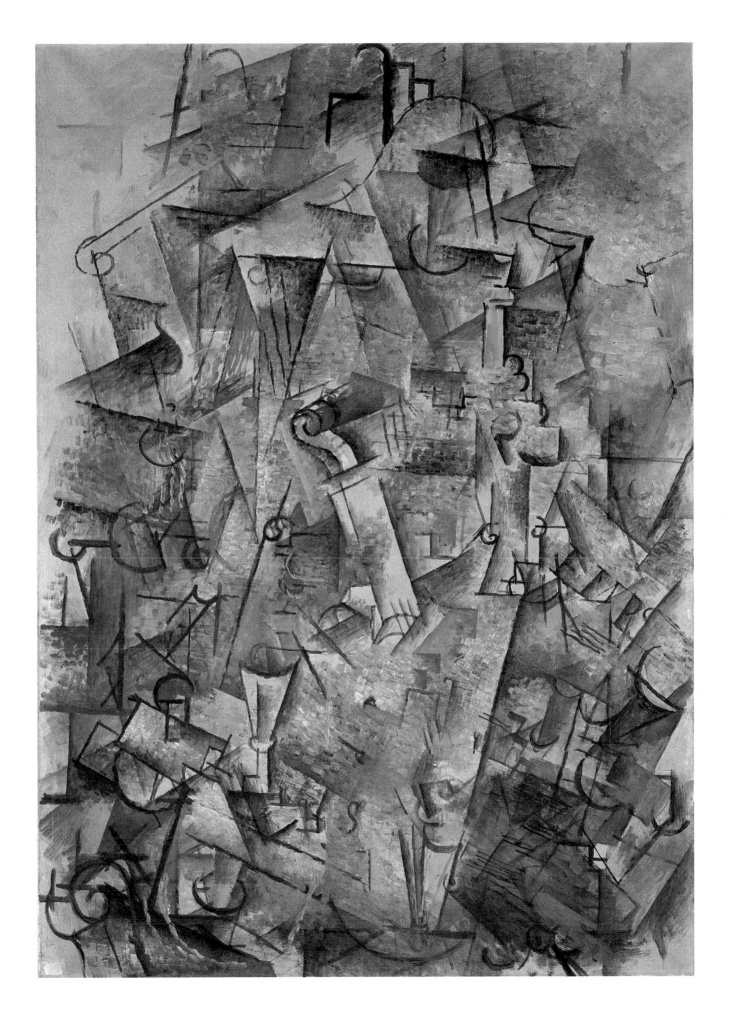

PLATE 11
Pablo Picasso
The Guitar, 1913
Oil on canvas
116.5 x 81 cm

Cubism, but, despite the tendency towards the monochrome, the colours are used with a far greater degree of freedom than in Picasso's *Portrait of Fernande*. Colour, too, has freed itself from the figurative and is imbued with its own specific meaning. With its clarity and formal precision, its lightness and lucid spirituality, *Still Life with Harp and Violin* exemplifies the 'Latin' pictorial language of the Cubist revolution.

As far as the relationship of picture to object is concerned, fragmentation is the new order of the day – an order which, strangely enough, was never expressly proclaimed by the artists but which they none the less followed on any number of occasions. The object is not eliminated, but it loses its privileged status and is tolerated only in a fragmentary form. Although it retains a voice in the concert of forms, this voice has grown weak; it is almost drowned by the picture itself. External reality has become a fund of pictorial material which the artist can exploit at will. In the fine tissues of lines embedded in the layered surface of the paint one barely discerns the remnants of figurative images. Here, as in Picasso's *Woman with a Mandolin* (Plate 5), the musicality of the picture is to some extent underlined by the rudimentary figurative allusions to musical instruments; however, the work does not depend on these allusions for its effect.

PICASSO

Picasso's still life *The Guitar* (Plate 11), painted in 1913, has an even more clearly 'Latin' feel. It is a completely 'unexpressive' composition with a perfect balance of forms and colours. The picture features the typical props of the Cubist still life: a table, a musical instrument and a bottle. Yet these objects are of little intrinsic interest. In so far as it almost oversteps the threshold of abstraction, the work is untypical of the artist's oeuvre as a whole: Picasso viewed the emergence of abstract art with scepticism and continued to reject abstraction throughout his life.

The picture exhibits a high degree of formal rigour. Unlike Braque's still life from the previous year, with its nervous, fragmented structure, *The Guitar* is made up of large, clear, harmoniously balanced areas of colour. Cubism has become fully two-dimensional. The forms have little sense of volume and physical presence; the black shadows which accompany some of them – a device rarely seen in Cubist painting – are no more than ornamental outlines; one two-dimensional form adjoins another. The picture differs from a number of its immediate predecessors in that the colours are strictly demarcated: they are not allowed to extend beyond the borders of the individual forms. Here and there, the paint is mixed with sand – a device to which both Picasso and Braque frequently resorted during this period in order to create interesting textural effects. Some sections of the picture have been given a pointillist treatment. One finds Picasso using a similar technique, covering individual parts of a picture with small dots of colour, in a large number of works dating from 1913 to 1915, including several versions of a small painted sculpture of an absinth glass, made in 1914 (see Fig. 30).

Fig. 30 Pablo Picasso, *Glass of Absinth*, 1914

Thus, the Cubists fragmented the object and embraced the principle of two-dimensionality. A natural consequence of this was their discovery, in 1912 or thereabouts, of collage, which opened a new and important chapter in the history of modern art. The idea of collage was quickly taken up by the Italian Futurists and, soon afterwards, by the Dadaists; its fructifying influence can be seen in almost all the artistic movements which followed. For artists everywhere, the realization that painting was not indispensable, that pictures could be stuck together from ready-made materials, had a tremendous, liberating significance. It was here that the rejection of traditional notions of painting and of the canons of 'high' art found its most radical expression. Since the function of art was no longer to imitate or idealize nature, there was no problem about using profane materials: indeed, the aim of desecrating art called for materials which were as trivial and cheap as possible, even for the deliberate inclusion of kitsch.

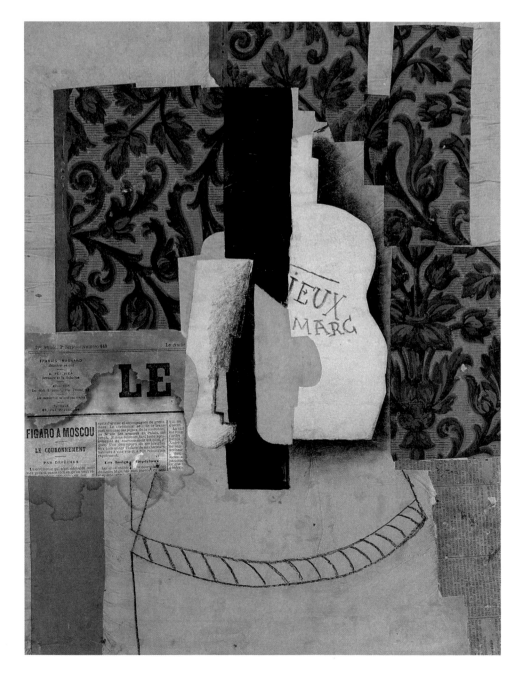

PLATE 12
Pablo Picasso
Still Life with Bottle and Glass, 1913
Collage, charcoal and oil on canvas, 62 x 48 cm

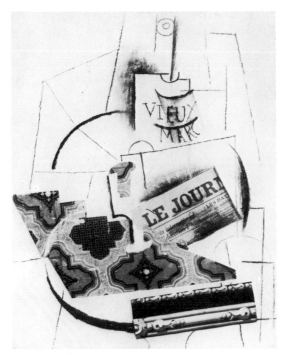

Fig. 31 Pablo Picasso, *Bottle of Vieux Marc, Glass, Newspaper*, 1912

In this way reality abruptly and surprisingly returned to art, just at the point when it had detached itself from reality. The collages did not merely depict real shapes, such as a string instrument or a cognac glass; they also used 'real' paper: bits of newspaper, wallpaper, music-paper, cigarette packets and the like. The invasion of art by reality was not merely illusionistic; it was concrete and tangible. This was only possible by virtue of the fact that art had ceased to reflect reality. Precisely because it had become non-figurative it could afford to incorporate real objects. In the natural setting of a picture based on illusion there was no place for real objects; reality had to be processed and transformed into 'painting'. Hence, paradoxically, more abstraction meant more opportunities for the real object, and art took a dialectical leap from abstraction to figuration. Picasso enthusiastically seized the opportunity offered by this sudden shift in the development of art. With the advent of collage, the dialogue between art and reality took on a new dimension, and the stimulating effect of this innovation was felt until well into the second half of the century.

*

Two collages created by Picasso and Juan Gris in 1913 and 1914 respectively (Plates 12, 13) show that, in stylistic terms, the step from such a painting as Picasso's *The Guitar* to the collages was relatively small: the flat coloured surfaces are no longer 'cut out' with a brush, but literally, with scissors. With their materiality, their patina and their partly printed surfaces, the different kinds of paper used in the collages also satisfy the strong interest in textures apparent in the paintings. Furthermore, the paintings themselves remind one of collages: the Cubists – Gris in particular – were much given to using paint to imitate the appearance of various sorts of paper. The school of painting which had rejected the illusionistic imitation of nature employed both 'real' and simulated materials.

Picasso's *Still Life with Bottle and Glass* (Plate 12) is made of newspaper clippings, pieces of wallpaper with a tasteless flower pattern

Fig. 32
Pablo Picasso
*Guitar, Glass
and Bottle*, 1912

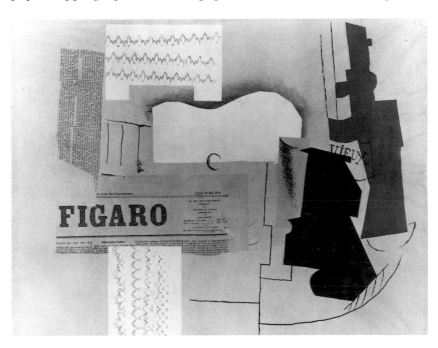

and cut-out shapes which denote the bottle and the glass; the table on which the objects stand is indicated by rough charcoal lines. The paper itself clarifies and emphasizes the two-dimensional structure, eliminates any lingering vestige of illusionism and, at the same time, introduces an element of everyday reality into the composition. This last effect is heightened by the pattern of the wallpaper, which brings kitsch into art as an aesthetic irritant – an innovation which was taken up by the Dadaists and Surrealists, who made liberal use of kitsch motifs.

Within the austere formal context of the picture, the newspaper clippings contribute a sense of life, of modernity: they, too, are a reference to reality which, to a greater degree than the highly formalized bottle and glass, punctures the abstractness of the picture. It is interesting to note that Picasso has taken the clippings from a thirty-year-old copy of *Le Figaro,* anticipating that the paper would eventually yellow and age. The aura of modernity, of up-to-dateness, was evidently more important to him than the real thing. His use of this material is not the product of a momentary flash of genius: he deals with it in a methodical and truly economical manner. Another, immediately adjacent section from the same page of the newspaper appears in a collage from the same period which is now in the Tate Gallery in London: *Guitar, Glass and Bottle* (Fig. 32). Between 1910 and 1920 Picasso took the arrangement of objects seen in this collage and modified it in a large number of paintings, collages and drawings – for example, *Bottle of Vieux Marc, Glass, Newspaper* (Fig. 31), which dates from 1912.

GRIS

In 1914 Juan Gris created his large-format collage *Teacups* (Plate 13). The formal rigour of the work contrasts sharply with the improvisational charm of Picasso's collage from the previous year (Plate 12). Here, too, a selection of objects is arranged on a table. The surface of the table, drawn in charcoal, has the appearance of a chessboard or a kind of picture puzzle, oscillating between the two-dimensional plane and three-dimensional space; it creates the effect of a set of steps, rising upward and – depending on how one looks at the picture – extending to the left or right. Gris employs the naturalistic device of *trompe l'œil* (deceiving the eye) in a non-naturalistic, predominantly abstract context. The device is repeated in the astonishingly realistic drawing of the pipe in the top left-hand corner: it lies next to a cup and saucer which have been fragmented almost beyond recognition.

This juxtaposition of opposites is a frequent feature of Gris's work. In his *Breakfast* (Fig. 33), which also dates from 1914, the appearance of the teacups is left intact, as a naturalistic accompaniment to the play of abstract forms. In this picture the clash of different styles becomes a deliberate stylistic device. The picture-puzzle effect is heightened by the pieces of wallpaper, which, on the one hand, strike a note of authenticity and, on the other, disavow this sense of reality by dint of their imitation-wood pattern. The artist evidently

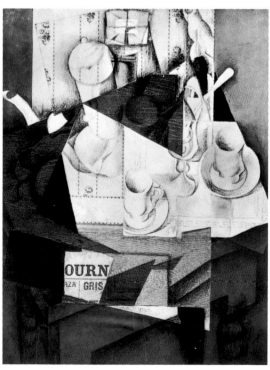

Fig. 33 Juan Gris, *Breakfast,* 1914

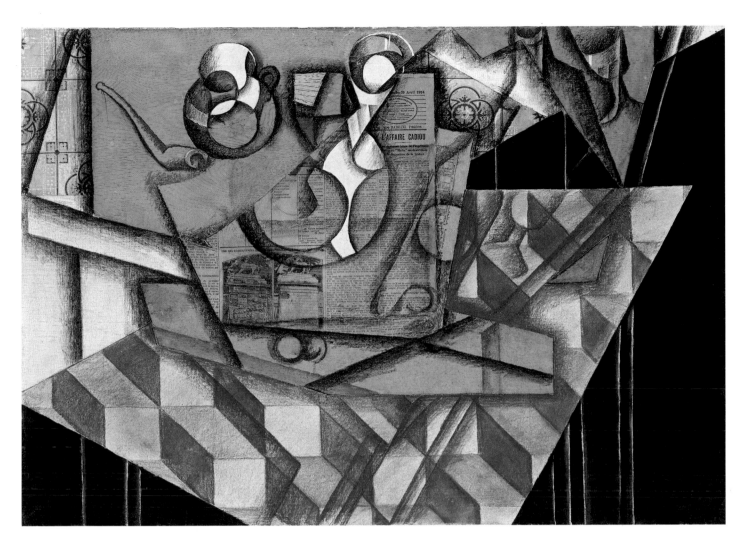

welcomed the tastelessness of the pattern as an additional aesthetic
irritant.

*

A variant on the motif of the wood-patterned wallpaper is seen in
Still Life (Violin and Inkwell) (Plate 14), which was painted in 1913.
Here, the imitation-wood pattern is itself 'imitated', that is, painted
in an illusionistic manner. The picture has the overall appearance of
a collage: the vertical strips look as though they had been cut out,
turned sideways on and rearranged. Gris used this method of compo-
sition in a variety of ways (see Fig. 34). It is a particularly effective
means of subjugating the object to pictorial law. As is so often the
case in Cubist pictures, *Still Life (Violin and Inkwell)* features a
string instrument, although the work has no specifically musical
resonance. Like all the other motifs, the instrument is cut up into
strips; the individual sections are dealt with in a manner which is
partly two-dimensional, partly linear, and the colouring also varies
from one section to another. The deep black shadows immediately
remind one of Picasso's still life from the same year (Plate 11), which
may well have been influenced by Gris, not only in respect of this
particular detail, but also in terms of the relatively 'puritan' overall
attitude to which Gris, of all the Cubists, inclined most heavily. A
further significant feature of Gris's still life is the inclusion of the
patterned silk ribbons: here, we find the artist exploiting the aesthetic

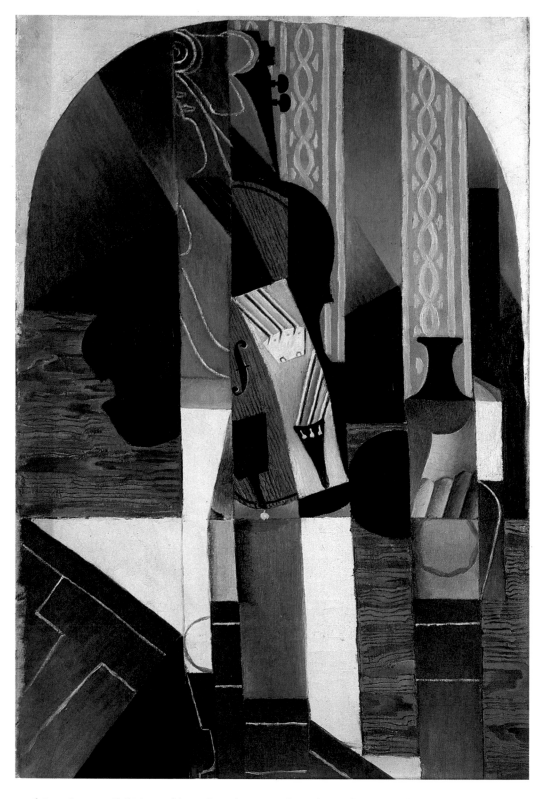

PLATE 14
Juan Gris
*Still Life (Violin
and Inkwell)*, 1913
Oil on canvas
89.5 x 60.5 cm

and ironic possibilities of kitsch. The round arch at the top of the
picture contributes a final element of surprise: like the oval framing
of some of Picasso's and Braque's still lifes, it strikes a highly tradi-
tional, almost antiquarian note which clashes with and, at the same
time, highlights the modernity of the picture.

*

A still greater measure of formal austerity is to be seen in *Still Life
with Newspaper* (Plate 15), which was painted in 1916. The almost

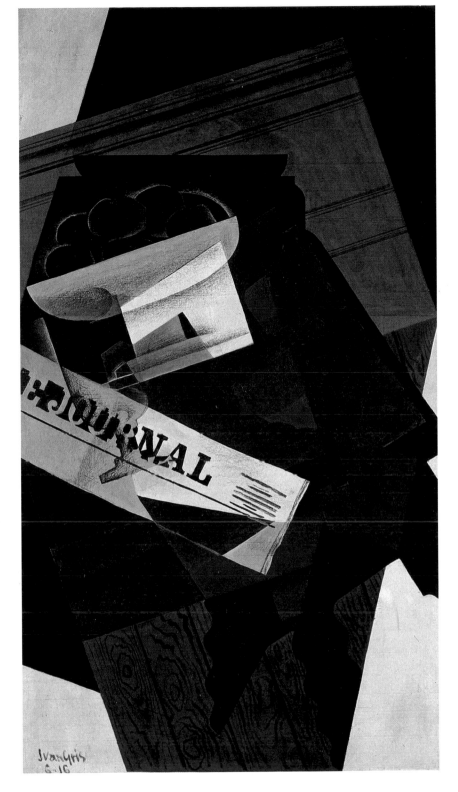

Fig. 34 Juan Gris, *Violin and Guitar*, 1913

puritanical style of the picture is typical of Gris's work from this period. There is little sense of movement in the colours: they rest lifelessly – flat, smooth and cold – on the hard surface of the panel. The forms are piled up in a heap of precariously balanced diagonal lines. To an even larger extent than in the first two pictures, the main emphasis is on form. The objects – the table, the fruit-dish and the newspaper – have been adapted to meet specifically formal requirements, in accordance with Gris's dictum that 'An object

39

painted by me is merely a modification of a pre-existent pictorial relationship.' Although Gris was not opposed in principle to the artistic approach of Picasso, he inclined more heavily than the latter towards a notion of the picture as an autonomous artefact, governed by its own internal laws. However, the illusionistic imitation of wood and the typographical play on the word 'Journal' show that Gris's austerity still left a certain amount of room for an element of playfulness.

CARRA

Although Carlo Carrà's collage *Still Life with Soda Syphon* (Plate 16), created in 1914, is a product of Italian Futurism, it bears a certain resemblance to the collages of Picasso and Gris. However, it is distinguished from these by its colourfulness and its sense of life and movement. The subject-matter is similar to that found in most of the Cubist collages: a still life with a bottle and glass. What makes the picture unusual is that individual parts of the image, such as the base, the middle section and the nozzle of the syphon, are three-dimensionally moulded, which emphasizes the character of the work as object. The sprinkling of coloured dots on the syphon immediately

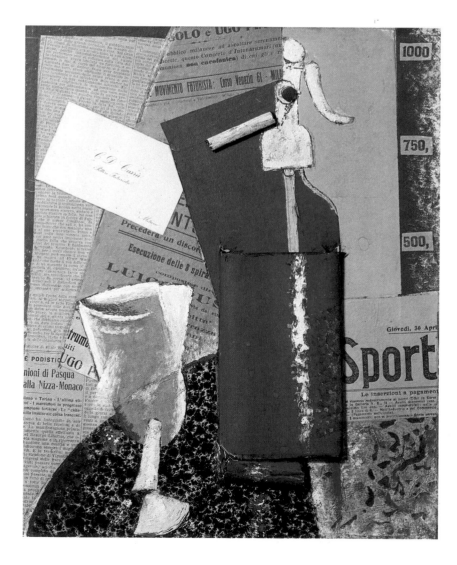

PLATE 16
Carlo Carrà
Still Life with Soda Syphon
1914
Collage and tempera on paper
44.5 × 33 cm

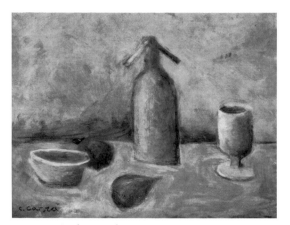

Fig. 35 Carlo Carrà
Still Life with Soda Syphon, 1965

reminds one of Picasso's painted bronze sculpture of an absinth glass (Fig. 30), which dates from the same year.

Despite its rigorous formal structure, Carrà's collage positively teems with life. On the one hand, there is the clarity of the demarcations between the individual sections, the almost geometrical appearance of the right-angles and semi-circles, the highly structured manner in which the separate parts of the image are put together, and the controlled alternation of colours from one part to another. On the other hand, the picture is packed with references to living reality: the newspaper clipping with the banner headline 'Sport', which is a calculated affront to traditional views of art; a clipping from a handout advertising a Futurist happening; a visiting card on which the artist styles himself 'Futurist Painter'; three miscellaneous price tags from a shop; a cognac glass leaning somewhat drunkenly to one side; and, finally, the soda syphon, wittily cobbled together from odd bits and pieces.

Shortly after he produced this collage, Carrà joined forces with Giorgio de Chirico in developing the style known as Metaphysical Painting (see Plate 49). From about 1920 onwards, however, he reverted to a more traditional style, painting mainly landscapes and still lifes with simple, basic forms. It would seem that the motif of the soda syphon and glass continued to intrigue him: in 1965 he painted a still life (Fig. 35) in which the form of the syphon is stabilized and confronted in a traditional manner with a small number of other objects. Unlike the Futurist collage, the late painting conveys a sense of harmony and tranquillity.

DELAUNAY

Such paintings as Picasso's *The Guitar* (Plate 11) and Gris's two still lifes (Plates 14, 15) show that, from 1912 onwards, Cubism had been moving away from its monochrome beginnings and gradually reconciling itself with colour. Within the circle of artists whose work is based on general Cubist principles, two painters in particular stand out as advocates of colour. One of these, Fernand Léger, is generally seen as a 'true' Cubist; the other, Robert Delaunay, as an exponent of what the poet Guillaume Apollinaire termed, somewhat obscurely, 'Orphic' Cubism.

In an exemplary fashion Delaunay's painting illustrates the liberation of both form and colour from the object. Delaunay augmented the Cubist fragmentation of the forms of external reality with an informed theoretical understanding of light and colour: he was especially interested in the coloured effects generated by the refraction of light. In this way he combined the tradition of Cézanne, handed down via Cubism, with that of Impressionism, as mediated by the Fauves. His interest in the theme of light and colour is initially exemplified by a number of pictures in which he explored the theories of Seurat. This was followed, in 1912/13, by the series of paintings entitled *Simultaneous Windows*, which has a central place in his oeuvre and exercised a major influence on European art.

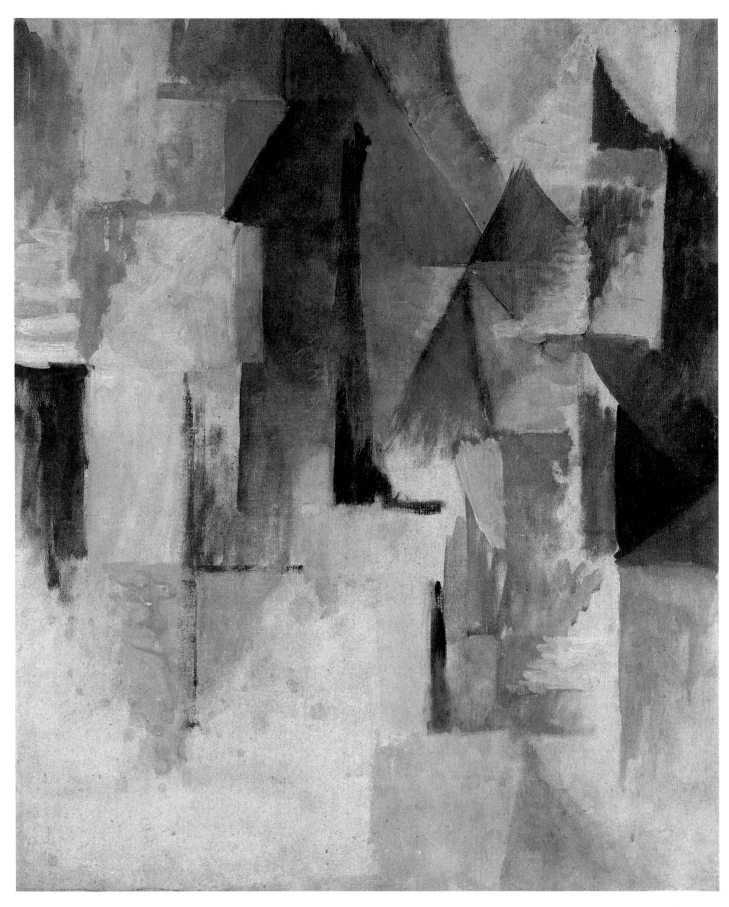

PLATE 17
Robert Delaunay, *Window*, 1912/13
Oil on canvas, 64.5 x 52.5 cm

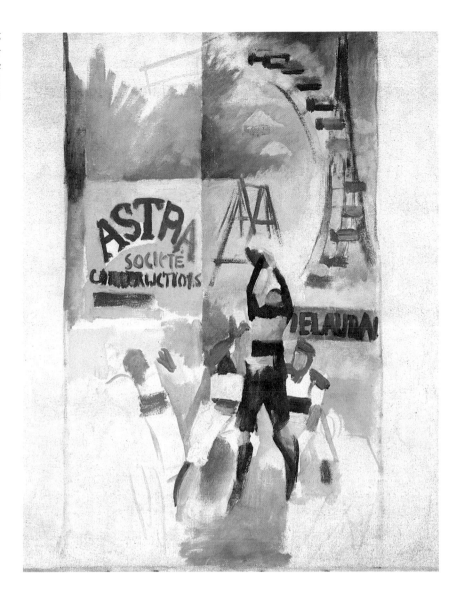

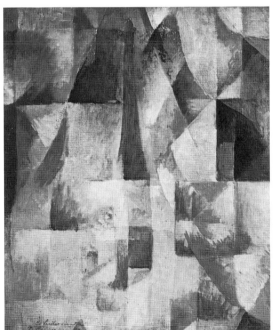

Fig. 37 Robert Delaunay, *Simultaneous Windows*, 1912

Although the work is undated, there can be no doubt that Delaunay's *Window* (Plate 17) was painted in 1912 or 1913. Here, light and space are suggested by the use of colour alone. Liberated almost entirely from the object, the colour is distributed over the surface of the picture in irregular, semi-geometrical rectangles and triangles. Between the vague outlines of the houses in the mosaic of coloured forms, the Eiffel Tower rears up as a green vertical line; it is recognizable by its familiar silhouette, and yet it appears as a coloured accent rather than a real tower. Once more we see the characteristic pyramid structure found in many Cubist paintings, but in this case with a new motivation in terms of content and a quite different approach to colour. Among Delaunay's 'window' pictures, this work stands out by virtue of its particular sense of lightness and space, of openness and freedom.

On the reverse of the painting there is a coloured sketch for *The Cardiff Team* (Fig. 36), one of Delaunay's major works. Here, too, the Eiffel Tower is a prominent motif, juxtaposed with the figures of the rugby players and the dominant image of an advertisement on the wall of a house, whose modern typography lends the picture a heightened feeling of urban reality. These motifs point to a view

43

of both art and reality which differs strongly from that of the Cubists, whose artistic mentality was, in a manner of speaking, historically superseded by the modernity of Delaunay – and of Léger. This feature of Delaunay's work would seem to have been one of the main factors in the influence which he exerted on a wide range of contemporary artists, from such painters as Marc Chagall, Léger, Klee and Macke to the Futurists and the first-generation exponents of abstract art. By dint of its emphasis on the autonomy of colour and its specifically modern quality, which extends beyond purely formal considerations, the work of Delaunay made a major contribution to the diffusion of new artistic ideas in the years immediately preceding the First World War.

*

The Tower with Curtains (Plate 18), painted in 1910, belongs to an earlier stage in the development of Delaunay's art. With its almost monochrome approach to colour, it is closer to mainstream Cubism: the bright colours of 'Orphic' Cubism are missing. Again, the view is from a window. The curtains on either side of the window strike a somewhat old-fashioned, even Romantic note, contrasting sharply with the modernity of the Eiffel Tower. The tower itself, rearing up above the houses, is depicted in greater detail than in the later *Window*, where it is reduced to a mere streak of colour. Its upward movement follows the natural movement of the eye: thus, Delaunay combines the idea of temporal succession with that of 'simultaneity', a notion which he had picked up from the Futurists, who were particularly interested in time and movement, but which he was soon to outgrow in his 'Orphic' pictures, although he continued to use the term. A further Futurist influence can be seen in the use of the Eiffel Tower as a symbol of technological progress and modern city life, a feature that deviates sharply from the iconography of Cubism, which remained 'artistic' in the traditional sense.

The importance of this picture to Delaunay can be gauged from the fact that he used the same motif in a number of other works: in two drawings – one in pen and ink, the other in chalk – done in 1910 (Fig. 39, 40) and in an oil sketch (Fig. 41) bearing the surprisingly late

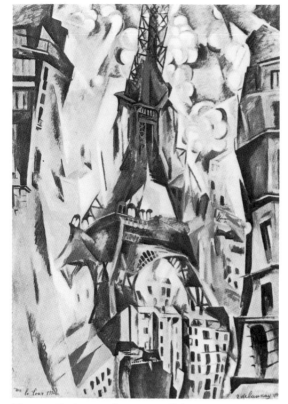

Fig. 38 Robert Delaunay, *Eiffel Tower*, 1910

Fig. 39 Robert Delaunay
The Tower with Curtains, 1910

Fig. 40 Robert Delaunay
The Tower with Curtains, 1910

Fig. 41 Robert Delaunay
The Tower with Curtains, 1914

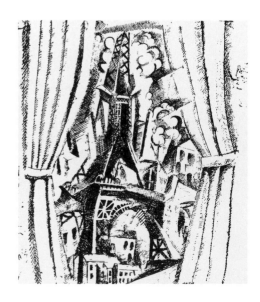
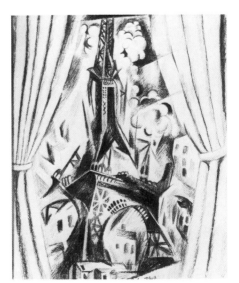
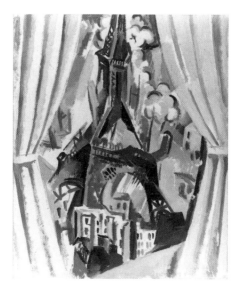

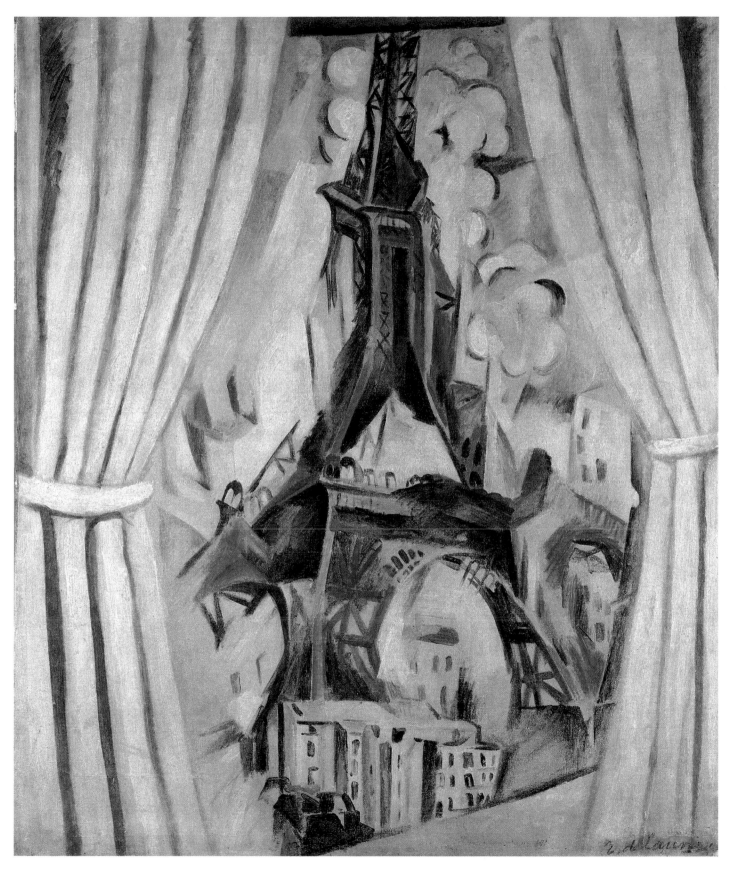

PLATE 18
Robert Delaunay
The Tower with Curtains, 1910
Oil on canvas, 116 x 97 cm

date of 1914, a full four years after the original painting. At the same time, he painted several pictures which are similar to *The Tower with Curtains* but from which the curtains have been omitted (see Fig. 38).

LEGER

Fernand Léger was one of Delaunay's closest friends. Although his artistic temperament was quite different from that of Delaunay, Léger was strongly attracted by the latter's positive attitude to colour and to the modern, urban world. In 1913/14 he painted a series of pictures entitled *Contrasted Forms* (Plate 19), in which, like Delaunay, he endeavoured to reconcile Cubism with the use of colour. However, he favoured bolder, more elementary and Fauve-like colours than Delaunay, whose preference was for gentler tones. Against the drift of mainstream Cubism – whose exponents were also beginning to experiment with the possibilities of colour – Léger strove to convey a sense of the volume, the physical bulk of objects. Proclaiming that pure forms should be treated as things and things as pure forms, he attached equal weight to the formal character of objects and the object-like character of forms. This was the fundamental principle of the artistic programme which he expounded in numerous lectures and essays. The consequence of this programme was the evolution of the tubular forms which are so often seen in the pictures from his Cubist period and which led his contemporaries to coin the ironic term 'tubisme'. The metallic, tubular shapes are modelled in pure, contrasting colours and imbued with a maximum degree of intensity, in respect of both colour and form. With his pronounced sense of rhythm, Léger assembles the colours – reds, blues and yellows, with white and black – on the canvas and sets them against the forms, thereby producing a play of contrasts. 'I organize the opposition between colours, lines and curves,' he said. 'I set curves against straight lines, patches of colour against plastic forms, pure colours against subtly nuanced shades of grey.' On a different occasion he declared: 'In future, pictorial contrasts will be the armature of modern paintings.' Concerned as he was to achieve the maximum possible effect, he was bound to reject what he called the 'spiders' webs', the finely textured monochrome pictures of the Cubists from Montmartre – he himself lived in Montparnasse. He detested all forms of lyricism, subjectivism and sentimentalism, and he was fully prepared to accept that people might find his painting crude and overly simplistic.

Léger's gaze was firmly fixed on reality. Even in such a picture as *Contrasted Forms*, whose language inclines towards the abstract, one detects a strong interest in modernity, in the world of machines and technology. The tubular forms evoke the artist's fascination with industry, with the harsh facts of living reality. Léger called for a new 'realism' in art, but his notion of realism was centred around the autonomy of form and colour, rather than the mimetic reproduction of reality. He drew a distinction between 'visual' and 'conceptual' realism, meaning, on the one hand, nothing more than the naturalistic depiction of the real and, on the other, the intellectual acceptance

Fig. 42 Fernand Léger, *Contrasted Forms*, 1913

PLATE 19
Fernand Léger
*Contrasted
Forms*, 1914
Oil on canvas
80.7 x 65.2 cm

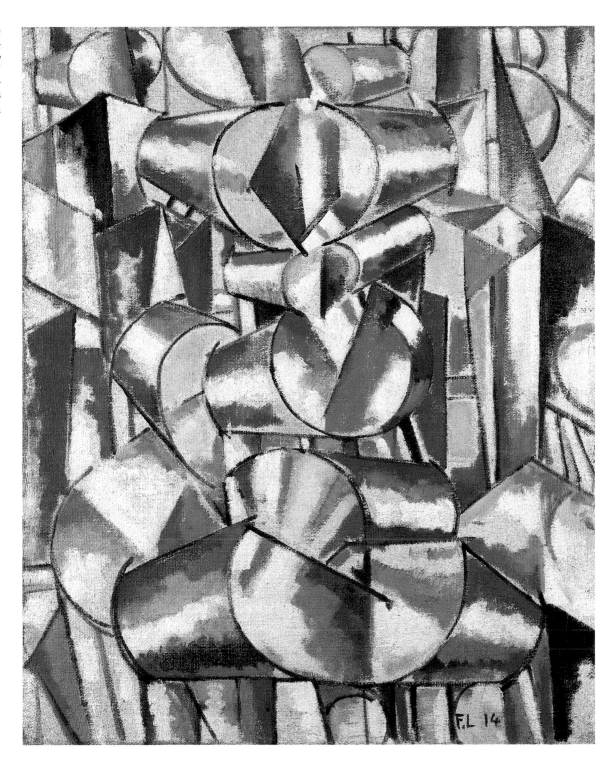

of reality in a far broader sense. For him, this broader sense embraced the reality of history and, with it, the modernity of artistic language as such. Léger referred to his own manner of painting as 'realistic' because it fully acknowledged the present. On one occasion he declared: 'The realistic value of a work is completely independent of its properties in terms of content. This truth must be recognized as a dogma and assume the validity of an axiom in the general understanding of painting.'

In the long term, however, he was not content merely to experiment with form and colour. The First World War provided him with an

overwhelming experience of 'reality'. In 1914 he was sent to the Front. Two years later, while home on leave, he painted *Soldier with a Pipe* (Plate 20), a picture redolent of the trenches which depicts a man caught up in the machinery of war, set grey in grey on the coarse brown canvas. Here and there, the grey is interrupted by subtle nuances of colour, but the only note of real warmth is in the red of the soldier's head. The abstract language of *Contrasted Forms* has been given a new content: the tubular forms find a natural use in the depiction of the soldier as a victim of modern technological warfare. 'If the object can interpolate itself without breaking the indispensable armature, then the picture becomes richer,' Léger proclaimed. His soldier resembles a knight in armour, made up of pieces of dully gleaming metal. Each section is a stereometric form; even the smoke from the soldier's pipe has the shape of five grey cannonballs. Yet although this work clearly anticipates Léger's subsequent series of 'robot' pictures, it does not mechanize the human form: it contains a specifically human element which penetrates the technical armour.

There is also an unmistakable note of social criticism in *Soldier with a Pipe*, in which one sees the artistic apotheosis of *les petits gens*, the underprivileged classes with whom Léger had already sympathized before the war brought him into closer contact with them. In his early masterpiece, *Nudes in the Forest* (Fig. 44) of 1909/10, he had already used the motif of working people. Here, too, the human figure is given a robot-like appearance. Thus, social criticism played a part in Léger's work right from the outset. After *Nudes in the Forest*, however, Léger turned his attention to the development of a new pictorial language, grappling with Cubism and endeavouring to evolve his own personal style. He saw himself as doing battle 'on the artistic front'; later he was to find himself fighting for real, in the trenches. In 1911 he painted a picture entitled *The Smoker* (Fig. 43), in which the objects and the figure are fragmented and shattered by the Cubist concept of form. The robot-like appearance of the smoker, with his mechanical hands, anticipates the figure in *Soldier with a Pipe*, but the picture is cast in a more formalistic,

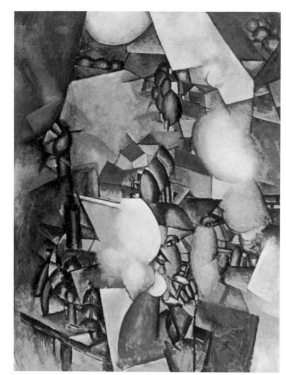

Fig. 43 Fernand Léger, *The Smoker*, 1911

PLATE 20
Fernand Léger
Soldier with a Pipe, 1916
Oil on canvas, 130 × 97 cm

Fig. 44
Fernand Léger,
Nudes in the Forest
1909/10

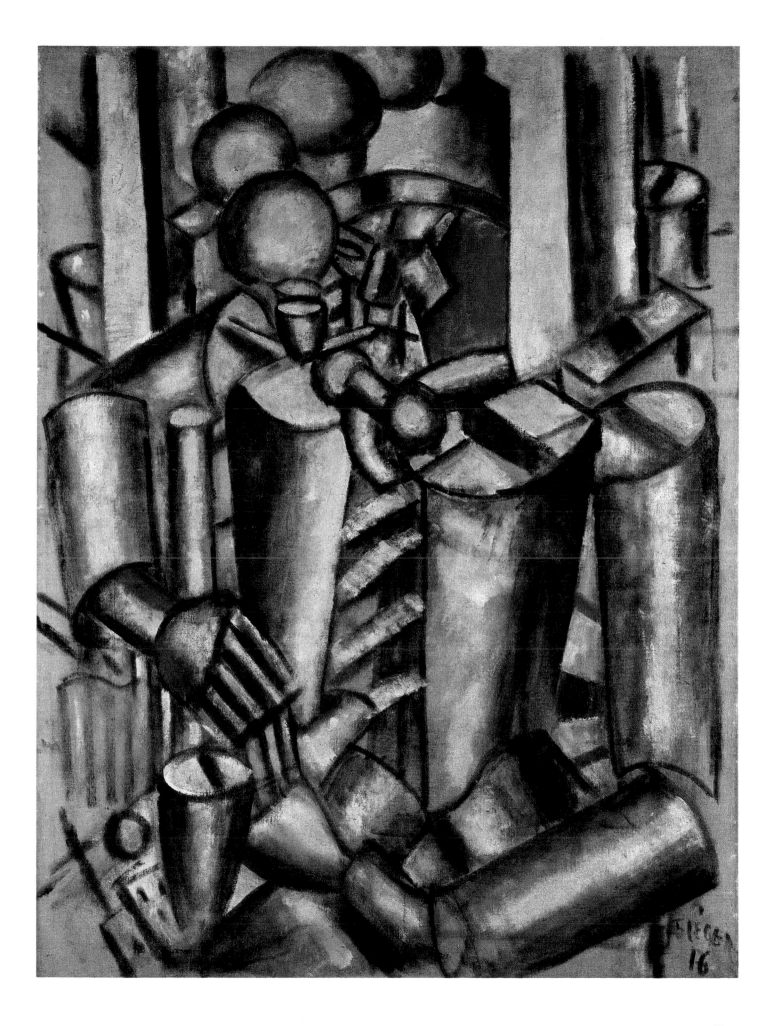

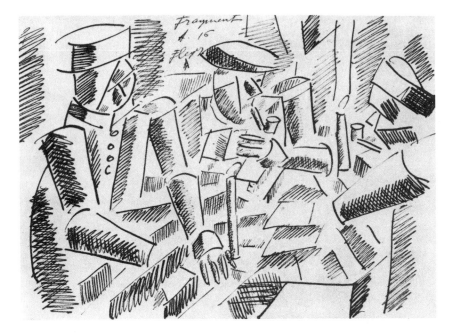

Fig. 45
Fernand Léger,
Study for
The Card-Players
(Fig. 47), 1916

more self-consciously 'artistic' mould: it smacks of the studio rather than of reality. In *Soldier with a Pipe* the figure is once again seen in its totality, in a more definitely human form. The soldier is no longer a plaything, the object of Cubist or Futurist stylistic exercises, but the *copain* of the artist, a member of the human community of the trenches. The wartime communal spirit is also celebrated in *The Card-Players* (Fig. 47), a large-format work which Léger painted the following year. Here, the pictorial language is more mechanistic and formal, and Léger returns to the polyphonic use of colour. The man with the pipe on the right-hand side of the picture corresponds to the soldier in the earlier work, but the 'human' element is secondary to formal considerations, as if the artist had inwardly withdrawn from the war, which for him was already over, and turned his attention back to pictorial problems. Shortly afterwards, the motif of the soldier was supplanted by that of the worker. In *The Mechanic* (Fig. 46) Léger depicted a worker as a monumental individual figure;

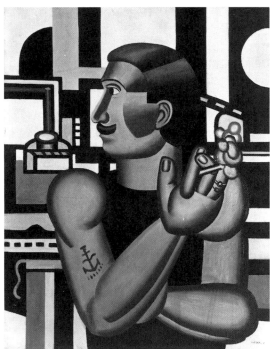

Fig. 46 Fernand Léger, *The Mechanic*, 1920

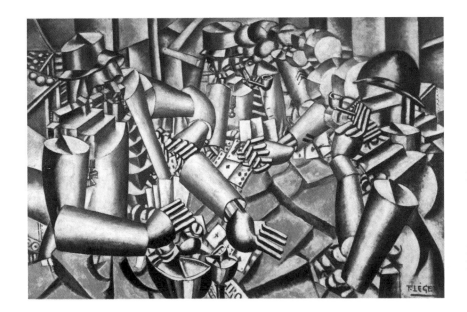

Fig. 47
Fernand Léger
The Card-Players
1917

50

Fig. 48 Pablo Picasso, Drawing, 1919

however, this is the only picture of its kind which is comparable with *Soldier with a Pipe*.

The Card-Players can be seen as a Cubist variant on Cézanne's pictures with the same title, one that transposes the figures into technical images. It was preceded by a series of wartime drawings in which Léger depicted soldiers smoking and playing cards (see Fig. 45). Despite the hastily sketched character of these genre scenes, they clearly contain, in embryonic form, the pictorial principles that were to govern the final painting.

PICASSO

Picasso spent the summer months of 1919 in St Raphaël on the Mediterranean coast. Here, he did a large number of drawings and watercolours whose main theme was a table set with various objects in front of an open window. These works bear little or no resemblance to Delaunay's 'window' pictures; there is no echo of Delaunay's principles of form and colour or of his interest in Paris and the modern urban world. The stylistic model that springs to mind is Matisse, with his numerous interiors which open outwards. The same influence is apparent in *Open Window* (Plate 21), which was painted in 1919 and is the product of a supremely relaxed artistic attitude, transcending the austere formal principles of Cubism – without which, however, the picture would be unthinkable. Although the lingering influence of Cubism is unmistakable, the Cubist techniques, especially that of 'semi-collage', are used in a free and confident manner. A number of the elements in the picture – especially the imitation-wood wallpaper, a popular motif in Cubist collages (see Plate 13) – look as if they have been stuck on to the canvas rather than painted. The figurative content is largely absorbed by the two-dimensional composition, and the motifs are seen in outline only: the three-legged table with a tablecloth, the iron bars of the balcony, the violin, bottle and vase on the round table-top, and the wall of a house in the background. The identity of those objects

Fig. 49
Pablo Picasso
*Sheet of Studies:
St Raphaël*, 1919

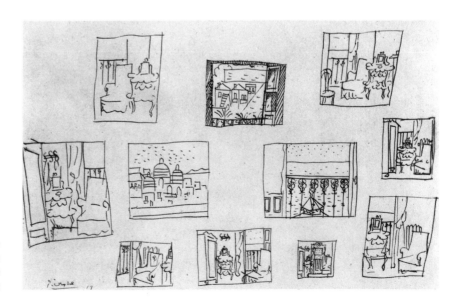

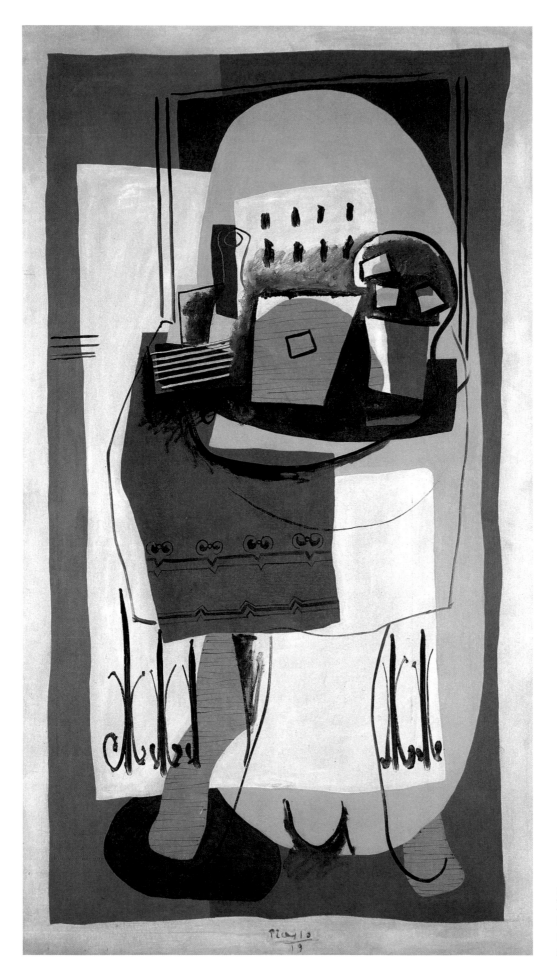

PLATE 21
Pablo Picasso
Open Window, 1919
Oil on canvas
209.5 x 117.5 cm

which remain obscure can be deduced from related drawings (see Fig. 48) and watercolours. However, the value of such pictorial clues is questionable; the main thing is the value assigned by the artist himself to the objects within the picture. If one compares *Open Window* with the numerous window interiors created by Matisse or Pierre Bonnard, the voice of the objects appears relatively muted; the action of the picture is dominated by the formal rather than the figurative.

FEININGER

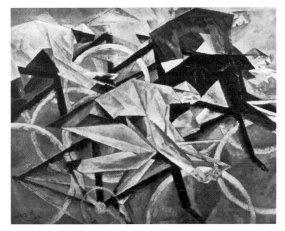

Fig. 50 Lyonel Feininger, *The Bicycle Race*, 1912

Cubism was essentially a Spanish and French affair. However, although there was no German Cubism to speak of, the influence of Cubism, transmitted via Delaunay and the Futurists, can be detected in the work of many German artists from this period, notably in the pictures of Lyonel Feininger from 1912 onwards. His painting *Umpferstedt I* (Plate 22) is decidedly Cubist in manner, although its style is quite distinct from that of Cubism proper; the same is true of *Umpferstedt II* (Fig. 53), which is admittedly a very different work. Despite the deformation of the image, the immediacy and physical integrity of the motifs – the church and the houses – remain largely intact: they are merely subordinated to a crystalline pictorial law. The treatment of the image is reminiscent of early Cubism: in the meantime, mainstream Cubism had moved on from its initial point of departure, taking the demolition of the object several stages further. In the work of Feininger the object is more than a mere pretext for formal experimentation. The artist was deeply attached to the architecture of the villages around Weimar, where he was living at the time – before the Bauhaus was founded there in 1919.

Feininger first encountered Cubism in 1911, at an exhibition of the Paris Salon des Indépendants which included a number of his own pictures. At this point, although he was almost ten years older than Picasso, he had been painting for only four years; when he painted *Umpferstedt I* he was already over forty. Right from the outset he had been interested in the theme of street life rather than in the vases and violins favoured by the Cubists. Hence, he was fascinated and influenced by the Futurists, with their emphasis on the city, on modernity and speed. There are obvious parallels between Feininger's *The Bicycle Race* (Fig. 50), painted in 1912, and Umberto Boccioni's street scene (Fig. 51) from the previous year; the diagonal forms and the fragmentation of light seen in these two pictures can also be found in the Umpferstedt paintings and in many other works from this phase in Feininger's oeuvre.

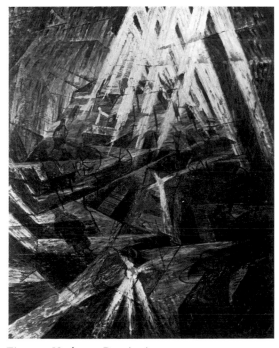

Fig. 51 Umberto Boccioni
The Forces of a Street, 1911

However, Feininger's sympathy for Futurism was tempered by his interest in the spiritual. Like other German painters of the time, such as Klee and Marc, he sought to invest the new ideas of form with a spiritual content. In his work the dynamic life of the big city, with its traffic and noise, is replaced by the tranquillity of the medieval village; instead of the brown tones of Cubist painting, one finds a transparent blue, a colour with distinctly Romantic emotional overtones.

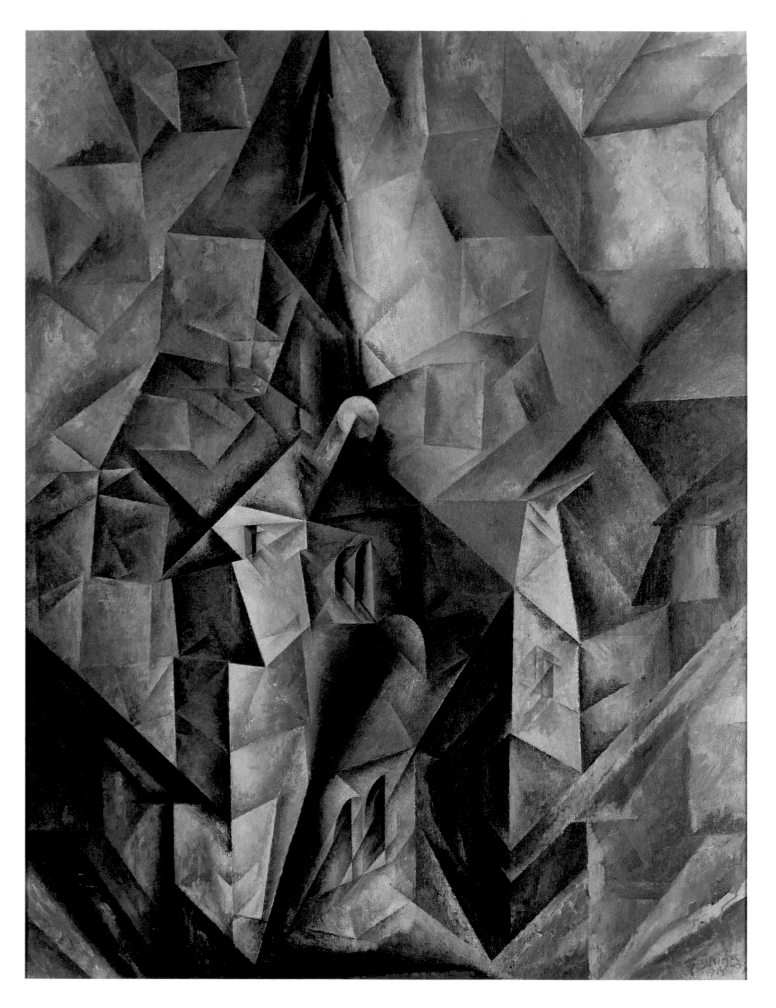

54

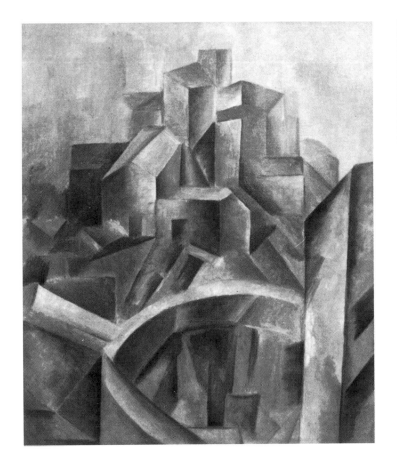

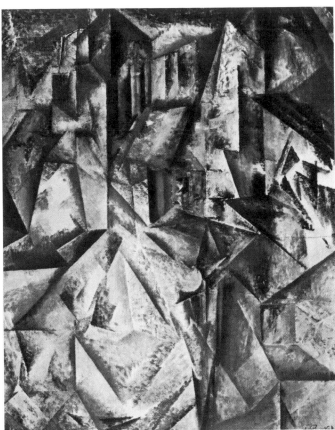

Fig. 52 Pablo Picasso
The Reservoir, Horta de Ebro, 1909

Fig. 53 Lyonel Feininger
Umpferstedt II, 1914

PLATE 22
Lyonel Feininger
Umpferstedt I, 1914
Oil on canvas
131.5 x 101 cm

The church spire is an especially obvious symbol of what contemporary critics identified as the 'Gothic' element in the Expressionist world of feeling, an element which is entirely missing from Cubism and Futurism. During this turbulent period there was much talk of the covertly Gothic spirit of German art as a whole, a notion which conveniently ignores the French provenance of the Gothic style – and the fact that Feininger was of American extraction. The Gothic striving for infinity can also be seen in Delaunay's pictures of the Eiffel Tower (see Plate 18), although, unlike Feininger's church towers, they are anthems to the age of technology. Feininger had made Delaunay's acquaintance in Paris in 1907, but, as he later explained, the ideas of the French artist on light and colour failed to interest him. He felt a greater sense of affinity with the *Blaue Reiter* artists, although he was not actually a member of the group. It was not until 1924, when he had been working at the Bauhaus for five years, that he joined forces with Kandinsky, Klee and Alexei Jawlensky to form the *Blaue Vier* (Blue Four) group, which preserved something of the spirit of the *Blaue Reiter*.

CHAGALL

Marc Chagall's *Self-Portrait with Brushes* (Plate 23), painted in 1909, is one of the earliest works of an artist who both delighted and confounded his contemporaries. The picture was probably painted in St Petersburg, where Chagall first encountered the new artistic ideas from the West. Despite its restrained quality, the work clearly

shows that the artistic world of St Petersburg was receptive to modern influences, although Fauvism and Cubism had yet to make their mark. However, Chagall still had a long way to go. The development of his style is documented here by the self-portrait (Fig. 54) which he painted five years later, following his return to Russia from Paris. In this painting the naivety of the earlier picture has been replaced by a bolder, more incisive attitude to form and colour, going beyond mere portraiture and yet sharply accentuating the contours of the face.

Chagall was born and grew up in the small provincial town of Vitebsk, where the influence of Hassidic Judaism was all-pervasive and painting was effectively outlawed: the depiction of man, who was made in God's image, was traditionally considered sacrilegious. In painting these self-portraits, Chagall was liberating himself from his own origins, and this is clearly apparent in the pictures themselves. Yet he did not reject his roots altogether: on the contrary, the world of his childhood continued to haunt him for the rest of his life and it became one of the dominant factors in his work. Chagall had decided to become a painter and to defy the Hassidic taboo on making images of man. He moved far away from Vitebsk, to St Petersburg, and thence, in September 1910, to Paris, the Mecca of modern art. There, he soon came into close contact with the most recent artistic movements.

The earlier self-portrait reminds one of the Old Masters, especially of Rembrandt (see Fig. 55), who painted himself in a similar pose, also with a black cap, and whom Chagall particularly revered. Artists continued to depict themselves in this way until well into the nineteenth century, with the obligatory cap and the palette and brushes, the tools of their trade (see Fig. 56). The young Chagall still clings to this ideal image of the artist. However, despite the hackneyed pose, there is evidence of a new spirit. In the non-naturalistic brown of the face one detects the influence of the icon painting of his native

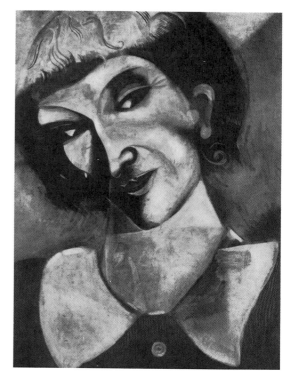

Fig. 54 Marc Chagall, *Self-Portrait*, 1914

Fig. 55 Rembrandt, *Self-Portrait*, 1640

Fig. 56 Wilhelm von Schadow
Portrait of Bertel Thorvaldsen and Wilhelm and Rudolph Schadow, 1815

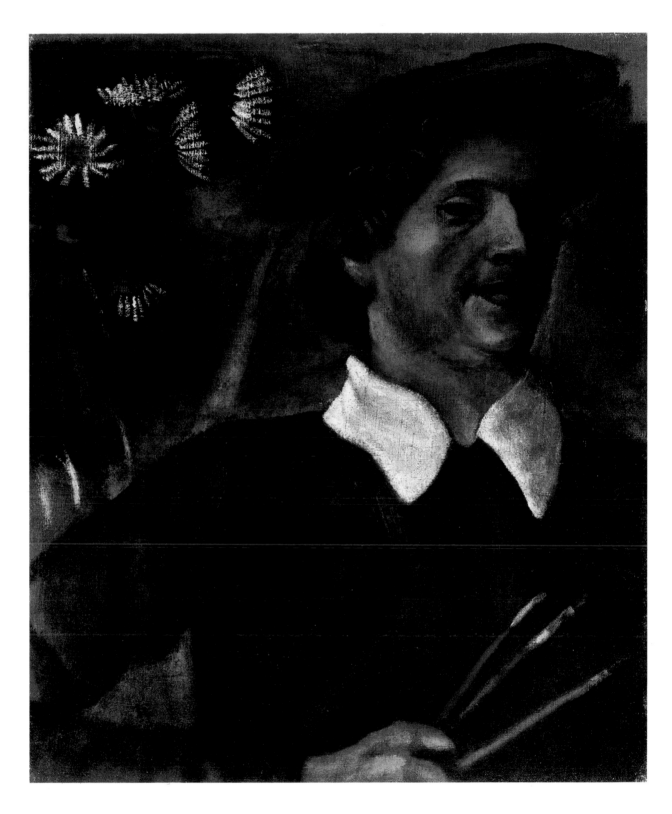

PLATE 23
Marc Chagall
*Self-Portrait with
Brushes*, 1909
Oil on canvas
57 x 48 cm

Russia, which aroused great enthusiasm among young artists at the time. The simple flowers, applied in a matter-of-fact manner, indicate that the artist is searching for a new form of expression, breaking away from the canons of realistic painting. The somewhat larger portrait of Chagall's wife, Bella (now in the Kunstmuseum, Basle), which was painted at roughly the same time and can be seen as a companion piece to the self-portrait, is also a highly touching document of the young artist's striving to free himself from traditional constraints.

Fig. 57 Marc Chagall,
Sketch for *The Violinist* (Plate 24)
1911

PLATE 24
Marc Chagall
The Violinist, 1911/14
Oil on canvas
94.5 x 69.5 cm

Fig. 58 Marc Chagall
The Violinist and the Child
1910/11

Two years later, in Paris, Chagall painted *The Violinist* (Plate 24), which looks as if it had been created in Russia (it is dated 1911/14). The picture seems largely untouched by all the modern artistic movements to which Chagall had suddenly been exposed in the French capital; only the bold, striking colours hint at a possible Fauvist influence. The subject-matter and, indeed, the whole tone of the work have more to do with Vitebsk than with Paris. Vitebsk is still very real: it has not yet metamorphosed into the dream world of Chagall's later pictures. Chagall's subject is the warmth, the sheltered atmosphere of a Russian village: the picture is quite different from *Feast Day* (Plate 25), where the tone is cooler, more Cubist and less naive.

The reality of the Russian-Jewish world is represented by a fiddler with a beggar-boy, a village street winding round a simple log cabin and, in the background, two women, one of whom is half-naked, suggesting an erotic longing rather than an interest in the folkloristic. The picture is nevertheless steeped in folklore: the figures have a peasant simplicity and the colours glow with a raw sensual power. Chagall derived part of his inspiration from Russian nineteenth-century popular imagery, with its crude figures and wooden houses (see Fig. 59). However, the simplicity and sensuality seen in *The Violinist* transcend the sphere of folk art: they point towards a specifically modern impulse to abandon traditional naturalism. Colour asserts itself as a medium in its own right, its use dictated solely by the temperament of the artist in disregard of naturalistic 'correctness'. Form, freed from the dominion of objects, also begins to speak its own language: in the half-open hands of the fiddler and the boy, in the strangely displaced eyes, in the semi-circular curve of the arm echoing the movement of the road, and in the disjointed perspective of the house. At the age of twenty-four, Chagall has delved for the first time into the Western repertoire of new artistic possibilities, and precisely these modern stylistic techniques, hesitant as his use of them may be, help him to depict the world of his childhood and youth in terms of legend, with a high degree of passion and expressive power.

Fig. 59
Russian
broadsheet
1859

A sketch for *The Violinist* has survived (Fig. 57) in which three men, instead of two women, can be seen in the background. The same motif of the violinist with the beggar-boy is found in a gouache painted in 1910/11 (Fig. 58). The violinist and the log cabin became part of Chagall's iconographical stock-in-trade, one of the several themes to which he returned again and again in the course of his career.

<center>*</center>

In 1914 Chagall returned to Vitebsk. The First World War broke out while he was there, and this forced him to stay in Russia, where he remained for several years. It was not until 1922, five years after the Revolution, that he was able to go back to Paris.

In Vitebsk Chagall re-encountered the world of his childhood, the world of the ghetto, with its familiar figures and rites. Here, in 1914, he painted a number of pictures on Jewish themes (see Fig. 61) which form one of the most impressive groups of works in his early oeuvre. One of these pictures is *Feast Day* (Plate 25). As is the case with several major works from this period of Chagall's development, there are two versions of the painting.

Feast Day shows a man with a prayer shawl draped around his shoulders, holding a citron in his right hand and a palm frond in his left. These are the emblems of the Feast of Tabernacles, one of the highest feast-days in the Jewish calendar. On the man's head, facing in the opposite direction, is a miniature replica of himself, which enhances the inner and outer stature of the figure and lends it an aura of wonder. The latter effect is heightened by the relatively realistic style of the picture, which is tempered, however, by an obvious Cubist influence. Chagall had adapted Cubism to his own needs in Paris; here, it is used as a given pictorial method in the service of the content, which is the main focus of attention. As a result of the Cubist interpretation of form, the content of the picture is clarified and sharpened and takes on an exceptionally high degree of pictorial intensity.

Chagall himself offered no clues to the meaning of the miniature figure. A conclusive interpretation of the motif may well be impossible. Since the artist himself remained silent, one should refrain from reading the figure as a representation of the main figure's alter ego or as an allusion to his secret wish to turn his back on the temple. In order to understand the picture, one merely has to accept the elevation of a simple event into the realm of the fantastic. Yet the image is not 'surreal': the action of the picture is firmly anchored in reality, as if such a scene were entirely within the bounds of physical possibility. 'Don't call me a fantasist,' Chagall said. 'On the contrary, I am a realist. I love the earth.' However, he also loved miracles, of the kind which are all the more miraculous for the fact that they occur in the midst of everyday life.

Chagall used the same motif several years later in a drypoint engraving (Fig. 60); for technical reasons, the figure faces the other way. The engraving was made in connection with Chagall's autobiography, *My Life*, which was written in 1921/22 and published in 1931.

Fig. 60 Marc Chagall, *The Rabbi*, 1922

Fig. 61 Marc Chagall, *The Praying Jew*, 1914

PLATE 25
Marc Chagall, *Feast Day (Rabbi with Lemon)*, 1914
Oil on cardboard mounted on canvas, 100 × 81 cm

In 1912 a number of pictures by Delaunay were shown in the *Blaue Reiter* exhibition in Munich. That year, Paul Klee, together with Macke and Marc, visited the French artist in Paris. Klee translated Delaunay's essay 'On Light' into German. In 1913 Delaunay and Apollinaire paid a visit to Macke in Bonn. The following year Klee, Macke and the Swiss artist Louis Moilliet travelled to Tunisia, where the landscape and the Moorish architecture brought the latent influence of Delaunay's 'Orphic' Cubism to the surface. The momentous journey to Tunis, which took on special significance for Klee, produced a rich artistic harvest, in the shape of a considerable number of watercolours (Klee had not yet begun to paint in oils), including *Red and White Domes* (Plate 26).

It was during this journey that Klee discovered the possibilities of colour. In the past he had largely confined himself to drawing and etching, and now, in a mood of jubilant elation, he wrote in his diary: 'Colour has got me. I no longer need to chase after it. It has got me for ever, I know it. That is the meaning of this happy hour: colour and I are one. I am a painter.' Drawing on the fund of inspiration provided by Delaunay, Klee also succeeded in devising a pictorial structure suited to his particular needs. The surface of the picture is divided up like a chessboard or mosaic into a number of geometrical fields, whose 'abstract' quality is offset by the sense of natural, living reality generated by the transparency of the colours and by the overlappings between the forms. In addition, Klee took pleasure in giving what he later called his 'figurative consent' to his pictures, by adding occasional details which refer more directly to reality. The chessboard effect became a frequent feature of his pictures in 1914, and he continued to use it until well into the 1930s, when his style underwent a fundamental change. The structures are seldom strictly geometrical; despite their apparent severity, they retain an animated quality. In a few rare cases they have a purely formal, 'abstract' character; as a rule, however, they are replete with content, denoting nature, earth, water and air. Klee remarked on one occasion: 'Like people, a picture has a skeleton, muscles and skin. One may speak of an anatomy peculiar to pictures.' At the same time, he demanded that the artist should maintain a 'dialogue with nature'. By this he meant that the mere copying of natural appearances is not enough: the artist's task is to respond via the medium of painting to the voice with which nature communicates its own specific message.

The pictorial anatomy of *Red and White Domes* is quasi-geometrical, but the geometrical element is qualified by the transparency and fluidity of the colours, an effect which is intensified by the use of watercolour. Although the tissue of forms initially appears 'abstract', the colours are full of living, breathing reality: they speak the language of nature, which has silently taken possession of the picture. There is a further dimension to this invasion by nature: the warmer zone at the bottom of the picture suggests earth, while the cooler, upper zone suggests the sky. Hence, the picture makes a discreet transition from the world of pure forms to that of nature, even before the artist has given his 'figurative consent'. The figurative element

Fig. 62 Paul Klee, *Motif from Hammamet*, 1914

Fig. 63 Paul Klee
Yellow House in the Fields, 1912

PLATE 26
Paul Klee, *Red and White Domes*, 1914
Watercolour and body colour on Japanese vellum
mounted on cardboard, 14.6 x 13.7 cm

is introduced not in an anecdotal or illustrative manner, but via strictly formal means: the semi-circles which Klee places in several of the 'abstract' rectangles resemble the domes of mosques. Suddenly, as if at the touch of a magic wand, the tissue of forms has been transformed into a Moorish city. And yet the picture remains a living surface rather than a representation of reality.

The elimination of all sense of perspective allows the picture to come into its own as a two-dimensional object. In his diary Klee wrote: 'Perspective is a bore. Should I distort it? Or how shall I construct a bridge between the internal and the external in the freest manner possible?' An example of this expressive distortion is supplied by the watercolour *Yellow House in the Fields* (Fig. 63), which Klee painted in 1912. Later, when he was teaching at the Bauhaus, he frequently allowed himself to use central perspective, but he did not regard it as an optical law to be followed implicitly. Instead, he saw perspective as one of a number of pictorial possibilities, and he deliberately violated physical rules: his heavily emphasized perspective is a confusing, irritating pseudo-perspective.

<center>*</center>

In 1914 Klee painted the watercolour *Remembrance of a Garden* (Plate 27), which also dispenses with perspective. The chequering of the ground is looser than in *Red and White Domes*; the horizontal and vertical lines are less definite. The picture as a whole has an irregular border. The squares of the 'chessboard' vary in size; their edges are blurred; the flat areas of colour are not fully two-dimensional; and there are no right-angles. The colours mingle and in many places overlay each other. By deviating from a fixed order, the picture calls attention to and, at the same time, questions the idea of order. This reflects Klee's attitude to nature, whose laws he recognized but which he also regarded as a sphere of freedom – a freedom which maintains its right to exist in the face of a law which it nevertheless acknowledges. The watercolour, too, maintains its right to exist: with its essentially fluid character, it stands its ground against the rigid order of the picture.

In this picture, however, nature asserts itself more directly, in a manner which is typical of Klee's art. The colouring has a natural look; at any rate, it does not conflict with nature. Here, too, Klee goes a step further, adding a number of plant-like forms, elements of vegetable life, which turn the picture into an image of nature. The title, *Remembrance of a Garden*, tells us that we are not looking at a garden as such, but at a remembrance, a general, somewhat hazy, approximate recollection. The specificity of the work is aesthetic, rather than topographical. With the help of the title and the vegetable forms, the viewer finds himself involuntarily transported to a garden, where, through the veil of memory, he becomes aware of flower-beds, plants, bushes and, here and there, something resembling a fence. It is the colours and the picture itself which blossom. Coupling restraint with luminosity, the picture inhabits an intermediate zone between nature and painting, a zone in which natural and pictorial forces converge and interact. Nature is seen not in its botanical form, but as a voice which echoes back from the polyphonic play of colours. The ideas of intermediacy and interaction are central to Klee's art.

Fig. 64 August Macke, *Market Place, Tunis, I,* 1914

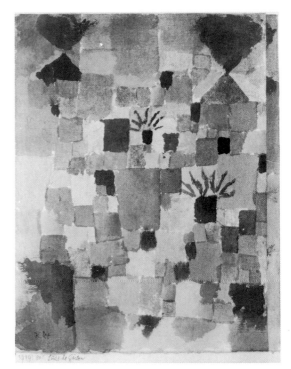

Fig. 65 Paul Klee, *Tunisian Gardens*, 1919

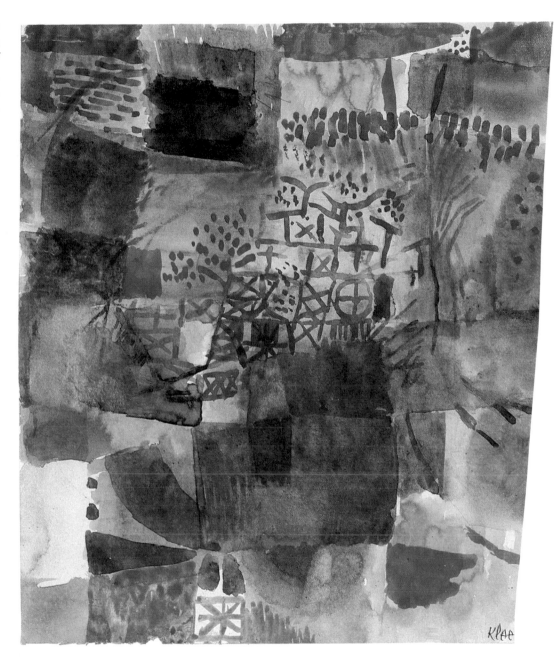

Tunisian Gardens (Fig. 65), which was painted in 1919, has a more definite formal pattern than *Remembrance of a Garden*: here, we are clearly dealing with 'gardens' rather than with a 'remembrance'. That Klee often depicted nature in the form of a garden is a function of his penchant for order. When he painted this watercolour, he may have been thinking of the garden of the house in St Germain in Tunisia where the three friends first stayed on their journey. He mentions it in one of his diary entries: 'The country house is beautifully situated, close to the seashore, built on sand. A sandy garden with artichokes and so forth.'

The watercolours which Klee's travelling companion Macke painted in Tunisia (see Fig. 64) also point to the influence of Delaunay, but Macke stuck more closely than Klee to the motif. Despite his willingness to accept the new ideas of autonomous form and colour, he did not abandon the use of perspective, and he took a more traditional approach to the object.

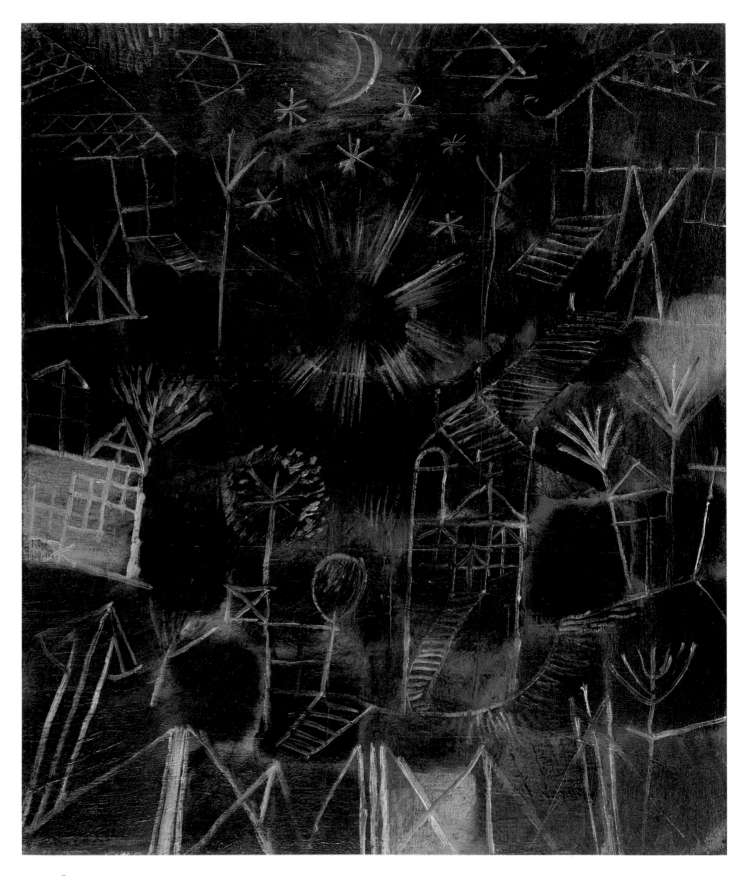

PLATE 28
Paul Klee
Cosmic Composition, 1919
Oil on panel, 48 x 41 cm

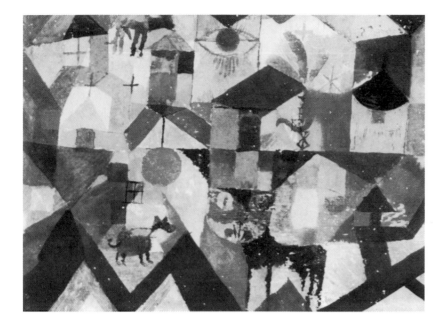

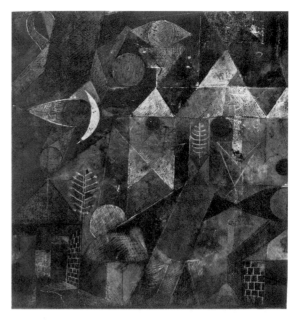

Fig. 66 Paul Klee
Zoo, 1918

Fig. 67 Paul Klee
Mystical City Scene
1920

After the end of the war, in 1919, Klee began to paint in oils for the first time. During this phase in his creative development he favoured 'cosmic' themes: his aim was to find a suitable means of pictorial expression for his idea of nature as a universal, spiritually animated sphere of being. Avowing his faith in the power of painting, he declared: 'Art is analogous to Creation. It is but one example, just as the terrestrial is an example of the cosmos.' Similar ideas can be found in the programmatic statements of Klee's friends from the *Blaue Reiter* group. In 1914, for example, Kandinsky wrote: 'The birth of a work of art is of cosmic character. The originator of the work is thus the spirit.' In similar vein, Marc proclaimed: 'Today we are searching for things in nature that are hidden behind the veil of appearances We look for and paint this inner, spiritual side of nature.' Which takes us back to Klee: 'I occupy a remote point at the origin of Creation, where I presuppose formulae for animals, humans, plants, rocks and the earth, for water, air and all circling forces at once.' Klee's *Cosmic Composition* (Plate 28), painted in 1919, can be seen as a poetic illustration of this much-quoted statement from his *Creative Confession*, written the following year, in which he set out his ideas concerning nature with mythical overtones that hark back to German Romanticism. In this picture, as in many of its predecessors, perspective is largely abandoned: its use is restricted to occasional details. The space is divided up into patches of colour, but the demarcations between them are blurred. 'Formulae', denoting the sun and moon, trees and plants, houses and steps, are inscribed in the patches. Among the stars a scarcely visible eye watches over the cosmic scene. The eye can be seen as a reference to the 'remote point at the origin of Creation' which the artist professes to occupy, or it can be interpreted as the eye of God. The same motif recurs in a number of other works from the period around 1920 (see Fig. 66, 67).

*

Camel in a Rhythmic Landscape of Trees (Plate 29), which was painted in 1920, has a similar patchwork structure, using simple forms which are offset by richly nuanced colours. It differs from

PLATE 29
Paul Klee, *Camel in a Rhythmic Landscape of Trees*, 1920
Oil on chalk-primed gauze mounted on cardboard, 48 x 42 cm

Fig. 68 Paul Klee
Study of an old Dromedary
1914

Fig. 69 Paul Klee
*With two Dromedaries
and a Donkey*, 1919

Cosmic Composition in respect of its emphasis on the horizontal rather than the vertical. The circular forms which are grafted on to the not quite parallel strips of colour provide the structure of the picture with a rhythmic backing. In the mosaic of quasi-geometrical coloured patches one sees the figure of a long-legged animal with two triangular humps which confirm that it is a camel, just as the vertical supports of the circles confirm that they are trees. This provides an excellent illustration of Klee's principle that the construction of a picture should start first with form and then move on to content. The circles and lines also forcibly remind one of musical notation, which is a further clue to the picture's content. The two associations to which the picture gives rise – trees and music – correspond to the themes suggested by the title.

A particularly important feature of the picture is the inherent ambiguity of the forms: they can be interpreted in a variety of ways. In one and the same picture, circles like the ones seen here can signify tree-tops or the eyes of an animal; similarly, triangles can be read as both the humps and the ears of a camel. Klee used the circle to represent trees in a number of other pictures from this period; in *Feather Plant* (Fig. 70), however, the same form serves to represent flowers.

Fig. 70 Paul Klee, *Feather Plant*, 1919

We re-encounter the motif of the camel in a coloured drawing (Fig. 68) which Klee did in 1914. Here, the animal is seen as a hastily sketched web of broken lines. Five years later the artist painted a picture of two dromedaries – followed by a donkey – with highly formalized, pyramid-shaped humps, in a setting which, again, is a mosaic of coloured patches, full of light and space (Fig. 69). In this painting, to use Klee's own words, 'the dimension of pictorial elements, such as line, light and shade, and colour' interacts with 'the dimension of the object'.

69

In Klee's painting the animal is a surprising figurative whim, arising from a formal operation. In the work of Franz Marc, however, it stands at the very centre of the artist's pictorial thinking. Marc is concerned with the animal as an exemplar of nature and the power of fate. The cats in his *Three Cats* (Plate 30) are highly individual creatures whose behaviour is nevertheless typically feline. The picture focuses on the tensions between male and female, victor and vanquished. These tensions are brought out by the contrasts of form and colour, and by the 'abstract' composition of the picture, whose transparent diagonal structure is clearly influenced by Futurism and the work of Delaunay. The animals are caught up in the interplay of formal forces, yet, at the same time, they insist on maintaining their own identity. This duality perfectly illustrates the opposition between captivity and liberty in nature.

One encounters the diagonal compositional structure in many of Marc's pictures. It can be seen at its most dramatic in *Yellow Cow* (now in the Solomon R. Guggenheim Museum in New York), where the animal's huge body leaps diagonally over the surface of the canvas. As a rule, the pictures feature two or more animals, set at different angles so as to create a kind of dialectical tension. There are marked resemblances between *Three Cats* and a series of works from the previous year showing animals gambolling and playing (see Fig. 72), all of which have a diagonal structure and establish a contrapuntal play of movement between the individual creatures. The yellow-and-black striped cat on the right, turning round to face the viewer – Marc also painted a postcard using the same motif (Fig. 71) – is clearly based on the painting *The Tiger* (Fig. 73), although this work, which was created in 1912, is structured in a more obviously 'Cubo-Futurist' manner.

Marc's Indian-ink sketch for *Three Cats* (Fig. 74) shows that the artist originally intended to put only two animals in the picture, although the form of the black-and-white cat in the foreground was established right from the outset.

Fig. 71 Franz Marc, *Seated Tiger*, 1913

Fig. 72 Franz Marc *Playing Dogs*, 1912

Fig. 73 Franz Marc *The Tiger*, 1912

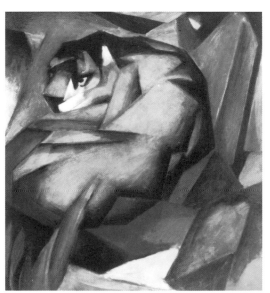

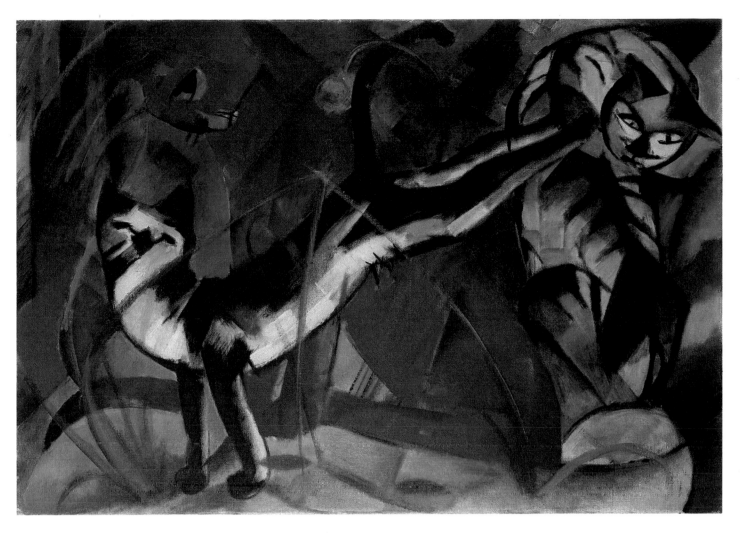

PLATE 30
Franz Marc, *Three Cats*, 1913
Oil on canvas, 72 x 102 cm

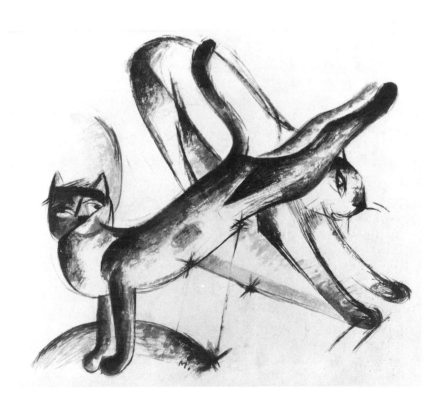

Fig. 74
Franz Marc
Playing Cats
1912

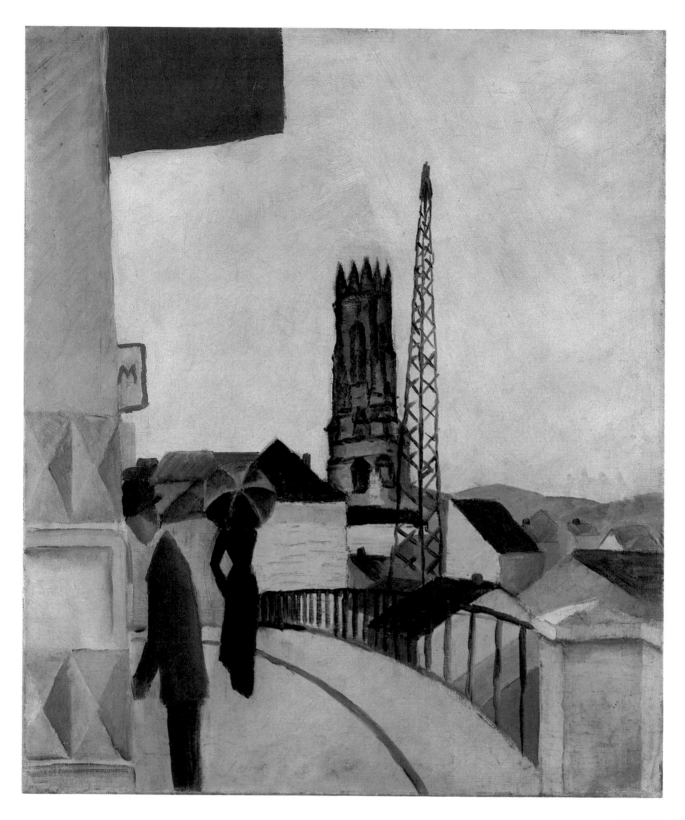

PLATE 31
August Macke
Fribourg Cathedral, 1914
Oil on canvas, 60.6 x 50.3 cm

MACKE

August Macke was one of the contributors to the *Blaue Reiter* almanac, and he also took part in the group's first exhibition in Munich in 1911. He was killed in action shortly after the outbreak of the First World War, two years before his friend Marc. The affinity between his work and that of Delaunay is less marked than in the case of Klee. His *Fribourg Cathedral* (Plate 31) differs sharply from

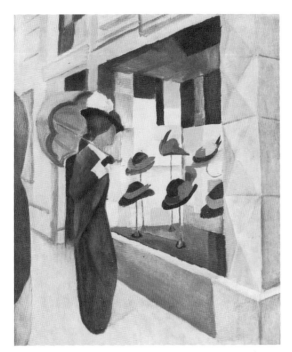

Klee's pictures to the extent that the object and the illusion of volume and space are left largely intact, instead of being absorbed by a two-dimensional pattern: indeed, it is scarcely possible to discern such a pattern. The geometrical forms and the finely graded colours assigned to them seem to be dictated in equal measure by the object itself and by specifically pictorial considerations. There is a perfect, seemingly natural balance between technique and motif: the artist's approach to the world of objects appears to be governed by a general formal sensitivity, rather than by specific formal intentions. Only the large red rectangle in the top left-hand corner speaks with a noticeably pictorial voice: its pictorial function outweighs its figurative significance, which is, in any case, difficult to construe. Otherwise, the forms are consonant with the given facts of external reality. This is especially true of the cube-shaped houses and the ornamentation on the wall of the building on the left, which reappears in one of Macke's shop-window pictures (Fig. 75). One should remember that Macke was killed before he had had a chance to reap the artistic harvest of the journey to Tunisia and to apply the lessons of 'Orphic' Cubism.

Together with his friend Moilliet, Macke visited the Swiss town of Fribourg in the spring of 1914. We know that he was particularly taken with the view of the cathedral from the elevated vantage-point of the street seen in this picture. Like the yellow-and-red advertising sign on the left, the cast-iron structure of the telegraph mast between the street and the cathedral strikes a note of abrasive modernity, reminding one of the work of such contemporary artists as Delaunay and Léger. Macke's outlook was urbane and cosmopolitan: with this intimate picture, he takes up a position between Delaunay's paintings of the Eiffel Tower (see Plate 18) and Feininger's Gothic village churches (see Plate 22). Although the town depicted here is by no means a bustling metropolis, Macke takes a specifically 'modern' interest in street life. A quite different, altogether more urgent response to the challenge of the city can be seen in the Berlin pictures of Kirchner (see Fig. 77), who was a member of the *Brücke* group. Whereas Macke took a relaxed, hedonistic attitude to the city and preferred the motif of the shop-window to that of the street itself, Kirchner's reaction to the hurly-burly of the metropolis was fuelled by a passionate sense of involvement and commitment.

KIRCHNER

The Intensification of Expression

In 1913 and 1914 Ernst Ludwig Kirchner painted a total of eighteen street scenes, including *Two Women in the Street* (Plate 32). This series of pictures was preceded by *Street* (Fig. 80), which dates from 1908/09, when the *Brücke* group was still based in Dresden; its colours glow with the same Fauvist intensity as those seen in *Girl under a Japanese Parasol* (Plate 3). Kirchner moved to Berlin in the autumn of 1911, following the break-up of the Dresden *Brücke* circle. Here, he began to use quieter, muted colours, abandoning brightness and variegation in favour of more subdued, even shades. At the same time, his brushstrokes became more nervous and hectic, as if infected by the pace of the metropolis. In *Two Women in the Street*, however,

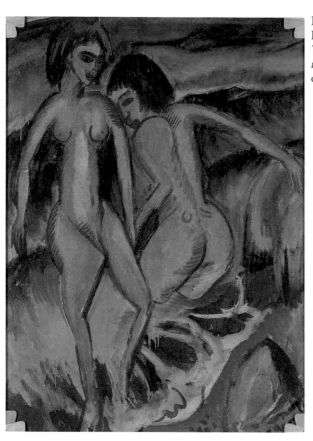

Fig. 76
Ernst Ludwig Kirchner
*Two Women Bathing
in the Waves* (reverse
of Plate 32), 1912

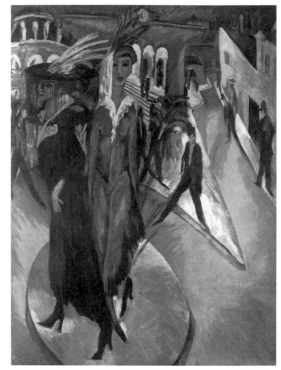

Fig. 77 Ernst Ludwig Kirchner
Potsdamer Platz, Berlin, 1914

PLATE 32
Ernst Ludwig Kirchner
Two Women in the Street, 1914
Oil on canvas, 120.5 × 91 cm

the metropolitan atmosphere is counterbalanced by the abundant use of green, against which the gold of the coat on the right and the harsh yellow of the two collars stand out in luminous contrast.

The forms of the picture are pointed and jagged, and the paint is applied in rapid, fluent brushstrokes. The two women form a steep pyramid, which is echoed by the anonymous pyramid-shaped object on the right. Individual forms are characterized by a series of sharp diagonal lines: in the slope of the women's shoulders, the fur-trimmed yellow collars of their coats, their blouses, their forearms and hands, and even their formalized, mask-like faces. The angular, stereometric form of their noses vaguely recalls the work of Modigliani (see Plate 8) and hence also 'primitive' art, which Kirchner and his friends had discovered for themselves at the turn of the century in Dresden.

The highly deliberate character of the composition is apparent in the diagonal parallels – for example, between the upper arm of the woman on the right and the slope of the other woman's shoulder, and between the necklines of both the women's coats. The two forearms are also parallel, as are the right shoulders, although the right arms are invisible. In the colour, too, Kirchner appears to be following a conscious, deliberate strategy. There is a curious cross-over between the colours of the hands and faces: the woman on the left has a pink face and a yellow hand, whereas her companion on the right has a yellow face and a pink hand. By the use of such compositional techniques Kirchner draws the various threads of the picture together and expunges the element of chance, endowing the work with a greater sense of permanence.

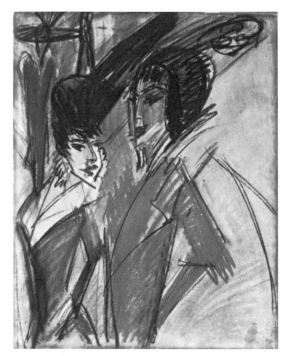

Fig. 78 Ernst Ludwig Kirchner
Street-Walkers, 1914

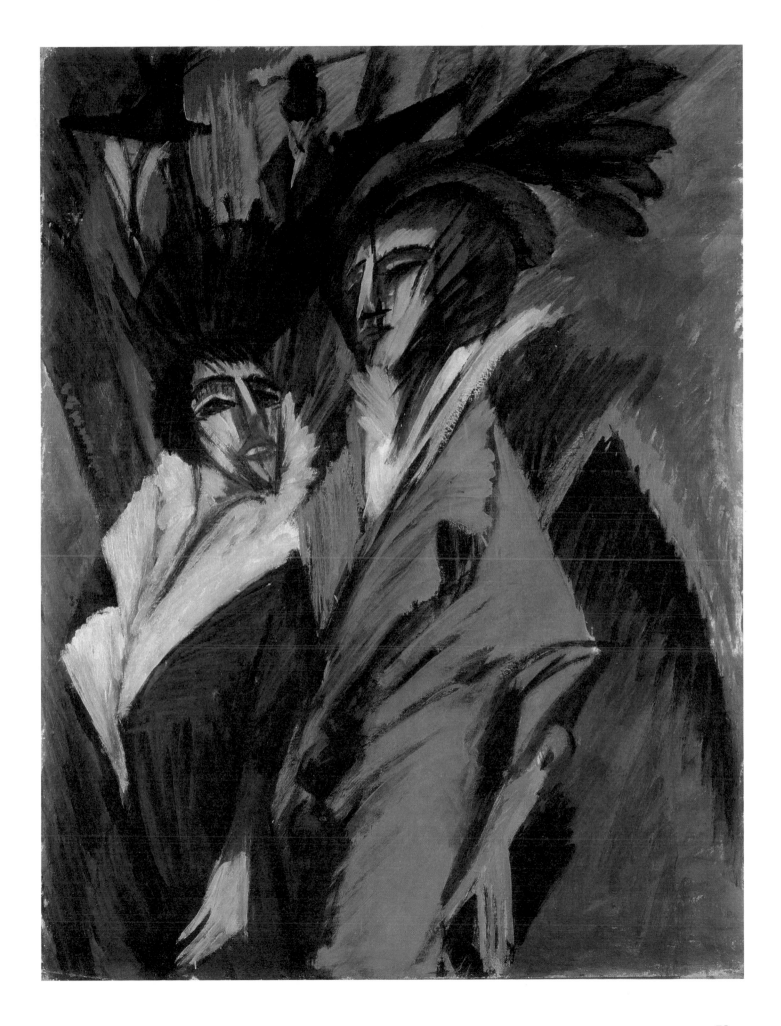

The picture thus documents an aspect of German Expressionism which is often overlooked. There is a tendency to ignore the Expressionists' passionate interest in form. These artists are concerned not only with expression itself, but also with the means of artistic expression, with form and colour. It is not true that their expressive urge explodes all formal constraints, and that Expressionist painting as a whole is formless. There are both dynamic and static elements in Expressionist art. Form is not sacrificed to expression; instead, it is activated and sharpened. In *Two Women in the Street* this is apparent even in the faces, which by their very nature are particularly sensitive to change and deformation: despite their eminently expressive character, they bear the stamp of a very definite formal sensibility. Thus, the forces of inner unrest are held at bay by the 'will to form'.

However, form and colour are not everything. The subject of the picture is a couple of prostitutes in a Berlin street: a pair of passersby quite different from those found, for example, in Macke's urban idylls. Kirchner's picture contains an element of social commentary, but not of an aggressive, critical kind; it is no more a protest against the evils of society than is Picasso's *Les Demoiselles d'Avignon*, which was painted seven years previously and is set in the same milieu. Since Toulouse-Lautrec the theme of prostitution had been used by artists as a vehicle for the expression of their opposition to bourgeois society and its artistic ideology. To this extent it also implied a form of social commitment which later came to the fore in the work of such artists as George Grosz and Otto Dix, whose pictures have an angry, denunciatory tone.

On his excursions into the urban jungle Kirchner was given to making fleeting sketches, some of which subsequently formed the basis of major paintings. Among his many paintings, drawings and prints on the theme of prostitution, there is a coloured sketch entitled *Street-Walkers* (Fig. 78) which would seem to be an immediate pre-

Fig. 79 Ernst Ludwig Kirchner, *The Street*, 1913

Fig. 80
Ernst Ludwig Kirchner
Street, 1908/9

cursor of *Two Women in the Street*. The finished version of the picture has succeeded in preserving the spontaneity of the initial, hasty impression.

At this point in Kirchner's creative development the metropolis was by no means his sole theme: he was also interested in the flight from the city into the countryside. Alongside the pictures of prostitutes he produced landscapes of the island of Fehmahrn. Naked girls confer an idyllic note on these pictures, which glorify the virtues of 'innocent' nature as compared with the wickedness and decadence of the city: nakedness symbolizes the state of original grace from which mankind has fallen. In echoing Jean-Jacques Rousseau's call for a return to nature, the pictures form a sharp contrast with the scenes of urban life, in the same way that, a few years later, Léger's glorification of nudity contrasts with his equally emphatic glorification of the modern world of machines and technology. On the reverse of the painting of the two prostitutes there is a picture of two naked girls bathing (Fig. 76). Kirchner himself rejected this work as substandard.

*

Artists who saw themselves as outsiders, marginalized by a society which took little notice of their work, were naturally intrigued by the twilight zones of that society. By virtue of their marginal status and the exotic nature of their calling, prostitutes were an object of particular interest, as were circus and music-hall performers. During his time in Dresden, and later in Berlin, Kirchner frequently turned his artistic attention to these essentially metropolitan themes (see Fig. 83). In 1911/12 he painted the two large-format pictures *Circus Rider* and *Negro Dance* (Plate 33), both of which hark back directly to the work of Toulouse-Lautrec's great contemporary Seurat, especially to his monumental paintings *The Circus* and *Le Chahut* (Fig. 85, 86) from the period around 1890.

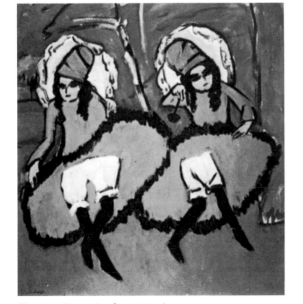

Fig. 83 Ernst Ludwig Kirchner
Two Dancers, 1910/11

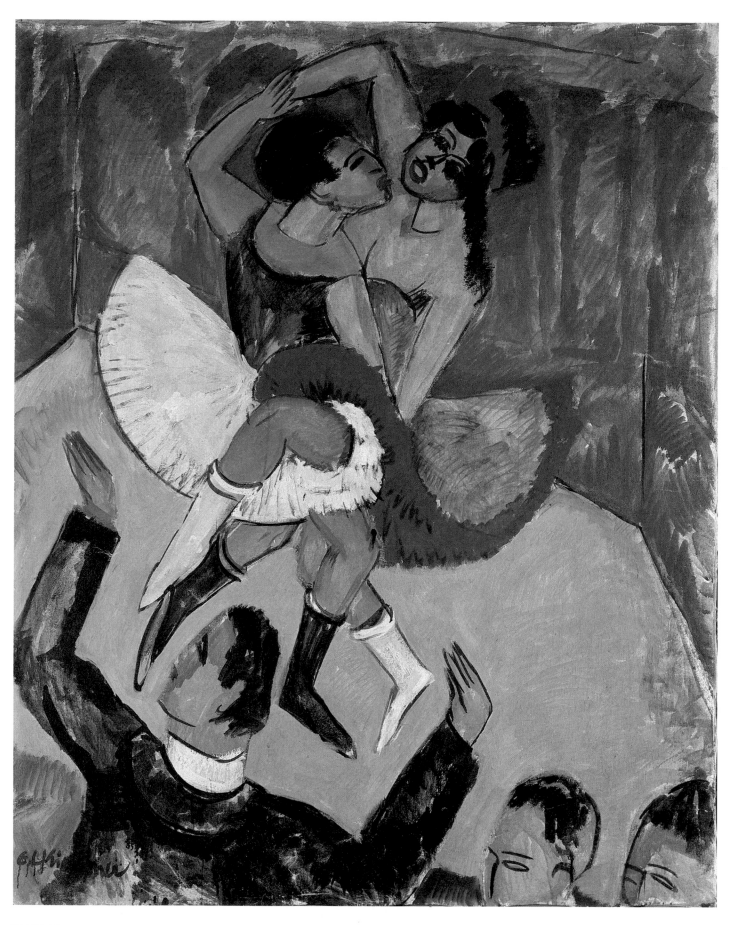

PLATE 33
Ernst Ludwig Kirchner, *Negro Dance*, *c.* 1911
Distemper on canvas, 151.5 x 120 cm

Fig. 84 Ernst Ludwig Kirchner
Music-Hall Dancers, 1911

It is a matter of conjecture whether *Negro Dance* was painted before or after Kirchner's move from Dresden to Berlin. The title would seem to be a reference to the Afro-American origins of jazz. Although the colouring to some extent follows the style of the earlier Dresden pictures, it shows a greater degree of subtlety and refinement: the 'pure' colours of Fauvism have given way to darker, more finely modulated shades. Despite the expressive haste of the painting, there are clear indications of a conscious striving for compositional balance. This is particularly apparent in the oddly symmetrical configuration of the dancers' legs with the arms of the conductor, a configuration which seems to freeze and capture the fleeting moment. The conductor, with his back to the viewer and his upper body abruptly cut off at the edge of the picture, forcibly reminds one of the clown and the musicians in the foreground of the two pictures by Seurat mentioned above: they, too, are seen from behind and appear to be directing the events taking place on stage. It is hard to imagine that Kirchner composed *Negro Dance* without reference to these pictures. The turn of the century forms an artificial dividing line between two generations which is so sharp that one tends not to realize how close in time they were. Kirchner, who was born in 1881, was only seventeen years younger than Seurat; *The Circus* and *Le Chahut* predate his music-hall scene by just twenty years.

Kirchner's sketch for *Negro Dance*, in pen and ink and wash (Fig. 84), already contains all the basic elements of the painting. With this picture, as with *Two Women in the Street* (Plate 32), the artist stuck closely to the preliminary study and succeeded in preserving much of its spontaneity and freshness in the finished painting. Nevertheless, the composition is conceived on a large scale, and the format of the picture enhances its monumental character.

In 1912 Kirchner painted *Green Lady in a Garden Café* (Plate 34), which is probably a portrait of his wife, Gerda. The picture derives

Fig. 85
Georges Seurat
The Circus
1890/91

Fig. 86
Georges Seurat
Le Chahut
c. 1888/90

Fig. 87 Edouard Manet, *The Plum*, 1877

Fig. 88 Edgar Degas, *Absinth*, 1876

Fig. 89 Henri de Toulouse-Lautrec
A Corner of the Moulin de la Galette, 1892

its specific character from the contrast between the rapid, nervous brushwork, which is typical of Kirchner's Berlin paintings, and the air of contemplative calm which surrounds the woman. Another characteristic feature of the painting is the highly subtle use of colour, noticeable in the large patches of violet-brown, the areas of green, and the flickering accents of white in the collar and cuffs and in the feather on the woman's hat. Notwithstanding the seeming nonchalance of the brushwork and of the artist's attitude to representation, the work is structured by a highly articulate pictorial intelligence, particularly apparent in the distribution of the areas of colour.

The picture belongs to a major European tradition which originated with Impressionism. The motif of the solitary drinker, sitting in a café or bar, held a special attraction for artists in an age when the café was one of the places where the intellectual élite gathered to observe the doings of its fellow human beings. The motif also symbolizes the isolation, the loneliness, of the individual – and of the artist – in modern society. Whereas the scenes painted by Edouard Manet (see Fig. 87) strike a relatively cheerful note, his contemporary Edgar Degas sees the drinker as a problematical figure (see

Fig. 90 Pablo Picasso
Dozing Absinth Drinker, 1902

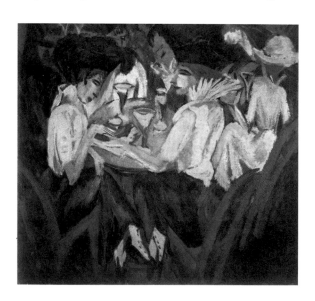

Fig. 91
Ernst Ludwig Kirchner
In the Garden Café
1914

PLATE 34
Ernst Ludwig Kirchner
*Green Lady in a
Garden Café*, 1912
Oil on canvas, 89.5 x 66.5 cm

Fig. 88). This tradition is continued by Toulouse-Lautrec (see Fig. 89), van Gogh (see Fig. 156), Munch and, a generation later, by Picasso (see Fig. 90) and Kirchner himself.

NOLDE

Emil Nolde deals with the world of the music-hall in a manner different from Kirchner. In his *Women and a Pierrot* (Plate 35), which was painted in 1917, the theme is not so much the show itself, with its momentary effects of movement and colour, as 'woman', seen as the incarnation of primeval, barbaric instinct. The picture draws on the experience of Nolde's journey to the South Sea islands in 1913/14, but, instead of celebrating primitive innocence, it shows the 'sinful' world of the city in the form of two semi-naked women, one of whom has a cigarette stuck in her painted mouth. The physical sensuality is echoed by the ardent sensuality of the colours, the glowing, expressive tones used in the depiction of the two women contrasting with the milky blue-and-white of the pierrot.

Here, too, we see one of the central motifs of European painting in the wake of Impressionism: the contrast between antithetical modes of human existence, depicted in terms of a spatial opposition between the different figures in a picture who, standing next to or behind each other, seem to be governed by some form of psychological relationship, although there is no direct dialogue or contact between them. This motif is often found in the pictures of Gauguin, and it is used to notable expressive effect by Munch (see Fig. 94). With its silent confrontation between man and woman, the one fully clothed and the other semi-naked, Nolde's *Women and a Pierrot* appears to be cast in the same mould as Gauguin's *Primitive Tales* (Fig. 93). The two artists were both much intrigued by primitivism.

Fig. 92 Emil Nolde, *Candle Dancers*, 1917

Fig. 93 Paul Gauguin
Primitive Tales, 1902

Fig. 94 Edvard Munch
Woman (The Sphinx), 1899

PLATE 35
Emil Nolde
Women and a Pierrot, 1917
Oil on canvas, 100.5 x 86.5 cm

83

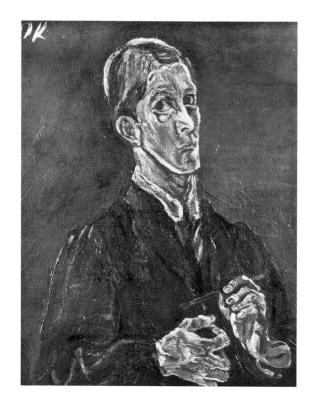

KOKOSCHKA

Oskar Kokoschka is one of the many painters in the history of art for whom the confrontation with their own self was a crucial intellectual and artistic need. His *Self-Portrait with Raised Paintbrush* (Plate 36), created in 1913/14, is one of a series of self-portraits which he painted in the years immediately preceding the First World War (see Fig. 95, 96). Like all his early portraits, it shows the artist struggling to come to terms with both the object and the mode of representation. The intensity of his self-investigation is accentuated by the technique of the painting: by the dark colours, by the flickering light playing over the face, with its deeply serious expression, and by the emptiness of the space surrounding the figure.

Before he painted this self-portrait Kokoschka had paid a visit to Venice, where he was particularly impressed by the pictures of Jacopo Tintoretto. The brushwork and the overall mood of the picture are clearly influenced by Tintoretto and El Greco (see Fig. 97), while the superficially conventional pose of the figure reminds one of Albrecht Dürer. Kokoschka was unwilling to break with the traditional canons of European painting for the sake of finding a modern pictorial language. His work remained largely unmarked by the major artistic discoveries made in the early years of the century: the autonomy of form and the liberation of colour. He was an Expressionist, but his expressive passion was directed towards the objects and the faces – his own included – which he painted. The exceptional intensity of these pictures has caused many critics to postulate some form of relationship between the art of Kokoschka and the psycho-analytical theories of Sigmund Freud. However, beyond the shared intellectual climate of early twentieth-century Vienna, Kokoschka and Freud had little in common, and there is no hard evidence to support the claim that their work was in any way related.

Fig. 97 El Greco, *Saint James the Great*, c. 1604/14

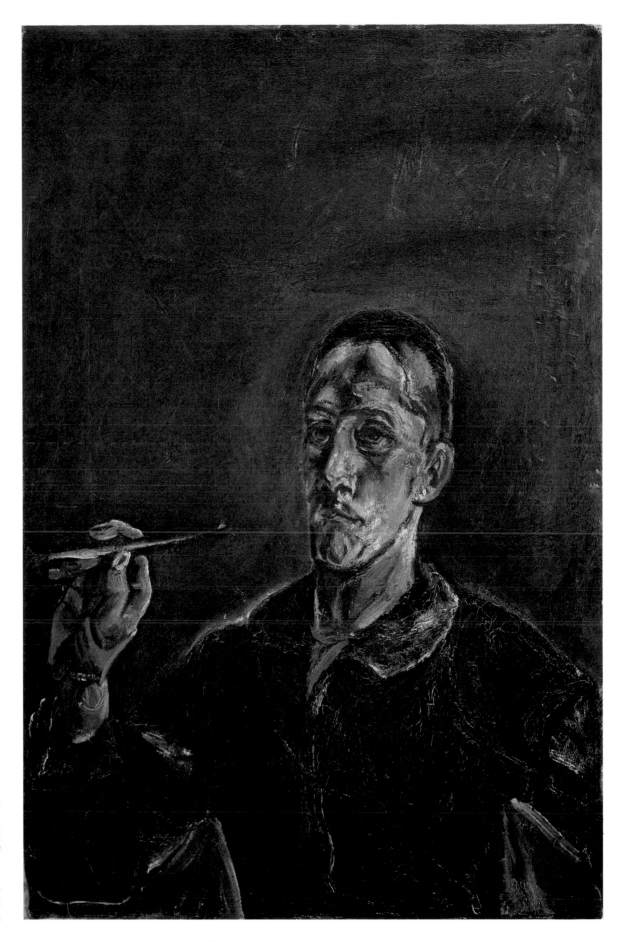

PLATE 36
Oskar Kokoschka
*Self-Portrait
with Raised
Paintbrush*
1913/14
Oil on canvas
108.5 x 70.5 cm

Although Expressionism was mainly a German movement, the French artist Georges Rouault can also be seen as a representative of this major school of twentieth-century painting. His work is comparable to that of Kokoschka in so far as it eschews the use of Fauvist pure colour and Cubist pure form, the two major innovations of the decade following the turn of the century. Rouault's *Moroccan* (Plate 37), which was painted in 1913, derives its expressive force from the dark glow of the colours and the visionary intensification of the facial features to form a kind of tragic mask. However, to the extent that the colours and the forms serve a primarily expressive function, distorting the natural appearance of people and objects, Rouault, too, draws on the specific language of twentieth-century art.

Rouault's favourite stylistic device is the use of heavy black lines to delimit the individual parts of the picture, a technique which reminds one of medieval stained-glass windows. This is Rouault's highly personal version of *cloisonnisme*, a technique developed in the 1880s by Gauguin and the other members of his circle. These artists had sought to reconsolidate form, which had been dissolved by the Impressionists, by painting bold contours around the two-dimensional shapes in their pictures. Rouault adopted this principle and stripped it of its original decorative function, linking it instead with a new spiritual passion which was fuelled by his ardent Catholicism. The contours themselves took on the character of an expressive script.

*

'Passion' is one of the key words in the vocabulary of Christian belief, and Rouault is the most important Christian painter of his age. In the 1920s, at the time when he painted *The Three Judges* (Plate 38), he embarked on the continuous series of pictures on Christian themes with which his name is most closely associated. Even his early pictures of prostitutes, which proved so shocking to

PLATE 37
Georges Rouault
Moroccan, c. 1913
Oil on canvas
102 x 69 cm

Fig. 98
Georges Rouault
The Condemned Man
1907

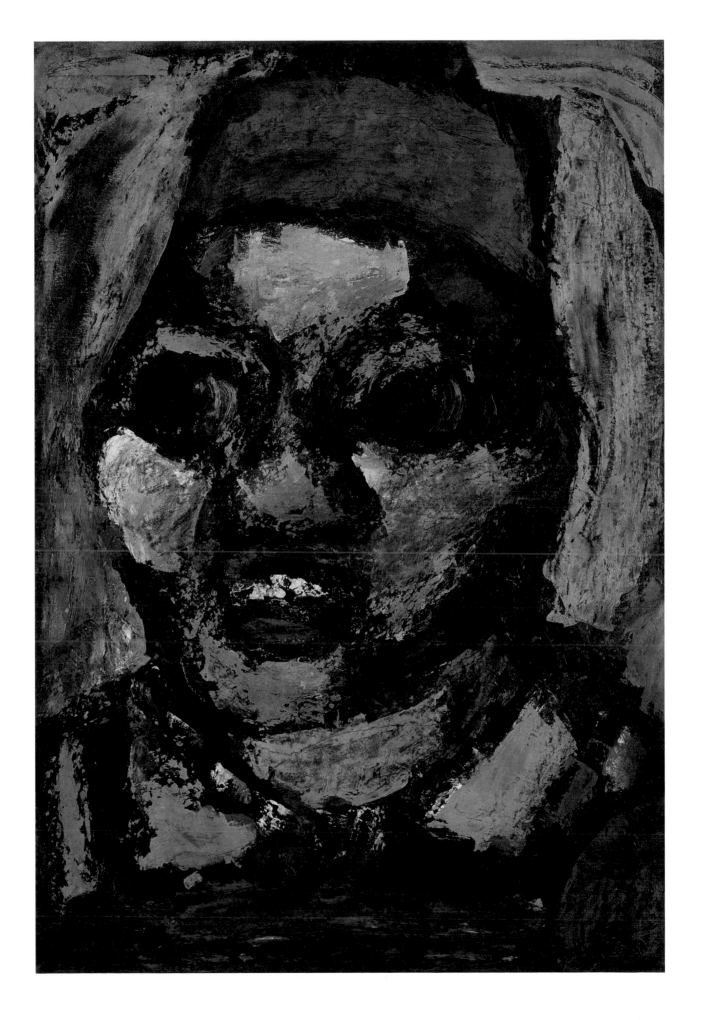

PLATE 38
Georges Rouault
The Three Judges, *c.* 1920
Oil on canvas, 76 x 105.5 cm

Fig. 99
Honoré Daumier
The Lawyers
1860

Fig. 100
Georges Rouault
Three Judges
1913

Fig. 101 Georges Rouault, *Upholder of Justice*, c. 1913

the contemporary public, are informed by Christian compassion, by sympathy for the sufferings of the poorest and most downtrodden members of society.

In an extended series of exceptional pictures (see Fig. 100, 101) Rouault addressed the theme of justice and judgment; here, too, the attitude which governs the pictures is framed by Christian beliefs. The central figure in *The Three Judges* instantly reminds one of the figure of Christ at the Last Supper, seated among his disciples and lost in silent contemplation. Rouault must surely have had this image in mind when he painted the picture. However, since his beliefs precluded the equation of secular justice with divine judgment, he refrained from making the judge into an overtly Christ-like figure. Indeed, the central figure appears to reconcile the roles of judge and accused (see Fig. 98).

In the nineteenth century the artist Honoré Daumier had been one of the foremost critics of the French judicial system. His numerous images of judges and lawyers (see Fig. 99) savagely caricatured the hypocrisy and indolence of the legal profession. Rouault's picture echoes the work of Daumier in its subject-matter, its expressive intensity and the darkness of its colouring. Like Daumier, Rouault mixed 'dirt' into his colours, thereby lending them a particular spiritual depth and conveying a sense of that wretchedness which places man in need of God's mercy. Here, too, we find a manifestation of Rouault's religious feelings.

BECKMANN

Max Beckmann painted *Night* (Plate 39) in Frankfurt in 1918/19. The picture, which is the finest example of his early work, was inspired by the horrors of war and by the general mood of despair and confusion which reigned in Germany towards the end of the First World War. It shows a scene of nightmarish torment, in which

Fig. 102
Master of the Karlsruhe Passion
The Capture of Christ
*c.*1450/75

Fig. 103
Max Beckmann
The Dream, 1921

the brutality of the events themselves is underlined by the manner in which they are portrayed: the theme is bestial, cold-blooded butchery, carried out without a shred of pity or remorse and depicted with a harsh, matter-of-fact realism. Beckmann's realistic style has nothing to do with conventional realism: it exaggerates and distorts the features and limbs of the characters and invests them with a high degree of expressive pathos. Details are taken seriously only where they serve an expressive function. Art of this kind has nothing to do with ancient Greece or the idols of Africa and the South Sea islands. Instead, one detects the influence of late medieval German art, in the dispassionate depiction of nature, in the grotesque facial expressions and especially in the composition, which crowds a mass of intertwined human bodies and limbs into a confined space. This influence is illustrated by a picture, selected almost at random, from the mid-fifteenth century: *The Capture of Christ* by the Master of

Fig. 104 *The Triumph of Death* (detail), mid-fourteenth century

Fig. 105
The Triumph of Death (detail), mid-fourteenth century

PLATE 39
Max Beckmann
Night, 1918/19
Oil on canvas, 133 x 154 cm

the Karlsruhe Passion (Fig. 102). The affinity between Beckmann's art and that of the medieval masters is demonstrated still more clearly by his oblong-format painting *The Dream* (Fig. 103). In 1922 Beckmann wrote: 'The important thing now is that we should not drift back into a time of anarchy; instead, by cultivating an awareness of our own crazy times, we should acquire an affectionate awareness of our ancestors.' Details such as the folds in the dress of the crouching woman on the right in *Night* are particularly reminiscent of fifteenth-century German art. Yet one also finds traces of a quite different influence. On the wall of his studio in Frankfurt Beckmann hung a reproduction of *The Triumph of Death* (Fig. 105), a monumental fourteenth-century fresco in the Campo Santo in Pisa. A detail from it (Fig. 104), the head of a blindfolded man, evidently served as the model for the head of the man with the cap on the right of Beckmann's picture.

Fig. 106-11 Max Beckmann, Studies for *Night*, 1917/18

Fig. 112
Max Beckmann
Night, 1919
No. 6 from
the series of
lithographs *Hell*

Night contains elements both of Expressionism and of the then nascent movement known as *Neue Sachlichkeit* (New Objectivity). Concerning his own 'objectivity', Beckmann wrote in 1918: 'I believe that the reason why I love painting so much is that it forces one to be objective. There is nothing I hate more than sentimentality. The stronger and more intense my desire becomes to capture and record that which is unsayable, the more tightly my mouth stays shut, and the colder my determination becomes to grab this twitching, living monster and lock it away in crystal-clear, sharp lines and planes, to quell it and strangle it. I do not weep: I loathe tears, for they are a sign of slavery. I think only of objects: of a leg or an arm, of the wonderful sense of foreshortening, breaking through the plane, of the division of space, of the combination of straight lines in relation to curved ones. And of the amusing juxtaposition of small, round forms with the straight and flat forms of the corners of walls, of table-tops, wooden crosses and the façades of houses. To me, the most important thing is roundness, captured in height and breadth. Roundness in flatness, depth in the sense of flatness, the architecture of the picture.'

Fig. 113 Max Beckmann, *Seated Man with Straddled Legs and Outstretched Open Hand*, 1919

Fig. 114 Honoré Daumier
Rue Transnonain, 15th April 1834, 1834

Here, Beckmann indicates his strong interest in form and composition, which is underlined by the series of preliminary sketches which he made for *Night* (see Fig. 106-11). In the foreground he had originally intended to paint a man hanging upside-down, with his legs forming a diamond shape. Instead, the finished picture shows a woman suspended by her wrists, with the diamond shape formed by her arms. Thus, he preserved the formal motif while changing the content, which, in view of the passionate interest in content which manifests itself in the picture, is rather surprising.

Unlike the fleeting sketches, Beckmann's drawing of a man seated on the ground (Fig. 113) shows the torture victim in almost the same pose as in the painting. The drawing bears a marked resemblance to one of Daumier's most famous lithographs, *Rue Transnonain, 15th April 1834* (Fig. 114), in which a murdered man is seen lying with his legs spread wide apart in the middle of a ransacked, corpse-strewn room. In 1919 Beckmann reproduced the composition of *Night* in a black-and-white lithograph (Fig. 112) which forms part of the series *Hell*.

DUCHAMP

Whereas Beckmann exposed and directly attacked the brutality of war, Dada reacted in a quite different fashion to the horrifying events of 1914 to 1918. The Dada movement was founded in 1916 in Zurich, where a group of miscellaneous artists, writers and cabaret performers had taken refuge, all of them sharply critical of the war and the social forces behind it. They were anti-nationalist and anti-patriotic; above all else, they prized individual freedom. Regarding conventional wisdom as deeply suspect, they placed a provocative emphasis on the value of nonsense. In a time of intellectual and cultural breakdown Dada succeeded in bringing forth a new form of art which was to exercise a major influence on the work of subsequent generations. Prior to the formation of the Dada movement in Zurich, a number of very similar artistic manifestations had already been seen in Paris and New York which later came to be regarded as an important prelude to Dada. The major exponents of this pre-Dada art were the French artist Marcel Duchamp and the Spaniard Francis Picabia, both of whom were members of the *Section d'Or* (Golden Section), an offshoot of the Cubist movement which had constituted itself in Paris in 1911. They both took part in the Armory Show in New York in 1913, a startlingly innovative exhibition which effectively introduced modernism to America.

From 1913 to 1915 Duchamp produced his first 'ready-mades'. These were banal, everyday objects to which the artist merely added his signature and a title, before putting them on show in art exhibitions (see Fig. 119). There is an obvious affinity between these highly provocative works, which opened a new chapter in the history of art, and Duchamp's *The Chocolate-Grinder* (Plate 40), which is a kind of painted ready-made – a simplified and de-functionalized, but deliberately banal depiction of a mechanical appliance which the artist had come across in the window of a shop in Rouen (see

The Banality of Objects

Fig. 115 Chocolate-grinder. Illustration from a sales catalogue, *c.* 1900

94

Fig. 116
Marcel Duchamp
*The Bride Stripped
Bare by Her Bachelors
Even (The Large Glass)*
1915-23

Fig. 115). In the two versions of the picture from February/March 1913 and February 1914 (Fig. 117, 118), both of which are in the Philadelphia Museum of Art, the machine stands on a round table with 'Louis XV' legs. A sketch in the Staatsgalerie in Stuttgart is closer to the Düsseldorf picture, which was painted in January 1914, shortly before the final version. In the Düsseldorf version the table is missing. The motif of the chocolate-grinder – with the table – appears yet again in the lower section of Duchamp's large-format picture on glass, *The Bride Stripped Bare by Her Bachelors, Even* (Fig. 116), on which he worked from 1915 to 1923 and which is often referred to as *The Large Glass*. Duchamp had already used mechanical forms in his early paintings, whose style combined Cubist and Futurist influences. In the various versions of *The Chocolate-Grinder*, however, his ambition was no longer to interpret the machine in terms of painting – in the manner, for example, of Léger in

Fig. 117
Marcel Duchamp
*The Chocolate-Grinder
No. 1*, 1913

Fig. 118
Marcel Duchamp
*The Chocolate-Grinder
No. 2*, 1914

his *Contrasted Forms* (Plate 19) – but to show the mechanical object itself, free of all aesthetic decoration: a simple everyday artefact which, when placed in an artistic context, constitutes a bold gesture of provocation. Nevertheless, *The Chocolate-Grinder* does have the character and status of a genuine work of art. Its specifically pictorial qualities obscure Duchamp's aesthetic nihilism, his programmatic rejection of Art with a capital 'A'.

Duchamp regarded *The Large Glass* (Fig. 116) as a form of erotic apparatus: the individual parts are allotted various sexual functions. The chocolate-grinder, according to the artist, represents 'the bachelor who grinds his own chocolate'; in other words, it symbolizes masturbation. It is difficult to assess whether this is meant seriously or jokingly; in Duchamp's work there is only a thin dividing line

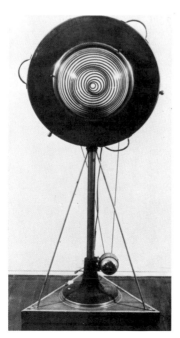

Fig. 119
Marcel Duchamp
Bicycle Wheel, 1913
(re-made 1964)

Fig. 120
Marcel Duchamp
Rotative Demisphere
1925

between sense and nonsense. This uncertainty is an integral part of Dada strategy. However, there can be no doubt about the underlying seriousness of Duchamp's intentions regarding the refusal to conform to conventional notions of what constitutes art.

In his earlier work Duchamp had taken a particular interest in machines on account of their purely technical, non-aesthetic and unsentimental character. He was especially intrigued by the idea of rotation. In 1911, for example, he painted a picture of a coffee-grinder (Fig. 123) which retains an overtly 'artistic' element, but which already points to his interest in technical artefacts and in the rotation motif. In the early 1920s he began constructing a series of rotating sculptures (see Fig. 120), which were followed in the 1930s by his 'Rotoreliefs'. One of his first ready-mades – the bicycle wheel mounted on a stool (Fig. 119), which he assembled in 1913 – indicates his specific interest in the wheel and hence in the circle, a form which took on an exceptional importance for avant-garde art as a whole.

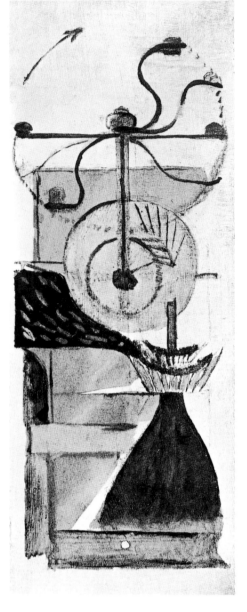

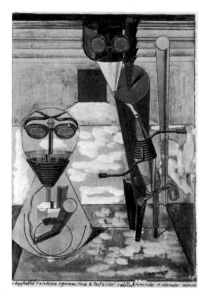 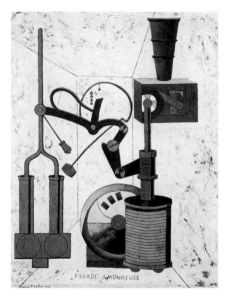

Duchamp's mechanical fantasies ushered in a spate of pictures in the period around 1920 which depicted machines in poetic and ironic terms. Stylistically, and in intent, these pictures are very different, but they share this common theme. The series extends from Duchamp (see Fig. 123) and Picabia (see Fig. 122), via Max Ernst (see Fig. 121), to Klee's *Twittering Machine* of 1922.

Fig. 121 Max Ernst, *1 Copper Sheet, 1 Zinc Sheet, 1 Rubber Cloth*, c. 1920

Fig. 122 Francis Picabia *Amorous Parade*, 1917

Fig. 123 Marcel Duchamp *Coffee-Grinder*, 1911

SCHWITTERS

Although the large-format 'Merz pictures' which Kurt Schwitters created from 1919 to 1921 (see Plate 41) are very different from Beckmann's *Night* and Duchamp's *The Chocolate-Grinder*, they, too, are a product of the restless, turbulent mood of the period following the war and the failed German revolution of 1918/19.

Schwitters wrote: 'I could see no reason why used tram tickets, bits of driftwood, buttons and old junk from attics and rubbish heaps

PLATE 41
Kurt Schwitters
*Merz Picture 25 A:
The Star Picture*, 1920
Montage, collage and oil
on cardboard, 104.5 × 79 cm

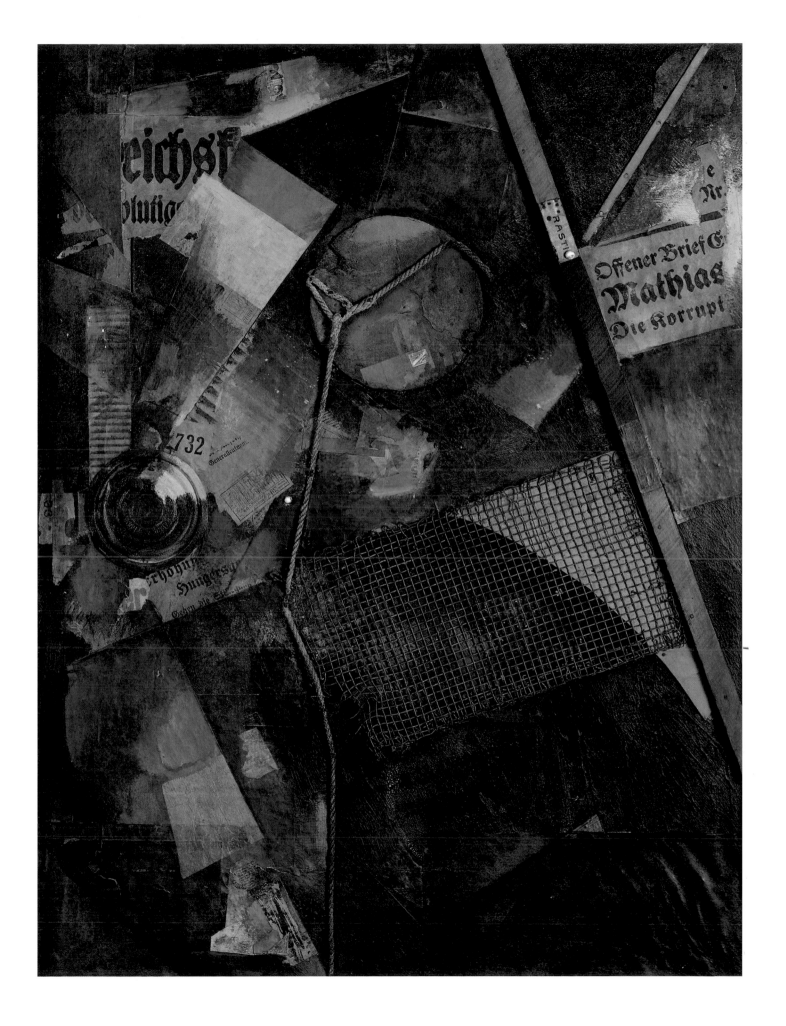

should not serve as materials for paintings; they suited the purpose just as well as factory-made paints The name which I gave to my new form of creation, using any and every type of material, was MERZ, which is the 2nd syllable of *Kommerz* [commerce]. It was coined when I made the Merz picture, a work which includes the word MERZ, cut out of an advertisement for the KOMMERZ- UND PRIVATBANK, which I stuck on the picture amid a number of abstract forms. Blending with the rest of the work, the word MERZ had become an integral part of the picture, and it had to remain where it was. I am sure you will understand why I called a picture with the word MERZ the Merz picture.... I then began to refer to all my pictures by the title of the most characteristic example of the genre. Later I extended the term Merz first to my writing – I have been writing since 1917 – and subsequently to all my other related activities. Now I call myself MERZ.' On another occasion Schwitters commented on the historical background: 'And suddenly the glorious revolution had arrived. I don't think much of such revolutions; humanity has to be properly prepared for them. It's like apples being blown off the tree before they are ripe: such damage and destruction. But it brought the swindle which people called "war" to an end. I left my job without so much as handing in my notice, and off I went. It was at this point that the ferment really got under way. I felt free and I had to cry out and broadcast my jubilation to the world at large. For reasons of economy I used whatever I could find: we were an impoverished country. It is possible to cry out using bits of old rubbish, and that's what I did, gluing and nailing them together. I

Fig. 124 Kurt Schwitters
The Merz Picture, 1919. Lost

Fig. 125 Kurt Schwitters
The Worker Picture, 1919

Fig. 126 Giacomo Balla, *Mercury Moves Past the Sun*, 1914

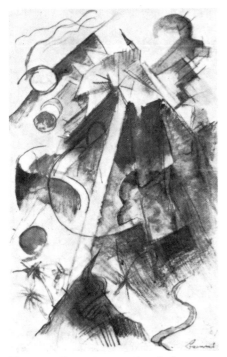

Fig. 127 Franz Marc, *Sketch from Brennerstrasse*, 1913

called it MERZ, but it was my prayer of thanks for the victorious end to the war: once again, peace had triumphed. Everything was in pieces, and the task was to build something new out of the bits. But that is MERZ It was like an image of the revolution within me, not as it was, but as it should have been.'

Shortly before he began work on the Merz pictures, in the winter of 1918/19, Schwitters had passed through a brief Expressionist phase, and he had been strongly influenced by Cubism and Futurism. In 1918 he had done a considerable number of charcoal drawings (see Fig. 128), in which he explored the possibilities of Cubist and Futurist compositional techniques, applying them to a variety of both figurative and abstract motifs. Where they depicted houses or churches, these drawings stood in much the same relation to Cubism as the early pictures of Feininger (see Plate 22). With its pyramid-like structure, Schwitters's *The Merz Picture* (Fig. 124) recalls the still lifes painted by Picasso and Braque in 1911/12 (see Plate 10). However, the formal system used by these artists is considerably modified by the effect of the materials in Schwitters's picture.

In the Merz pictures and the collages – and even in the early charcoal drawings – Schwitters repeatedly uses the motif of the circle, which is doubtless associated with the image of the sun or the stars. This is illustrated by a strongly Expressionist landscape from 1918 (Fig. 129). Schwitters himself would almost certainly have characterized the circular shapes in *The Merz Picture* and *The Worker Picture* (Fig. 125) as 'pure' forms; however, such a title as *The Star Picture,* while meant ironically, contains an obvious cosmic reference, in keeping with the artistic spirit of the times, which oscillated between the twin poles of the cosmic and the purely formal. In this respect, it is instructive to compare Schwitters's picture with one that Giacomo Balla painted in 1914 (Fig. 126) and with a work by El Lissitzky (Plate 65) dating from 1923. A watercolour by Marc (Fig. 127) shows how the 'Cubo-Futurist' formal scheme used by the members of the *Blaue Reiter* circle permeated into the work of the group associated with

Fig. 128
Kurt Schwitters
Eindorf, 1918

Fig. 129
Kurt Schwitters
Mountain Grave
1919

the Berlin periodical and art gallery *Der Sturm* (The Storm), of which Schwitters was a member. There are numerous similarities between these pictures, right down to the titles. While Schwitters entitles his collage *The Star Picture*, Balla gives his painting the title *Mercury Moves Past the Sun*. Even Lissitzky speaks of the 'Victory of the Sun', although he explains: 'The sun as an expression of the old energy of the world is torn down from the sky by modern man, who creates his own source of energy through his mastery of technology.' Schwitters, too, tears down the sun and the stars from the sky. Yet by putting them in the picture in the shape of a tin lid and a round piece of cardboard, he sets free a quite different form of energy, which has nothing to do with technology. To a greater extent than Dada's use of everyday materials might lead one to expect, Schwitters's large pictures from the period around 1920 are informed by an Expressionist impulse. The Merz pictures in general, and *The Star Picture* in particular, retain much of the pathos and the cosmic longing of Expressionism, but with the difference that the celestial forms of the Expressionist visionaries have metamorphosed into banal discs of tin and cardboard – pieces of everyday waste with battered surfaces and torn edges that are symbols of the poverty and misery of the post-war period rather than images of the firmament. The subdued pathos of Schwitters, the 'Expressionist Dadaist', allies itself with the existing repertoire of Cubo-Futurist forms and with the Dada cult of commonplace materials. The scraps of newspaper among the various remnants of everyday life strike a topical note, which contrasts with the abstract action of the picture and lends it a political dimension – an aspect that harks back to Futurism rather than Cubism. On the one hand, Schwitters vehemently rejected overt political commitment in art: this was the message of his *Manifest*

PLATE 42
Kurt Schwitters
Mz 150: Oskar, 1920
Collage on cardboard
13.1 x 9.7 cm

PLATE 43
Kurt Schwitters, *Mz 169:
Forms in Space*, 1920
Collage on cardboard
18 x 14.3 cm

PLATE 44
Kurt Schwitters
Mz 271: Chamber, 1921
Collage on cardboard
17.8 x 14.3 cm

Proletkunst (Manifesto of Proletarian Art) of 1923, which was also signed by Jean Arp and Theo van Doesburg. On the other hand, his art opposed prevailing canons of taste and thereby flew in the face of authority, whether it contained direct political references, as in *The Star Picture*, or whether it was superficially non-political.

*

Somewhat misleadingly, Schwitters referred to his small-format collages as 'Merz drawings'. He worked on this series of pictures, of which there are several hundred, from the winter of 1918/19 until the time of his death. In them, he allowed his creative imagination to roam at will, showing the playful side of his artistic nature which complemented the theoretical dimension of his approach to art. While he was attracted and inspired by the element of chance in the arrangement of the scraps of paper, his sense of form constantly intervenes in these pictures. Rejecting the anti-art slogans of other Dadaists, he emphasized that art was a question of balance, of the deliberate formal co-ordination of individual parts. He avowed himself to be an abstract painter, and he categorically stated: 'Merz is form.'

In the collage *Mz 150: Oscar* (Plate 42) the dark expansiveness of the large Merz pictures is crowded into a small space; the work also conveys something of the covert cosmic-Expressionist mood of the larger pictures. Even its formal structure shows certain similarities with that of *The Star Picture*; it is a star picture in miniature. However, such resemblances are found only in a small number of the early collages. Most of these works – *Forms in Space* and *Chamber* (Plates 43, 44), for example – are pure games based on coloured forms and structures, with little or no expressive character.

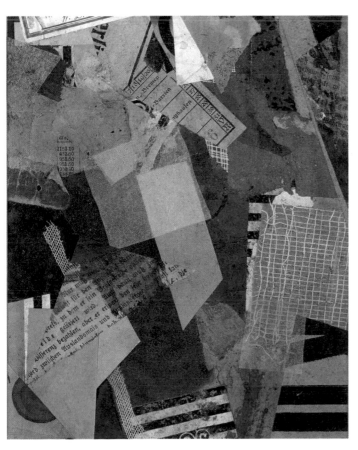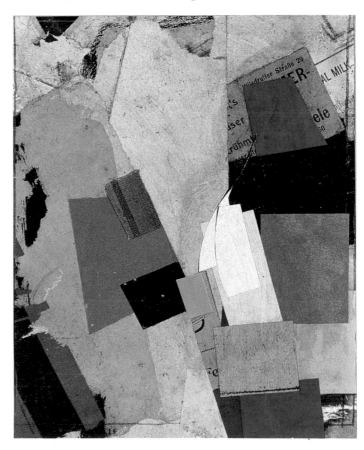

In 1919, the year in which Schwitters made his first Merz pictures and Beckmann completed *Night* (Plate 39), Joan Miró painted *Nude with a Mirror* (Plate 45). The picture, which took shape in a quite different atmosphere, untouched by the war, is crystal-clear, devoid of expressive pathos; despite its thoroughly modern character, it is hard to believe that it is contemporary with the works of other European artists of the post-war years. As early as 1914 Chagall had painted his picture of a Jew surrounded by empty space (Plate 25), abolishing any sense of external relationship, combining realism and Cubism with a subtle hint of the surreal, and anticipating the Verism and Magic Realism of the 1920s. Miró, after a phase of Fauvist-Expressionist painting, tempered by Mediterranean clarity, began painting a series of deliberately naive, realistic landscapes which culminated in *Farmstead* (1921/23). At the same time, he experimented with the possibilities of the portrait, the still life and the nude. As in all his other pictures from this period, the figurative content in *Nude with a Mirror* is reproduced with a heightened, painstaking accuracy which, paradoxically, lends the motif a certain air of unnaturalness. Like Chagall, Miró borrows selectively from Cubism, deliberately misinterpreting the aims of the movement to serve his own legitimate pictorial interests. He also takes a characteristically Southern pleasure in clarity and sharpness. In the same way that Beckmann sought inspiration in late medieval German art, Miró looked back to the southern European *quattrocento*. A further notable feature of this picture is the sense of humour which manifests itself in every line and formal twist, especially in the incongruous petit-bourgeois decor with the carpet and seat. The embroidered pouffe, which was owned by Miró's parents (see Fig. 130), still exists.

This picture represents the culmination of several years spent grappling with the theme of the female nude. In 1915 Miró tackles the subject by using bold contours with heavy hatching (see Fig. 131). Two years later he takes a Cubist approach (see Fig. 132). In 1919 we find him working directly from the model, in a 'realistic' manner (see Fig. 133). In *Nude with a Mirror*, as in a number of other pictures

The Objectivity of the Real and the Unreal

Fig. 130 Pouffe from the home of Miró's parents (see Plate 45)

Fig. 131 Joan Miró, *Drawing of a Nude*, 1915
Fig. 132 Joan Miró, *Drawing of a Nude*, 1917
Fig. 133 Joan Miró, *Drawing of a Nude*, 1919/20

PLATE 45
Joan Miró
Nude with a Mirror, 1919
Oil on canvas, 113 x 102 cm

from the same year, Miró combines naive realism with Cubist elements and thereby arrives at a highly personal style. This he was to abandon only a few years later, under the influence of Dada and as a result of his association with Surrealism, in favour of the wholly untrammelled exercise of the artistic imagination (see Plate 85).

DE CHIRICO

In the same decade, but before the outbreak of the First World War, a new and highly insistent voice began to make itself heard in European art: the voice of Giorgio de Chirico. De Chirico wished his art to be understood in 'metaphysical' terms, as transcending mere physical reality. 'Metaphysical Painting' was thus the name that he and his collaborators, Carrà and Giorgio Morandi, gave to the artistic movement which they founded in 1917. If one leaves aside such isolated figures as Klee and Chagall, this new Italian movement represents the first major step in twentieth-century painting towards the development of an art of fantasy. The step which followed, and which would be inconceivable without the pioneering contribution of de Chirico, was Surrealism.

One of de Chirico's favourite images was that of the tower, which symbolizes his striving to break through the confines of earthly existence and serves as a vehicle for his dreams. 'Our spirit,' he wrote, 'is beset by visions which come from inexhaustible sources. Shadows set out their geometrical puzzles in city squares. The walls are surmounted by towers without meaning, topped with small coloured flags. Everywhere there is infinity, everywhere there are secrets.' These words can be read as a commentary on his *The Great Tower* (Plate 46). The towers in his paintings take a wide variety of forms: round and rectangular, high and low, slender and broad. One is tempted to see this preference for the motif of the tower as a manifestation of *Italianità*: the campanile is the very epitome of Italian architecture. In their dreams artists such as de Chirico and his friends returned to the Middle Ages and the *quattrocento*, to the cities of the past, with their towers and graceful arcades. They also dreamed of Giotto, of whom de Chirico wrote: 'In the work of Giotto the architectural principle results in high metaphysical spaces. All the open architectural elements (towers, arcades and windows) which accompany his figures give one an idea of the wonder of the universe.' Miracles, puzzles and secrets are the implicit themes of de Chirico's pictures, in which time appears to stand still. He creates an atmosphere of mystery by juxtaposing different kinds of objects, some of which are calculatedly banal, or by setting them in bizarre, disquieting surroundings. His towers, too, are frequently banal, notwithstanding their classical columns; often they are prosaic factory chimneys. However, with all the things and figures which populate his pictures – towers, statues, squares and puppets – he dreams of a reality beyond the bounds of our everyday world.

De Chirico's *The Great Tower* has five storeys, three of which are surrounded by columns, while the walls of the other two are blank, interrupted only by a door and two windows. The columns are

Fig. 134 Giorgio de Chirico
The Tower, c. 1913

Fig. 135 Vesta Temple, Rome

Fig. 136 Giorgio de Chirico
Study for *The Great Tower*
(Plate 46), 1913

PLATE 46
Giorgio de Chirico
The Great Tower, 1913
Oil on canvas
123.5 x 52.5 cm

modelled on those of the ancient, so-called Vestal Temple in Rome (Fig. 135), which also features a door and two windows inside the row of columns and has a tiled roof, added at a later date. When de Chirico painted the picture, in Paris, he adhered closely to the original model: the only feature that he changed substantially was the Corinthian capitals, which are radically simplified. However, by piling three temples on top of each other and separating them by two storeys without columns, he created a quite different building, far removed from the world of classical antiquity: an architectural structure which is a cross between a watchtower and a lighthouse, part ancient and part modern, devoid of any specific temporal reference.

The picture also lacks a specific sense of place: the tower seems to stand in the middle of nowhere. It rises up from the void and its base is concealed by the large platform at the bottom of the picture. Otherwise, all we see is the sky, which seems to extend below the visible part of the tower. The platform, too, has an unreal, even surreal, appearance, projecting into the picture like a dais in front of an infinite space. At first sight, the picture seems extremely simple, but on closer inspection one discovers a mysterious, baffling quality which is initially disguised by the matter-of-fact air with which the

PLATE 47
Giorgio de Chirico
The Silent Statue (Ariadne), 1913
Oil on canvas, 99.5 x 125.5 cm

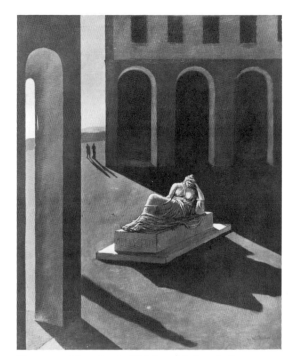

Fig. 137 Giorgio de Chirico, *Melancholy*, 1912

Fig. 138 Giorgio de Chirico
The Soothsayer's Recompense, 1913

Fig. 139 Ariadne. Roman copy of a lost
Hellenistic statue. The Vatican Museum, Rome

image presents itself. This enigmatic quality is enhanced by the light: the sun appears to be low in the sky, behind the base of the tower, but also casts long shadows on the platform.

*

In 1912/13 de Chirico painted a number of pictures (see Plate 47 and Fig. 137, 138) centering around the image of a classical statue, a Roman copy of a Hellenistic figure of the sleeping Ariadne (Fig. 139). The artist was fascinated generally by the world of classical mythology, which to him seemed like a lost paradise, and he found a source of immediate inspiration in the melancholy, dream-like quality of this figure, which, incidentally, led him to make a plaster statue of his own. He was also intrigued by the importance which the mythological figure of Ariadne held for Friedrich Nietzsche, whom he greatly admired. De Chirico placed the figure in a setting which comprises an anonymous arcade, whose style combines elements of both neo-classical and *quattrocento* architecture, and a red tower which has the appearance of a medieval fortification but, at the same time, reminds one of a modern factory chimney. The classical and the modern, ancient mythology and contemporary reality, converge and coalesce. In de Chirico's other pictures with the Ariadne figure this meeting of extremes is further accentuated by the inclusion of a railway train with smoke belching forth from the funnel of the engine. By the use of such stark contrasts the world of classical antiquity is made to seem all the more remote; it becomes an unreal world of dream and fancy. This sense of unreality is suggested by a reality which is, in fact, scarcely modified, and in which only the stone witnesses of a distant past are permitted to speak. Whereas in the other pictures the statue is placed in its 'natural' setting of an Italian piazza, in this work it is removed from any customary spatial context and brought forward to the edge of the canvas, closer to the eye of the viewer than to its surroundings. The melancholy mood of the figure – de Chirico gave other works in this series such titles as *Melancholy* (Fig. 137) or *The Melancholy of a Beautiful Day* – overflows into the colours, the empty arcades, the ruined tower and the blue-black sea. With the exception of the flags fluttering in the breeze, all spatial and temporal movement has come to a standstill. Thus, de Chirico prepares the ground for the transition in his work

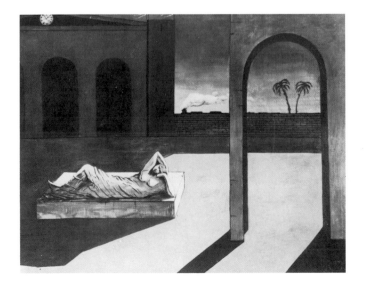

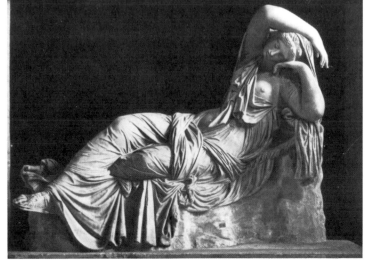

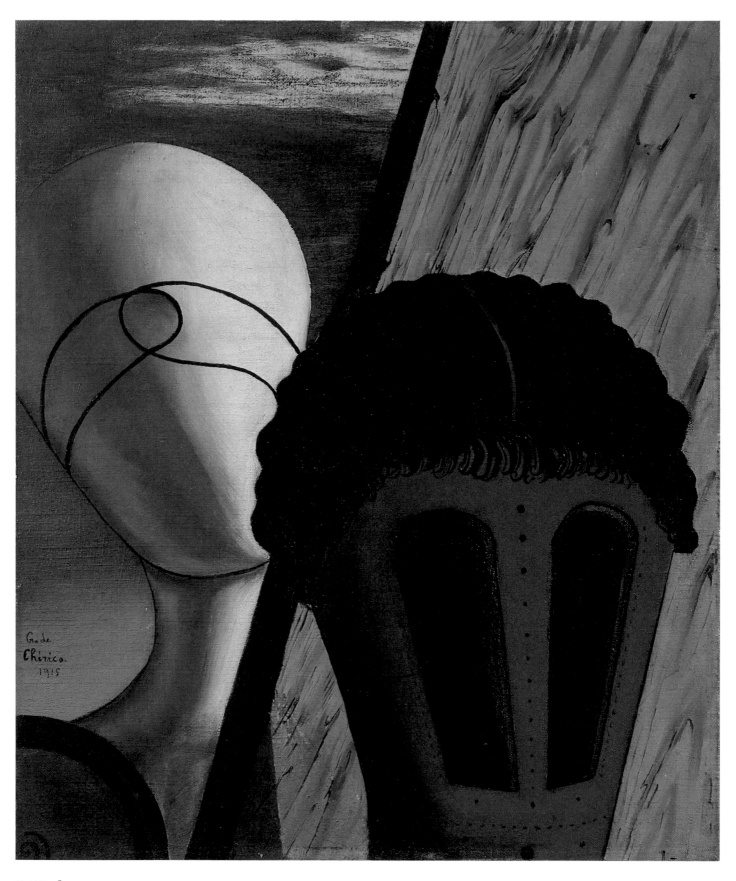

PLATE 48
Giorgio de Chirico
The Two Sisters (The Jewish Angel), 1915
Oil on canvas, 55 × 46 cm

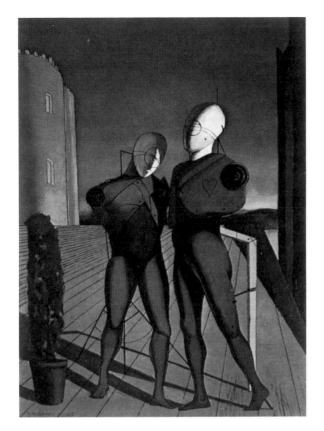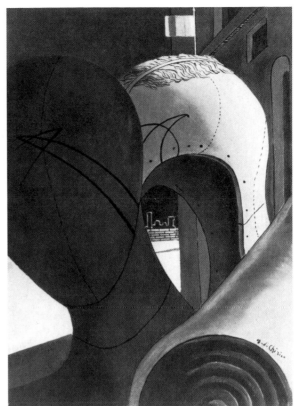

Fig. 140
Giorgio de Chirico
The Duo, 1915

Fig. 141
Giorgio de Chirico
The Fatal Light, 1915

from the real to the unreal, a transition which is fully completed in *The Two Sisters* (Plate 48).

*

In *The Two Sisters*, a small-format picture which was painted in 1915, the artist goes further than in his previous work towards the violation of 'normal' reality, although the objects which he uses are in themselves explicitly real. They are reproduced with a Veristic sharpness of definition, and yet bear only a distant resemblance to objects with which we are familiar: the context in which they are placed is strange and 'alienating'. The picture is dominated by the faceless heads of two dummies from a tailor's workshop or a shop-window, which are endowed with an oneiric significance. These objects have a magical presence: one feels that one could almost reach out and touch them. The strangeness of the picture is underlined by the banality of the objects: the banal dummies, the banal plank, the banal clouds in the banal Italian sky. As if to emphasize the mythical element in the picture, de Chirico appended the words 'The Jewish Angel' to the title. The two heads are firmly anchored in the artist's personal iconography. In a variety of constellations they recur in a number of pictures from the period between 1914 and 1917 (see Fig. 140, 141) and in de Chirico's later work.

CARRA

Metaphysical Painting constituted itself as a movement in 1917, when de Chirico joined forces with Carlo Carrà, who was in the process of liberating himself from Futurism. Carrà performed an

astonishing *volte-face*, rejecting the Futurist cult of progress and modernity in favour of de Chirico's nostalgic preoccupation with the archaic and the classical. Like de Chirico, he wrote an essay on Giotto, in 1917, together with a further piece on Paolo Uccello. He, too, succumbed to the fantastic, magical appeal of inanimate objects, seen in the melancholy context of precisely those Italian national traditions which the Futurists – with Carrà's full support – had set out to demolish only a few years before. In 1919, at the end of his brief 'metaphysical' period, he painted *The Girl from the West* (Plate 49). The title was taken from a popular play of the period. A female tennis player, clutching a racket and ball, stands to the left of centre in a dream-like scene which is emptied of meaning. Here, too, the figure is both tangible and unfathomable; it is not a thinking, seeing being but a blind dummy, epitomizing the enigma of human existence. The head has the form of a handle, a banal object whose dimensions are disproportionate to those of the body; it is an absurd conclusion to the curve of the neck, like the stopper in a bottle. As in the pictures of de Chirico, the 'alienation' of the object adds to the sense of enigma. The setting comprises an empty, windowless building with two rows of arcades which symbolize the lost paradise of Italy's past; two objects with no apparent meaning or purpose; and magic lines which denote the net of a tennis court and, at the same time, suggest a transparent glass wall. And here, too, the central figure – the anonymous 'Girl from the West' – is swathed in mystery.

In a drawing from the previous year (Fig. 142) Carrà had already assembled the basic elements of the picture. A later sketch (Fig. 143), done in 1921, moves the scene indoors. The figure of the tennis player, which can be either male or female but invariably stands alone, reappears in a number of Carrà's pictures from the period between 1917 and 1921 (see Fig. 144-46). The motif is difficult to interpret. It may possibly have autobiographical significance: in an essay published in 1918/19 Carrà wrote, concerning the tennis player in his *Oval of the Apparitions* (Fig. 145): 'further in the background stands the archaic statue of my childhood (a shy, anonymous mistress

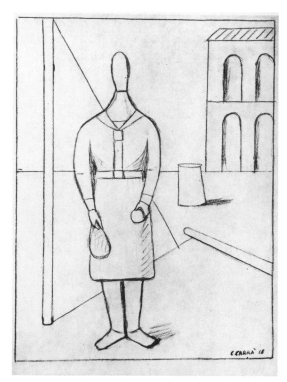

Fig. 142 Carlo Carrà, Study for *The Girl from the West* (Plate 49), 1918

PLATE 49
Carlo Carrà
The Girl from the West, 1919
Oil on canvas, 90 × 70 cm

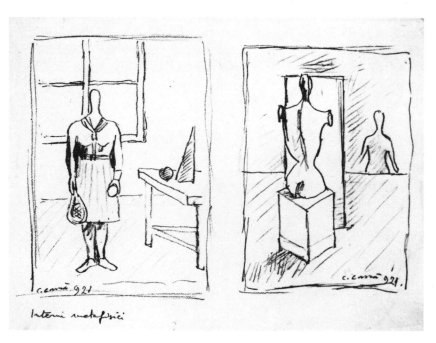

Fig. 143
Carlo Carrà
Metaphysical Interiors
1921

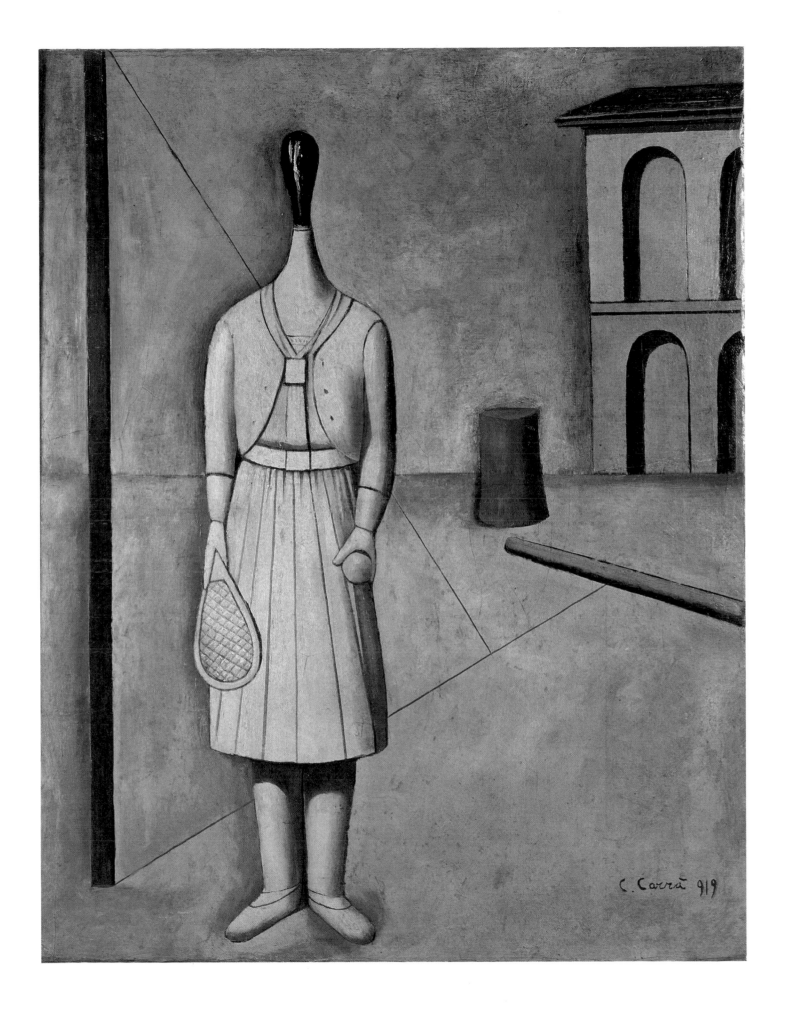

or an angle without wings?). She is holding a tennis racket and a tennis ball.' This indicates that the figure may relate to a childhood reminiscence, an interpretation which is supported by the fact that, in two of the pictures, the tennis player is a young boy.

Fig. 144 Carlo Carrà
Metaphysical Muse, 1917

Fig. 145 Carlo Carrà
Oval of the Apparitions, 1918

Fig. 146 Carlo Carrà
The Son of the Architect, 1921

MORANDI

Giorgio Morandi's still lifes from the years 1916 to 1919 follow the stylistic model of Metaphysical Painting. Morandi had seen reproductions of de Chirico's 'metaphysical' pictures and later made the acquaintance of de Chirico and Carrà. However, their direct influence on his work was short-lived. *Still Life (The Blue Vase)* (Plate 50), which was painted in 1920, exemplifies the subsequent phase in the development of Morandi's art. The objects are no longer

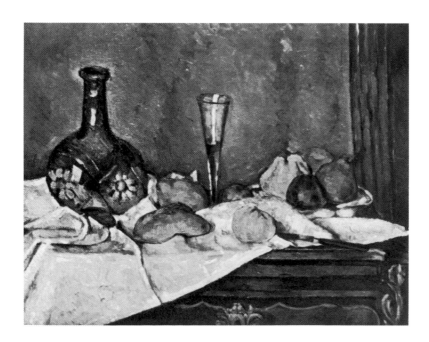

Fig. 147
Paul Cézanne
Dessert
c. 1873/77

Giorgio Morandi
Still Life (The Blue Vase), 1920
Oil on canvas, 49.5 x 52 cm

Fig. 148
Giorgio Morandi
Still Life, 1920

presented in enigmatic isolation, in an air-tight vacuum. They are cloaked in painting, enveloped in the light emanating from the colours. Unusually for Morandi, the picture was painted not from life, but from a reproduction of a still life by Cézanne (Fig. 147), which also served as the model for a further, similar painting from the same year (Fig. 148). Thus, Morandi parted company with Metaphysical Painting under the tutelage of the great French master.

*

From this point onwards, Morandi took the identity of colour and light as the main theme of his art. He produced endless variations on this subject, using the same objects over and over again: a set of vases and other small receptacles which he owned all his life (see Fig. 149) and whose particular fascination for him lay in the way that the layer of accumulated dust on them caught the light. The extent of his absorption with this theme is indicated by a series of still lifes which includes *Still Life (Cups and Boxes)* (Plate 51). In a number of pictures from the series the artist does not even vary the positioning of the objects (see Fig. 150-52). The pictures all speak of the same process: the conversion of colour into light and vice versa. Their particular charm stems from the simple arrangement of the objects, which are of equal height; the attitude to composition is quite different from that seen in the more traditional still life of 1920, which follows the model of Cézanne. All sense of compositional hierarchy has been dissolved: what we see is simply a cluster of silent objects, each of which is just as important – or unimportant – as the next. Although he took great care of his collection of vases and pots, Morandi maintained that these artefacts were unimportant in themselves: what intrigued him was light. Yet he did not paint the objects in the way that Monet painted his haystacks, in the changing light of day between sunrise and sunset. Instead, Morandi was fascinated by the light which transfigures objects by transforming them into colour, and this places his work in the tradition of Jan Vermeer.

Fig. 149 Objects in Morandi's house in Bologna

PLATE 51
Giorgio Morandi
Still Life (Cups and Boxes), 1951
Oil on canvas, 22.5 x 50 cm

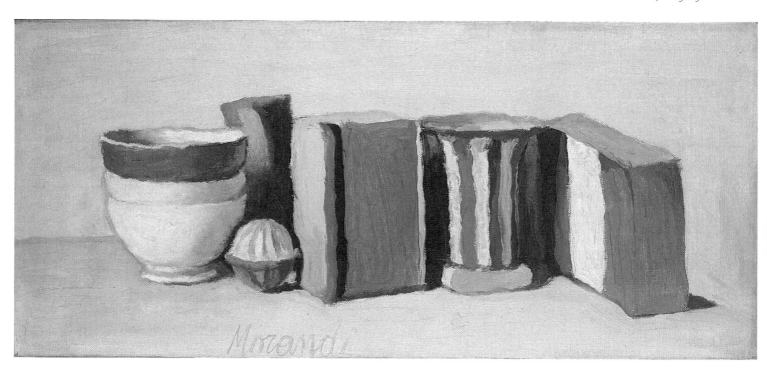

Fig. 150
Giorgio Morandi
Still Life, 1951

Fig. 151
Giorgio Morandi
Still Life, 1951

Fig. 152
Giorgio Morandi
Still Life, 1951

Fig. 153 George Grosz
Jakobstrasse, 1920

Fig. 154 George Grosz
Republican Automatons
1920

GROSZ

Italian Metaphysical Painting influenced the work of artists in several other countries, including a number of painters whose outlook was anything but metaphysical. Even the early work of George Grosz testifies to an intimate acquaintance with the pictorial problems addressed by the Italians. His *Untitled* (Plate 52), which was painted in 1920, shows a faceless, doll-like figure in an empty space which is physically real and tangible, but denatured: an urban street scene with meaningless objects standing around to no obvious purpose. However, the significance of the dummy here is social, rather than poetic: with its black suit and high, stiff collar, it represents the archetypal bourgeois. One detects an additional element of social comment in the empty windows and the petit-bourgeois green blinds of the window on the right; in the canvas, whose mechanical herringbone pattern adds considerably to the effect of the picture; and, finally, in the anonymity of the painter's style, which is underlined by the rubber stamp on the reverse of the picture: 'George Grosz 1920 konstruiert' (George Grosz constructed 1920). Sharply contrasting with the sublime *Italianità* of Carrà, this picture presents the reality of Berlin in the early years of the Weimar Republic. It is a reality seen not as a poetic no-man's-land suspended between past and present, but as a wholly contemporary scene of struggle and challenge.

A lithograph dating from 1915 (Fig. 155) shows how, some time before his brief dalliance with the pictorial forms of Metaphysical Painting, Grosz had taken up the theme of the dead urban façade with its long rows of empty windows. *Jakobstrasse* (Fig. 153), painted in 1920, uses the same setting as *Untitled*, although the figures are no longer dummies but passers-by, hurrying along the street; in *Republican Automatons* (Fig. 154) they are transformed into mechanically controlled robots carrying a national flag and wearing a medal.

PLATE 52
George Grosz
Untitled, 1920
Oil on canvas
81 x 61 cm

Fig. 155 George Grosz, *By the Canal*, 1915

In a text published in 1920 Grosz offered the following comments: 'I aim to be comprehensible to everyone, without the "depth" which is called for these days and into which it is impossible to plunge without a veritable diving suit stuffed full of spiritual, cabbalistic twaddle and metaphysics. If one tries to find a clear, simple style, one inevitably drifts into the company of Carlo Carrà. However, I am miles away from him: he wants his work to be understood in metaphysical terms, and his conception of the problems of art is bourgeois. My pictures can be seen as athletic exercises – a systematic form of training – with no outlook on eternity! In my so-called artistic works I try to construct a truly real platform. Man is no longer depicted as an individual, with minutely detailed attention to psychology, but as a collectivist, almost mechanical concept. . . . The aim is no longer to cover the canvas with brightly coloured Expressionist wallpaper exploring the workings of the soul. The neutrality and clarity of an engineering drawing is a better model for learning about art than all the uncontrollable drivel about the cabbala and metaphysics and the ecstasy of sainthood. . . . The time will come when the artist will no longer be a flabby Bohemian anarchist, but a cheerful, healthy worker in the collectivist community.'

Four years before Grosz wrote those words and painted the untitled street scene his work had followed a very different course: it was far removed from Metaphysical Painting and more akin to German Expressionism. His early paintings also have an angry, accusatory tone, as do his numerous drawings, which castigate the German bourgeois as a reactionary and lethally dangerous species of social animal. The same anger and disgust fuels his depiction of *The Lovesick Man* (Plate 53), a spineless, dissolute figure with elegant walking-stick who drowns his sorrows in alcohol. A drawing from the same period (Fig. 161) proves that the disappointed lover is a portrait of the artist himself. His dress and manner suggest a lounge lizard, a small-time crook, a drug addict or a pimp; at all events, he is the very opposite of an upstanding, patriotic citizen. The picture abounds with images of banality and triviality: the bones which have been gnawed clean by the sleeping dog, the fishbones on the left and the human skeleton in the background on the right – images which point to the banality of death. The morbidity of the colours, saturated with poison and disgust, corresponds to the aura of morbidity surrounding the central figure.

The figure is, of course, not merely a disappointed lover: it has a further significance. To depict such a blatantly civilian individual in wartime was a gesture of deliberate defiance to militarism, calculated to undermine the morale of the troops. This was how the picture was seen, and meant to be seen, by those who had credulously allowed themselves to be pressed into military service or who sent others to die in the trenches. The portrayal of moral turpitude, of weakness and decadence, is a protest against the collective glorification of the supposedly masculine virtues of the soldier. It goes without saying that Grosz was an ardent moralist, who attacked moral corruption wherever he found it. He was an artist with a mission to change the world, and his work later became a major point of reference for the politically committed art of the period after the Second World War.

PLATE 53
George Grosz
The Lovesick Man, 1916
Oil on canvas
100 × 78 cm

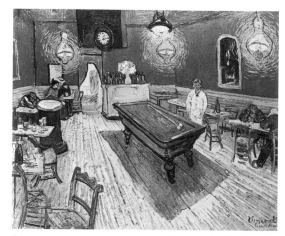

Fig. 156 Vincent van Gogh, *The Night Café*, 1888

Fig. 157 Marc Chagall, *The Yellow Room*, 1911

Fig. 158 Marc Chagall, *The Drunkard*, 1911/12

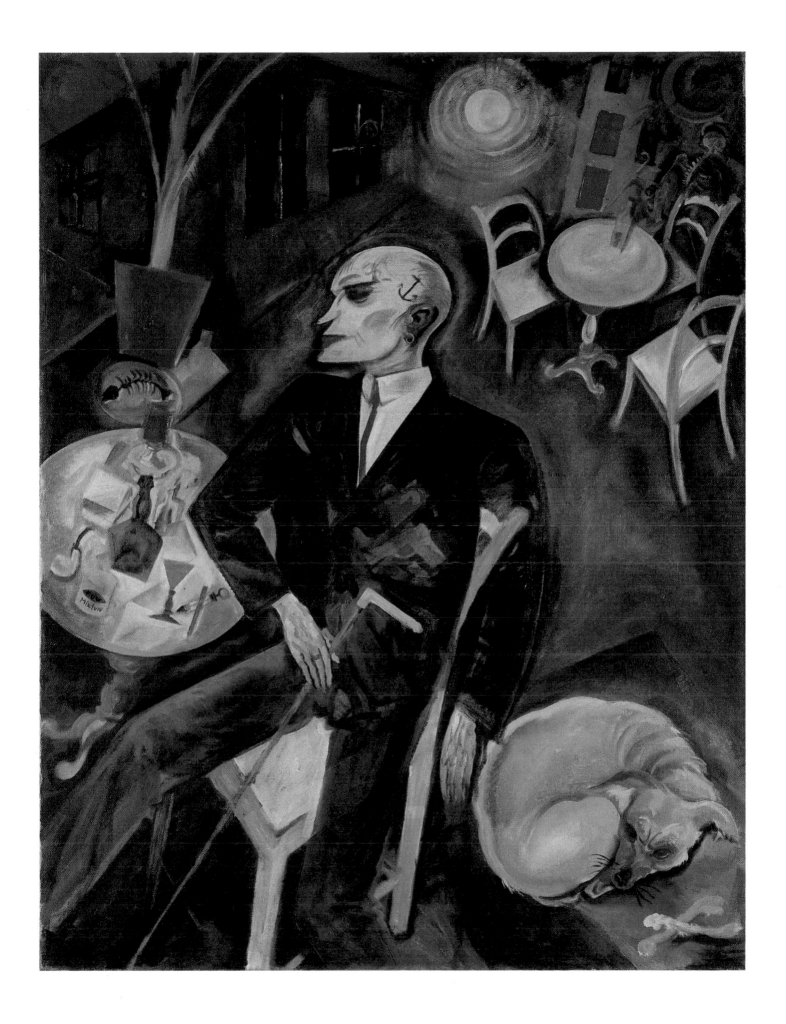

Turning aside from the highly suggestive content of the picture, whose fascination is hard to resist, one discovers a number of interesting art-historical references. Van Gogh's *The Night Café* (Fig. 156) lurks in the background of Grosz's picture. The depiction of the furniture, with its sense of dynamic movement, is reminiscent of Expressionism, and one detects a hint of Cubism in the still life on the round table. There are even a number of references to Chagall, whose work had been popularized in Berlin by Herwarth Walden, the editor of the Expressionist journal *Der Sturm*. Transferred from the realm of fantasy to the cruel world of everyday reality, several of the motifs are anticipated in pictures by Chagall from around 1911/12: in *The Yellow Room* (Fig. 157) we already find the furniture set at a drunken angle, the round form of the sun and – instead of the dog in Grosz's picture – a reclining cow on the right. In *The Drunkard* (Fig. 158) the appearance of the objects on the table is distorted in a similar Cubist fashion. There can be no doubt that Grosz was influenced by the work of Chagall, despite the latter's diametrically opposed outlook and manner of painting, just as he was influenced four years later by Carrà, whose ideas were equally different from his own.

The Coffee House (Fig. 159), which was also painted in 1916, shows a similar scene. Again, a man is seen sitting at a round table in a café, although the dominant colour is red, as opposed to the green of *The Lovesick Man*. With the pensive figure at the table and the small group in the background, the picture reminds one of Kirchner's *Green Lady in a Garden Café* (Plate 34). Like *The Lovesick Man*, it is rooted in the Expressionist tradition with which Grosz parted company the following year, turning instead to *Neue Sachlichkeit*, with temporary borrowings from Italian Metaphysical Painting.

Fig. 159 George Grosz, *The Coffee House*, 1916

Fig. 160 George Grosz
The Gold-Digger, 1916

Fig. 161 George Grosz
Self-Portrait, 1917

Fig. 162 Max Beckmann, *The Iron Footbridge*, 1922

After a phase of semi-Expressionist painting, documented by *Night* (Plate 39), Max Beckmann, too, gravitated towards *Neue Sachlichkeit*. This change in the stylistic orientation of his work is exemplified by *The Iron Footbridge* (1922; Plate 54), which is completely devoid of Expressionist pathos. The picture is topographically accurate. It shows the iron footbridge which links the historical centre of Frankfurt with the suburb of Sachsenhausen, with its neo-Gothic church, on the opposite side of the River Main. Next to the church we see a cluster of buildings with formalized windows, under a murky sky traversed by two sets of power cables. In the background, smoke belches forth from a factory chimney. The painter has invented very little: everything in the picture corresponds to the reality of the place in question, right down to the hoarding on the wall of one of the buildings, advertising the services of an undertaker. Beckmann was unwilling to distort reality for the sake of 'beauty' or expressive power. In this picture at least, he was not concerned with emotion, but with sober fact.

Sachlichkeit, meaning objectivity or neutrality, should not be confused with naturalism. The picture does not merely reproduce the external shape of reality; it suppresses inessential details and uses specific artistic techniques, such as simplification, to draw out and highlight the essential significance of the forms with which it deals. Its style can be seen as tinged with Expressionism: instead of rendering an optical impression or a set of bare naturalistic facts, it conveys the experience, the expressive impact of this dreary scene, with its collection of buildings, structures and machinery, in the midst of which a handful of tiny figures can be seen working. There is a sense of passionate intensity and excitement in the sweeping diagonal of the bridge, in the oblique angles at which the houses and the church

Fig. 163
Max Beckmann
The Iron Footbridge
1923

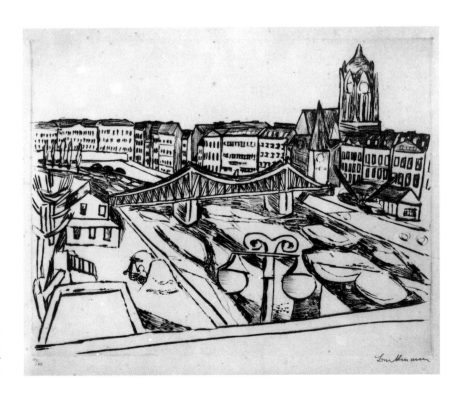

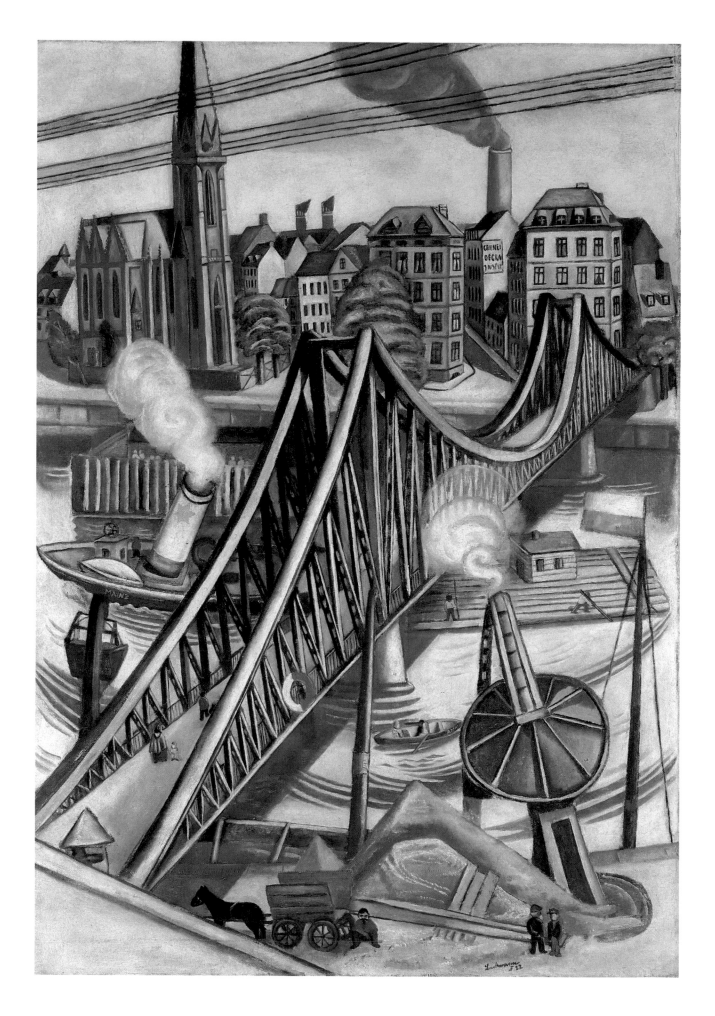

Fig. 164 Ernst Ludwig Kirchner, *The Iron Footbridge and the Dreikönigskirche in Frankfurt am Main*, 1915

PLATE 54
Max Beckmann
The Iron Footbridge, 1922
Oil on canvas
120.5 x 84.5 cm

are set, in the emphatic interplay between the grey of the bridge and the other colours, and in the visual to-and-fro between the two banks of the river, contrasting with the dead streets and windows of the city. The picture is the product of a highly personal stylistic urge which takes possession of the raw material supplied by the eye and transforms it into something new. At the same time, however, it preserves a measure of objectivity. Although it is full of 'mistakes', it is 'correct', both topographically and in terms of expression.

The Iron Footbridge contains elements of both desolation and joy. On the one hand, it shows the city as an unnatural, uninhabitable environment, but, on the other, it depicts life on and around the river as an animated bustle of purposeful activity. The artist does not merely criticize 'society'; he paints a picture which speaks in equal measure of the vital energy and the bleak gloom of the city. The beauty, if such it can be called, of this urban scene is a beauty whose commitment to truth forbids it to ignore ugliness.

Beckmann used the same set of motifs in an etching (Fig. 162), the printing technique resulting in a lateral inversion of the image. The following year he painted a further, oblong-format picture of the footbridge, seen from a different angle. An etching also exists of this work (Fig. 163). The dynamic form of the bridge over the River Main evidently held a certain fascination for artists: Kirchner made two drawings of it in 1915 (see Fig. 164).

The Iron Footbridge belongs to a series of pictures, including *The Synagogue* (1919; Fig. 165) and *The Nizza in Frankfurt am Main* (1921), which Beckmann painted while he was living in Frankfurt. The buildings in the last two works are toy-like and brightly coloured, as in *The Iron Footbridge*, but the spatial distortion of the façades, especially in *The Synagogue*, lends them a more Expressionist air.

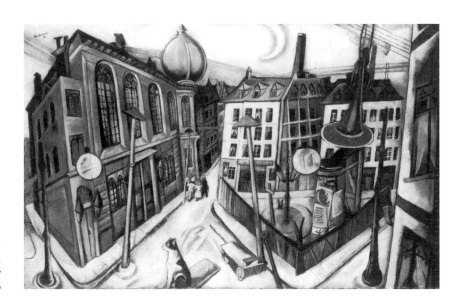

Fig. 165
Max Beckmann
The Synagogue
1919

125

The post-war trend towards 'objectivity' in art brought forth several conflicting movements. Even the German school of *Neue Sachlichkeit* was by no means homogeneous: some of its exponents sought to use art as a vehicle for social criticism, while others embraced a form of Romanticism which precluded political militancy. And 'objectivity' also became the slogan of a number of artists who were interested solely in formal innovation. Yet although they eschewed overt political comment, their artistic ideology was also directed towards social reform, and they joined forces with the adherents of 'objectivity' in other fields, such as architecture, industrial design and typography. These artists were not out to criticize, but to reform, to make the world a better place to live in. They saw their art as a kind of laboratory for new ideas and models which would transform the human environment. One of the ideas in which they were particularly interested was the integration of art into architecture. This entailed the rejection of subjective expression in favour of 'objective', anonymous, collective form. A number of artists went so far as to proclaim the end of easel painting; it was time, they said, to replace aesthetic individualism with the collective application of artistic skills.

SCHLEMMER

Ideas of this kind were discussed and put into practice at the Bauhaus, which was founded in Weimar in 1919 and moved to Dessau in 1925. Before his appointment to a teaching post at the Bauhaus, Oskar Schlemmer made his *Ornamental Sculpture on a Split Frame* (Plate 55). The work is dated 1919, with the inscription 'neu hergestellt 1923' (re-made 1923) on the reverse. It may conceivably be a replica of an earlier sculpture, but there are grounds for supposing that it is, in fact, the original version, although a comparison between the sculpture and an earlier photograph indicates that Schlemmer may have renewed the centrepiece at a later date. He also made two casts, in plaster and silver (Fig. 166, 167), of the central relief, whose form reminds one of a set of organ pipes. In his writings Schlemmer himself occasionally mentioned 'the organ', and this may be a reference to these works.

Schlemmer characterized his reliefs from this period as 'decorative-architectonic'. Like many other contemporary artists, he dreamed of a renaissance of mural painting, of reconciling art with architecture and thereby re-uniting the artist with society. His sculpture, which is a form of wall-picture, is clearly inspired by a Utopian spirit. It is far from coincidental that, when Schlemmer started work at the Bauhaus in 1921, he took charge of the workshop for wall painting; the following year he was also appointed head of the workshop for wood and stone sculpture.

The idea of multi-coloured sculpture, coupled with the overall aesthetic approach of this work, places Schlemmer firmly in the context of the contemporary avant-garde. There is a particular affinity between his work and the 'sculpto-painting' of Alexander Archipenko, which was much discussed in Germany at the time.

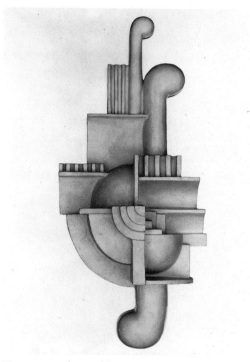

Fig. 166 Oskar Schlemmer, *Ornamental Sculpture*, 1919

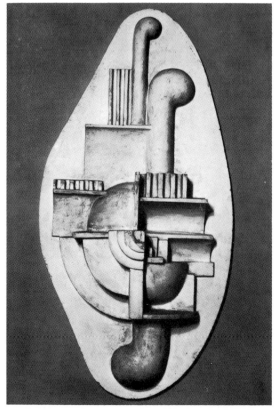

Fig. 167 Oskar Schlemmer, *Ornamental Sculpture on an Oval Base*, 1919

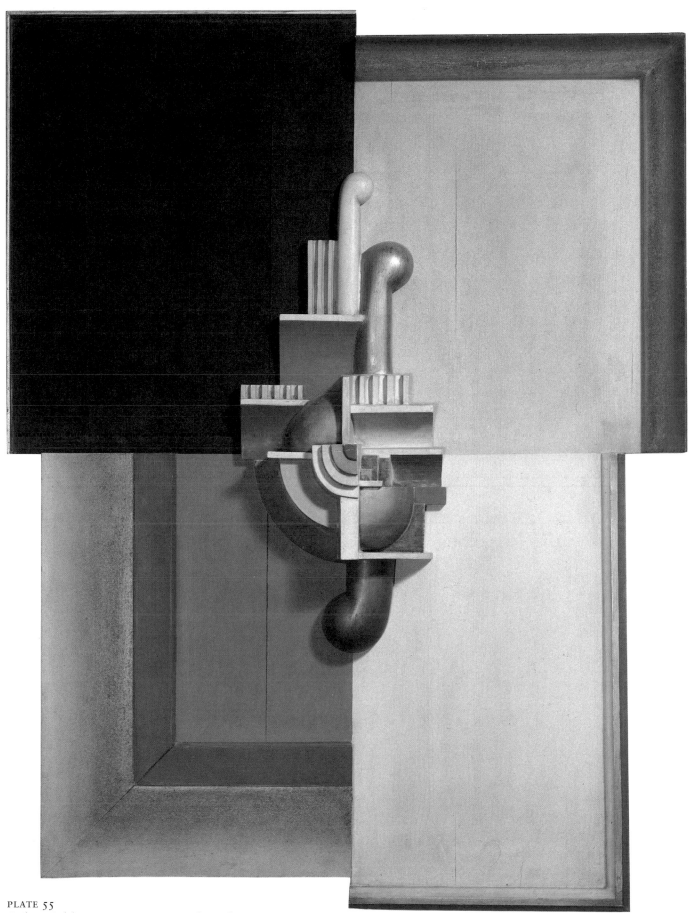

PLATE 55
Oskar Schlemmer, *Ornamental Sculpture
on a Split Frame*, 1919 (re-made 1923)
Limewood painted in oil on a chalk ground, 90 x 68 x 4.2 cm

The singularity of this sculpture lies in the use of prefabricated picture frames – an almost Dada device – and the irregular form of the ground, which is made of different-sized flat pieces of wood. This anticipates certain procedures – the shaped canvas, for example – in the art of the 1960s. The work is distinguished by an even, rhythmical balance in the alternation between flatness and three-dimensional form, between the concave and the convex, between straight and curved lines, between primary and secondary motifs. With its horizontal, vertical and semi-circular forms, the rhythmically animated centrepiece is set at the junction of the four flat sections which form the ground. The work is visibly influenced by the geometricism of the contemporary avant-garde; surprisingly, however, it also incorporates a number of elements which several years later became part of the formal vocabulary of Art Deco.

PLATE 56
Willi Baumeister
Wall Painting with Metals, 1923
Oil, gold leaf and cardboard
on canvas, 89 × 61 cm

BAUMEISTER

There is a marked similarity between Schlemmer's *Ornamental Sculpture on a Split Frame* and Baumeister's *Wall Painting with Metals* (Plate 56), which was painted in 1923, the year in which Schlemmer made the final version of his relief. Baumeister and Schlemmer were close friends; they had both been members of the Stuttgart circle headed by the much older Adolf Hoelzel. *Wall Painting with Metals* has a number of features in common with the work of such artists as de Chirico, Carrà and Grosz, whose pictures were in other respects quite different from those of Baumeister: it, too, radically dispenses with psychology and even with true physiognomy, and it presents the human face as an anonymous, stereotyped form, emptied of individuality. Yet unlike the exponents of Metaphysical art, who preserved three-dimensional space as an arena for the exercise of the imagination, Baumeister aligned himself with Schlemmer in embracing the principle of two-dimensionality: the task of the artist was merely to structure the flat surface, following a form of geometrical logic. In his series of 'wall paintings', created between 1919 and 1923, the idea of the wall-picture is anticipated in the medium of easel painting. In 1922 Baumeister also painted three actual murals, but, like the wall paintings which Schlemmer produced for the Bauhaus in 1922/23, these works were subsequently destroyed.

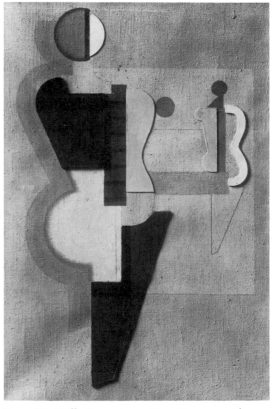

Fig. 168 Willi Baumeister, *Two Figures with a Circle*, 1923

SCHLEMMER

In the 1920s there was much talk of the end of easel painting, which was to be replaced by collective forms of artistic production, such as the wall-picture. Similar ideas have gained currency in more recent years. However, artists such as Schlemmer and Baumeister were far from willing to give up easel painting altogether, and it was by no means only the lack of commissions for wall paintings that induced them to continue painting on canvas. In 1923, at the time Baumeister was working on *Wall Painting with Metals*, Schlemmer painted *Women at Table* (Plate 57), a highly intimate picture which, despite

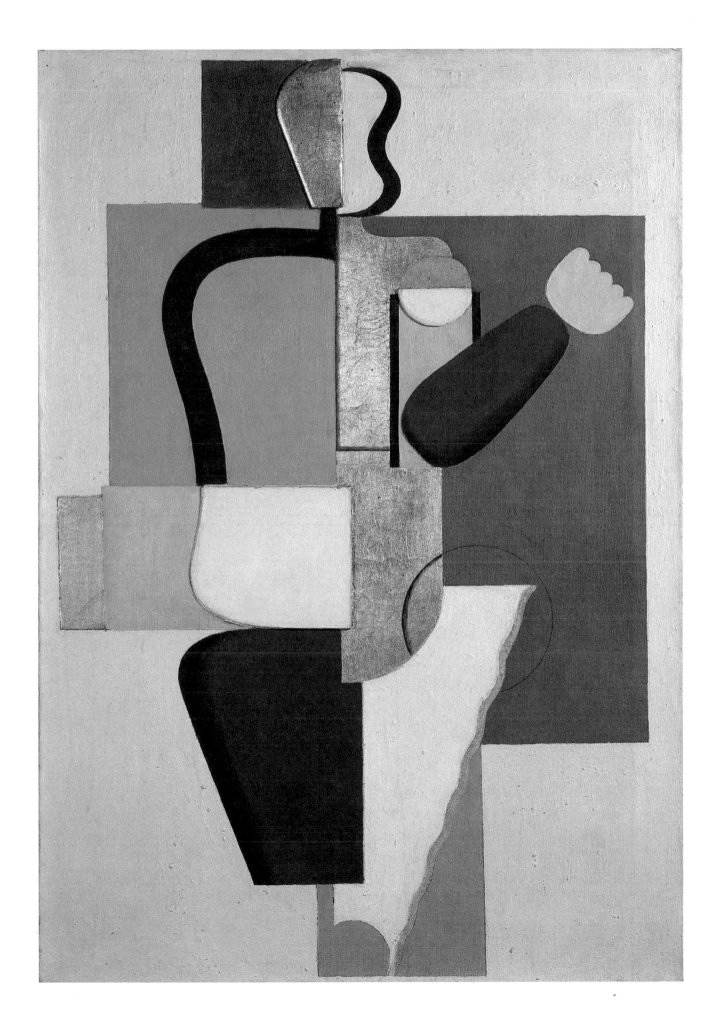

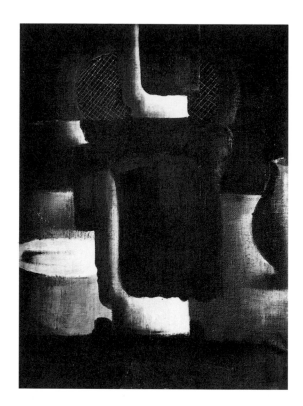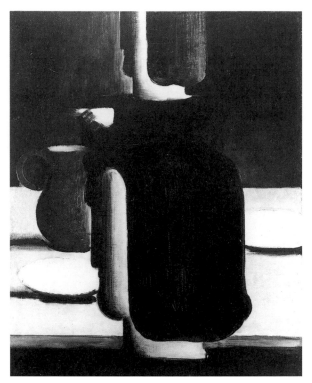

Fig. 170
Oskar Schlemmer
*Two Women at
Table*, 1925

Fig. 170
Oskar Schlemmer
*Two Women at
Table*, 1925

its rigid architectural structure, is the product of a liberated imagination and contains a strong element of poetic feeling. This picture and others like it stand apart from the ideology of 'objectivity'. The artist sees the conjunction of people and objects as a specifically human theme and, at the same time, as a motif which is subservient to pictorial laws. It is a theme which he varied many times in a large number of paintings and watercolours.

Like several other works from the same period (see Fig. 169, 170), *Women at Table* reminds one of the work of the Swiss painter Otto Meyer-Amden (see Fig. 171), who was a fellow member of the Hoelzel circle at the Stuttgart Academy and who later joined Baumeister and Schlemmer in founding the Uecht group, which held its first exhibition in 1919. Schlemmer and Meyer-Amden remained firm friends until the latter's death in 1933. The following year Schlemmer wrote an extended essay as an introduction to a monograph on Meyer-Amden, who was an important influence on his work. However, although Meyer-Amden placed similar emphasis on the immanent laws of the picture, he was far less concerned than Schlemmer with the notion of pictorial objectivity; on the contrary, his work has a thoroughly subjectivist, contemplative tone, which is underlined by his preference for miniature formats. His favourite motif was people in space, or, to be more precise, schoolchildren in the classroom. He emphasized the emotions of the figures – both the experience of community and the individual's sense of loneliness in the crowd – more strongly than Schlemmer in his related series of pictures. Schlemmer took up painting in the grand manner, with large-format works whose natural conclusion was the mural. It was not until 1943, shortly before his death, that he returned – partly at the instigation of his friend Julius Bissier – to the smaller, more intimate format seen in his series of 'window' pictures, whose subdued, introverted manner revived the memory of his dead friend.

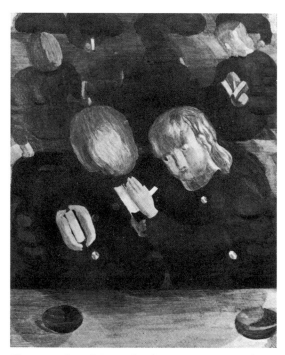

Fig. 171 Otto Meyer-Amden, *Two Boys with Song-Books*, c. 1929

Oskar Schlemmer
Women at Table, 1923
Oil on canvas
73 × 61 cm

It was the constructive rather than the affective aspect of Schlemmer's art which earned him his appointment as an instructor at the Bauhaus in 1920. He was already working there at the time when he painted *Women at Table*, and the motif reflects the everyday reality of the school: what we see is a group of students sitting around a table, not far from the classroom of Meyer-Amden. Together with the rounded chair-backs, the formalized heads and upper bodies of the figures make up a rhythmical pattern which animates the surface of

the picture. The pictorial space is built up in a series of horizontal layers. The even rhythm is interrupted only by the brown jug and the bright surfaces of the plates, catching the light.

In these pictures Schlemmer was inspired not only by his mentor Meyer-Amden; at the same time, the French Purists were attempting to develop a strictly tectonic form of painting, and this new movement could hardly have escaped Schlemmer's notice. The Purists' manifesto, entitled *Après le Cubisme*, was published in 1918. The exponents of Purism, led by Amédée Ozenfant (see Fig. 172), largely confined themselves to painting bottles, glasses and musical instruments, the preferred motifs of the Cubists, and ignored the human figure. However, the principle of pictorial order which governs their work is similar to that seen in a picture such as *Women at Table*. Moreover, they, too, showed a strong interest in the idea of the collective mural and in the Utopian project of integrating art into architecture.

*

When Schlemmer painted his *Group at the Banisters I* (Plate 58) in 1931, he had already left the Bauhaus and was teaching at the Academy in Breslau (Wroclaw). Nevertheless, the picture can be seen as epitomizing the intellectual spirit of the Bauhaus; the scene itself would appear to be set in Walter Gropius's celebrated building in Dessau. Schlemmer's large *Bauhaus Stairway* (Fig. 176) was also painted in Breslau. The four human figures in *Group at the Banisters I* are more realistic than those in *Women at Table* (Plate 57): they are real live students rather than schematic forms. Yet at the same time, they are more abstract: the artist reduces them to mere figurines in the choreography of the picture. They have a purely structural

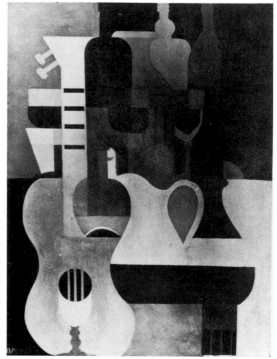

Fig. 172 Amédée Ozenfant, *Still Life*, 1921

PLATE 58
Oskar Schlemmer
Group at the Banisters I, 1931
Oil on canvas, 92.5 x 60.5 cm

Fig. 173
Oskar Schlemmer
Three Figures, 1931

Fig. 174
Oskar Schlemmer
Study for *Group at the Banisters I*, 1931

132

Fig. 175 Oskar Schlemmer
Five Men in Space, 1928

Fig. 176 Oskar Schlemmer
Bauhaus Stairway, 1932

function, and the subliminal emotional quality of earlier pictures, such as *Women at Table*, is absent. The picture derives its sense of animation largely from the contrast between the colours of the figures and the rectangular, Mondrianesque structuring of the white windows and the banisters. It is more extroverted, brighter and more colourful than the earlier work; larger, more expansive and less hermetic; a picture glorifying healthy, free, cosmopolitan youth, the youth in which Weimar Germany placed all its hopes for the future, before the Nazis stepped in and seized control of young people's minds. This glorification of youth and health – and, of course, of sport – was by no means restricted to those who sought to enlist the support of the younger generation in building a new authoritarian state. It was a widespread attitude in the inter-war years, which one also encounters in countries where the cult of youth was not harnessed to political ends. Léger, in particular, ceaselessly reiterated his belief in the ideal of *mens sana in corpore sano*, a subject to which he devoted numerous speeches and essays. He saw this ideal embodied in America, a 'young' and 'free' country untrammelled by the restrictions of the Old World.

Schlemmer repeatedly returned to the subject of people on staircases, which accorded with his particular interest in spatial structure and in the distribution and linking of figures in space. The motif of *Group at the Banisters I* is replicated in two large-format watercolours (see Fig. 173) and in two drawings (see Fig. 174) which are the same size as the painting. There is also an obvious affinity with *Scene at the Banisters*, which was painted in the same year; the latter picture is more crowded, because of the larger number of figures. The series of works on this theme culminates in *Bauhaus Stairway* (Fig. 176), a larger and comparatively realistic painting which is Schlemmer's most important of the year 1932.

PLATE 59
Fernand Léger
Woman Holding Flowers
1922
Oil on canvas
73.3 x 116.5 cm

LEGER

In the 1920s and early 1930s artists of vastly differing calibre and intellectual persuasion can be found addressing the same basic set of formal and pictorial problems. Léger's *Woman Holding Flowers* (Plate 59) was painted in 1922, in close temporal proximity to the works by Baumeister and Schlemmer discussed above. Here, too, the form of the human body is at once intensified and defamiliarized – the limbs are disjointed, and the faces lack all trace of an individual psychology – and the manner of painting is anonymous, following the idea of collective creation. In the simplified shapes of the arms and legs, the breasts and necks, one detects an echo of the tubular forms in *Contrasted Forms* (1913/14; Plate 19); the shapes are also reminiscent of Léger's 'machine' pictures, whose cold formal language is modified and combined with a human, animated element. The faces look inwards and outwards simultaneously: they seem to be waiting for something, wrapped in eloquent silence, withholding a question which has formed in their minds, lost in a world of dreams. Yet Léger always insisted that his intentions were 'unsentimental', and, accordingly, he was unwilling to concede a higher status to the human figure than to the dead objects which were later to dominate his pictures.

Despite the modernity of his work, Léger had a strong sense of tradition; hence, there can hardly be any doubt that he had Manet's *Olympia* (Fig. 177) in mind when he painted this picture. There is a gap of more than half a century between the two works. Manet's

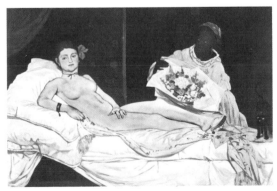

Fig. 177 Edouard Manet, *Olympia*, 1863

Fig. 178 Fernand Léger
Three Women (The Large Breakfast)
1921

Fig. 179 Fernand Léger
Two Women with Flowers
1927

pre-Impressionist realism has given way to a form of emblematic abstraction; all trace of narrative and anecdote – in the visual tensions between the naked white woman, the clothed black man and the black cat – has been expunged. The opulent bunch of flowers has been replaced by three denatured flowers which look as though they are made of metal. The anatomy of the female body is subordinated to the laws of the picture, to the point of total distortion. A drawing of a nude (Fig. 180), dating from 1921 and including the same diamond patterning of the cushions, shows the violence which the artist inflicts on the body in order to make it conform to pictorial laws. In *Woman Holding Flowers* the conflict between the organic law of the body and the mechanical law of the picture is resolved in the picture's favour, as is particularly apparent in the position of the legs.

This approach to the human figure, tending towards the monumental and the classical, is seen in Léger's work from 1920 onwards. Increasingly, his pictures are constructed around heroic female figures. One of the major works from this period is *Three Women (The Large Breakfast)* (Fig. 178), which was painted in 1921; the still life on the table in the centre documents Léger's rapprochement with French Purism. Here, too, the stereometric, semi-cylindrical forms of the women's bodies are set against a geometrically patterned background. And again, all trace of psychology is eliminated from the silently expectant gaze of the figures, which boldly confront the beholder. The manner in which they address the viewer is quite different from that seen in the pictures of Schlemmer, whose figures seek no contact with the world outside.

A number of details from *Woman Holding Flowers* recur in other pictures: Léger uses them as stock motifs which can be moved around from one context to another. For example, the motif of the hair cascading over the woman's shoulder is repeated in *Three Women*

Fig. 180 Fernand Léger, *Reclining Woman*, 1921

Fig. 181
Fernand Léger
The Readers
1924

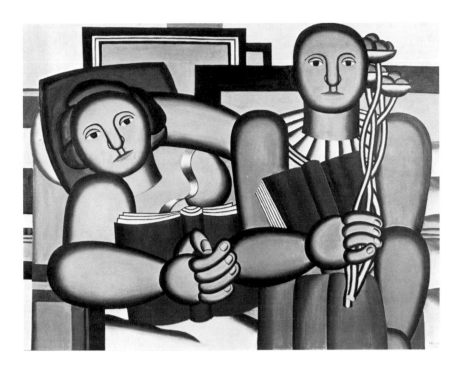

and several other works. The heavy, seemingly metallic flowers also occur elsewhere, notably in *The Readers* (Fig. 181).

Léger himself had the following general comments to offer on the style of his pictures of the human figure from this period: 'Since this civilization will find its fulfilment and its balance, we shall, I hope, see the coming of a new religion, the cult of beauty, in which we live and which we create. A concrete, objective realism will happily replace the old religions whose aim was always to tranquilize the world with the opium of a future life, whose reality remains to be proved. In future, we shall live in light, in brightness, in nakedness. Therein lies an entirely new source of joy, which is our future.' Thus, Léger introduced a note of Utopian idealism into his cosmopolitan realism: this was the programme on which he continued to base his art for the rest of his life.

PICASSO

In the early 1920s Pablo Picasso also devised a new approach to the depiction of the human figure, adopting a 'neo-classical' style which was in part a reaction against Cubism, although the artist continued at the same time to apply Cubist principles in many of his other pictures. This change of stylistic orientation was sparked off by his work with Sergei Diaghilev's Russian Ballet Company, which he accompanied on its visit to Rome and Pompeii in 1917. Even before this, however, Picasso had shown signs of a nostalgic interest in the classical past: two years previously, for example, he had drawn a series of portraits in the spirit of the nineteenth-century French painter Dominique Ingres. Throughout his life Picasso had a certain penchant for classicism, one that manifested itself in both his style and his choice of motifs, which were often taken from classical mythology.

The monumental *Two Seated Nude Women* (Plate 60), which was painted in 1920, only a year after *Open Window* (Plate 21), is one of the first and finest works from this major phase in the development of Picasso's art. As in Léger's pictures, but in a completely different way, the human figure is 'the measure of all things'. The two women are seated like goddesses in the centre of a scene whose other elements – the drapery, the box-shaped seat and footrest – are mere incidentals. The dominant influence is the 'Roman' spirit of the French neo-classical painter Jacques-Louis David. In Picasso's later pictures of the human figure, especially in *Women at the Well* (1921), one finds a more subdued form of classicism; here, however, the monumental, Michelangelesque bodies of the two women almost explode the confines of the imaginary space. They are women from a race of Titans, heavy-limbed and burdened with weighty thoughts, Amazons in a setting of Spartan simplicity. The scope of the picture extends from the academic to the mythical, from the massive power of the bodies and hands to the meditative calm of the woman on the right, resting her head on her hand in a pose which vaguely reminds one of Dürer's *Melencolia* (Fig. 183). The huge physical bulk of the figures is offset by the delicacy with which the flesh, the drapery and the walls are painted, in extremely thin glazes of colour tinged with black.

Picasso returned to this motif in a small, oblong-format pastel (Fig. 184), which is dated 4 April 1921. At this point he was also occupied with a further theme: that of two youths engaged in conversation while lying on a beach.

The typical studio props in the picture – the cube-shaped seat and footrest – make an earlier appearance in a drawing of a nude

Fig. 182 Pablo Picasso
Seated Woman, 1920

Fig. 183 Albrecht Dürer
Melencolia, 1514

Fig. 184 Pablo Picasso, *Two Seated Nudes*, 1921

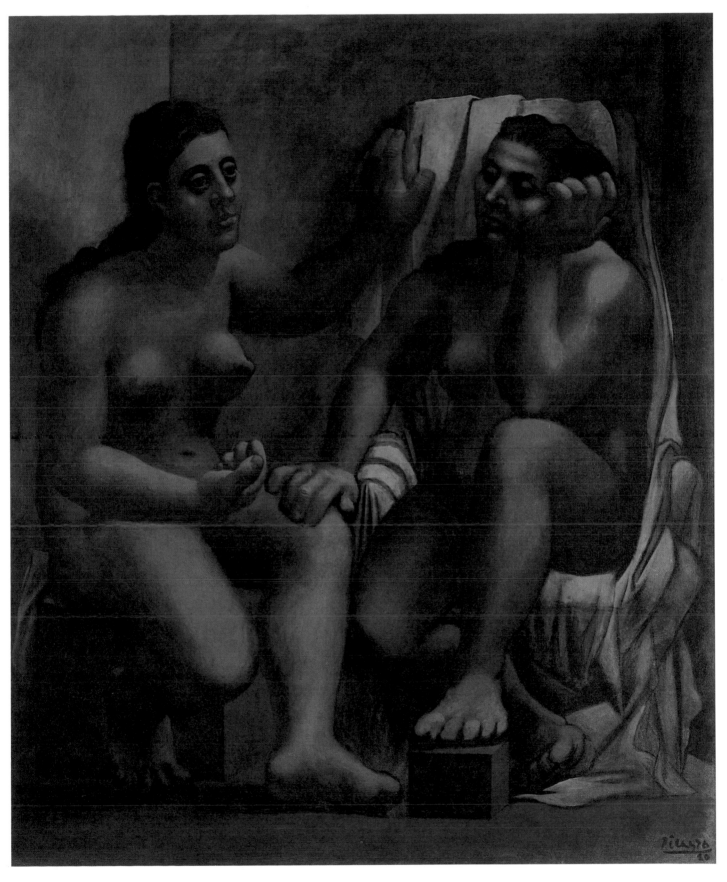

PLATE 60
Pablo Picasso
Two Seated Nude Women, 1920
Oil on canvas, 195 x 163 cm

(Fig. 186) which Picasso did in 1896, at the age of fifteen. Even twenty-five years later, long after he had broken with Cubism, he did not hesitate to use the motif of the cube. The box and the drapery can also be found in one of the major examples of French neo-classicism, David's *The Dead Marat* (1793; Fig. 185), which is characterized by a similar Spartan asceticism. Here, too, the scene has a semi-abstract quality and is set against a dull, monochrome background.

The theme of the two seated women runs right through Picasso's work. In *Two Nudes* (1906; Fig. 188), one of the main works from his 'Iberian' period, one can already see the opposition between his inclination towards the classical and towards a wholly unclassical colossality. Shortly afterwards, in paintings such as *Les Demoiselles d'Avignon*, he embarked on the expressive decomposition of the body. In 1908 he painted a second picture entitled *Two Nudes* (Fig. 189) which documents the beginnings of Analytical Cubism. The version of *Two Nudes* which he painted in 1920 (Fig. 190) is a reworking in 'neo-classical' terms of the theme of 1908; although it was painted in the same year as *Two Seated Nude Women*, it is more lyrical and less monumental than that work. However, in 1920/21 Picasso painted several other nudes (see Fig. 187) in the same monumental vein as *Two Seated Nude Women*; here, too, we see thick-limbed, powerful figures with boldly contoured faces and large, sculpted eyes, set against drapery and monochrome backgrounds. The two women seem to merge – even in such a detail as the unnaturally massive feet – in the clothed, pensive figure in *Seated Woman* (1920; Fig. 182).

Throughout his life Picasso repeatedly returned to particular themes and forms, despite the continual shifts in stylistic orientation which

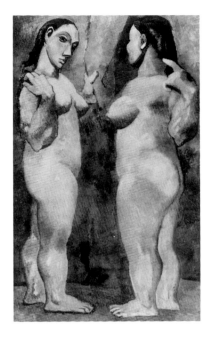
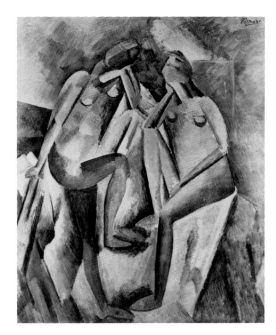
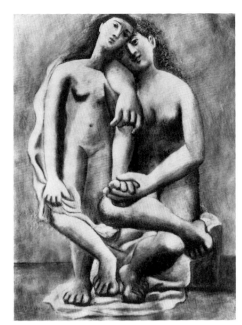

Fig. 188 Pablo Picasso
Two Nudes, 1906

Fig. 189 Pablo Picasso
Two Nudes, 1908

Fig. 190 Pablo Picasso
Two Nudes, 1920

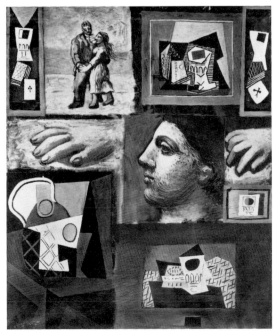

Fig. 191 Pablo Picasso, Sheet of studies, *c*. 1920

are such a prominent feature of his oeuvre. He addressed these themes in a deliberate, methodical fashion, but he always left sufficient scope for surprise and momentary inspiration. Notwithstanding the ever-changing, protean character of his art, on which critics have so often remarked, there are certain constants and basic themes which confer a stable identity on his work. In the past this aspect of his art was often obscured by his apparent tendency to leap abruptly from one style to another. Yet precisely this stylistic fickleness is an essential part of Picasso's artistic identity. His visual curiosity was insatiable, and his dynamic creative drive never allowed him to rest on his laurels and accept the limitations of a given style. For him, a style was not an end in itself, but a means of tackling a new artistic challenge. His reluctance to regard any of the styles in which he worked as an immutable doctrine is demonstrated by the fact that he had no difficulty whatsoever in simultaneously following conflicting stylistic principles: in 1921, for example, shortly after he had entered his so-called 'neo-classical' phase, he also painted *Three Musicians* (now in the Philadelphia Museum of Art), which is firmly rooted in the tradition of Cubism. This easy-going attitude to the concept of style is further exemplified by a sheet of casual sketches made in 1921 (Fig. 191), in which classicism and Cubism, naturalism and abstraction, stand cheek-by-jowl, with no sense of conflict or controversy.

MONDRIAN

There is a world of difference between the classicism of Picasso in the early 1920s and the work of Piet Mondrian. Although the Dutch painter was nearly ten years older than Picasso, his approach to art was uncompromisingly modern. Whereas Picasso eschewed doctrines and dogmas, Mondrian adhered to a clearly defined set of strict aesthetic principles. He and his supporters exercised a far greater influence than Picasso on contemporary art and on such

other forms of cultural expression as architecture, typography and design. In the 1920s the group *De Stijl* (Style) and the journal of the same name stood at the forefront of the avant-garde, and it was only logical that the books of Mondrian (for example, *Der Neo-Plastizismus*) and Theo van Doesburg should have been published by the Bauhaus. Even so, Mondrian was decisively influenced by Picasso and Braque. Between 1912 and 1914 he painted a series of pictures which would have been unthinkable without the example of Cubism (see Fig. 192). Yet even in these early, Cubist works one notices a preference for geometrical, rectangular forms and an inclination towards abstraction.

For Mondrian, geometry was above all a spiritual principle, the guarantee of a universal spiritual order rising above the sensual diversity and chaos of nature. At the same time, it embodied a notion of spiritual dignity, an ethical conception of humanity. Throughout his life Mondrian defended this theoretical position with an almost religious fervour; together with his unerring sense of proportion in the use of form and colour, the zeal with which he propagated his theories makes him the leading exponent of geometricism in the twentieth century. Although, as some critics have pointed out, Mondrian's 'ascetic' art is rooted in the Protestant puritanism of his native country, it has a universal historical significance which extends far beyond such geographical confines. In any case, other countries, too, were producing great artists who based their work on geometrical principles: one thinks, for example, of Kasimir Malevich in Russia.

After a phase of semi-geometrical experimentation, Mondrian began, in 1920, to divide his pictures up by means of straight black lines into rectangular fields of varying sizes which he painted in different colours (see Fig. 193). These black horizontal and vertical

Fig. 192 Piet Mondrian
*Composition in Brown and Grey, c.*1913

Fig. 193 Piet Mondrian
Composition, 1921

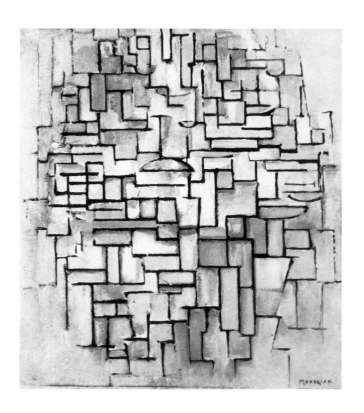

PLATE 61
Piet Mondrian
Composition with Yellow Patch
1930
Oil on canvas
46 x 46.5 cm

bars prevented the fields of colour from overlapping or intersecting with each other. Mondrian categorically rejected spatial effects. He regarded the depiction or suggestion of three-dimensionality as a hangover from the illusionistic representation of nature, which he sought to abolish. From 1920 onwards the only colours which he used – apart from the 'non-colours' white and black – were the primaries, red, blue and yellow.

From about 1922 onwards Mondrian began to reduce the number of coloured fields in his pictures, leaving a large part of the canvas white. This reduction can be seen in *Composition with Yellow Patch* (Plate 61), which was painted in 1930. The picture has a lyrical,

meditative quality whose source, in view of the extreme asceticism of the geometrical forms, is by no means easy to identify. The work allows the viewer to sense that, despite its seemingly rigorous, mathematical logic, it is based on the exercise of intuition. Mondrian did not work out the form of his pictures in mathematical terms: his many drawings show that he groped his way forward towards the finished picture in successive, hesitant stages, relying solely on his sense of proportion. Rational as the spirit which informs these pictures may be, the manner of their making is none the less irrational and intuitive. Their effect, too, is better described as 'spiritual' than as 'rational'.

<p style="text-align:center">*</p>

With its tall oblong format, which is also found in two other, related pictures from the same period, *Vertical Composition with Blue and White* (1936; Plate 62) reminds one of the pictures of towers which Mondrian painted in 1909/10 – for example, the two works entitled *Lighthouse at Westkapelle* (Fig. 194, 195). It is conceivable that the artist consciously returned, some twenty-five years later, to these emphatically vertical forms. The formal language of the brightly coloured tower pictures combines pointillist and Fauvist influences, but already points towards a rectangular order. A few years later we find the artist working in close proximity to Cubism, using church façades as a point of departure for experiments in the rhythmical organisation of the picture plane (see Fig. 196). Shortly afterwards, the tower motif, together with all other forms of figurative content, disappears from Mondrian's pictures. Nevertheless, the tall formats of the late 1930s still contain a vague reminiscence of the towers – one should remember that, at this point, Mondrian was very much concerned with urban structures. Yet it must be admitted that there is no direct reference to the motif. The architecture of the three pictures has no figurative point of comparison. The only thing to which the pictures can be seen as referring is a higher form of spiritual order.

Fig. 194 Piet Mondrian
Lighthouse at Westkapelle, c. 1909

Fig. 195 Piet Mondrian
Lighthouse at Westkapelle, c. 1910

Fig. 196 Piet Mondrian
Composition 9 (Blue Façade), c. 1913

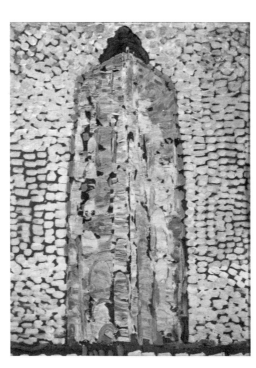

PLATE 62
Piet Mondrian
*Vertical Composition
with Blue and White*, 1936
Oil on canvas
121.3 x 59 cm

PLATE 63
Piet Mondrian
Rhythm of Black Lines
c. 1935/42
Oil on canvas
72.2 × 69.5 cm

Nothing was more alien to Mondrian than allowing external experience to intrude on his geometrical icons. However, looking at a picture such as *Rhythm of Black Lines* (*c.* 1935/42; Plate 63), one inevitably thinks of modern architecture, in which the artist was greatly interested, and of such urban structures as the strictly rectangular layout of the streets of Manhattan. At this point we find him painting pictures with such titles as *Place de la Concorde* and *Trafalgar Square*; in 1942/43 he painted *New York City* and *Broadway Boogie Woogie*. Nevertheless, despite these allusions to real places, his artistic intentions had nothing to do with the representa-

tion of reality, even in the most abstract terms. He was concerned solely with the autonomous and concrete reality of the picture itself, and it was no doubt for this reason that he preferred to speak of 'concrete' rather than 'abstract' art. Over and beyond this, his aim was to evoke the absolute harmony of a universal truth. This was the philosophical meaning of his art, whose intellectual roots lie in the Symbolism of the 1890s.

*

In 1940 Mondrian emigrated to New York, where he died in 1944. Here, he hit upon a new method of making pictures, possibly based on his discovery of a new material. In the past he had mapped out his pictures with the aid of a pencil; now he took to using thin strips of coloured paper which he moved back and forth on the canvas, glueing them into position when he was satisfied with the arrangement. This discovery would in itself have been of little use if Mondrian had not simultaneously decided to allow coloured lines in his pictures, instead of the black lines which had dominated his work for the past two decades: a new artistic departure opened his eyes to a technical device which he had previously overlooked, which he had been bound to overlook. He was now able to 'sketch in' the picture with the strips of coloured paper, before colouring in the lines with the brush as before. (It seems that Mondrian had occasionally used coloured paper in the past, but this was probably to test the effect of the coloured areas, rather than to map out the system of lines.) The artist died before he could put this new method of making pictures into full-scale practice. There is only a single finished painting with coloured lines which was, presumably, preceded by a study using strips of coloured paper. Apart from that, all we have

Fig. 198 Piet Mondrian
New York City I, 1942

Fig. 199 Piet Mondrian
New York City III, *c*. 1942/44

are three preliminary studies for pictures whose final version was never painted (and the strips of paper on one of these were renewed at a later date, some time after the artist's death). The pictures are all entitled *New York City*, the studies being numbered from one to three (Plate 64, Fig. 198-200). This short but crucial series of works culminates in *Broadway Boogie Woogie* and *Victory Boogie Woogie*, which are partly painted and partly glued. These pictures, too, are anthems to the city of New York, and their titles point to the surprising fact that Mondrian, the artistic Puritan *par excellence*, was an enthusiastic dancer.

New York City II (Plate 64) is thus not a collage, but an outline of a picture which was never painted. It affords us a glimpse into the artist's workshop: we see how he moves the strips of coloured paper back and forth across the bare canvas, experimenting with various arrangements, altering the course of a line here and the size of an area there, making hasty corrections with an additional strip of paper or a touch of white paint. The picture is full of retouchings and patchings, of mess and even dirt, which one scarcely expects to find in the work of an artist who was so obsessively concerned with the notion of purity. It offers a singularly striking demonstration of the intuitive manner in which Mondrian worked in his endless search for perfect proportion.

The picture embodies a number of blatant artistic and intellectual contradictions. Its provisional character, the careless way in which it is stuck together, conflicts with Mondrian's ideological insistence on formal rigour: the canvas is bare and dirty at the edges, and the strips of paper are torn and flawed. The visible process of experimentation, of laborious trial and error, vitiates the ideal of geometrical form.

Fig. 200 Piet Mondrian, *New York City*, 1942

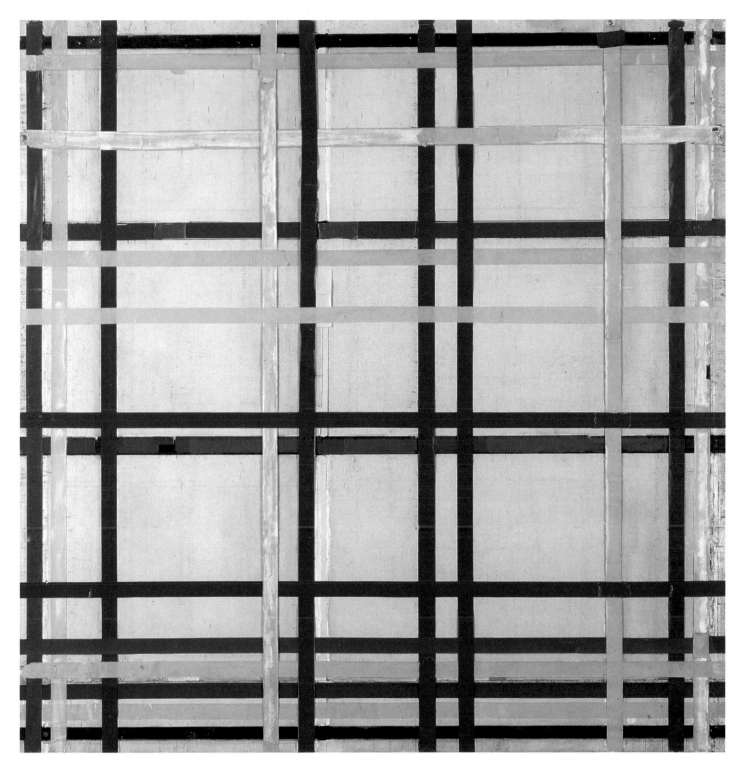

PLATE 64
Piet Mondrian
New York City II
c. 1942/44
Oil and paper on canvas
119 × 115 cm

New York City II also violates the sacred principle of flatness: the strips of paper do not merely intersect, but run under and over each other, in a kind of basketwork pattern. The result is a three-dimensional effect which is highly untypical of Mondrian's work and which the artist probably viewed with disapproval. It is possible that this effect was the reason why he refrained from painting a finished version, in which the overlapping between the strips of colour would have been retained, in optical if not in physical terms. In the two 'Boogie Woogie' pictures he solved this problem by painting or glueing a coloured square at the intersection of the

coloured lines; in this way he strictly avoided any three-dimensional overlap.

EL LISSITZKY

A vigorous and varied avant-garde emerged at the beginning of the 1920s in Eastern Europe, especially in the Soviet Union, where the avant-garde spirit persisted until the advent of the doctrine of Socialist Realism. The new movement was influenced to a considerable extent by the recent wave of artistic innovation in Western Europe; an additional impetus was supplied by the hopes which the October Revolution had awoken in the hearts of many artists and intellectu-

PLATE 65
El Lissitzky
Proun G7, 1923
Distemper, tempera,
varnish and pencil
on canvas
77 x 62 cm

Fig. 201
El Lissitzky
Study for *Proun G7*
(Plate 65)
1922

Fig. 202
El Lissitzky
Proun 43
1924

Fig. 203 El Lissitzky, Study for *Proun G7*
(Plate 65), 1922/23

als. Together with Malevich, El Lissitzky was one of the leading figures of the Russian Constructivist movement. In 1923, during a two-year stay in Germany, he painted *Proun G7* (Plate 65), a rationally constructed picture which nevertheless derives its artistic and spiritual meaning from a Utopian longing. The 'meaningless' word 'Proun' which El Lissitzky applied to his experimental art is an anagram composed of the initial letters of the Russian words for 'founding of new forms in art'. As the artist himself explained, 'Proun was the name we gave to the station on the way towards the building of a new art which stands on the earth fertilized by the corpses of paintings and their artists.' Lissitzky accepted that art had 'the capacity to activate awareness through the discharge of emotional energy', but he rejected attempts to make it into an 'emotional, romantically isolated affair'. Significantly, he had studied architecture and engineering. Now he dreamed of integrating art into architecture and into the general life of society. This was the dream of an entire generation of artists, architects and designers, with whose leading representatives El Lissitzky maintained close contact, especially following his move to Germany at the end of 1921. First taking up residence in Berlin, he then moved to Hanover and quickly established connections with the *De Stijl* group and the Bauhaus; together with Hans Richter, he edited the journal *G* (the title is the initial letter of the German word *Gestaltung*, meaning 'design'), and he co-edited an edition of the magazine *Merz* with Schwitters. In 1923 he exhibited his 'Proun' pictures for the first time in Berlin, under the auspices of the November Group. Soon after this he took his principles to their logical conclusion by abandoning fine art altogether and confining his attention to architecture, typography and other forms of applied art.

El Lissitzky saw himself in the first instance as a technician, an engineer, a constructor. This is clearly demonstrated by the drawing (Fig. 203) which preceded *Proun G7*: it is a form of technical blueprint, a set of precise instructions which the artist follows to the letter in the finished painting. Nevertheless, the basis of such a construction is the formal imagination of the individual: despite

its semblance of sober functionality, it is, in fact, inherently non-functional and non-rational. The vocabulary is rationalistic, but the forms owe their existence to deep-rooted, emphatic feelings. The circles, ovals and diagonals are above all symbols of an impassioned commitment to a new ideal. These same forms occur repeatedly in El Lissitzky's art, not only in paintings, such as *Proun 43* (Fig. 202), which dates from 1924 and is very similar to *Proun G7*, but also in the posters (see Fig. 204) and agit-prop hoardings (see Fig. 205) with which he took art out of the museum and on to the streets. There was an element of deliberate iconoclasm, of anti-Romantic protest, in this subordination of art to practical ends, but it was an approach which was none the less inspired by an eminently Romantic dream – the dream of devising an artificial language to meet the demands of the new era, a collective, neutral and objective language which could be understood by people of all backgrounds and classes. It was this grand Utopian vision which motivated the extreme objectivity of El Lissitzky's pictures and simultaneously lent them an exceptional emotional force.

Fig. 204 El Lissitzky
*Beat the Whites with the
Red Wedge*, 1919

Fig. 205 El Lissitzky
Agit-prop hoarding in front of
a factory in Vitebsk, 1919

SCHWITTERS

Although his artistic temperament seemed wholly opposed to the principles of Constructivism, the Dadaist Kurt Schwitters also went through a geometrical phase in the 1920s, creating a number of pictures which are closely related to the work of such rigorous formalists as El Lissitzky and Laszlo Moholy-Nagy. This phase is exemplified by the simple tempera picture *Untitled* (Fig. 206), which was painted in 1923 and is a product of the prevailing *Zeitgeist* rather than of Schwitters's personal genius, and by *Relief with Cross and Sphere* (Fig. 208), which dates from the following year. In 1923 he made an untitled assemblage which is known by the title *Kijkduin* (Fig. 207) and which, despite its obvious Constructivist leanings, bears the unmistakable stamp of the artist's own imagination. This however, was tantamount to a betrayal of doctrinaire Constructivism. Schwitters follows the same path in *Little Seamen's Home* (Plate 66), which he produced three years later. In 1926 he lived and worked

Fig. 206 Kurt Schwitters, *Untitled*, 1923

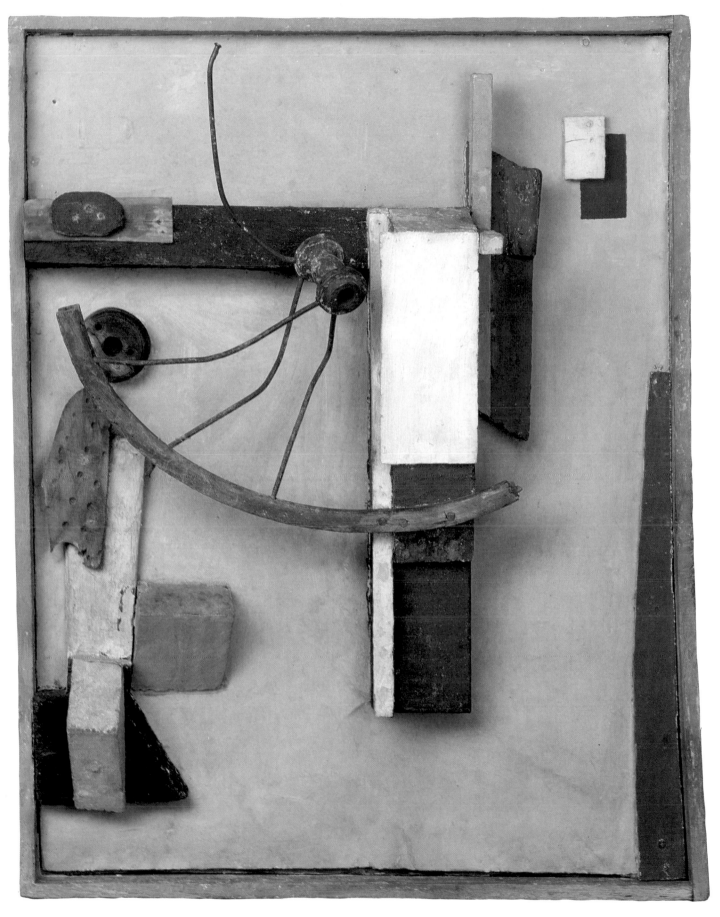

PLATE 66
Kurt Schwitters, *Little Seamen's Home*, 1926
Montage on cardboard, 66 x 52 cm

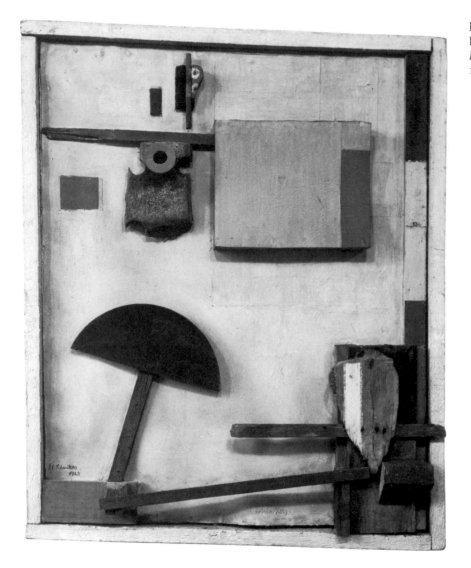

Fig. 207
Kurt Schwitters
Kijkduin
1923

for several months in the house of a painter-friend on the Dutch coast. His friend recalls that, during his stay, Schwitters made a coloured sculpture, some nine feet tall, of wood and plaster, which he called *Seamen's Home without Bobbed Hair*. To the extent that its dominant form is the right-angle, *Little Seamen's Home* is in tune with the ideas of numerous other contemporary artists. In addition to right-angles, it contains triangles and the segment of a circle. However, these forms are cobbled together from odd pieces of wood, whose crude, unfinished appearance conflicts with the spirit of geometricism and the fanatical obsession of the Constructivists with the idea of formal purity. The segment, for example, is a section of an old cart-wheel with bent and rusty spokes. (It is possible that this detail was added at a later date: an early photograph shows the work without the wheel.) The work also features several decayed objects whose form is wholly irregular and ungeometrical. To use Schwitters's own term, he has 'merzified' Constructivism and thereby adapted it to his own artistic temperament.

Like Dada itself, the Dada-influenced Merz art of Schwitters can be seen as a gleeful celebration of disorder. However, even in his early pictures and collages one can easily find certain types of structure which conflict with this assault on order. Schwitters queried the very

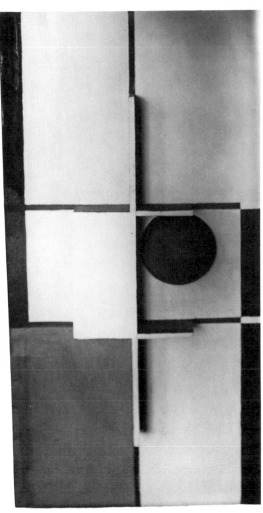

Fig. 208 Kurt Schwitters, *Relief with Cross and Sphere*, 1924

notion of form and emphasized the importance of the chance element in art, yet the works of art which he produced nevertheless obey recognizable formal laws. This is the key to understanding how such a committed exponent of Dada could be attracted to the formal ideals of Constructivism. Schwitters maintained close links with El Lissitzky and the Bauhaus. However, in order to preserve his own identity, he was obliged to modify the Constructivist approach. He very rarely used exact geometrical or stereometric forms and, although he often painted the surfaces of the materials in his works, he took care to ensure that the pieces of wood and metal retained at least a part of their original character. The constructive impulse could not be allowed to suppress the element of chance, of destructive energy. Schwitters was far more interested in raw, crude, battered and broken materials than in the quasi-technical materials and forms used by his friend Moholy-Nagy. Even those of his works which more or less follow Constructivist principles are not really 'constructed': they are nailed, screwed and glued together in a somewhat arbitrary, random fashion. The spokes in *Little Seamen's Home*, for instance, had to be bent in order to be acceptable as diagonals. The spontaneity of formal invention serves as a corrective to the Constructivist idea of form. Finally, the jokiness of such a title as *Little Seamen's Home* would scarcely have met with the approval of a dyed-in-the-wool Constructivist.

Schwitters had especially close ties with Holland. In the winter of 1922/23 he had joined van Doesburg and Vilmos Huszár in arranging a lecture tour which was advertised as a 'DADA Dutch Crusade'. From then on he repeatedly returned to Holland, until 1935, when he emigrated to Norway, whence he later moved to England, where he remained for the rest of his life. In the summer of 1926 he met Moholy-Nagy while staying on the Dutch coast, and it was here that he found the inspiration for the nautical theme and the title of *Little Seamen's Home*. It is possible that he also gathered the pieces of wood for the work on the local beach.

KANDINSKY

In 1922 Vassily Kandinsky was appointed to a teaching post at the Bauhaus in Weimar, three years before the school moved to Dessau. The year 1922 also marks the beginning of his geometrical phase. *Transverse Line* (Plate 67), which was painted the following year, is one of the major works from this period. The large-format painting still contains much of the expressive force found in Kandinsky's earlier work, but his former improvisational verve is tamed by precise geometrical form. The mountains in *Composition IV* (Plate 4) have been replaced by trapezoid forms, by triangles and, above all, by the circle, which from this point onwards becomes one of the dominant forms in Kandinsky's pictures; the dynamic streaks of black have given way to straight lines. However, the formal language of the picture is a far cry from the strict geometricism of Mondrian. In Kandinsky's work even geometrical forms have an expressive function. Instead of striving for a numinous objectivity, form points to the subjectivity of the painter himself.

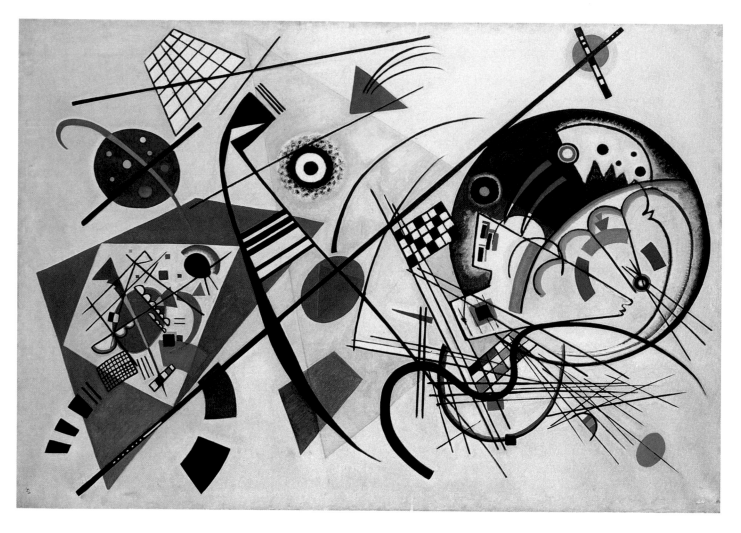

PLATE 67
Vassily Kandinsky
Transverse Line, 1923
Oil on canvas, 141 x 202 cm

The picture is dominated by the unbroken diagonal line, ending in a cross, and by the circle, which has a dynamic character: the forms which accompany it appear to set it in motion. Other artists of this period, such as Duchamp, were also interested in moving, rotating circles. Indeed, the circle in general was one of the leitmotifs of the contemporary avant-garde: we find it representing the sun or the moon in the paintings of Klee, Delaunay and others; as an absolute form in the work of Malevich; and as a form among other forms in the pictures of El Lissitzky and Moholy-Nagy. It can be a cosmic symbol or a geometrical form; as a rule, even in the work of the Constructivists, it is a combination of the two. This ambivalence is clearly apparent in Kandinsky's use of the circle: it can be seen, for example, in his *In the Black Circle* (Fig. 209), which was painted in the same year as *Transverse Line*, and in *Some Circles* (1926; Fig. 210), where the multitude of circles against the dark background inevitably reminds one of stars in the night sky.

*

The small-format picture *In the Blue* (1925; Plate 68) also uses geometrical forms, and here, too, Kandinsky retains a measure of formal freedom, refusing to accede to the dictates of pure geometricism; there is even a touch of playfulness in the picture, whose forms have a vaguely toy-like appearance. In this work, however, in contrast to *Transverse Line*, the geometry is orchestrated

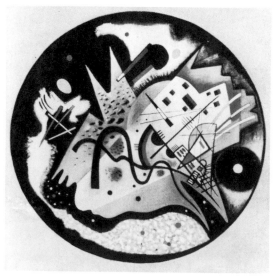

Fig. 209 Vassily Kandinsky, *In the Black Circle*, 1923

PLATE 68
Vassily Kandinsky
In the Blue, 1925
Oil on cardboard
80 x 110 cm

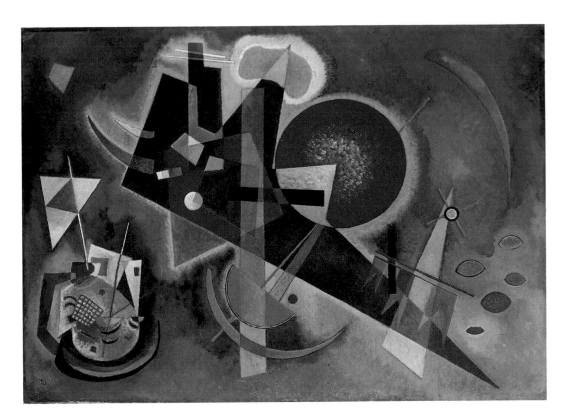

in a euphoric riot of colour, set against, and anchored in, a deep blue background which introduces a musical connotation and transports the picture into the realm of dream and the irrational. The red disc suggests the sun; the floating forms may be stars and planets; the blue background can be interpreted as the sea or the universe; the form on the left, decked with flags, appears to be a kind of toy sailing boat. Kandinsky frequently declared that geometrical form was only a means to an end. Even in this formally rigorous and seemingly 'rational' phase in the development of his art he refrained from casting aside the ideas of dream and 'Romanticism'.

<center>*</center>

In 1939, six years after he had moved to Neuilly-sur-Seine, near Paris, Kandinsky painted the tenth of his 'compositions' (Plate 69). Here, too, the language of the picture is emotional, despite the formal precision of the work. Yet, as in the pictures of the Bauhaus years, the subjective impulse is channelled and filtered through the strict laws of the picture, which has its own specific vocabulary, grammar and syntax. This conjunction of feeling and law is typical of his art. It is an art which possesses both great warmth and a certain degree of coldness.

What we see in the picture is a multitude of large and small forms, set against a black background. Although their borders are precisely delineated, they are not strictly geometrical: their shapes vary from the straight-edged to the rounded, from the simple to the complex, from the rigid to the dynamic. They look like paper cut-outs. This is especially the case with the two large silhouette-like forms and the sprinkling of small forms, which resembles a hail of confetti. Some of the smaller forms – those enclosed in the brown 'bubble' in the top left-hand corner, for example – have the appearance of an ordered

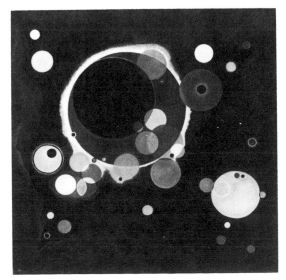

Fig. 210 Vassily Kandinsky, *Some Circles*, 1926

157

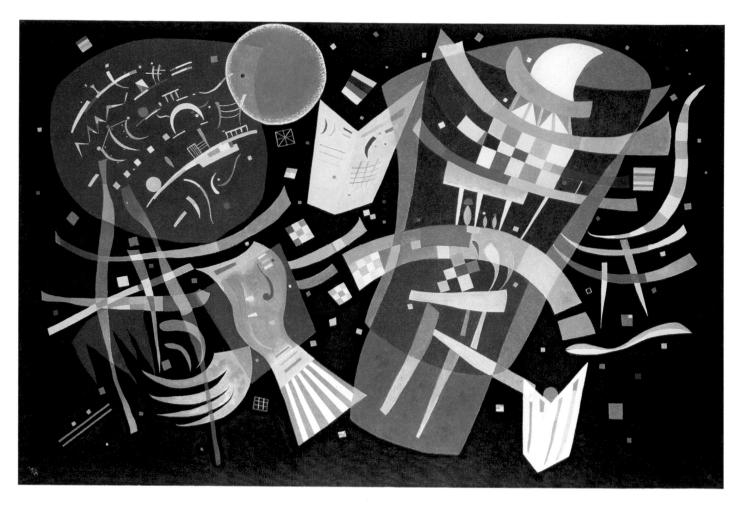

PLATE 69
Vassily Kandinsky
Composition X, 1939
Oil on canvas
130 × 195 cm

script, while others are loosely distributed throughout the picture. This wide variety of shapes is held together by the formal movement which sweeps freely over the surface of the canvas, and by the sense of polyphonic harmony which suffuses the work. Musical comparisons are inevitable: the picture itself invites one to describe it in terms of sounds, chords, rhythms and vibrations. Harmony, melody, polyphony, orchestration: the list of possible musical associations is endless; even the title, *Composition X*, has a musical connotation. If it were a piece of music the picture would clearly be set in a major key. The abstract artists of this period often compared their work with music, which is inherently abstract; in this case, the comparison is particularly apt in view of the theme and the mood of the picture. It should be remembered that Kandinsky belonged to the generation of Art Nouveau and Symbolism, movements whose artistic thinking allotted a crucial significance to the musicality of line and form.

Although the picture was painted in 1939, it is completely unmarked by the events of that fateful year. It bears no trace whatever of the historical catastrophe which was to shake the entire world. The reason for this is not that Kandinsky saw art as an ivory tower, a refuge from the outer world, but that, for him, art was a self-sufficient reality which had nothing in common with the external reality in which we live. Kandinsky's lifetime achievement consisted in the elaboration of a set of specific pictorial laws which excluded all

non-artistic realities. He expounded these principles in his numerous theoretical writings and consistently put them into practice in his artistic work, not least in the pictures which he painted towards the end of his life.

KLEE

Paul Klee also taught at the Bauhaus, from 1921 to 1931. It is possible that the capital 'B' in his *L-Square under Construction* (1923; Plate 70) is an allusion, albeit a covert one, to the Bauhaus. At all events, the picture is clearly influenced by the spirit of the Bauhaus: the 'cosmic' ideas which had until recently played such a prominent part in Klee's thinking have seemingly lost their appeal. Here, the geometricism already hinted at by the chequered pattern of the ground in *Cosmic Composition* (Plate 28) has come into the open: it is manifest rather than latent. Inscribed in the straight lines and even curves of the geometrical construction, one sees a kind of architectural plan, an urban blueprint, complete with the schematic outlines of several buildings and a church tower. Klee has added the word 'Plan' in the bottom left-hand corner to emphasize that the square — and the picture itself — is planned rather than merely improvised. Everything is clear and bright. The air of mystery and enigma in Klee's earlier, more Romantic pictures has been dispelled by rational thinking and planning. Although the image of the sun is

PLATE 70
Paul Klee
L-Square under Construction, 1923
Watercolour and body colour on chalk-primed newspaper mounted on cardboard
39.5 x 51.7 cm

159

included in the urban scene, it is no more than a round form. The picture is dominated by letters. Their effect is not semantic; they seem to be part of a game, quite unlike the letters in earlier pictures, such as the celebrated *Villa R*, where they confer a mysterious meaning on the image of the house. The title, written in the centre, pins the action of the picture down to a specific place, far away from the world of Romantic dreams: a square in a specific, albeit unidentified, city. Yet despite its rational character, the picture retains an element of poetry and playfulness.

In the same year Klee painted a similar picture which he called *Projection of Houses* (Fig. 212). Here, the outlines of a number of buildings are arrayed along the line running through the centre of the ground, whose chequered pattern is more clearly defined than in *L-Square under Construction*. There are even closer similarities between the latter work and a further one from 1923, entitled *Sequel to a Drawing of 1919* (Fig. 211). Although the lines and curves closely resemble those found in *L-Square under Construction*, the picture appears entirely abstract. Nevertheless, it still allows a certain amount of scope for figurative interpretations: the structure in the bottom left-hand corner, for example, reminds one of the forms resembling toy boats which are to be found in a number of Klee's earlier works. Hence, the filigree forms retain a certain figurative resonance, while at the same time insisting on their linear autonomy. Conversely, they render tribute to the 'modern' thinking of the Bauhaus, but refuse to sacrifice musicality and poetic content. As if with these pictures in mind, Klee wrote: 'First give the small, living functions space and form, and then build the houses around them.' This is an accurate description of his general method of procedure: as a rule, he built the picture up from formal elements and subsequently gave it a figurative twist. He did the same thing with the free, organic forms which he continued to use during his time at the Bauhaus. To him, geometrical and constructive form was merely one of a number of options; a further option was organic form, which was closer to nature and hence more in accord with his particular way of thinking.

ARP

The avant-garde of the 1920s comprised a wide variety of different, and often conflicting, tendencies. However, despite the prevailing plethora of competing dogmas, the dividing lines between the various styles were less rigid than one might expect. There is a direct line of descent, for example, from Dada to geometricism, which abhorred Dada's 'nonsense'. This genetic connection can be seen in the work of both Schwitters and Jean Arp. Arp was a member of the group of artists who founded Dada in Zurich in 1916, and he maintained close links with the Dada 'cells' in Cologne, Hanover and Berlin. In later years his art formed a bridge between geometricism and Surrealism, again a very different movement, in whose activities Arp took part. He ignored the divisions between these various schools of art, just as he disregarded the border between Germany and France; as a native of Alsace, he was at home in two cultures, and he wrote

Fig. 211 Paul Klee, *Sequel to a Drawing of 1919*, 1923

Fig. 212 Paul Klee, *Projection of Houses*, 1923

Other Realities

160

PLATE 71
Jean Arp
Three Walking-Sticks, 1927
Painted wood, 113 x 145 cm

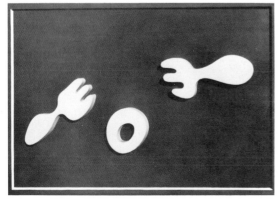

Fig. 213 Jean Arp, *Forks and Navel*, 1927

poems in both German and French. He also paid little heed to the demarcation between art and literature or to that between the two artistic disciplines of sculpture and painting.

Arp's principal concern was form, and he became a proponent of abstraction, of the form of art which Doesburg preferred to call 'concrete', since it did not refer to, or abstract from, any kind of world beyond the picture. This brought him into the orbit of the artists associated with the Paris magazines *cercle et carré* and *Abstraction – Création: Art non-figuratif*. He himself only rarely used strict geometrical forms; instead, he favoured organic, biomorphic forms which, although they were abstract, retained a living, natural character, with even a certain figurative element.

In Arp's relief *Three Walking-Sticks* (Plate 71), which dates from 1927, the flowing forms have not yet attained the same high degree of formal perfection and self-sufficiency as in *Amphora* (1931; Plate 72). The bizarre structures are full of life and even humour, unlike the elementary, natural forms in the later work. The three 'walking-sticks' have taken on a life of their own; they seem to march like cheerful ghosts across the far horizon. They have clearly identifiable

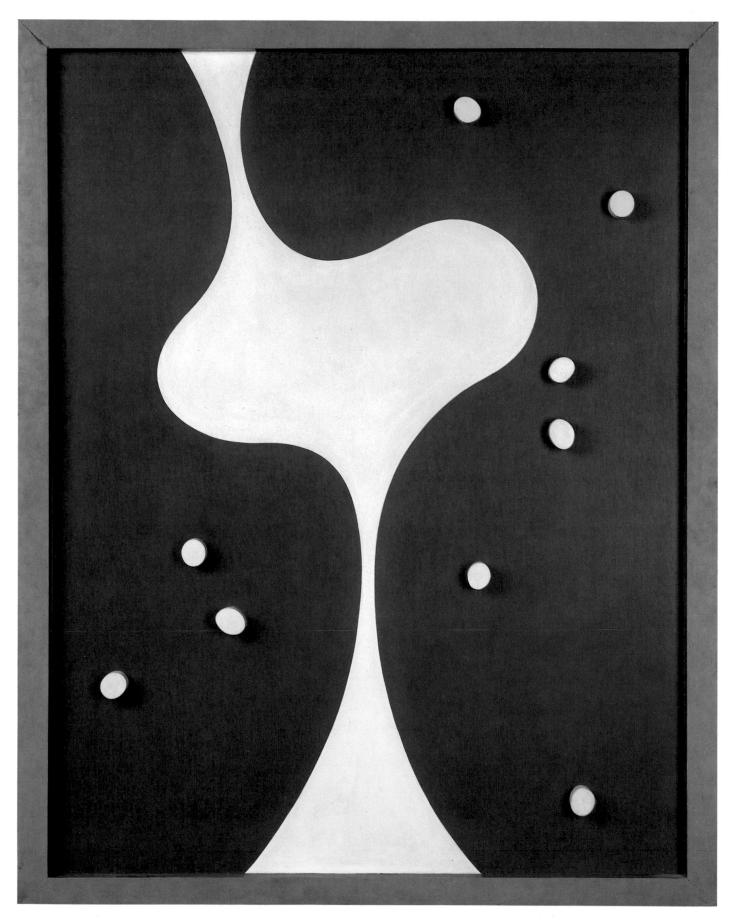

PLATE 72
Jean Arp, *Amphora*, 1931
Painted wood, 140 x 110 cm

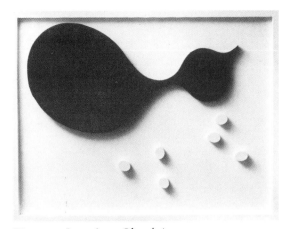

Fig. 214 Jean Arp, *Cloud Arrow*, 1932

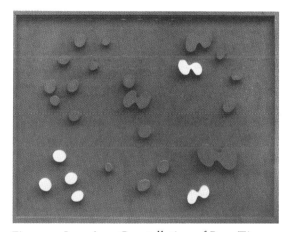

Fig. 215 Jean Arp, *Constellation of Bow-Ties and Navels II*, 1932

heads; the figure on the far left even has eyes, a nose and ears. The scene has the tangibility of a puppet theatre or a parade, lacking neither wit nor form.

At the time when he made the relief Arp was closely associated with the Paris Surrealists. The scene with the three other-worldly figures has an obvious connection with the imaginative universe of Surrealism, but its particular *esprit* and humour point to the continuing influence of Dada on Arp's work. The relief is a Dadaist-Surrealist vision of three strange figures at the world's end or on the outer edge of an unknown star set in an endless sky. Here, and in a series of other works, the artist indulges his imagination, using simple forms which nevertheless evoke a wide variety of associations; biomorphic forms which remind one of protoplasmic or embryonic organisms, but whose shape also recalls the world of banal, everyday objects, such as forks, dishes, fried eggs – and walking-sticks. They combine Dada and Surrealism with 'pure' abstraction.

*

This element of playfulness in Arp's work was gradually displaced by a striving for formal perfection. His art inclined increasingly towards the sculptural, towards 'form' in the grand manner. Even his later pictures contain occasional figurative references, which testify to his disregard for all forms of orthodoxy. The form in *Amphora* (Plate 72) is indeed reminiscent of a vase, and it also conjures up associations of the female body. However, Arp's art was emphatically abstract, or, in the terminology of the day, 'concrete'. Form, rather than content, was the primary consideration: the function of the object was not to represent a vase or a woman, but to be its own 'concrete' self.

By the time that he created this relief in 1931 Arp had abandoned Dada, whose influence on his work had persisted until the mid- to late 1920s, and had already parted company with Surrealism, which had passed its historical zenith. With its sinuous central form and the nine small spherical forms, whose order is dictated by the law of chance (to which Arp refers in the title of another picture), *Amphora* belongs to the same category of works as *Cloud Arrow* (Fig. 214) and *Constellation of Bow-Ties and Navels II* (Fig. 215). Although Arp had come to reject the formal vocabulary of Dada, the titles of these two reliefs, which both date from 1932, still contain a residue of Dada wit.

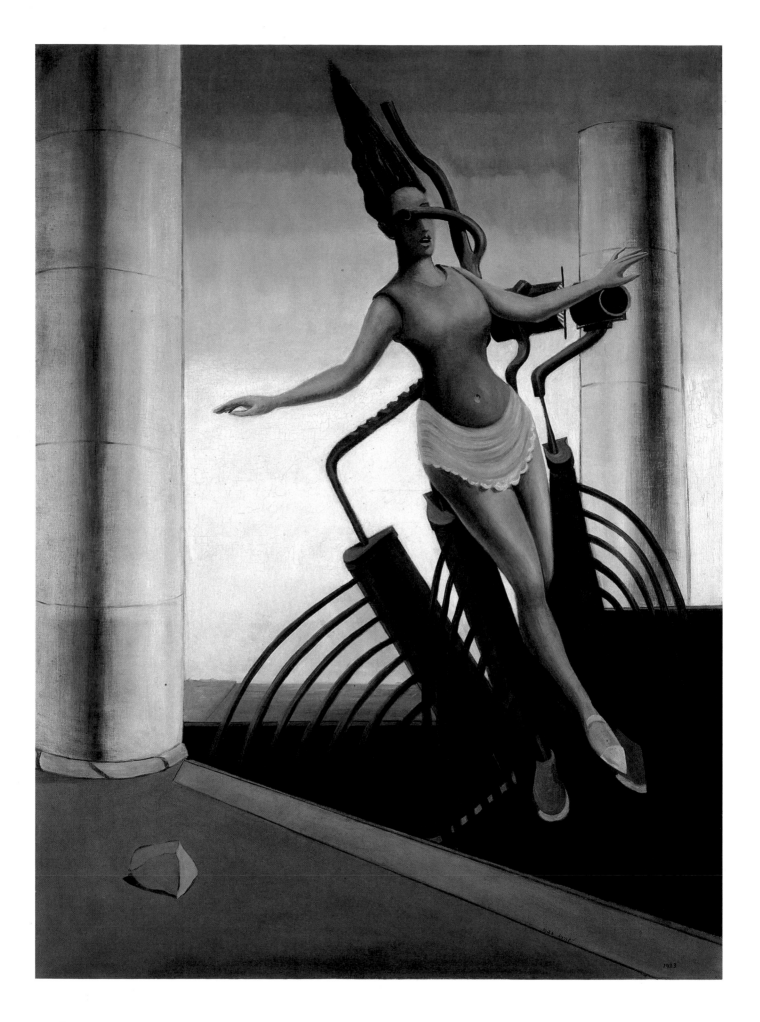

The artistic approach of the Surrealists, which had its roots in Dada and Metaphysical Painting, was diametrically opposed to geometricism and Constructivism, with their emphasis on strict formal purity. André Breton published the first *Manifeste du Surréalisme* in 1924. The natural progression from the anarchy of Dada to Surrealism, which had a solid grounding in philosophical, psychological and aesthetic theory, is particularly apparent in the work of Max Ernst, the Dada artist from Cologne who moved to Paris in 1922 and shortly afterwards became one of the founders of the Surrealist movement. It was in Paris, in 1923, that he painted *The Wavering Woman* (Plate 73), together with *The Beautiful Gardener* (now lost), *St. Cecilia* and *Pietà, or the Revolution by Night*. As in *St. Cecilia*, where the central figure is trapped in a massive wall, the woman in this picture is snared in a sinister machine made of wood and metal. Like a passive doll – half wooden, half living flesh – the scantily clad figure seems to float in mid-air, balancing with outstretched arms between the deadly rods and clamps of an imaginary instrument of torture with an organic, snake-like extension at the top: a modern vision of Laocoon. The hair forms a tall pyramid shape, as if air were being blown up from beneath by a concealed machine. The mouth is half-open, making the woman look as if she were asleep. Her seemingly blind right eye is replaced by the mouth of the snake-like tube. Yet menacing as it may be, the machine does not appear to harm the woman: drunken with sleep and lost in a dream world, she withstands the murderous assault. Hence, the picture combines several typical components of the Surrealist ideology: the emphasis on fantasy and dream, somnambulism and sadism. The nightmarish horror of the scene is made to appear all the more natural and inescapable by the contrastingly smooth technique of the painting, by the milky paleness of the colours and by the classical columns on either side, with the view of the serene blue-green sea in the distance. The picture is a hallucination set on a stage designed by the vertiginous imagination of de Chirico.

It is known that Ernst took his inspiration for the principal motifs of this picture from two illustrations in old magazines (Fig. 216, 217). In one of these journals, which he often used as a source of material for his collages, he came across a picture of a ship's engine which he copied in detail, committing an act of sacrilege by violating the principle of artistic originality. In another magazine he found an illustration showing a circus artist hanging upside down, which he took as the basis for the image of the woman in the painting. She is shown the other way up, but her hair, her clothing and the position of her arms and legs are almost unchanged. Ernst made a kind of collage out of the two motifs, completely changing their meaning in the process.

If one seeks an interpretation of the picture which goes beyond pure fantasy, then the title *The Wavering Woman* leads one towards the notion of the vagaries of fortune. As a former student of the history of art, Ernst was familiar with the allegorical figure of Fortuna in Renaissance painting (see Fig. 218). He had no inhibitions about seeking inspiration in the art of the past, as well as in illustrated

Fig. 216, 217 Illustrations from two French magazines, late nineteenth century

PLATE 73
Max Ernst
The Wavering Woman, 1923
Oil on canvas
130.5 × 97.5 cm

magazines from the late nineteenth century: to him, this seemed a perfectly natural thing for the artist to do. As far as he was concerned, even the most direct borrowing could not diminish the artistic authenticity of his work.

*

In 1923/24 Ernst lived for several months in the house of the poet Paul Eluard in the small town of Eaubonne, to the north of Paris. He took advantage of Eluard's hospitality to paint a series of pictures on the walls and doors of the small house. The result was one of the very few major cycles of murals in the history of modern painting. The subsequent owner of the house had the pictures painted and papered over, and they only came to light again in 1967. They were carefully freed from the layers of paint and wallpaper under which they had been hidden for nearly half a century, and those of the pictures which had been painted on stone surfaces were transferred on to canvas.

The painting *At the First Clear Word* (Plate 74) – the title was taken, after the rediscovery of the work, from a poem by Eluard – originally covered the end wall of a room in Eluard's house (see Fig. 219). The scene which it shows was continued in a picture on the adjoining wall, which was later given the title *Natural History*. The entire room was transformed into an illusionistic scene in a manner reminiscent of the wall paintings at Pompeii. The walls thus opened out on to a garden, with palm trees, various kinds of plants, walls and winding paths, under a blue, Italianate sky (which had to be completely renewed during restoration: the artist signified his approval of the result by appending his signature).

The motif in the picture is simple, but none the less highly enigmatic. There is a possibility that it relates to an essay by Sigmund Freud

Fig. 218 Giovanni Bellini, *Fortune*, *c.* 1490

PLATE 74
Max Ernst
At the First Clear Word
1923
Oil on canvas
232 x 167 cm

Fig. 219 Max Ernst,
Murals in Paul Eluard's
house at Eaubonne
(after the removal
of subsequent paperings)

166

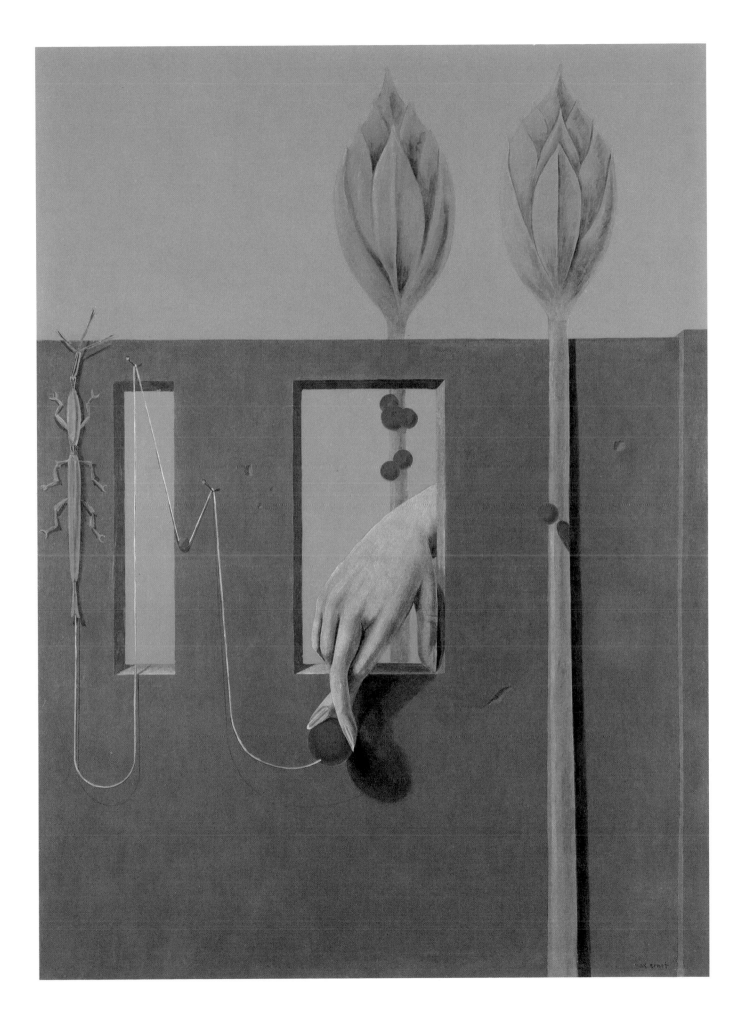

entitled 'Delusion and Dream in V. Jensen's *Gradiva*', concerning a novella by the Dutch writer Vilhelm Jensen in which the hero, an archaeologist, dreams of a young girl called Gradiva. The dream is set in Pompeii. In his psychoanalytic interpretation of the story, Freud comes to the conclusion that a particular scene in which Gradiva is seen catching lizards is a symbolic representation of 'man-catching'.

It is conceivable, although by no means certain, that this episode formed the basis of Ernst's painting, in which the lizard has been replaced by a large green insect, resembling a locust, whose vertical position represents the male principle. A long, looping thread connects the insect with a disembodied hand, which is clearly female. The thread traces out the letter 'M', the initial of the artist's forename. It ends in a red ball which is held in the two crossed fingers of the hand emerging from the wall; if the hand drops the ball, the insect – a symbol of masculinity – will be dragged down off the wall. However, the picture lacks any sense of drama or immediate threat; with its enigmatic quality and its quiet, dream-like mood, it doubtless lent great charm to the room in which it was painted. What makes the Gradiva interpretation problematical is, above all, the fact that the painting on the adjoining wall cannot be accommodated in this Freudian reading of the picture.

The motif of the hand projecting through an aperture in a wall and holding an object by its finger-tips is found in numerous other pictures by Ernst, notably in *Oedipus Rex* (Fig. 220), which was painted in 1922. The title of this work is an obvious reference to Freud. The Surrealists took a keen interest in Freud's ideas, and the figure of Gradiva particularly stimulated their imagination. Salvador Dalí drew a 'Gradiva' in 1932; André Masson painted a picture in oils with the same title in 1939. In 1937 Breton, the spokesman and high priest of Surrealism, opened a gallery in Paris called the Galérie Gradiva. The venture was less than successful: it was overshadowed by the political events of the day, and it was launched at a point when Surrealism had long since passed the peak of its historical significance.

*

In 1927 Ernst painted *After Us, Maternity* (Plate 75). The picture features a family of grotesque, semi-Baroque, bird-like creatures; in the centre one sees a mother-and-child group which pokes gentle fun at a traditional and venerated artistic motif. Given that both his pictures and his writings contain numerous references to the Renaissance artist Raphael, it is by no means far-fetched to suppose that Ernst is alluding here to Raphael's depictions of the Virgin and Child (see Fig. 221). The scene with the birds, which is both humorous and heroic, is not localized in concrete reality. The oddly flat, blue silhouette of a bird on the left forms a puzzling contrast with the nocturnal background, and the Baroque form of the 'console' on which the central group is set gives the motif a sculptural look which also surprises the viewer. The picture is made up of a wide variety of disparate elements. It combines an almost plastic tangibility with two-dimensionality and a free linear construction, extending into space, to create a spectacle which is simultaneously banal and mys-

Fig. 220 Max Ernst, *Oedipus Rex*, 1922

Fig. 221 Raphael, *The Tempi Madonna*, c. 1507

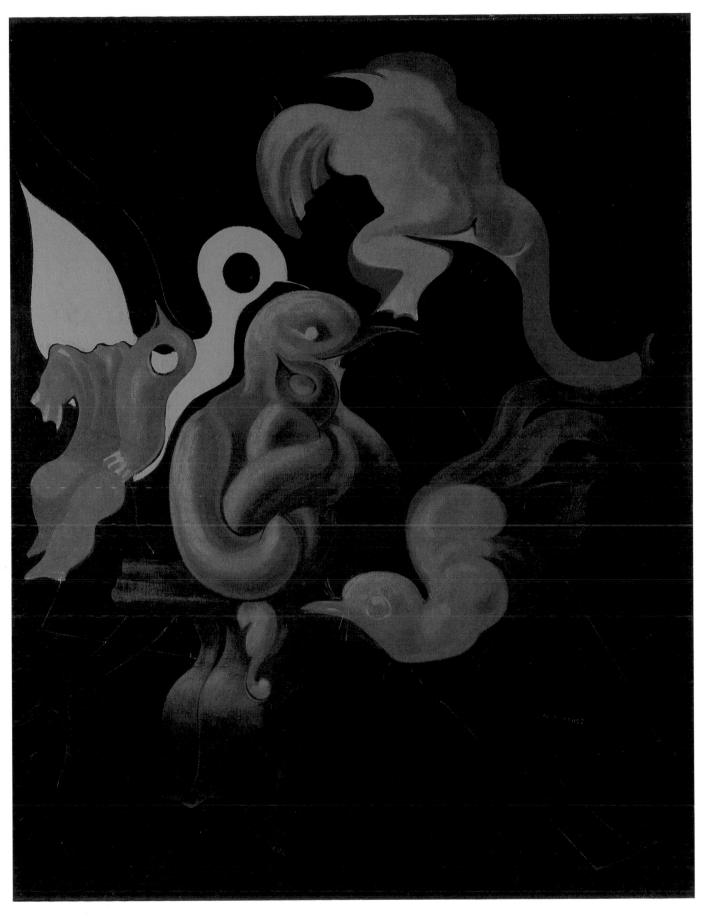

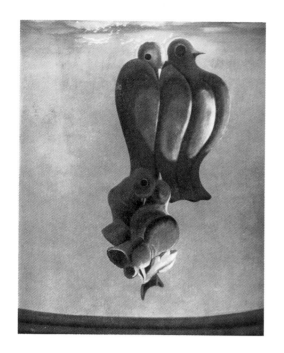

terious, a drama in which a literary idea is successfully translated into a specifically pictorial vision and thereby attains full artistic legitimacy.

Throughout his life Ernst continually returned to the motif of the bird, dealing with it in a large number of different ways. The memory of a childhood encounter with a dead bird continued to haunt him, and birds played an important part in his work, especially in his pictures from the mid- to the late 1920s. Birds appear as a kind of personal totem, as the alter ego of the artist, and are often given bizarre names, such as 'Loplop' or 'Hornebom'. A striking feature of these pictures is that the birds are frequently linked with scenes or symbols which have a specifically female connotation. They personify unconscious feelings or ideas and translate them into mythical terms. However, Ernst never wholly abandons his attitude of ironic detachment: he remains a disinterested observer of the workings of his own imagination. His work is invariably controlled and precise, and his mythologization of the unconscious shows a high degree of intellectual and artistic calculation.

*

With its mythical birds, forests and cities, the work of Ernst increasingly took on the character of a mythology of nature, featuring a wide variety of figures and alluding not only to the early German painters Grünewald and Altdorfer, but also to the work of Caspar David Friedrich and Philipp Otto Runge. This development begins with the cycle of lithographs entitled *Natural History* (1926), the 'bird monuments' (see Fig. 222, 223), the 'bird weddings' and the 'forest' pictures of the 1920s, and continues with the 'aircraft traps' and the landscapes and urban visions which Ernst painted in the 1930s. In these pictures we find the artist addressing nature on surprisingly intimate terms: succulent greenery and carnivorous insects are painted with a hyper-realistic attention to detail. However, the tangled undergrowth also harbours fabulous beasts and other bizarre forms which render nature enigmatic. At the very moment

Fig. 222 Max Ernst
Monument to the Birds, 1927

Fig. 223 Max Ernst
Monument to the Birds, 1927

Fig. 224 Max Ernst, *The Locust*, 1934

PLATE 76
Max Ernst
Landscape with Sprouting Corn
1936
Oil on canvas
130.5 x 162.5 cm

when he turns to the reality of nature Ernst promptly oversteps its boundaries, populating it with creatures deriving from his own imagination.

Landscape with Sprouting Corn (Plate 76), which was painted in 1936, forms something of a contrast to Ernst's emphatically naturalistic, but nevertheless surreal landscapes. It lacks the abundance of luxuriant tropical vegetation, the teeming variety of plants and flowers, found in many of the artist's other works. Yet this, too, is a picture of burgeoning nature, in all its wanton fruitfulness.

The landscape appears to be seen simultaneously from a distance and at close quarters. On the one hand, it can be read as a sharp-edged mountain range jutting up into the distant expanse of the blue sky and, on the other, as a confined and heavily magnified cross-section of the earth, with a layer at the bottom like a tangled mass of innards, two zones of red and blue, and a layer of vegetation on the top. A huge insect, resembling a locust, lies diagonally in the centre of the picture, nestling in the bowels of the earth, whose juices it is greedily extracting. A number of birds, seen only in shadowy

171

PLATE 77
Max Ernst
The Cocktail Drinker, 1945
Oil on canvas, 116 × 72.5 cm

Fig. 225 Max Ernst, *Euclid*, 1945

Fig. 226 Giuseppe Arcimboldi, *The Market Gardener*, c. 1590

outline, are caught up in the play of natural forces, in which the only evidence of human participation is the violet-and-black hand holding the red bird at the bottom of the picture. A red beak sucks at the exposed guts of the earth; above it a multi-coloured form projects sharply upwards like a mountain; and on the left we see an artificial form, reminiscent of a musical instrument, which is echoed by the blue-green shapes floating in the sky.

*

Ernst painted *The Cocktail Drinker* (Plate 77) and *Euclid* (Fig. 225) in New York in 1945, shortly before he moved to Arizona. At first sight, *The Cocktail Drinker* appears to be a caricature of a party guest holding a cocktail glass in an affectedly elegant pose. Beyond this, however, it contains a marked element of the surreal and the fantastic. The picture is structured after the manner of a conventional portrait: it reminds one not only of the work of the Italian Mannerist Giuseppe Arcimboldi, an artist, much fêted by the Surrealists, whose highly suggestive portraits are made up of combinations of fruits and plants, but also – especially with regard to the pyramid structure and the way that the arms rest at the bottom of the picture – of Leonardo's *Mona Lisa*. This classical reference strikes an additional note of absurdity.

Working for the first time within a traditional pictorial scheme, the artist nevertheless allows his imagination to run riot. The figure is a conglomeration of natural and artificial forms, wittily and skilfully combining vegetable, mineral and human elements, mixing death and decay with images of life and growth. Widely differing areas of reality are amalgamated into a surreal farrago of Romantic sensibility and intellectual irony. It is interesting to note that Ernst derived a substantial part of his inspiration from technical procedures. He was the originator of three new artistic techniques, which he called *frottage*, *grattage* and *décalcomanie*. The mechanical element of chance created by these devices was a spur to his pictorial imagination. In *The Cocktail Drinker* the structures in the lower part of the picture are produced by *décalcomanie*, that is, by pressing a plate on to the wet colour and thereby creating a pattern which the artist subsequently manipulated to make a bizarre network of vegetable forms.

OELZE

Richard Oelze painted his *Everyday Tribulations* (Plate 78) in 1934, at the time when Ernst was creating his luxuriant visions of nature. The picture was probably painted in Paris, where Oelze lived, in considerable poverty, from 1933 to 1936, occasionally drifting into the ambit of the Surrealists. It recalls the mythical forests of Ernst and the visionary sea pictures of Yves Tanguy, with their tall structures rearing up in the foreground. In 1929 Oelze had been deeply impressed by the experience of seeing, in Ascona, a number of reproductions of works by René Magritte and Ernst. However, his association with Surrealism remained tenuous: when he moved to Paris he did not join the Surrealist circle. His temperament con-

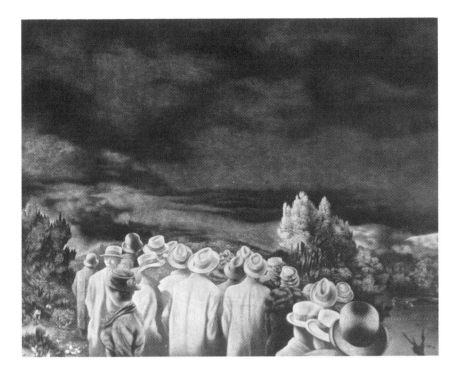

Fig. 227
Richard Oelze
Expectation
1935

PLATE 78
Richard Oelze
Everyday Tribulations, 1934
Oil on canvas, 130×98 cm

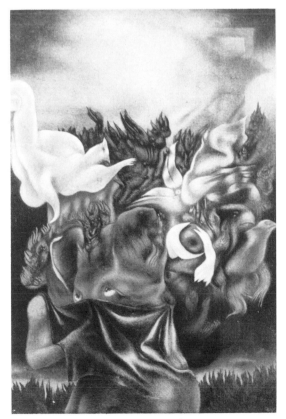

Fig. 228 Richard Oelze, *Daniel*, 1934

demned him to lead a solitary existence. Apart from *Everyday Tribulations*, Oelze's few known works from the period before 1939 include the closely related *Daniel* (1934; Fig. 228) and the famous *Expectation* (Fig. 227), which was painted in 1935 and bought in 1940 by the Museum of Modern Art in New York, where *Everyday Tribulations* had been shown four years earlier in the momentous exhibition 'Fantastic Art, Dada, Surrealism'. Following these early successes, little more was heard of Oelze, who after the war moved to Worpswede and thence to the Weserbergland in Lower Saxony. Shrouded in obscurity, he became something of a living legend.

Everyday Tribulations is a picture full of secrets, disturbing, depressing and perhaps even somewhat repellent. It is steeped in melancholy and neurosis. Nature is shown in full bloom, but the scene has an air of fetid sickliness: it appears to be set in a tropical swamp, which contrasts oddly with the leaden, Northern sky. The viewer finds himself involuntarily drawn into the picture; his gaze wanders questingly from one figure to another, seeking an answer to the puzzle, until he finally understands that there is no answer because there is no puzzle to solve.

However, the viewer does find a wealth of interesting things to look at. His gaze alights on a number of more or less identifiable animals, on details such as eyes, claws and wings, on various forms of animal and plant life which are caught up in a process of continual transformation. Combing through the picture in search of natural phenomena, one discovers familiar forms and others which are unfamiliar. There are zoomorphic flora and floral fauna, and there is also a human element, in the shape of two figures which are largely concealed in the tangle of vegetation. The large structure in the centre, whose form reminds one of a tree, a toadstool or a lump of coral, is crowned by the head of an otherwise invisible man looking out from behind. It is a mask-like, grey and ill-looking face with blind eyes;

the right-hand corner of the mouth is covered with pustules. The temptation to interpret the man, if not as a self-portrait, then as a projection of the artist in his own picture is irresistible. Hidden in the foreground, behind the vertical conglomeration of animals, there is also a girl; all that can be seen of her is a cascade of auburn hair, decorated with a red flower which resembles a bird. The picture suggests that there is some form of troubled, painful relationship between the two figures: there may be an allusion here to the battle of the sexes. The title *Everyday Tribulations* allows scope for a wide variety of interpretations. It has no apparent autobiographical reference.

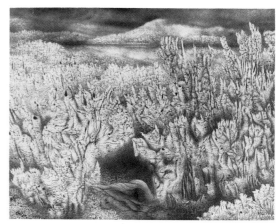

Fig. 229 Richard Oelze, *A Landscape (Distance)*, 1935

Notwithstanding the fluid boundaries between one motif and another, and the intermingling of fur, feathers and bodily organs, the picture is painted with a degree of naturalistic precision which reminds one of the Old Masters. The composition is studied and careful, rather than dictated by the workings of the unconscious: it progresses in gradual stages from the bank of the stream to the water, from which the large fungus-shaped form emerges, and thence to the area of land – perhaps an island – beyond, with two forests, one of them dark and the other pale and ghostly, which foreshadow those in Oelze's later murals – for example, *A Landscape (Distance)* of 1935 (Fig. 229). Behind this there is a further stretch of water, with a conventionally painted view of a town on the distant shore. The picture is thus organized in a succession of horizontal layers, an effect which is continued in the sky, divided as it is into two sections by the heavy band of dark cloud, accompanied by animal figures, which drifts across the picture from left to right like a giant funereal banner.

MAGRITTE

There is a world of difference between the Romanticism of Ernst and Oelze and the sober, methodical pictorial manner of the Belgian Surrealist René Magritte, who started to paint in 1925/26. One of the premier examples of Magritte's early work is a picture which was initially entitled *Young Girl Eating a Bird* and was subsequently given the unauthentic title *Pleasure* (Plate 79). The picture shows a girl, barely more than a child, standing under a tree in whose branches several birds of paradise are perching; she is biting into a live bird, whose blood spurts down the front of her Sunday-best dress. The girl shows no sign of either appetite or disgust, and the scene lacks all sense of drama: the actors – the girl herself and the birds in the tree – seem inwardly detached from the events which the picture depicts. The brushwork, too, is smooth and undemonstrative: everything in the painting appears perfectly normal and natural. This, of course, is precisely the source of its surreal effect. The picture may legitimately be interpreted as a secular version of the story of Eve and the apple in the Garden of Eden. Here, Eve is a middle-class child, eating a bird instead of the forbidden fruit; the loss of her innocence is signified by the blood-stain sullying the white collar of her dress. This is a highly 'literary' idea of a kind which one often encounters in Surrealist thinking, in which the

Fig. 230 René Magritte, *Pleasure*, 1946

Fig. 231 René Magritte, *The Murderous Sky*, 1928

confrontation between middle-class propriety and the promptings of desire plays a central part.

The motif of the girl with the bird makes a further appearance in a gouache of the same title (Fig. 230) that Magritte painted twenty years later, in 1946. In this work, which is about half the size of the oil painting, the artist used a more or less Impressionist technique whose anachronistic character was in itself mildly shocking. The image of the fatally injured bird recurs in a landscape entitled *The Murderous Sky* (Fig. 231), which was painted in 1928. Here, there are four birds, depicted in a similar pose to that of the bird in *Pleasure*.

*

One of Magritte's favourite motifs is that of balustrade posts, resembling chessmen or skittles, which appear in his work for the first time in 1926 and frequently figure in his later pictures (see Fig. 232, 233), where they are found in a wide variety of constellations that never cease to puzzle and disturb the viewer. The early picture *The Meeting* (Plate 80) features two groups of three such balusters, which stand facing each other with an air of solemnity and aloofness. It may be that one of the groups is looking at itself in a mirror,

177

PLATE 80
René Magritte
The Meeting, 1926
Oil on canvas
139.5 × 99 cm

Fig. 233 René Magritte, *The Art of Conversation*, 1961

although the two images do not match exactly. The tall posts have an anthropomorphic appearance: the eyeballs with the irises and pupils are by no means the only features which endow them with a figurative character. Their dignified manner is echoed by the subdued theatrical pathos of the scene. Thick dark-blue curtains hang down from the ceiling at either end of the raised platform on which the figures are standing; in the centre there is a kind of frame, whose figurative significance is somewhat uncertain but which may contain the mirror. Beyond or behind the platform – depending on whether we are seeing a mirror image or a 'real' image – the viewer looks out into a moonlit valley, at the far side of which black mountains rear up into the clouded nocturnal sky.

This picture and others like it hark back to Italian Metaphysical Painting, with its bizarre combinations of heterogeneous objects which are shrouded in an aura of mystery. Familiar objects, whose figurative identity is left intact, are transformed into actors in a universal drama of enigma and ambiguity. In the work of Magritte this transformation is performed in a highly inventive manner which has the effect of puzzling and confusing the viewer. In his pictures we find a wealth of disturbing combinations and mutations of objects and living things; he deceives the eye and disarranges the world, with consequences which are at once amusing and troubling. While feigning to obey the laws of rationality and normality, he in fact suspends them and pulls the rug out from under the viewer's feet.

At first sight, the object in *The Empty Mask* (Plate 81), which was painted in 1928/29, also appears to belong to the normal, everyday world. The picture shows a painting divided into four sections, standing on a wooden floor which provides a sense of perspective. What makes the painting strange is not only its irregular shape and

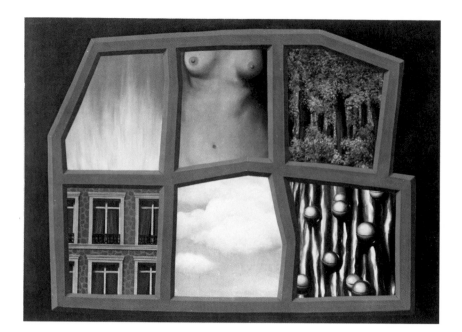

Fig. 234
René Magritte
The Six Elements
1928

the way that the frame divides up the four sections, but, above all, the fact that, instead of pictorial images, it contains only words: 'ciel' (sky), 'corps humain (ou forêt)' (human body [or forest]), 'rideau' (curtain), and 'façade de maison' (house façade). Thus, the picture contents itself with showing an intellectual concept, a pure idea which could be held to be more important than the actual execution of the work. However, the artist himself has *painted* this conceptual picture: he has not abandoned the making of pictures. What is conceptual is not his own painting but the picture within the picture. Nevertheless, by giving a new meaning to the written word in this and other pictures, Magritte anticipated the strictly conceptual art which emerged at the beginning of the 1970s, in which the concept entirely replaces the work. Yet compared with this later, logical development of Magritte's idea, *The Empty Mask* retains a large measure of sensual immediacy.

Fig. 235 René Magritte, Drawing for *The Empty Mask* (Plate 81), 1929

Fig. 236
René Magritte
Living Mirror
1926

PLATE 81
René Magritte
The Empty Mask, 1928/29
Oil on canvas
73 × 92.5 cm

In 1929 Magritte wrote: 'The words in a painting have the same substantiality as the images.' In his work words and images are indeed interchangeable. It is interesting to compare *The Empty Mask* with the painting *The Six Elements* (1928; Fig. 234), in which the themes of the sky, the forest and the human body are treated naturalistically, rather than merely adumbrated by the use of words. The artist is evidently less concerned with surreality than with the promotion of an attitude of detachment towards the world of visible objects. To the extent that this attitude can be ambivalent, as the two very different pictures show, it demonstrates the absolute freedom of the human spirit, to which Magritte frequently referred in his writings. His personal freedom manifests itself not only in his manner of dealing with objects as such, but also in the way that he alternates between one artistic style and another, as in the two pictures of the girl eating a bird (Plate 79, Fig. 230), one of which is naturalistic, while the other is a pastiche of Impressionism. The artist takes the liberty of using whatever style he pleases, and thereby challenges the authority of the very notion of style; or he allows himself the freedom to choose between painting a picture of sky or a human body or simply alluding to them by the use of words.

TANGUY

In his typically oblique manner, André Breton once remarked: 'Surrealism is the appearance of Yves Tanguy in the form of a huge, dishevelled bird of paradise.' Tanguy was a native of Brittany, and anyone who has seen the coastline of this region, with its stony beaches and rocky outcrops, will realize just how much reality Tanguy's surreal visions contain. Before the First World War Tanguy had travelled the world with the French merchant navy, and he drew on his maritime experiences in his art. From 1927 onwards he took part in all the 'official' manifestations of Surrealism, and he became a member of the movement's inner circle. When the Second World

Fig. 237
Yves Tanguy
Proésépé
1929

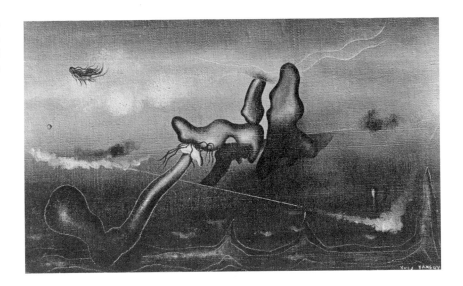

War broke out in 1939 he emigrated to New York, and he took out American Citizenship in 1946. He died in 1955 at the age of fifty-five.

Nearly all Tanguy's pictures are Surrealist landscapes. They invariably follow the same principle: a variety of strange, unidentifiable forms are set in a comparatively natural landscape which generally contains areas of water, land and sky. In the early pictures the landscape is painted in sombre blues and greys, suggesting rain and mist, but later the colours become sunnier and brighter. The varied forms of the early years – denoting vegetation and bone-like objects – are subsequently replaced by hard structures with a more emphatically plastic character; the visionary deserts which Tanguy painted in the years immediately preceding his death are littered with stones. This progression is illustrated in the Düsseldorf collection by a comparison of *The Dark Garden* (1928; Plate 82) with *The Absent Lady* (1942; Plate 83).

There are no people in Tanguy's landscapes, which look as if they are located on a distant, unknown planet or in some remote, unknown era. They are filled with objects which resemble relics of the prehistoric past. Tanguy makes the viewer feel that, somewhere in the vast expanse of the universe, these landscapes actually exist. *The Dark Garden* (Plate 82) is an imaginary landscape that nevertheless seems real, with an overcast sky, a rocky shore, a distant horizon and an expanse of water which could be either the sea or a flood threatening the continent: the unearthly scene invites a variety of interpretations. What makes the landscape fantastic is not only the bizarre rock formations, but also the various shapes flying around in the air, as if some invisible force had triggered off an explosion in the hidden depths of the earth, causing these forms to burst forth from the ground like projectiles. This primeval landscape is not dead, but animated by the workings of mysterious forces. That is what fascinated Tanguy, and it remained the subject of his art for the rest of his life.

The biomorphic, often bone-like forms in Tanguy's pictures frequently remind one of the sculptures of Arp (see Fig. 238). Over the

years, this sculptural tendency in Tanguy's work became increasingly marked, with the result that the motifs often look like painted sculptures, standing in the foreground and casting a deep shadow into the depths of the picture. This is the case with the dominant figure in *The Absent Lady* (Plate 83), which was painted in 1942. Standing immediately behind the figure, which is clearly female, there is a further figure, striped like a zebra, which is conceivably male and is echoed by a miniature replica in the far distance. In addition, the scene is decorated with a number of small, toy-like forms. The motifs are painted in an almost photographic manner: they are real and yet, at the same time, surreal, as if the landscape were set on another planet, despite the natural-seeming yellow sky. The combination of realism and unreality engenders an alternative reality. It is as if the petrified relics of a bygone age, of a world which has long since ceased to exist, had survived the passing of the millenia in an eternal continuum from which all trace of human life has been erased.

The projection of surreal events into natural landscapes and the quasi-photographic reproduction of fantastic figures are devices which recall the work of Dalí, in whose pictures from the 1920s perspective also plays a similar role to that seen in *The Absent Lady*. Dalí, too, often used miniature replicas of the motifs in the foreground of his paintings to create an additional effect of depth in the work as a whole.

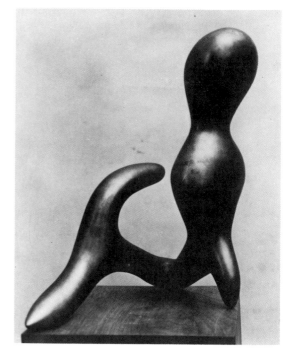

Fig. 238 Jean Arp, *Siren*, 1942

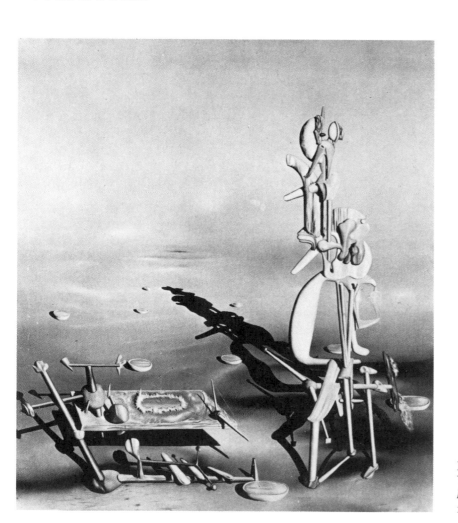

PLATE 83
Yves Tanguy
The Absent Lady
1942
Oil on canvas
115 x 89.5 cm

Fig. 239
Yves Tanguy
Infinite Divisibility
1942

184

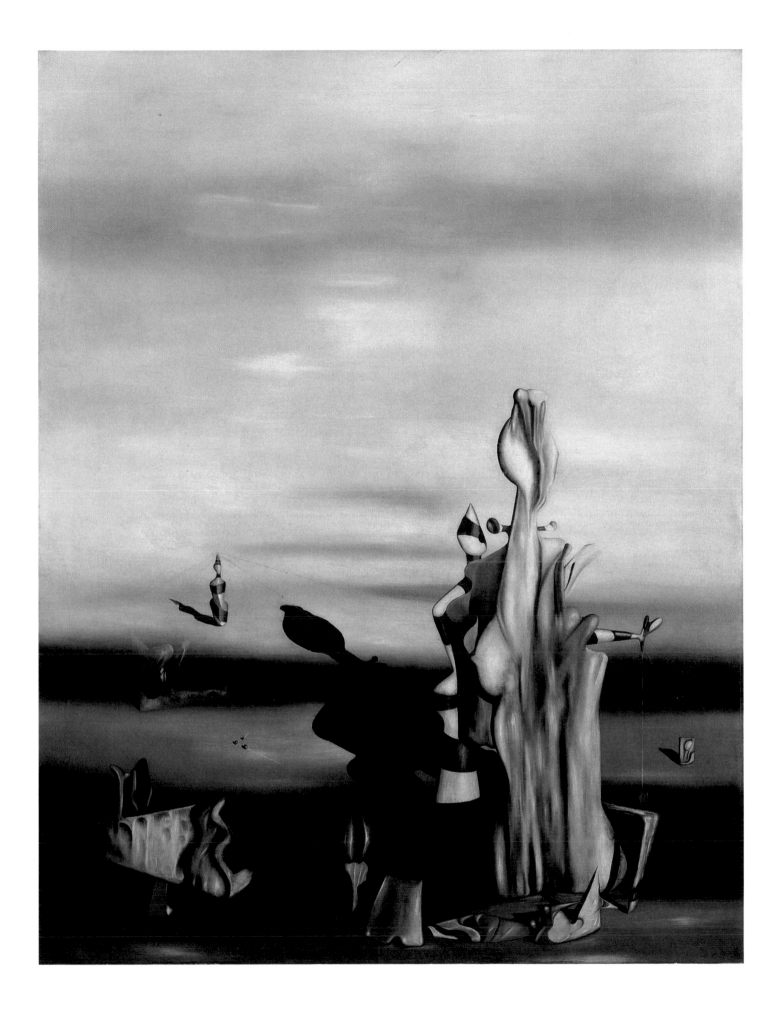

DALI

Salvador Dalí reached the peak of his artistic achievement in a series of small-format pictures from the early to mid-1930s which includes the painting *The Anthropomorphic Chest of Drawers* (1936; Plate 84). The picture, which is painted on wood, shows a reclining female figure, supporting herself on her left arm and stretching the other arm out horizontally, as if to shore up the rectangular picture. There is a sharp contrast between the more or less naturalistic style in which the woman's limbs are painted and the surreal quality of the drawers projecting from her chest, three of which bear sexual characteristics restated in terms of the furniture. This motif is inspired by the dream interpretations of Freud, in which Dalí took a keen interest: in 1938 he visited Freud in London, after the psychoanalyst had been driven into exile by the Nazis. He used the motif again in two drawings (Fig. 241, 242), which are closely related to the painting. Shortly afterwards he painted *The Burning Giraffe* (Fig. 240), the most popular variant on the drawer theme. Dalí himself spoke of the 'narcissistic pleasure' which we feel 'in contemplating each of our drawers'; the woman does indeed appear to be absorbed in self-contemplation. A further likely source of inspiration for the motif is the series of etchings entitled *Capricci* (see Fig. 243) by the Italian Mannerist Giovanni Battista Bracelli, in which human figures are depicted as pieces of furniture. Dalí, who characterized himself as an anti-modernist and provocatively declared that his artistic ideal was the painted photograph, combines the naturalistic style of drawing of the Renaissance masters with the flickering chiaroscuro of an Italian Baroque painter such as Alessandro Magnasco. *The Anthropomorphic Chest of Drawers* also reminds one of

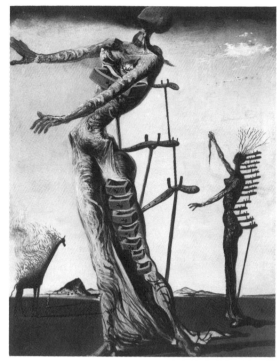

Fig. 240 Salvador Dalí, *The Burning Giraffe*, 1936/37

PLATE 84
Salvador Dalí
The Anthropomorphic Chest of Drawers, 1936
Oil on panel, 25.4 × 44.2 cm

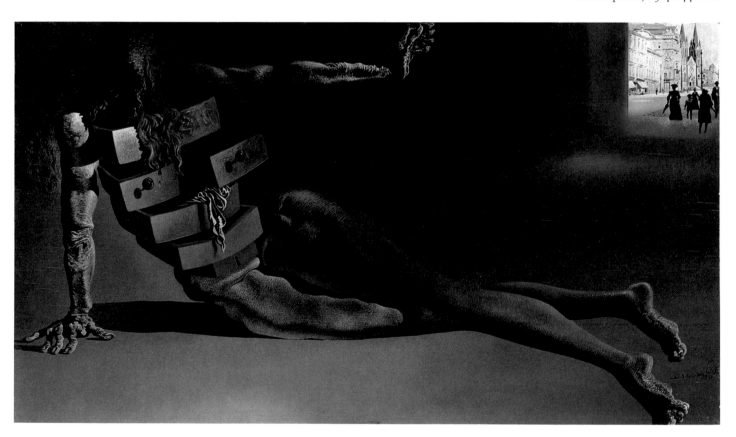

Fig. 241
Salvador Dalí
The City of Drawers
1936

Fig. 242
Salvador Dalí
The City of Drawers
1936

Fig. 243 Giovanni Battista Bracelli, Etching from the *Capricci* series, 1644

the interiors in seventeenth-century Dutch painting, which often look out on to a street scene.

From its very beginnings the twentieth-century avant-garde was accompanied by a demonstrative anti-modernism. Kokoschka, for example, flatly rejected the trend towards the autonomization of form and colour which played such an important part in the development of modern art. Picasso disapproved of abstraction. And the Surrealists, especially Dalí, looked down on the social commitment and reforming zeal of such movements as the Bauhaus and *De Stijl* with a certain intellectual arrogance.

A very different version of Surrealism is to be found in the work of Joan Miró. Instead of using semi-photographic techniques of painting to depict a 'higher', fantastic reality, Miró exploited the inner imaginative resources of painting itself. This, too, was fully in keeping with the Surrealist programme. Miró's almost monochrome picture *Stars in Snails' Sexes* (Plate 85), which was painted in 1925, appears to be a direct realization of Breton's notions of psychic automatism and *écriture automatique*, the theory of artistic creation as a spontaneous process dictated by the workings of the unconscious mind. In art of this kind, however, it is difficult to distinguish between the unconscious and the conscious elements. The work of Miró has a nocturnal, hallucinatory, dream-like quality, but it also bears the mark of a keenly alert creative intelligence which makes use of the unconscious but does not allow itself to be controlled by it. Miró also accepted the Surrealist principle of chance, but refused to let it dominate his work. 'I throw down the gauntlet to chance,' he wrote: 'For example, I prepare the ground for a picture by cleaning my brush over the canvas. Spilling a little turpentine can also be helpful.' This, perhaps, is how he set about painting *Stars in Snails' Sexes*. On the brown, washed-out, blotted ground one sees a large, freely drawn red circle and a star with a comet's tail; the playfully poetic title *étoiles en des sexes d'escargot* is inscribed over a tangle of blue lines in the top left-hand corner. Miró referred to these pictures, which feature poems or words, or sometimes only single letters and numbers, as *tableaux-poèmes*.

Fig. 244 Joan Miró, *The Body of my Brunette*, 1925

These texts are quite different from those found in some of Magritte's pictures. Miró was completely uninterested in such theoretical issues as the question of the identity or non-identity of word and image. His aim in using words was merely to add a poetic dimension to his pictures. In *Catalonian Landscape* (Fig. 245), an earlier picture which was painted in 1923/24, before the *tableaux-poèmes*, the inscription looks as if it has been typeset rather than hand-written. Shortly afterwards Miró embarked on a series of largely monochrome pictures, some of which include texts, and the dark tones of the works

Fig. 245
Joan Miró
*Catalonian Landscape
(The Hunter)*
1923/24

Fig. 246 Joan Miró, Study for *Stars in Snails'
Sexes* (Plate 85), 1925

from the mid-1920s subsequently gave way to lighter, more colourful shades. The world-wide artistic movement, variously known as Action Painting, *peinture de geste* or Lyrical Abstraction, which emerged at the end of the Second World War, owed a great deal to the Miró of the 1920s, as well as to the early work of Kandinsky. The exponents of this movement also attached great importance to the unconscious and the element of chance in art, and they cited Breton's idea of automatic writing. Miró himself, however, was relatively indifferent to these central tenets of Surrealist theory. This is demonstrated by his detailed study for *Stars in Snails' Sexes* (Fig. 246), which proves that the picture was not improvised but carefully planned in advance.

*

In 1934 Miró painted his large-format picture *Rhythmic Figures* (Plate 86). (The title was not of his own invention and was coined at a later date.) Although by this point he had parted company with the Surrealist movement, the theme of this work is more patently surreal than that of the earlier picture. It features a collection of anthropomorphic and animal figures who have gathered together to

dance the night away in an imaginary space under a dark, crescent-shaped moon. The centre of the picture is dominated by a large female figure with a bulky white torso, accompanied by a thinner figure on the left. The abstract creatures in the upper section contrast with the more realistic female figure in the bottom right-hand corner. Right at the top, an agile, animal-like creature looks out of the picture. In terms of both line and colour, all the elements in the scene are sharply demarcated. The figures stand out as flat, but by no means two-dimensional, patches of black, white, red and yellow against the blurred ground, which is divided up into large zones of colour.

The picture derives its sense of animation not only from its surreal content, but also from the rhythmical feel of its forms and colours. It has a thoroughly festive character, an exceptional visual allure which partly stems from the fact that it was originally painted as a design for a wall-hanging – a functional application which places the picture beyond the pale of Surrealist ideology. The humour with which the pictorial anecdote is presented is Miró's own sense of humour; the scene shows a sense of fun and a formal *esprit* which are naive and direct, and hence far removed from the world of Surrealism.

This was not the only design for a tapestry which Miró made for the workshop of Marie Cuttoli in 1934. His second design, which also has a high aesthetic value in its own right, is entitled *Snail, Woman, Flower, Star* (Fig. 247): the title is inscribed in French across the large canvas. There is a close affinity between these two works and the series of collages which Miró produced in the same year – for example, *Homage to Prats* (Fig. 248). In these he stuck photographs of bathing beauties, hats and other fashionable motifs in

Fig. 247 Joan Miró, *Snail, Woman, Flower, Star*, 1934

Fig. 248 Joan Miró
Homage to Prats, 1934

Fig. 249 Joan Miró
Drawing, 1934

190

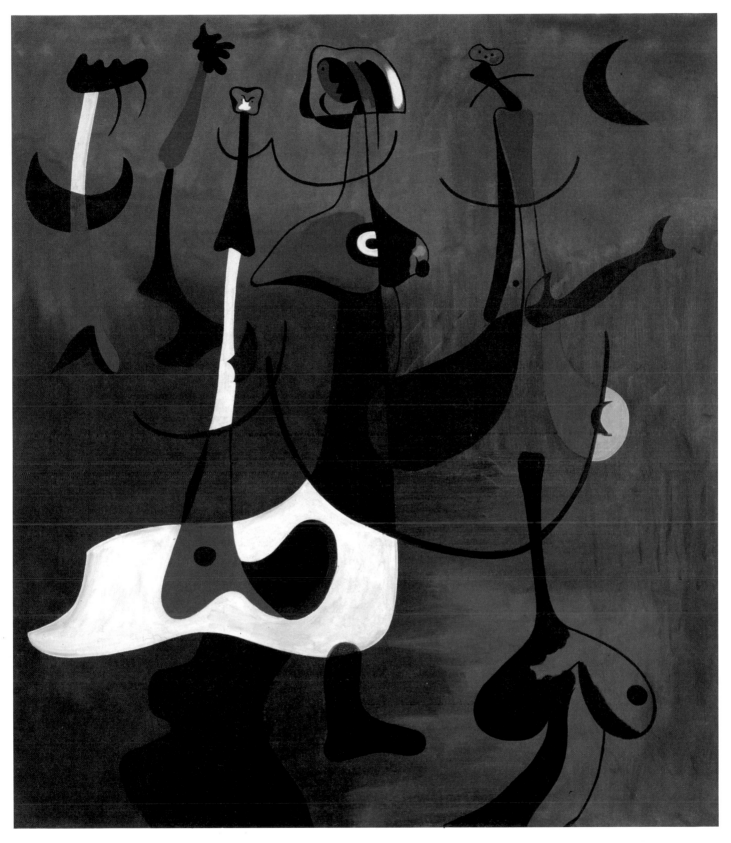

PLATE 86
Joan Miró
Rhythmic Figures, 1934
Oil on canvas
193 × 171 cm

among the curved lines which form graceful figures. In a number of drawings which are contemporary with these pictures (see Fig. 249), the overlapping lines create flat areas which in some cases are filled in with colour, in a manner which resembles the patches of colour in *Rhythmic Figures*.

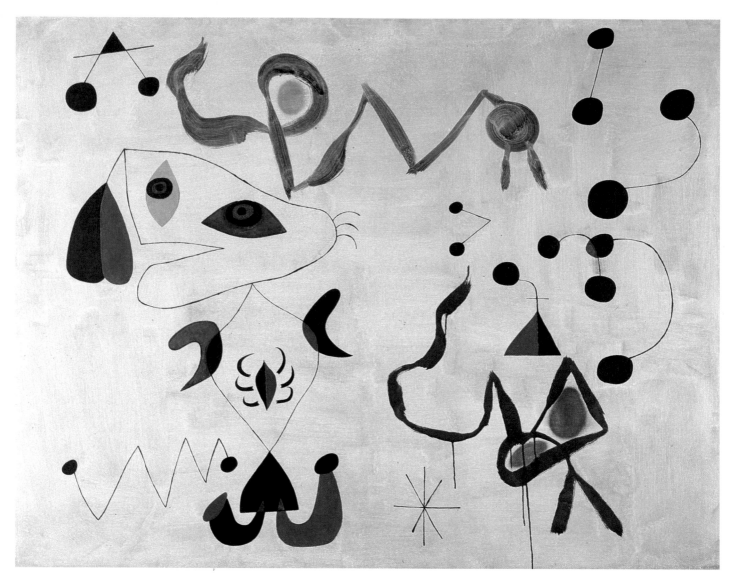

PLATE 87
Joan Miró
*Women and Birds
in the Night*, 1945
Oil on canvas
114.5 x 146.5 cm

The Spanish Civil War drove Miró into exile in France, but he returned to Spain during the Second World War. The historical events which so deeply affected his life had little impact on his work. Concerning the war years, he later wrote: 'I deliberately retreated into myself. Music, the night and the stars began to play an increasingly important part in my pictorial ideas. I had always been attracted to music, and at this point it started to become as important to me as poetry had been in the 1920s.' In the series of lithographs entitled *Barcelona* which Miró created in 1939 (see Fig. 251) the surface of the paper is already populated with moons, stars and all manner of signs, in addition to a variety of grotesque figures. The following year the artist produced a series of twenty-three gouaches entitled 'Constellations' (see Fig. 250), which are made up of countless stars and brightly coloured celestial bodies. Shortly after the end of the Second World War he painted a series of pictures with a light background (see Plate 87 and Fig. 252) which feature the same signs and figures, albeit in smaller numbers, and hark back not only to the 'Constellations' but also to the earlier *Barcelona* series, which was not published until 1944, five years after it was created. The black humour of *Barcelona* gives way to a relaxed, playful mood. However, there are direct and obvious resemblances between a pic-

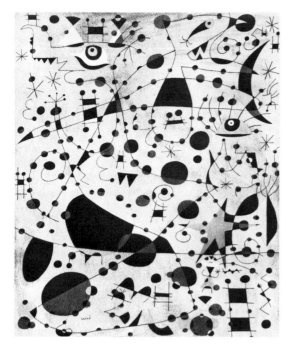

Fig. 250 Joan Miró, *Constellation: On the 13th, The Ladder Brushed the Firmament*, 1940

Fig. 251 Joan Miró, Lithograph from the *Barcelona* series 1939 (published 1944)

Fig. 252 Joan Miró, *Woman Dreaming of Escape*, 1945

ture such as *Women and Birds in the Night* (Plate 87) and the earlier lithographs. In the lithographs one already finds the large, linear figures seen in the later paintings (although their appearance is more 'evil' and expressive than in the latter works), with the characteristic eyes and the rudimentary shock of hair, and there are also freely drawn forms, such as the greenish snake at the top of *Women and Birds in the Night* or the brown form on the right. Miró's iconography took on an ever-increasing degree of clarity and concentration. Right until the end of his life Miró continued to paint women, birds and stars, but his pictures are so varied that one is led to speak of the richness rather than the poverty of his imagination.

Miró uses a set of private symbols which can be read and interpreted in a variety of different ways. He himself set great store by the polyvalency of the signs in his pictures. The gender of the figure in *Women and Birds in the Night* is clearly recognizable, but the form dangling in front of her nose is wholly enigmatic: it seems to be a flash of pure pictorial inspiration which, despite its lack of determinate meaning, possesses a certain humoristic reality. One has little difficulty in interpreting the abstract forms whirling through the air, which clearly represent the birds referred to in the title. In addition to the precisely outlined figures and the purely linear signs, there are the fluently and freely drawn 'calligraphic' inscriptions. The disciplined choreography of the earlier *Rhythmic Figures* (Plate 86) has been replaced by a more relaxed, vivacious and 'musical' rhythm, and the darkness of the night has lightened, which may be an allusion to the universal sense of relief at the ending of the war. Here, too, as in *Woman Dreaming of Escape* (Fig. 252), the picture does not merely serve to illustrate an anecdote: the figures are no more than spontaneous interpretative extensions of lines which are essentially occupied with themselves. Miró's art has softened and relaxed: the ogres of the *Barcelona* series have vanished, and even the remaining grotesque elements have a friendly appearance. One finds a liberated musicality of line and colour which the artist's earlier work lacks.

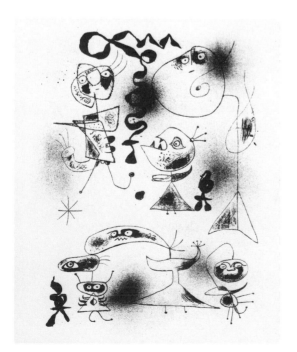

Given his particular intellectual and artistic temperament, it is scarcely surprising that Picasso, too, was fascinated by Surrealism from the outset. The programmatic statements of the Surrealists, their theories of the unconscious and the mechanisms by which it governs human behaviour, failed to incite his interest: his world was the world of concrete visual experience. What attracted him was the forms of the absurd and the fantastic which Surrealism introduced into art. After his 'neo-classical' phase in the early 1920s (see Plate 60), a new mood of unrest became apparent in his art; his pictures took on a character which was not directly Surrealist but would have been unthinkable without the influence of the Surrealist movement. This change in Picasso's artistic approach is documented by the large number of paintings and drawings from the period between 1927 and 1937 which feature sculptural figures – highly abstract, but anthropomorphic forms composed of individual plastic elements which are joined together in a purely additive fashion. The essential thing about these figures is their formal character, whose importance far outweighs that of the 'demonic' element which some see in them.

The large-format painting *Seated Nude* (1933; Plate 88) shows a woman whose body is divided up into a number of differently shaped volumes which lack any intrinsic connection; her face, denoted by three small dots, is reduced to a minimal figurative trace. However, despite the ruthlessness with which the artist breaks up the figure, the picture conveys an impression of sculptural serenity. Even where form has once again begun to disintegrate, classicism maintains its hold over Picasso's imagination.

This sculptural understanding of the human figure is clarified by a drawing entitled *The Studio* (Fig. 254), which also dates from 1933. Here, the same figure is shown as a real sculpture lying on a table, next to a painting on an easel. The inorganic joining of organic

Fig. 253 Pablo Picasso, Study for *Seated Nude* (Plate 88), 1933

PLATE 88
Pablo Picasso
Seated Nude, 1933
Oil on canvas
130 × 97 cm

Fig. 254
Pablo Picasso
The Studio
1933

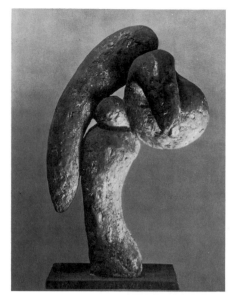
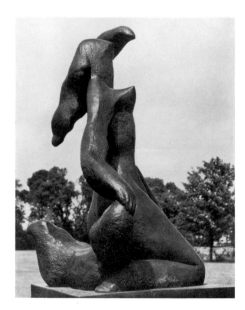

forms seen in *Seated Nude* is found in many of Picasso's drawings from this period (see Fig. 255) and in the sculptures which he made in his studio in Boisgeloup (see Fig. 256). The same plastic principle is apparent in the work of the sculptor Henri Laurens (see Fig. 257), who was influenced by Picasso.

Fig. 255 Pablo Picasso
Pen-and-ink drawing, 1928

Fig. 256 Pablo Picasso
Head of a Woman, 1932

Fig. 257 Henri Laurens
Oceanide, 1933

BONNARD

The pictures by Miró, Ernst and Tanguy discussed above lead us well into the 1940s, into a time when 'modern' art already looked back on four decades of history and the first-generation representatives of the avant-garde had passed through more than one developmental stage. They had put their joint struggles of the past behind them. Each of these artists was developing and expanding his work beyond the confines of the 'movement' in which he had originally been involved. Thus, the 1940s saw a succession of major works by artists – for example, Picasso, Braque, Léger, Klee, Beckmann, and even Matisse – who had risen to prominence in the early years of the century and had since been overtaken by more recent movements. Although Pierre Bonnard's large-scale picture *The Terrace at Vernon* (Plate 89) was painted at an earlier date, in the late 1920s, it, too, is a relatively late flowering of a genius which had first emerged at the turn of the century, in the context of a youthful, innovative movement.

*Late Works by
First-Generation Modernists*

Fig. 258 Pierre Bonnard, *The Terrace at Vernon*, 1923

One is tempted to say of Bonnard's monumental picture that it revels, even wallows, in the sheer act of painting. At the beginning of his career Bonnard had joined in the contemporary discussion of formal questions, but here he appears to have lost all interest in such problems. It would seem that all he wanted to do was to paint, disregarding the past lessons of Cubism, Futurism and Dada, and ignoring such recent developments as Constructivism and Surrealism. He was exclusively concerned with the beauty and richness of painting itself, with the miraculous transformation of nature into

PLATE 89
Pierre Bonnard
*The Terrace at Vernon, c.*1928
Oil on canvas, 242.5 x 309 cm

art and the equally miraculous process whereby a blank canvas is transformed into a piece of nature. It is as if the art of Antoine Watteau and Jean Honoré Fragonard had found a new voice in the twentieth century, and there are also obvious allusions to Impressionism (see Fig. 259), Gauguin (see Fig. 260) and Art Nouveau. *The Terrace at Vernon* is a picture which strives to attain a timeless validity, but it is also manifestly a product of the twentieth century, of the era in which Bonnard – right up to the time of his death in 1947 – exercised a powerful influence on the work of younger French artists.

If one looks closely at the surface of the canvas one realizes that, despite the apparent richness of the work, the colours are used with an economy which borders on the frugal. Unlike his contemporary and comrade-in-arms Edouard Vuillard, and other artists who followed in his footsteps, Bonnard does not linger lovingly over each brushstroke; instead, he applies the colour in a straightforward, almost crude manner, with a marked lack of extravagant gesture. It is this combination of refinement with coarseness, of richness with frugality, which lends his art its particular charm. This picture is

Fig. 259
Claude Monet
The Garden, Giverny
1917

Fig. 260
Paul Gauguin
*Landscape at
Martinique*, 1887

very far from being a celebration of 'beautiful' painting, and yet it is one long anthem to the beauty of art and nature. The only artistic 'problems' which it contains are those which have been overcome. Bonnard regarded art as perfect only when it had solved its problems to an extent where they became invisible. In painting this picture, he in fact faced considerable problems: it was far from easy to maintain control over such a large surface and to keep the rich colours – especially the wealth of greens – in check. Yet the work says nothing about these challenges or, indeed, about the challenges of the contemporary world. Hence, it can be seen as an expression of escapism, of an unwillingness to confront the more problematical aspects of reality. However, to dream the dream of paradise on earth can be a legitimate and humane task for the artist, even in the middle of the twentieth century and in the small house by the Seine, not far from the capital, where Bonnard lived for over ten years before moving to the South in 1927. The village of Vernon is only a short distance from Giverny, where Monet lived until his death in 1927. The two painters often visited each other. A number of other artists, Vuillard and Matisse in particular, were also frequent guests at Bonnard's house in Vernon.

BRAQUE

The traditionalism of French painting also manifested itself in *Still Life with Fruit-Dish, Bottle and Mandolin* (Plate 90), which Georges Braque painted in 1930. However, unlike Bonnard's landscape, this picture does not deny the rupture which had occurred in the history of art in the early years of the twentieth century; it uses the vocabulary of Cubism, but reconciles Cubist ideas with the specific continuity of French painting. It thus marks Braque's loyalty to Cubism

PLATE 90
Georges Braque
*Still Life with Fruit-Dish,
Bottle and Mandolin*, 1930
Oil on canvas, 116 x 90 cm

while, at the same time, indicating his detachment from the movement. Instead of speaking with the angry voice of youthful genius, it articulates the maturity and calm self-assurance of a middle-aged master who has liberated himself from theories and programmes and freely avails himself of the formal techniques which he had pioneered some two decades previously.

The subject-matter of this picture is much the same as that in earlier, avowedly Cubist works, such as *Café-Bar* (Fig. 261), which was painted in 1918. The objects arranged on the three-legged table – the cloth, the newspaper, the mandolin, the bowl of fruit, the vase and the jug – can be found in numerous other still lifes from Braque's Cubist period. Although they are less fragmented than the objects in his earlier pictures (see Plate 10), they, too, are little more than a pretext, an alibi, for the creation of a particular kind of pictorial harmony. Braque himself once said: 'One has to arrive at a specific temperature, at which the objects become malleable.' *Still Life with Fruit-Dish, Bottle and Mandolin* is characterized by precisely this temperature, this pictorial warmth: the objects, which have little value in themselves, do indeed become malleable. The artist is principally concerned with the complex rhythms of the muted colours, with the density of the pictorial space, with the preciousness of the painted surface, with nuances rather than contrasts: his aim is to evoke a general spiritual resonance.

Fig. 261 Georges Braque, *Café-Bar*, 1918

LEGER

There could hardly be a sharper contrast than that between, on the one hand, Bonnard and Braque, whose work is firmly anchored in the artistic traditions of the past, and, on the other, Fernand Léger, who was keenly aware of the problems of the contemporary world

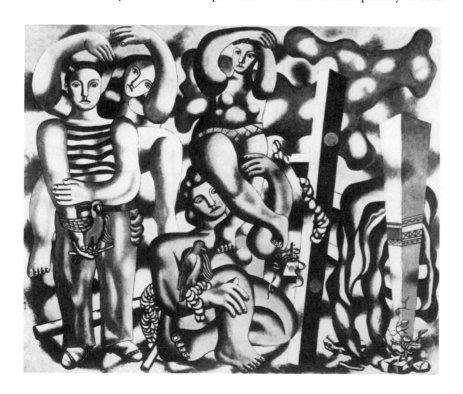

Fig. 262
Fernand Léger
*Composition with
Two Parrots*
1935-39

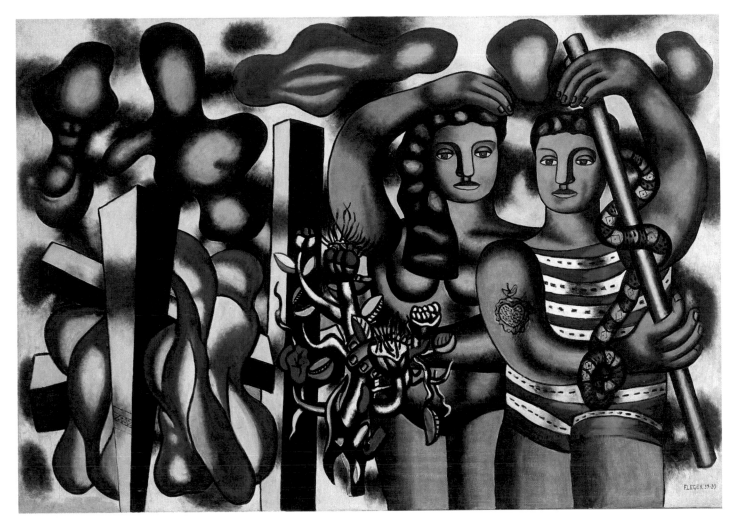

Fernand Léger
Adam and Eve, 1935-39
Oil on canvas
228 x 324.5 cm

and dreamed of a better, happier future. In the 1930s Léger abandoned the mechanical style of his earlier figurative pictures, but, instead of adopting a more private, contemplative pictorial manner, he took a thoroughly extroverted approach to composition, painting large-format pictures which resemble murals. He sought to devise a truly monumental style, based on the human figure rather than on geometrical form. One of his major works from the 1930s is the large-format painting *Adam and Eve* (Plate 91), which is part of a series of pictures of acrobats and athletes. As is so often the case in Léger's oeuvre, a number of the elements in the picture recur in other works from the same period. The large painting was preceded by a much smaller version (Fig. 265). At the time when he painted *Adam and Eve* Léger was working on a number of commissions for murals and stage designs. In an interview he later remarked: 'I am bold enough to approach the grand subject ... but my painting always remains object painting. It starts in 1936 with *Adam and Eve*. My figures become human again, but I always stick to the pictorial state: no rhetoric, no Romanticism.' Notwithstanding Léger's lifelong adherence to the principle of pictorial objectivity, and despite his deep-seated mistrust of anything which smacked of the emotional, this picture – like *Woman Holding Flowers* (Plate 59) – has an involuntary poetry all of its own, which derives partly from the colours, but mainly from the contrived naivety of the two acrobats, with their air of solemn seriousness and their gawkily graceful poses.

Fig. 263 Fernand Léger
Two Dancers, 1928

Fig. 264 Fernand Léger
Study for *Composition
with Two Parrots* (Fig. 262)
1937

There can be no doubt that the picture was influenced by the art of Henri Rousseau (see Fig. 266), whom Léger had known personally: he felt a strong affection for *le Douanier* and greatly admired his work.

The bulky, heavy-limbed figures in Léger's pictures of this period are often shown attempting to overcome their clumsiness by dancing (see Fig. 264), an activity whose gestures signal the dream of future happiness in a better world. The characteristic poses, which, like all Léger's human figures, are heavily stereotyped, can already be found in a number of pictures from the late 1920s, at which point Léger began to take particular interest in objects and figures which float

Fig. 265 Fernand Léger
Adam and Eve (first version), 1939

Fig. 266 Henri Rousseau
Apollinaire and his Muse, 1909

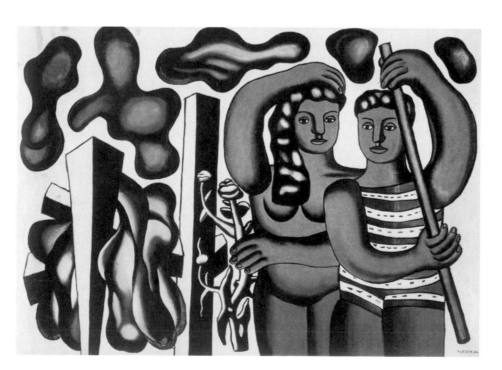

freely in space. They are also much in evidence in *Composition with Two Parrots* (Fig. 262), the artist's other major monumental painting from the 1930s. One repeatedly encounters the same faces, the same hands and plants, in Léger's drawings from this period – for example, in *Two Dancers* of 1928 (Fig. 263).

PICASSO

The year 1936 saw the beginning of the Spanish Civil War, the grim prelude to the Second World War. In February of the following year, after he had completed the hate-filled series of etchings entitled *Dreams and Lies of Franco* and shortly before embarking on the preparatory studies for *Guernica*, Picasso painted *Woman at the Mirror* (Plate 92), a particularly fine picture which shows a woman sitting cross-legged on the floor and quietly contemplating a drawing. Although the figure is seemingly untouched by the events in Spain, the picture conveys a somewhat Andalusian mood. The motif is anticipated in three pictures entitled *Interior with a Girl Drawing* (Fig. 267-69), which were painted in 1935. In each of these a woman is seen drawing in the foreground, while another sits at a table, resting her head on her arms; a vase stands on the table and a large mirror on the floor. The expressive vehemence of these pictures contrasts sharply with the relaxed, meditative tone of *Woman at the*

PLATE 92
Pablo Picasso
Woman at the Mirror, 1937
Oil on canvas
130 × 195 cm

203

Fig. 267
Pablo Picasso
*Interior with a Girl
Drawing*, 1935

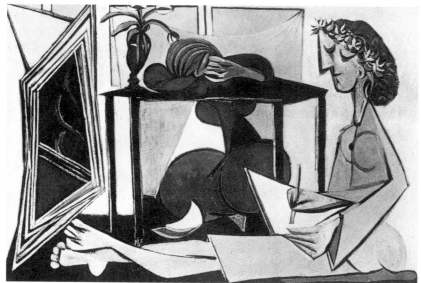

Fig. 268
Pablo Picasso
*Interior with a Girl
Drawing*, 1935

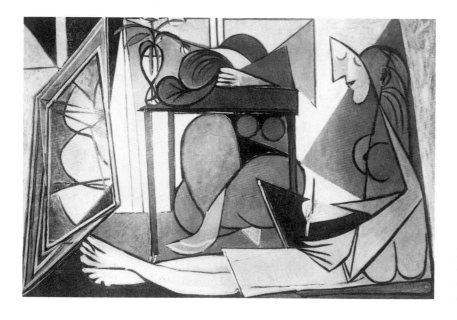

Fig. 269
Pablo Picasso
*Interior with a Girl
Drawing*, 1935

Fig. 270 Pablo Picasso, Studies after *Woman at the Mirror* (Plate 92), 1937

Mirror. Here, the scene has been radically simplified. The table with the second woman has disappeared, and the woman sitting on the floor is no longer drawing, but simply looking at the work in front of her; the mirror has been retained, but the vase now stands on the floor as an equal partner in what might be described as a *sacra conversazione.* On the right of the picture a French window opens on to a balcony whose railing is markedly similar to that in *Open Window* (Plate 21) and generally reminds one of the series of window pictures which Picasso painted in 1919. Especially in his watercolours on this theme, Picasso came surprisingly close, in terms of both motif and mood, to the art of Matisse. The triangular forms on the surface of the mirror in *Woman at the Mirror* are not merely reflections: as a casual sketch (Fig. 270) made at a later date on a cigarette packet in a Paris café shows, they are also an extension of the lines around which the picture is constructed. However, Picasso deviated somewhat from his original plan, and it is this deviation which creates the combination of formal discipline and freedom from which the picture derives its particular appeal.

Despite the obvious stylistic parallels between *Woman at the Mirror* and *Guernica*, the two pictures are remarkably dissimilar. With its air of contemplative calm, the former work entirely lacks the aggressive, accusatory tone of Picasso's monumental depiction of the horrors of war. However, the woman's head clearly anticipates the face with the wide-open mouth in *Guernica* (Fig. 271). Both these heads hark back to the larger-than-life bronze busts which Picasso sculpted in 1932 (see Fig. 284), using Marie-Thérèse Walter as his model. The picture of the seated woman once again exemplifies the fundamentally classical character of Picasso's artistic approach, even though it is qualified here by the inclusion of overtly modern touches, such as the oversized violet hand and the odd positioning of the eyes.

*

Shortly after painting *Woman at the Mirror*, Picasso began work on *Guernica*. In an attempt to convey the full horror of the Spanish Civil War he returned to the Cubist deformation of figure and object, exploiting its expressive resources to the full. This was the tone which governed Picasso's artistic attitude in the years immediately

Fig. 271
Pablo Picasso
Guernica (detail)
1937

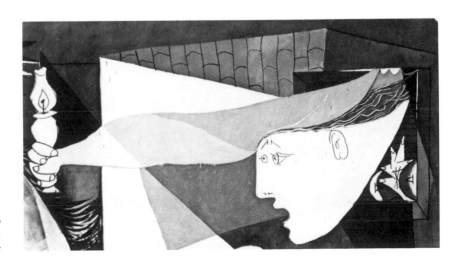

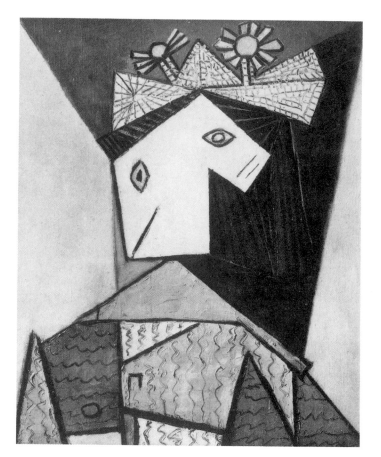
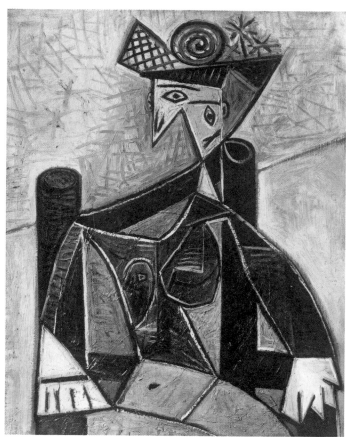

preceding the Second World War and during the war itself. The same vehemence, the same ruthlessness towards the subject of the picture – even though she is the artist's own mistress – can be seen in *Woman Sitting in an Armchair* (Plate 93), which was painted in German-occupied Paris in 1941 and forms part of a series of major portraits of women, especially of Dora Maar (see Fig. 272, 273). Although the picture speaks of the violence and destruction of the war, the language which it uses is not in itself destructive; it is a language of self-assertion in the face of terror, of resistance to the rape of humanity, a language which, even in such an openly aggressive work of art, preserves an element of grace and serenity. Picasso's intention in painting this portrait of his mistress is not specifically to protest against the war. What drives him to invent and modify forms and colours is, in the first instance, his almost erotic appetite for visual gratification: he takes a palpable delight in splitting up the woman's head, disarranging its features and crowning the result with an impudent little hat, and in breaking the body and hands up into jagged, disconnected forms. His decorative urge also manifests itself in the elaborate pattern of the wallpaper, which contrasts with the bareness of the walls in *Woman at the Mirror*. It is as if the artist had been inspired by his model to discover a new source of pictorial vitality. Nevertheless, he retains the traditional scheme of the portrait. Picasso shows the woman face-on, sitting in an armchair in a symmetrical, thoroughly conventional pose. In this work, as in many others, his pictorial 'maltreatment' of the model is directed not only towards the picture, but also at the woman herself.

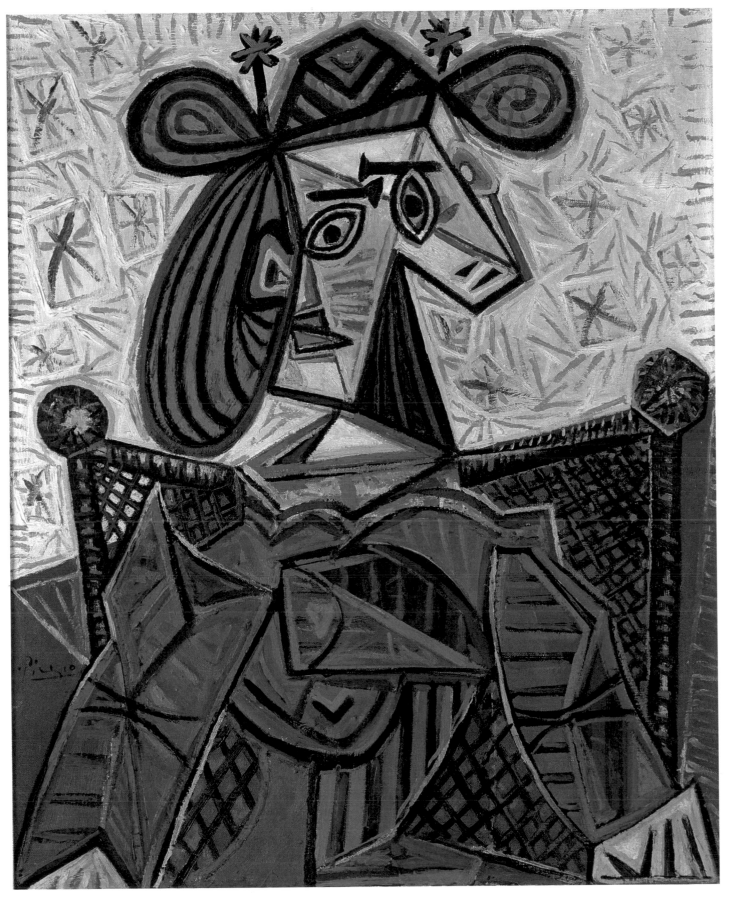

PLATE 93
Pablo Picasso, *Woman Sitting in an Armchair, 12 October 1941*, 1941
Oil on canvas, 80.7 x 65 cm

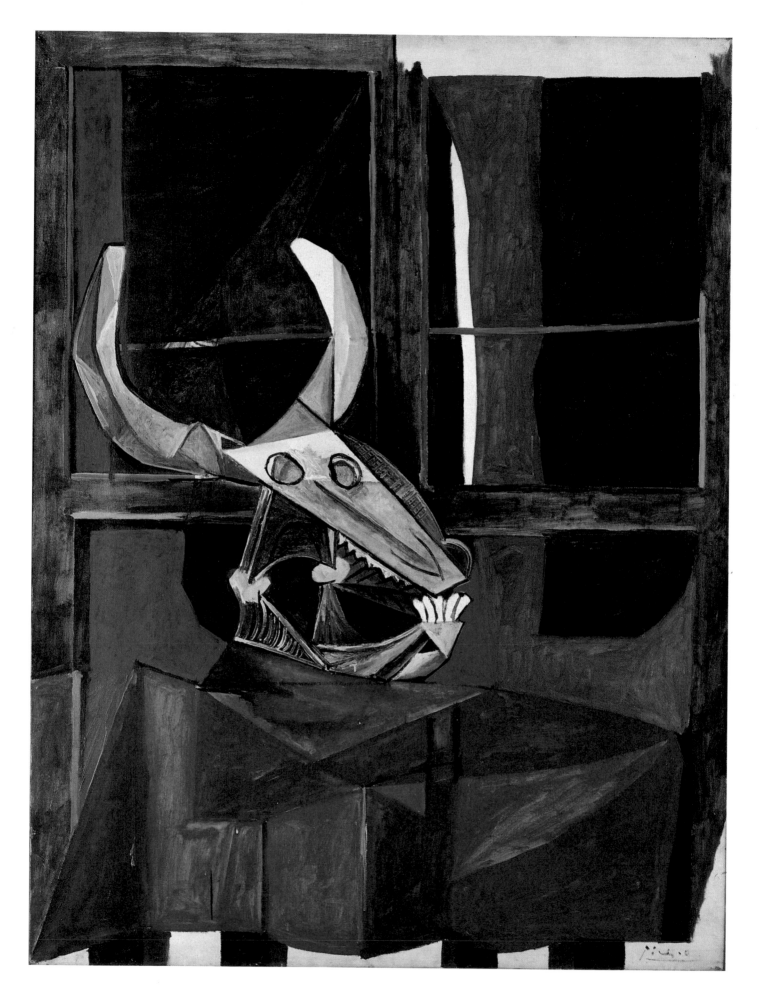

Fig. 274
Pablo Picasso
Bull's Head,
1943

Fig. 275
Pablo Picasso
*Goat's Skull
and Bottle*
1951

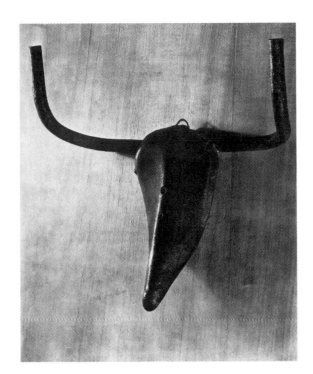

PLATE 94
Pablo Picasso
Still Life with Bull's Skull, 1942
Oil on canvas, 130 x 97 cm

Fig. 276 Pablo Picasso, *Bull's Skull on a Table*,
1942

Still Life with Bull's Skull (Plate 94), which was painted the following spring, is completely devoid of aggression: the brushwork, colours and composition are notably restrained. The picture was preceded by a more vehement version (Fig. 276) which Picasso created a few days earlier. It was painted a week after the death of the sculptor Julio González, as a memorial to a close friend who, from 1929 to 1931, had assisted Picasso in the making of a series of iron sculptures. The bleached skull of a bull lies, as it were, in state, on a dark cloth which is painted in a Cubist manner; the skull is a symbol of death, the bull a symbol of the Spanish people, to which both Picasso and González belonged. This is one of the few pictures in which Picasso addresses the subject of death, a theme from which he otherwise shied away.

The motif of the bull, and especially of the bullfight, runs right through Picasso's oeuvre. It is one of the great constants in his art. A bull's skull recurs a year later, in a bronze cast of an emblematic assemblage (Fig. 274) made from the seat and handlebars of a bicycle. In 1951 Picasso created a three-dimensional still life with a bottle and goat's skull (Fig. 275), which is also a cast, subsequently painted, of an assemblage of everyday objects; there is an obvious resemblance between the goat's skull and that of the bull in the earlier painting.

Still Life with Bull's Skull documents the continuing significance of Cubism for Picasso's work. This is clearly apparent in the painting of the dark cloth on the table and in the modelling of the skull, with its sharp-edged horns. Cubist elements can also be found in such relatively extroverted pictures as *Woman Sitting in an Armchair* (Plate 93): the blue dress, in particular, recalls the pictorial techniques of Picasso's earlier years. Despite its repeated shifts in stylistic approach, the art of Picasso exhibits a considerable measure of formal continuity.

Paul Klee's *Heroic Roses* (Plate 95), which was painted in 1938, strikes a similar note of sombre heaviness to that which characterizes Picasso's portrait of Dora Maar (Plate 93). There is, of course, no direct connection between the two pictures, but they were both influenced by the contemporary historical climate. It is also interesting to note that Picasso had visited Klee in Berne the previous year. Klee had returned to Berne, his native city, in 1933, after his dismissal from the Academy in Düsseldorf. A number of his pictures were included in the exhibition of 'degenerate' art which the Nazis organized in 1937. At this point, Klee had already contracted the disease from which he was to die in 1940. Towards the end of his life the twin burdens of his illness and the political events of the day led to a change in his artistic approach. His work lost much of the relaxed playfulness which one finds in his pictures from the Bauhaus period (see Plate 70). From 1931, when he moved to Düsseldorf, his art took on a progressively more austere character. The signs became more allusive, and the forms and lines grew ever coarser. The dominant motif of *Heroic Roses*, the flower, is surrounded by hard, angular signs which look as though they are made of cast iron. The ground is still structured like a mosaic, but here it reminds one of stained glass, with strips of lead separating the individual sections. Klee's artistic thinking, which was orientated towards the world of organic, vegetable forms, has clearly undergone a major change: he appears to have lost his erstwhile faith in the forces of nature. In this picture, as in his earlier work, his attention is fixed on a natural process, the blooming of a flower; however, he no longer allows the forms to grow from within, in a manner analogous to nature. The difference is illustrated by a drawing from 1921, *Plants in the Field I* (Fig. 278), which describes the process of blooming in gently flowing curves, as a passive operation governed by the forces of nature. In the later picture it seems as though the same process were taking place in the face of some kind of resistance. Whereas the drawing evokes a mood of dream-like inertia, the forms in the painting appear to be dictated by an iron will, as if the waning of life had paradoxically strengthened

Fig. 277 Paul Klee, *Timid Brute*, 1938

Fig. 278
Paul Klee
Plants in the Field I
1921

PLATE 95
Paul Klee
Heroic Roses
1938
Oil on primed jute
68 x 52 cm

the will to live. The title of the picture is surprising, since Klee rejected all forms of heroism; indeed, he frequently satirized it, especially in his drawings. One can be certain that the title is not a gesture of homage to a time which many people regarded as heroic. However, 'heroic' plants would have been unthinkable in Klee's early work.

The spiral form in the centre of the picture reappears in another picture, entitled *Timid Brute* (Fig. 277), which was also painted in

1938. Here one sees a 'brutal' human figure whose 'timidity' is signified by the arrow pointing backwards and breaking his stride as he marches boldly forwards. One should not try to read too much history and politics into a picture of this kind, but it does appear to symbolize the conflict between violence and natural timidity, in a manner which is both humorous and formally serious. The artistic language is the same as in *Heroic Roses*. The titles of both pictures refer to ideas and feelings which were entirely alien to Klee. Although the pictures are not direct political statements, their titles allow one to sense the change which had occurred in the contemporary political climate, as well as in Klee's artistic approach.

BRAQUE

Klee was just under sixty when he painted *Heroic Roses*; he died two years later. Picasso was the same age when he painted *Woman Sitting in an Armchair* (Plate 93) in 1941. Despite his age, he attacked his theme with a verve which remained undiminished in the following years: the conciliatory tone, the transfigured mood, which often mark the work of older artists is entirely absent from his pictures. The work of Georges Braque, his erstwhile fellow-Cubist, followed an altogether different path. The fascination of Braque's *The Studio II* (Plate 96), which was painted in 1949, is both artistic and spiritual: in terms of its composition and execution and in respect of its spiritual dimension – of a kind which so often manifests itself in the mature work of great artists – it is a highly complex picture. The dead objects in the studio become mysteriously animated; in their midst, opposite the seemingly living face of the sculpture, a giant ghostly bird appears like a messenger from another world or a harbinger of death. Picasso never spoke in such spiritual terms, not even in his requiem for his dead friend González (Plate 94). In

Fig. 279 Georges Braque, *Marriage*, 1939

Fig. 280
Georges Braque
The Studio III
1949

PLATE 96
Georges Braque
The Studio II, 1949
Oil on canvas, 131 x 162.5 cm

this picture and others of its kind Braque takes stock, as it were, of his artistic career. Unlike the work of Picasso, with its constant shifts of stylistic approach, his art developed in a single, continuous progression. The influence of Cubism persisted, much more obviously than in the case of Picasso. It is clearly apparent in the forms of *The Studio II* and in its monochrome colouring: Braque never used the bright colours which one finds in Picasso's *Woman Sitting in an Armchair*, and he continued to abhor all forms of expressive excess.

The Studio II is one of a series of eight studio pictures which Braque painted between 1948 and 1956 and which represent an incomparable late flowering of this artist's genius. The principal motifs of *The Studio I* – a palette, a jug, a bust of a woman seen in profile and a giant bird – recur in a number of pictures from the series. The first and fifth paintings differ from the others by reason of their vertical format, the first also being considerably smaller than the rest. The one which most closely resembles *The Studio II* is the third version (Fig. 280), in which, however, the bust is missing. It reappears in *The Studio VI* (1950/51), where the large bird, which in this work is

headless and is shown in schematic outline only, is joined by a
further, smaller bird perching on the easel with outstretched neck.
In his late work, especially in his pictures from the mid-1950s, Braque
frequently used the motif of the bird in flight: it is the dominant
image in *The Studio VII* (1954-56), although it is missing in the final
picture in the series. The female bust is reminiscent of the sculptures,
with their archaic or classical appearance, which Braque had made
a decade earlier (see Fig. 279).

PICASSO

The princely allure of Picasso forms a sharp contrast with the late
work of Braque. His *Large Profile* (Plate 97), painted at the age of
eighty-one with an incomparable mastery of form and colour, is at
once both classical and modern, a female icon for the contemporary
world. Together with a number of other female portraits, the picture
was painted in Picasso's last studio, at Mougins. There is a certain
connection with the profile of the sculpture in Braque's 'Studio'
pictures. As in these, one detects a continuing Cubist influence,
especially in the structuring of the head. Throughout the picture one
finds Picasso working with a high degree of artistic freedom, be it
in the formal construction of the head or in the use of harsh yellows
and greens, applied in bold, emphatic brushstrokes, to form a
contrast with the almost monochrome colouring of the rest of the
work.

In the many portraits of women which he painted in the course of
his long career Picasso seldom depicted his subjects in full profile.
He preferred the three-quarter view, possibly because of its greater
spatial and plastic potential. In the 1960s, however, when he created
a number of sculptures in paper and sheet metal (see Fig. 282),
he began to use two-dimensional views of the human head. The
structuring of the head in this picture testifies, nevertheless, to his
continuing interest in the spatial. With its classical attitude, the
picture immediately reminds one of the art of ancient Greece, as

Fig. 281 Greek vase-painting (detail), *c.* 510 B.C.

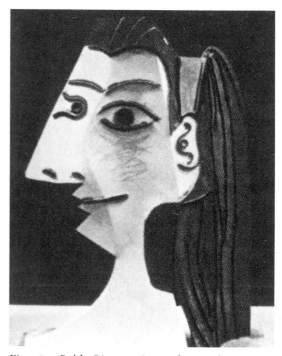

Fig. 282 Pablo Picasso, *Jacqueline with a Green Ribbon*, 1962

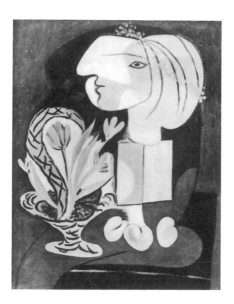
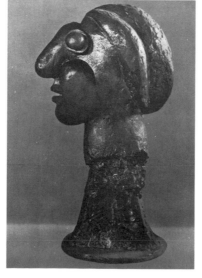

PLATE 97
Pablo Picasso
Large Profile
1963
Oil on canvas
130 × 97 cm

Fig. 283 Pablo Picasso
Still Life with Tulips, 1932

Fig. 284 Pablo Picasso
Head of a Woman, 1932

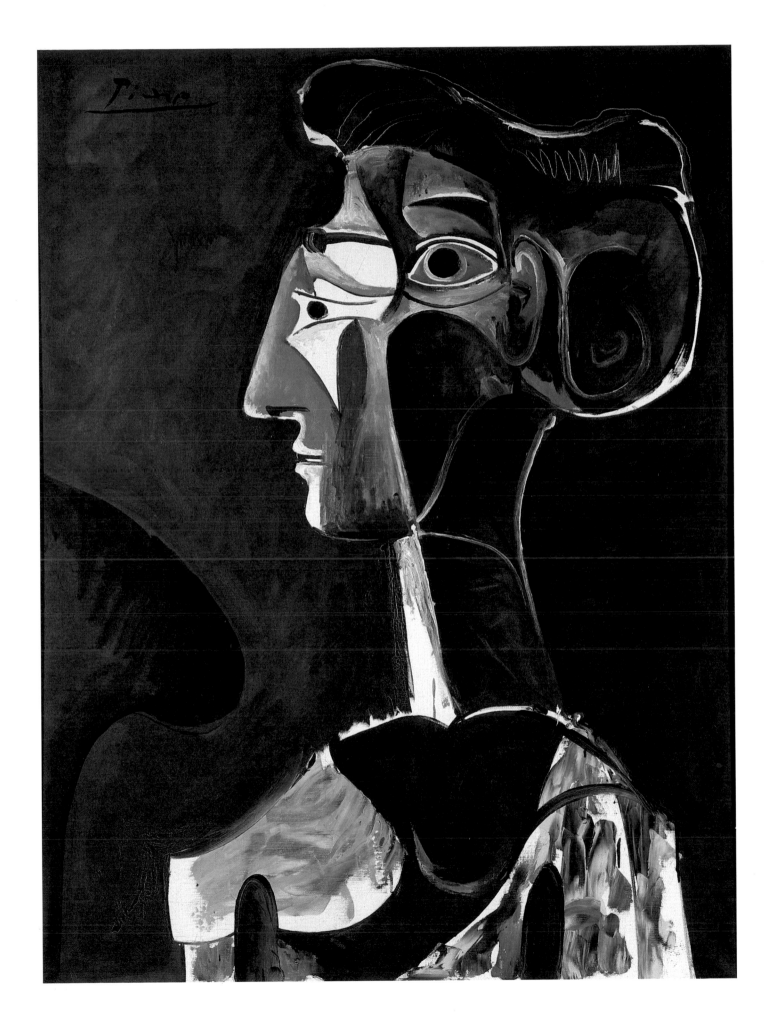

215

216

Fig. 285 Henri Matisse, *The Blue Window*, 1911

PLATE 98
Henri Matisse
*Red Interior: Still Life
on a Blue Table*, 1947
Oil on canvas, 116 x 89 cm

Fig. 286 Henri Matisse, *The Window: Interior
with Myosotis*, 1916

exemplified here by a detail from a painted vase (Fig. 281). This is not to say that the picture is directly based on classical models; it is merely informed by the general Mediterranean, classical spirit which one so often finds in the work of Picasso, conflicting with the anti-classical, expressive streak which also runs through his art. During his 'neo-classical' phase, as in his early work, he very rarely painted the human face in profile; he maintained his interest in the physical modelling of the face. The profile did not enter his art until around 1932, when he painted *Still Life with Tulips* (Fig. 283), in which, as in the bronze busts made at the same time (see Fig. 284), the oversized nose is particularly notable.

MATISSE

From 1946 to 1948, as he was approaching eighty, Henri Matisse enjoyed a brief respite from illness which enabled him to paint a final series of magisterial pictures, before his increasing feebleness obliged him to begin working with scissors and coloured paper, instead of with a brush – a physical limitation which led to a resurgence of his genius. Together with these *papiers découpés* of his last years, the late paintings form the artistic testament of the great painter whose work had contributed in such a decisive manner to the emergence of modern art at the turn of the century. In *Red Interior: Still Life on a Blue Table* (Plate 98), which was painted in 1947, Matisse uses the expressive techniques which he had developed over the previous decades with a freedom that no longer needs to call attention to itself in the demonstrative manner of his early, Fauvist pictures. The language of the picture is highly refined but, at the same time, beautifully simple. Bold though it may be, the work does not create an impression of risk-taking for its own sake: even its most daring features – the black zig-zag lines on the brilliant red ground, the two-dimensional interpretation of space, the sudden interruption of the wall by the view out into the garden, the bunch of flowers which look as if they have been cut out of coloured paper, the medallion on the wall – even these features have an almost matter-of-fact air, combining maximum economy with maximum effect. This picture contains no hidden secrets: the means with which Matisse operates are totally open and honest. The only mystery in his work is the enigma of its singular perfection.

The theme of the interior with the open window, combined with the two-dimensional interpretation of space, runs right through Matisse's oeuvre, from *The Blue Window* (1911; Fig. 285) and *The Window: Interior with Myosotis* (1916; Fig. 286) to the pictures of his last years. In *The Blue Window* the distinction in terms of perspective between interior and exterior has already been abolished, and the table-top and the mats are painted in a two-dimensional manner; here, too, the flowers in the vase seem to be cut out of paper, and the evenness of the blue in which the picture is steeped anticipates the uniformity of the red in *Red Interior*. The view from interior to exterior evidently presented a challenge which fascinated Matisse all his life, because it forced him to recast a specifically spatial motif in the two-dimensional terms which he favoured.

Matisse and Beckmann: one would be hard put to think of two artists who more perfectly illustrate the differences between German and French art. The contrast is especially apparent in two pictures which were painted almost contemporaneously: Matisse's *Red Interior* of 1947 and Beckmann's *The Cabins* (Plate 99), which dates from the following year. The confrontation between the lightness of Matisse's world and the darkness of the art of Beckmann is apt to reinforce the nationalistic cliché of French superficiality versus German profundity.

After visiting America for the first time in 1947, Beckmann moved to New York in 1949, where he died at the end of 1950. He painted *The Cabins*, giving it this English title, immediately after his first trip to the USA, when the strong impression which the country had made on him was still fresh in his mind. The first mention of the picture in his diary is in the entry for 15 June. On 23 June he wrote: 'Finished *Cabins*, another 4-5 hours. Am myself quite astonished. Was utterly exhausted as well, but felt amazingly rested on waking.' Beckmann's diary shows that he continued working on the picture, to which he occasionally refers by the alternative title *The Boat*, throughout the following month.

The large-format picture was painted three decades after *Night* (Plate 39). With its rough-hewn composition, using individual scenic compartments, it resembles the pictorial narratives found in chapbooks and in medieval stained-glass windows. More clearly than the picture itself, the title indicates that what we are looking at is a boat, with cabins and port-holes – perhaps one of the houseboats in Amsterdam, where the picture was painted. On the left one sees the wall of a house and on the right the sea, with an enigmatic, fish-like form in whose open belly a steamboat ploughs through the waves. In the centre of the picture a sailor wraps his arm around a large fish which is strapped tightly to a board. In the individual compartments, some of which are round, some rectangular, human figures appear which the viewer involuntarily associates with the giant fish. In the lower right-hand corner a young girl is busy painting a picture of a ship. In the port-hole above her another girl is combing her hair. On the far left one sees the reclining figure of a girl in a corset. Between the two wooden beams one's gaze falls on a woman's back. The tripartite section in the top left-hand corner shows a wake, while the adjacent field contains a somewhat theatrical vision of a white angel.

The central motif of the fish, which frequently appears in Beckmann's work (see Fig. 289), has been interpreted by some critics as a phallic symbol, a reading for which there is some justification. However, in *The Cabins* the motif gives rise to a further association. The body of the fish, set on the diagonal between the two wooden beams, reminds one of traditional depictions of Christ's deposition from the cross. In 1917 Beckmann himself painted a large-format *Deposition* (Fig. 287), in which, as in *The Cabins*, a man's arm is wrapped around the body. A few years later, in 1921, the same motif recurs in *The Dream* (Fig. 288), a painting whose elongated vertical

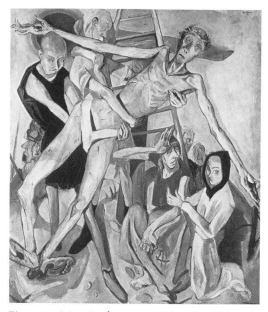

Fig. 287 Max Beckmann, *Deposition*, 1917

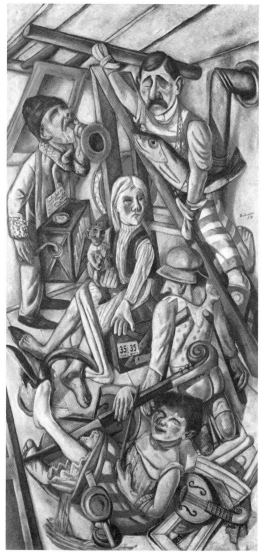

Fig. 288 Max Beckmann, *The Dream*, 1921

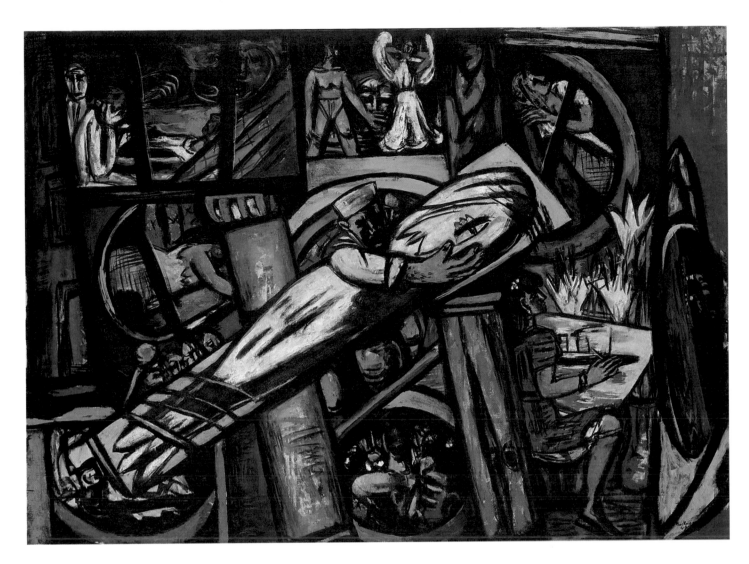

PLATE 99
Max Beckmann
The Cabins, 1948
Oil on canvas, 140.5 x 190.5 cm

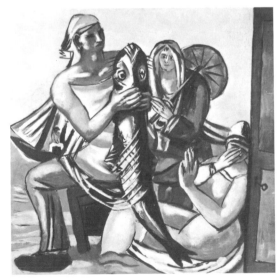

Fig. 289 Max Beckmann, *The Catfish*, 1929

format is reminiscent of the wing of an altarpiece. Here, too, we find the traditional compositional scheme of the Deposition, albeit in a quite different, secular context; and here, too, there is a fish, held by the man on the ladder.

Since the artist himself offers no clues to the meaning of the fish, one hesitates to interpret it as a symbol of Christ, or to read the various images of human life around the fish in *The Cabins* as images of the sins from which Christ redeemed mankind by his death on the cross. Rather than indulging in iconographical speculation, it would seem preferable to view the picture as a meditation on the human condition as a whole, the salient features of which are work, sex, death and salvation. This heavy burden of meaning is carried not only by the content; it is also conveyed in formal terms, by the composition, the heavy black contours and the colours, which burst forth from the darkness. Despite the oppressive and often confusing wealth of content in his pictures, Beckmann is no mere story-teller, but a painter who gives his work a powerful structure, in this case by means of the two inclining beams and the diagonally positioned board to which the huge fish is strapped.

There are a number of important modern painters, such as Josef Albers, Mark Tobey, Ben Nicholson, Julius Bissier and Alberto Giacometti, whose art straddles two different generations. Although by birth they belong to a generation which had its roots in the 1920s and 1930s, they produced their most significant work after 1945. In their pictures early modernism is united with the art of the post-war era: the generations merge. Tobey, for example, who is essentially a post-war artist, was only three years younger than Gris, Chagall and Schwitters and two years younger than Schlemmer and de Chirico; he was born a year before Ernst and three years before Miró. Bissier, who was three years Tobey's junior and hence an exact contemporary of Miró, is also a member of the earlier generation, although his art belongs very much to the period after 1945 or, at any rate, to that after 1930. Schlemmer and Albers were both born in the same year, 1888, but the one is an artist of the inter-war years, while the other, although he worked with Schlemmer at the Bauhaus, is primarily a post-war figure. Giacometti, on the other hand, who was born in 1901 and was therefore an exact contemporary of Jean Dubuffet, rose to prominence at an early age, in the context of the Surrealist movement; his reputation was consolidated after the Second World War.

ALBERS

Of those painters whose work straddles two generations, Josef Albers was the oldest but the one who most strongly influenced the development of post-war art. In the 1920s he had worked at the Bauhaus, and he continued to embody its principles in the USA, both in his teaching and in his creation of pictures which excluded subjectivity and emotion and were based on a systematic theory of colour. During the later decades of his life he concentrated exclusively on a single form: the square (see Plates 100, 101). With this continual repetition of an elementary form, which varies only in size and colour, Albers contributed to the emergence of the notion of 'serial' artistic production which proved so fruitful in the art of the 1960s. A crucial feature of Albers's art is the way in which the rigorous absolutism of form, symbolized by the square, is combined with the relativization both of the squares themselves and the colours. The rationality of this formal scheme is programmatically illustrated by a diagram in which the artist gives the exact proportions of the squares (Fig. 290). Since Albers also treated the colours in his pictures as quantifiable values, they, too, are based on rational principles. However, the end result of this strictly rational approach to the production of art has a meditative, spiritual character, and herein lies the real key to the artistic quality of Albers's work. In his painting rationality changes almost imperceptibly into irrationality.

Ever since Malevich painted his *Black Square* in 1914/15 (Fig. 291), European artists had regarded the square as the epitome of geometrical art and as a symbol of a universal order manifesting itself in pure form. The circle was seen in similar terms, but Albers, like Mondrian,

Fig. 290 Josef Albers, Diagram of the 'Square' pictures

PLATE 100
Josef Albers
Homage to the Square:
Red Va, 1967
Oil on hardboard
121.5 x 121.5 cm

PLATE 101
Josef Albers
Homage to the Square:
Suffused, 1969
Oil on hardboard
121.5 x 121.5 cm

eschewed circular forms: his attention was directed exclusively to one side only of the programme encapsulated in the title of the French avant-garde magazine *cercle et carré*.

NICHOLSON

The work of Ben Nicholson, who was six years younger than Albers, is based on a very different attitude to geometricism. In his early years Nicholson, too, espoused the cause of geometrical form, but he rejected the dogmatic purism of Mondrian and continued at the same time to paint figuratively. Among his most strictly geometrical pictures are the 'White Reliefs' from the 1930s (see Fig. 292), which are variations on the theme of *cercle et carré*. After the Second World War he began to combine the geometrical language of forms with a more painterly approach. In this way he sought to humanize and spiritualize the laws of geometry, while retaining the dignity of pure form. Form reigns supreme in his pictures, but its character is essentially metrical rather than geometrical. Although everything is carefully ordered and proportioned, there is nothing mathematical about Nicholson's work.

Dec 1965, Amboise (Plate 102) presents itself to the viewer as a delicately balanced surface with intriguing nuances of texture and colour. The painterly element is not suppressed: indeed, it is used as a deliberate counterweight to geometricism. Nicholson even includes a 'dirty' patch of colour which strikes a calculatedly discordant note in the geometrical ensemble. The 'objective' order of the picture is combined with a delicate, subjective sensitivity which finds its freest expression in Nicholson's drawings, especially those depicting landscapes and architectural motifs (see Fig. 293). The drawings, which were done from life, confirm that Nicholson was principally concerned with form; but here he allows himself to indulge in a playfulness which is missing from his paintings.

Fig. 291 Kasimir Malevich, *Black Square*, 1914/15

Fig. 292
Ben Nicholson
White Relief
1935

Fig. 293 Ben Nicholson, *Rievaulx No. 3*, 1969

Ben Nicholson, *Dec 1965, Amboise*, 1965
Painted hardboard, 187 x 122 cm

Fig. 294 Alberto Giacometti
The Invisible Object, 1934

PLATE 103
Alberto Giacometti
Annette, Seated, 1957
Oil on canvas
99.5 x 60.5 cm

GIACOMETTI

The painter and sculptor Alberto Giacometti joined the Paris Surreal-
ist group in 1930 and was a regular participant in its activities until
1935, when he was formally expelled from the movement. In the late

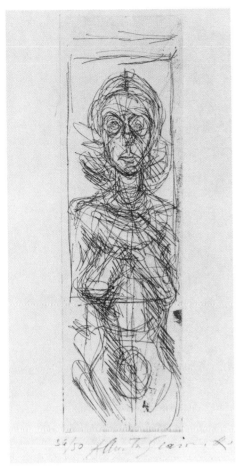

Fig. 295 Alberto Giacometti
Annette Facing Front, 1955

1930s he began to model human heads from life, thereby demonstrating that he had also broken with Surrealism in artistic terms. During the war he embarked on the series of elongated figures which continued to occupy him until his death in 1966.

Although Giacometti had taken up painting at an early age, it was only after the war that the art world began to take note of his work in this field. In 1946 he left his native Switzerland and returned to Paris. From this point onwards, he divided his attention equally between painting and sculpture, and in the two decades before his death he painted a large number of nudes, portraits, landscapes, still lifes and studio interiors. In his painting, as in his sculpture, he used a limited range of themes and forms.

In *Annette, Seated* (1957; Plate 103) the model – the artist's wife – sits squarely in the centre of the pictorial space, facing the viewer front-on. The space, painted in an indeterminate grey, fluctuates around the fragile figure, who appears almost entirely dematerialized: her physical being would seem to have been extirpated and replaced by a purely spiritual form of existence. The distance between artist and model – and hence also between viewer and model – is no longer spatial but spiritual. The individual recedes behind the fact of his isolation in the world. Here, we find the same view of the human condition as in Giacometti's sculpture *The Invisible Object* (Fig. 294), which predates the painting by over twenty years.

Although loneliness and the constitutive isolation of the individual appear to be the dominant theme of Giacometti's images of human beings, the artist himself denied that this was the case. In 1962 he declared: 'In the past I have never thought about loneliness when working, and I don't think about it now. Yet there must be a reason for the fact that so many people talk about it.' The reason lies in the appearance of the figures themselves, isolated as they are from the world and from other human beings, solipsistically absorbed in their own selves, leading an attenuated, purely spiritual existence. It is far from coincidental that, in 1948, the leading Existentialist philosopher, Jean-Paul Sartre, wrote an extended essay on Giacometti, and it is also significant that Jean-Louis Barrault commissioned the artist to design the set for his production of Beckett's *Waiting for Godot* at the Odéon theatre in Paris in 1963. This was the intellectual climate to which the painting and sculpture of Giacometti belonged during the last twenty years of his life. His art has often been called 'Existentialist'. At all events, it is an art of suffering, of permanent, unrelenting despair at the impossibility of fully comprehending other human beings. If one were seeking an alternative title for any of Giacometti's works, or, indeed, for his oeuvre as a whole, the words 'ecce homo' would suggest themselves as considerably more appropriate than in the case of most other artists.

*

The symmetrically positioned, motionless figure in *Standing Nude* (Plate 104), which was painted in 1958, is also dematerialized and spiritualized: one can only guess at its physical identity and gender. It stands erect with its arms hanging loosely down, like Giacometti's nude sculptures, in which the figure is also reduced to a bare mini-

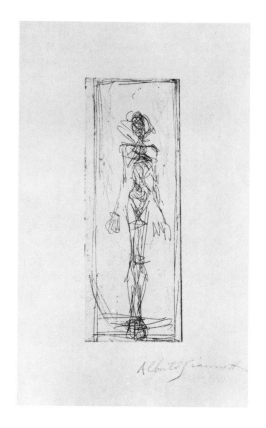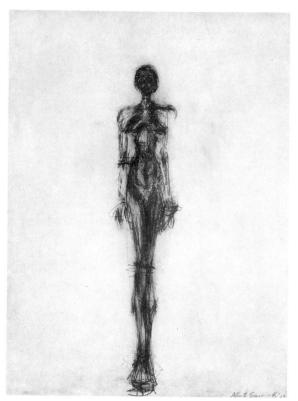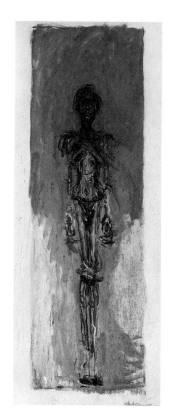

mum (see Fig. 299). The form of its body is hinted at by a small number of fleeting, nervous, broken lines which nevertheless form a supporting structure for the head. Impatient streaks of grey blur and erase the contours of the body, so as to concentrate the expression in the skull-like, closed form of the head, with the deep hollows around the eyes. Here, in the woman's head, the spontaneity of the painting is interrupted: the dissolution of the figure comes to a halt. Whereas the overall pictorial language is open and vehement, the painting of the head is hermetic and introverted.

Giacometti once said: 'If the gaze, which means life, is the main thing, then the most important thing is indubitably the head. The other parts of the body are limited to the function of antennae which make human life possible – life which has its seat in the skull.' In the picture one sees both the skull and the antennae, the sensory apparatus of the body. Giacometti also said: 'When I see a head from a great distance, it ceases to be a sphere and becomes an extreme confusion falling down into the abyss.' This could serve as a description of the way of seeing which governs the urgent, powerful drawing of the head in this picture. Giacometti supplies an artistic answer to the question of the human condition, but the questioning still continues: the individual remains mysterious, confusing and, as the picture seems to show, a prisoner of the alienation which, at the same time, constitutes his identity. The imprisonment of the individual within himself: this, rather than human freedom, is the dominant theme of Giacometti's work. The skeletal form of the body in *Standing Nude* also conjures up the idea of death, an association which is doubtless intentional.

Nevertheless, the picture is painted with an exceptional degree of freedom: it has an almost sketch-like quality. Apart from the irregu-

Fig. 296 Alberto Giacometti
Small Nude Standing, 1955

Fig. 297 Alberto Giacometti
Standing Nude, 1955

Fig. 298 Alberto Giacometti
Large Standing Female Nude, 1962

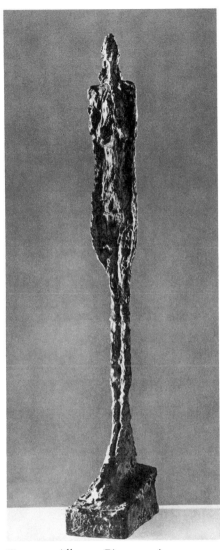

Fig. 299 Alberto Giacometti
Woman of Venice VIII, 1956

PLATE 104
Alberto Giacometti
Standing Nude, 1958
Oil on canvas
155 × 69.5 cm

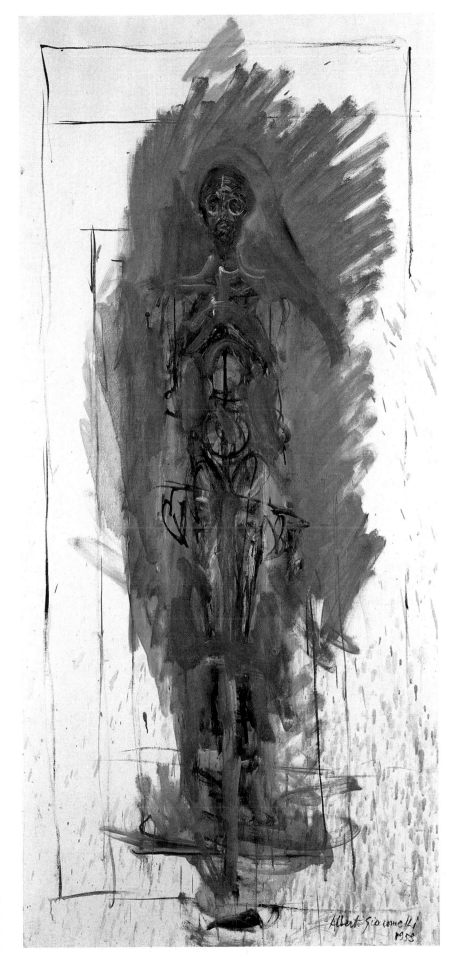

larly drawn black rectangles which frame the figure, there are three main elements which work together to determine the character of the picture: the hurried brushstrokes which are applied with scant regard for form, leaving a large part of the canvas blank; the sensitively drawn outlines of the female body; and the more precise form of the head, emerging from the formlessness of its surroundings. At the time when this picture was created, towards the end of the 1950s, the dominant movement in painting was *Art Informel*. Although Giacometti had no connection with this movement, it is possible to see informal, gestural elements in his painting, which also contains 'scriptural' signs of a kind often found in *Art Informel*. Yet the theme of his pictures is not the freedom of the artist to dispense with form: it is man himself, seen as a ghostly, frightened creature emerging from the barely articulated, cloudy grey of the pictorial space. The seemingly diffuse, hurried manner of painting contrasts with, and heightens, the intensity of the motionless standing figure. Giacometti's pictures are nearly always grey. In the year he painted *Standing Nude* he explained in conversation: 'If I see everything in grey, and in grey all the colours which I experience and which I would like to reproduce, then why should I use any other colour? I've tried doing so, for it was never my intention to paint only with grey. But in the course of my work I have eliminated one colour after another, and what has remained is grey, grey, grey!'

PLATE 105
Francis Bacon
Lying Figure No. 3
1959
Oil on canvas
198.5 × 142 cm

BACON

For centuries painters have concerned themselves with the theme of the human figure in space, using it to formulate their view of man's place in the world. In our century Schlemmer solved this problem in his own way (see Plates 57, 58); Giacometti supplied an Existentialist answer; and Francis Bacon, whose *Lying Figure No. 3* (Plate 105) was painted a year after Giacometti's *Standing Nude*, also deals with the individual human figure, set in an empty space which conveys the idea that man is essentially alone in a hostile world. Whereas Gia-

Fig. 300 Francis Bacon
Study after Velazquez's Portrait of Pope Innocent X, 1953

Fig. 301 Francis Bacon
Chimpanzee, 1942

Fig. 302 Francis Bacon
Two Figures, 1953

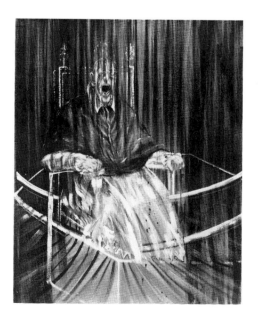

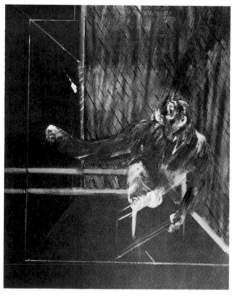

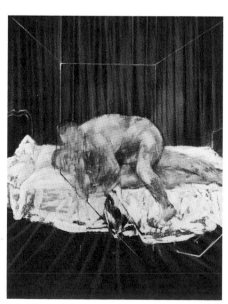

PLATE 106
Francis Bacon, *Man in Blue V*, 1954
Oil on canvas, 198 x 137 cm

230

Fig. 303 Francis Bacon, *Self-Portrait*, 1956

cometti uses the rigid, formalized pose and empty gaze of his female figure to emphasize the strangeness of human existence, Bacon achieves a similar effect through the distortion of the limbs and the cadaverous grimace. In both cases the individual is imprisoned in space rather than sheltered by it. Although Giacometti's Annette is seated on a stool in the artist's studio, one encounters her in a dimension which extends beyond the spatial. In Bacon's picture only the abstract contours of the bed and the bright green of the carpet serve to indicate the space around the figure; otherwise, all is darkness. It is a space which leaves the figure exposed and alone, affording neither protection nor a sanctuary. The vulnerability, the utter defencelessness, of the individual is one of the major themes of this deeply troubled artist.

Above all, it is the presence of death which fills Bacon's pictures with a sense of the intensity of life. Bacon himself remarked on one occasion that the more one is obsessed with life, the greater one's obsession with death. His work repeatedly addresses the existential ambivalence of desire versus death, seen in the facial expressions of his laughing, grinning, screaming figures. This is apparent in his self-portraits, in his *Study after Velazquez's Portrait of Pope Innocent X* (Fig. 300), in his pictures of a chimpanzee crouching in its cage (Fig. 301) and of a couple engaged in erotic struggle (Fig. 302). In the midst of such carnality and sensuality, the baring of the teeth is tantamount to a revelation of death, an ineluctable fact of human existence. The obsession which has fuelled Bacon's work for several decades is not only that with the naked human figure, but that with man's overall existential nakedness – a concern which sets him apart from every other artist of his time, with the exception of Giacometti, whose art, in other respects, is very different from his own.

⋆

Five years before *Lying Figure No. 3* Bacon painted a series of seven portraits, entitled *Man in Blue* (see Plate 106 and Fig. 304), of a man whom he had met in a hotel in England. He painted the man in several different poses, sitting at a table, which is shown in outline only, in front of a vertically striped wall. One is reminded of the way in which a photographer continually varies the pose of his subject. Bacon eliminates all extraneous detail and concentrates entirely on the figure itself, whose features are highly individual but, at the same time, mysteriously veiled. The face is smeared and blurred yet retains its integrity. There is an odd discrepancy between the man's spectral appearance and the bourgeois smartness of his clothes: the dark suit, the white shirt and the black tie. Since the whole scene is steeped in deep, dark blues and the contours of the interior are merely hinted at, the human figure appears lost in a space which lacks definition and offers no shelter – a lonely stranger of whom we know nothing, but who nevertheless attracts our attention. In the self-portraits which he has painted at all points in his career Bacon depicted himself in a similar fashion, distorting his own facial features (see Fig. 303).

In the twentieth century the portrait has become a highly problematical genre. It has entered a crisis even more serious than the crisis of the object, since it is conventionally defined precisely by the ideas

Fig. 304 Francis Bacon, *Man in Blue I*, 1954

of similarity and representation which the avant-garde has largely rejected. In the last forty years very few major painters have managed to tackle this theme without compromising their artistic principles. The most successful examples of an attempt to renew the portrait are to be found in the work of Bacon and Giacometti, whose approaches to painting are very different but have a common Existentialist structure of feeling. Although they both reduce the individuality of physical appearance, they at the same time emphasize the fact of individual existence: in their pictures individuality is seen as a facet of man's ineluctable destiny rather than as a mere set of personal attributes.

TOBEY

The American painter Mark Tobey belonged to the same generation as Giacometti. Although the two artists grew up in different worlds and under very different circumstances, they both sought to grasp a spiritual reality and translate it into artistic terms. Like Giacometti, Tobey was influenced by Surrealism, especially by the idea of *écriture automatique*, but the experience which decisively shaped his art was his encounter with the spirituality of the Far East, to which he was first introduced in the early 1920s. In 1934 he travelled to China and Japan, and it was then that he became interested in Japanese calligraphy, which had a powerful impact on his work. Until the early 1940s he continued to paint semi-figurative scenes of urban life, incorporating calligraphic devices (see Fig. 305); subsequently, however, he abandoned figurative painting altogether. Despite his strong interest in Eastern art and religion, Tobey remained aware that he was very much a citizen of the Western world. He denied being an 'Orientalist' and declared that the only thing he had taken from Japanese culture was what he called the 'calligraphic impulse', which had opened up new dimensions in his art: 'I could create the rush and confusion of the big cities, the interlacing of lights and the rivers of people caught up in the meshes of its web.'

The 'interlacing of lights', of freely drawn lines, was to become the main theme of Tobey's art. In one picture after another he enmeshed himself in tangled webs of lines, piling layers of white and coloured lines on top of each other to create an effect of infinite space. 'The cult of space can become as dull as that of the object,' he declared. 'The dimension that counts for the creative person is the Space he creates within himself. This inner space is closer to the infinite than the other, and it is the privilege of a balanced mind – and the search for an equilibrium is essential – to be as aware of inner space as he is of outer space.' Painting, for Tobey, became a form of meditative exercise. 'I believe,' he said, 'that painting should come through the avenues of meditation rather than the canals of action.' His pictures nevertheless embody a form of action, but not of the extroverted kind found in the canvases of Jackson Pollock or Franz Kline (see Plates 120, 121); in Tobey's case the action is introverted and directed towards a centre in which – following the ideas of Eastern philosophy – the individual is identical with the general. Hence, Tobey's lines are, in themselves, almost entirely devoid of expression. They are

Fig. 305 Mark Tobey, *Broadway Boogie*, 1942

PLATE 107
Mark Tobey
Plane of Poverty
1960
Oil on canvas
186 x 112 cm

233

PLATE 108
Mark Tobey
*Shadow Spirits of
the Forest*, 1961
Tempera on paper
48.4 x 63.2 cm

painted in a manner which makes them look as if they had been left to their own devices, following their own energies. Untouched by emotion, they are the perfect medium of a mind occupied solely with its own workings. According to Tobey, space 'is always charged with life ... with electrical energy, with waves, rays, spores and seeds, with possible sighs, possible sounds ... and God knows what else.' In this infinite space, filled with power, energy and light, Tobey moves, in his characteristically deliberate fashion, from one picture to another.

Tobey's unique position in American art stems not only from his age and his interest in Oriental culture (for this he shared with the younger Sam Francis); it also has to do with the fact that in 1960, just at the point when America's self-confidence was booming, in art as in other fields, he turned his back on the country and went to live in Basle. That year he painted *Plane of Poverty* (Plate 107), a large-format picture in whose seemingly monotonous, close-meshed network of fine lines one gradually discovers a concealed richness of colour and formal movement. In 1961 Tobey painted the luminous *Shadow Spirits of the Forest* (Plate 108); this, too, is a filigree web of countless lines whose silent movement has the character of a meditative text. Critics subsequently coined the term 'all-over' to describe this kind of pictorial structure, which covers the whole picture plane and dispenses with dominant formal motifs. 'All-over' structure was one of the hallmarks of the new American painting. One can find similar ideas in European art of the late 1950s, notably in Dubuffet's 'Texturologies' (see Fig. 306), where the surface of the painting is also covered with uniform micro-structures which supply their own intrinsic rhythm, with no overriding principle of compositional organization.

Fig. 306 Jean Dubuffet, *Texturology XXVII*, 1958

In his later years, while he was living in Basle, Tobey made the acquaintance of the German painter Julius Bissier, who was almost exactly the same age as Tobey himself. Bissier had started out as an exponent of *Neue Sachlichkeit* but had soon become aware of the limitations of that style; at the end of the 1920s he had been introduced to non-figurative art by Baumeister. This precipitated a major crisis in Bissier's work, but, from the early 1930s onwards, he began to evolve a new style of his own, painting abstract, calligraphic forms in Indian ink on paper (see Fig. 307). Realizing that form is only valid when it has a spiritual content, he began to look at form in terms of its semiotic and symbolic significance and found himself strongly attracted to the artistic ideas of the Far East. At the same time, he studied the symbolism of classical antiquity via the writings of Johann Jakob Bachofen, the nineteenth-century Swiss historian of mythology. He subsequently realized that he could dispense with symbolic signs, replacing them by a form of free pictorial script which gave full expression to his being (see Fig. 308).

At the time when Bissier was exploring these new avenues, that is, from around 1933 onwards, art of this kind was proscribed in Germany as 'degenerate'. With his paintings in Indian ink, which for many years was his sole medium and retained a central importance for his art throughout his life, Bissier became one of the major pioneers of *Art Informel*, the dominant artistic movement of the 1950s and early 1960s. Of all the various figures associated with *Art Informel*, Bissier is probably the most 'spiritually' inclined.

In the second half of the 1950s Bissier embarked on a new series of pictures which rapidly became of equal importance to his oeuvre as the paintings in Indian ink. He took to painting small-format pictures

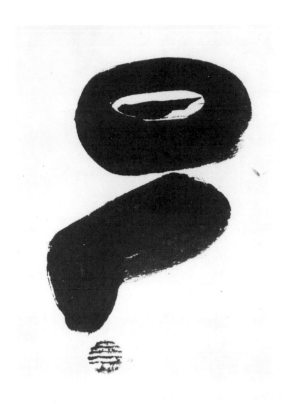

Fig. 307 Julius Bissier, *After Insemination*, 1938

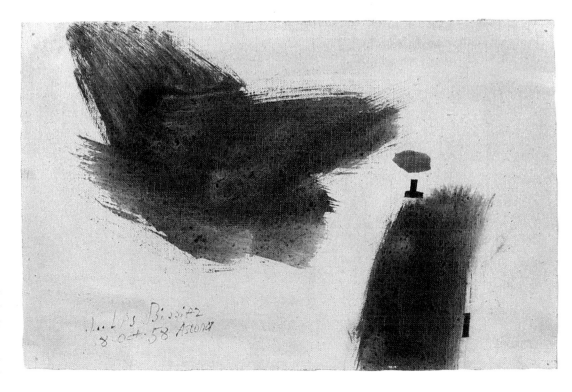

PLATE 109
Julius Bissier
8 Oct. 58 Ascona
1958
Egg and oil tempera on linen
17.5 × 26.8 cm

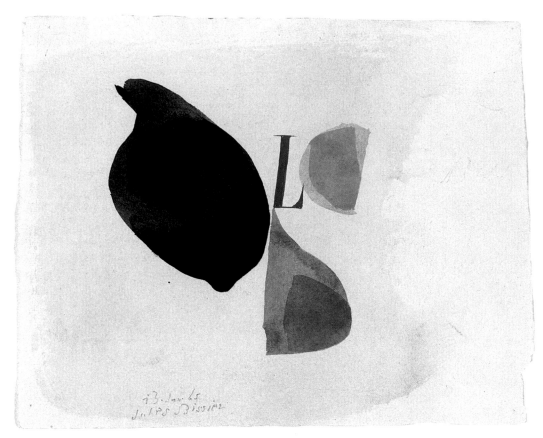

PLATE 110
Julius Bissier
13 Jan. 65
1965
Watercolour
on cotton duck
16 × 20 cm

in egg and oil tempera on canvas with an irregular border (see Plate 109) and also did a number of watercolours (see Plate 110) which combine aesthetic charm with the spiritual depth which, in Bissier's view, was the sole justification for abstract art and, indeed, for art in general. In addition, he painted a smaller number of large-format works in the same style. What Kandinsky termed 'the spiritual in art' is based, in Bissier's pictures, on the transparency and fluidity of the colours, on the quiet meeting of forms in an infinite – as it were, microcosmic – space. The mood evoked by these works is semi-religious, and many critics have remarked on the monastic character of Bissier's 'miniatures'.

Within his generation Bissier was by no means an isolated figure, although his Indian ink paintings were ahead of their time: it was not until the early 1950s that the style which Bissier had pioneered became generally accepted. Another German, Hans Hartung, who was ten years Bissier's junior, had trodden a similarly bold path in the early 1920s (see Fig. 309). Shortly afterwards, the Surrealists promulgated the notion of psychic automatism, which especially influenced the work of Masson, who was somewhat younger than Bissier and who, in the 1950s, painted a series of pictures using calligraphic signs (see Fig. 310). Henri Michaux, who was born in 1899, also took to painting in Indian ink in the 1950s (see Fig. 312), shortly after Pollock had begun to produce the large canvases which established him as one of America's foremost painters (see Plate 120). There is a particular affinity between the work of Bissier and the Indian ink paintings and lithographs produced by Tobey in the 1950s and 1960s (see Fig. 311). A number of parallels exist between the lives of these two artists, who both came from the relative

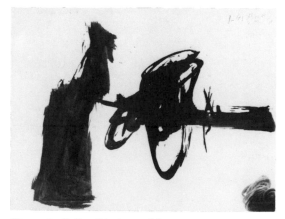

Fig. 308 Julius Bissier, *7 May 58*, 1958

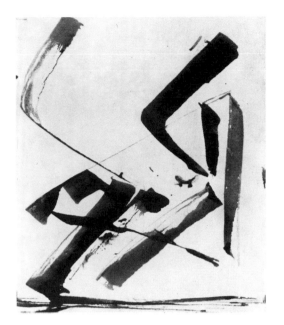

Fig. 309 Hans Hartung, *E 1923*, 1923

Fig. 310 André Masson, *Couple*, 1958

Fig. 311 Mark Tobey, *Calligraphic Structure*, 1958

obscurity of the provinces, German in the one case, American in the other. Their paths eventually crossed in 1960, by which time Bissier had begun to work on the coloured 'miniatures' which absorbed much of his artistic energies for the rest of his life, although he continued to paint in Indian ink.

'Painterly' Painting

Fig. 312 Henri Michaux, Lithograph, 1967

Although abstraction has its roots in the early decades of the twentieth century, the breakthrough of non-figurative art in France did not take place until after 1945, by which time abstraction was no longer automatically associated with geometricism but had come to mean the liberation of painting from the trammels both of the object and of geometrical form. In some cases this liberation led to the emergence of an expressive, freely 'gestural' art. Some artists, on the other hand, consciously looked back to the specifically French artistic tradition linked with such names as Bonnard, Braque and Delaunay, a tradition whose exponents regard painting as a craft concerned with the production of beauty, who see the picture as a rhythmically structured surface and colour as an equivalent of space, light and nature. Cubism continued to exert a strong influence on French painting, which retained its powerful attraction for artists from other countries. This attraction is illustrated by the fact that painters from such different backgrounds as the Portuguese artist Maria Helena Vieira da Silva and the German Hartung came, in the course of their respective careers, to embrace the principles of the Ecole de Paris.

VIEIRA DA SILVA

Like so many other artists of her generation, Maria Helena Vieira da Silva was initially influenced by Surrealism. This is clearly apparent in her early works, such as *The Flags* (1939; Plate 111), a mosaic of small diamond-shaped forms whose use of space, abolishing perspective, has a deliberately confusing effect. In the procession of flags

237

and 'crucified' figures reality is seen as a phantom apparition which nevertheless poses an acute and immediate threat, reflecting the grim mood of the times. Vieira da Silva's Surrealist beginnings can also be seen in other pictures, such as *Lisbon Studio* (1940; Fig. 313), with its magical, bewitched interior. In both these works the rational principle of perspective gives way to irrationality, a transformation with which one is familiar from the interior scenes painted by Klee in the 1920s and from the spatial fantasies of Roberto Mattá.

PLATE III
Maria Helena Vieira da Silva
The Flags, 1939
Oil on canvas, 80 x 140 cm

Fig. 313
Maria Helena Vieira da Silva
Lisbon Studio, 1940

In 1955 Vieira da Silva painted *The Overhead Railway* (Plate 112), a monumental, gesturally expansive cityscape. The canvas, whose dominant colour is grey, is traversed by a multitude of lines and marks, meandering off on their own and then coming together to form tight clusters. Light and dark alternate in rapid succession. Some of the lines describe large, relaxed curves, while others begin and end with equal abruptness; here and there, lattices and grids are formed where the lines intersect. The rich network of lines varies in density: in some places it takes on an almost dramatically eventful quality, whereas in others substantial sections of the ground are left empty. The picture is entirely abstract: there is not a single detail which obviously refers to a specific object. At the same time, however, it invites the viewer to read it in figurative terms, as a representation of reality. One is tempted to interpret the double curved line on the right as a bridge, an iron or steel structure which the eye can follow almost step by step, as it moves through space towards the horizon at the top of the picture, where it turns into a kind of railing or banister.

Hence, the drama of the picture is a drama in space, the space of an urban landscape. If one takes the narrow band of blue at the top of the canvas as representing the sky, the rest of the picture can be seen as a landscape with hills and hollows, ditches and ravines. Abstract

PLATE 112
Maria Helena Vieira da Silva
The Overhead Railway, 1955
Oil on canvas, 160 × 220 cm

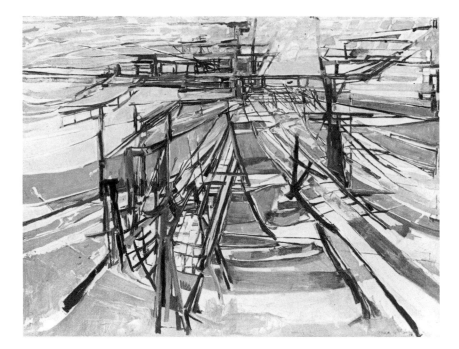

Fig. 314
Maria Helena Vieira da Silva
The Flooded Railway Station
1956

as the style of the work may be, what one sees is altogether real, a segment of nature in which human will has intervened. The scene can be interpreted as a huge building site, where unseen workers are shifting masses of earth, driving piles and laying railway tracks. It is impossible to say whether these events are taking place above ground or in some vast subterranean cavern: in this painting the internal and the external combine. The action of the picture is set in a sphere in which the oppositions between top and bottom, inside and outside, are suspended in favour of a single all-enveloping space, governed by an imagination which transcends the limits of earth, air and human construction.

BAZAINE

Jean Bazaine was the leading figure in the group of artists which first brought itself to the attention of the public by holding an exhibition under the title 'Jeunes Peintres de Tradition Française' in German-occupied Paris in 1941. This was the prelude to the emergence of a major movement in French post-war art. The title of the exhibition was not only a piece of political camouflage; it also indicated the artists' intention to continue the French tradition in painting while making use of new forms. Their self-appointed mission was to reconcile this tradition with the principle of abstraction, thereby liberating abstract art from the dogmatism which they saw as characteristically Germanic and Slav, and leading it towards a more painterly sensibility, coupled with a greater awareness of nature. Bazaine himself was particularly concerned with the artistic treatment of nature, which leavened and softened his increasingly abstract pictures. His art harks back to the Rayonnism of the period immediately preceding the First World War (see Fig. 315); in structural terms it is also reminiscent of Cubism. The following passage from Bazaine's 'Notes sur la peinture d'aujourd'hui' (Notes on Pres-

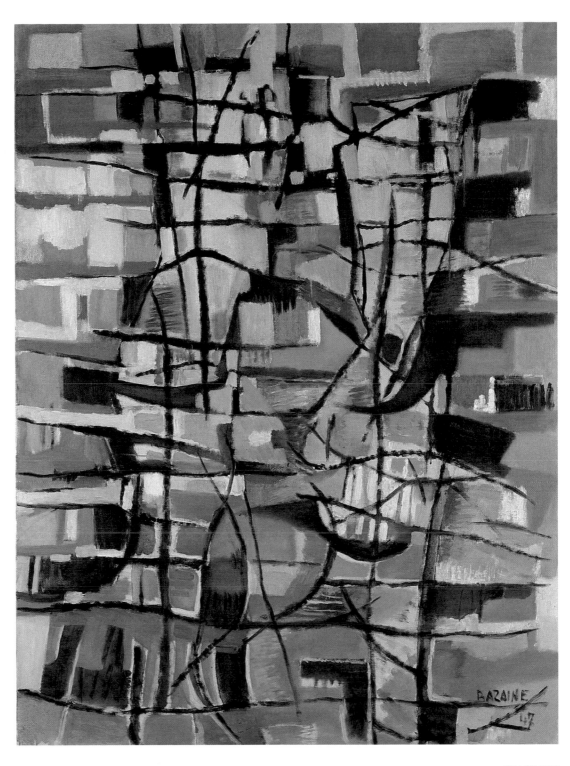

PLATE 113
Jean Bazaine
The Moon and Bird of the Night, 1947
Oil on canvas
130 × 97 cm

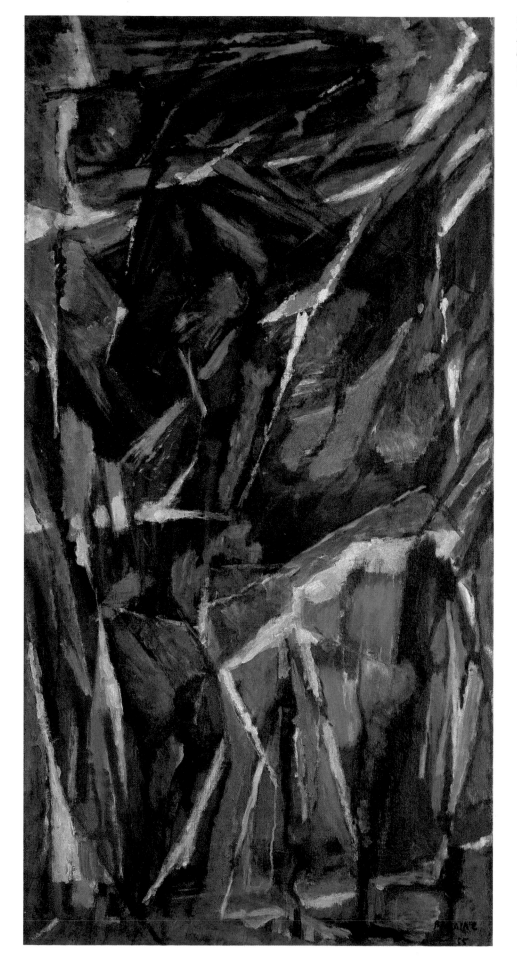

PLATE 114
Jean Bazaine
Stone, 1955
Oil on canvas
120.5 x 60.5 cm

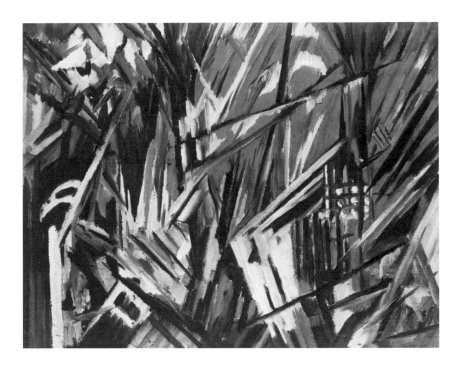

Fig. 316 Alfred Manessier,
Stained-glass window in the church
at Les Bréseux, 1948

ent-Day Painting), written in 1953, offers a number of interesting insights into his work: 'Let us try to rediscover the abstract by submerging ourselves in nature. It is by no means easy to get out again. An irresistible force holds us back; such embraces leave an indelible trace. . . . True sensibility arises only when the painter discovers that the movements of trees and the skin of water are related; when, after the world has gradually contracted and condensed, he sees the truly essential signs emerging from the multitude of appearances, the signs which are both his own personal truth and the truth of the universe. Vague gestures of friendship with nature are not enough; the important thing is to mark and sign it, to absorb its content and intention to the full. . . . In the most self-evident way man is star, leaf and stone; he is rich in the vegetable and mineral; all the roots in the world feed and nourish him.'

In Bazaine's early picture *The Moon and Bird of the Night* (1947; Plate 113) this identity of painting and nature has not yet been attained. Despite the geometrical character of its underlying structure, the work is painted in a relaxed, uninhibited manner, albeit with marked restraint in the use of colour. It is just possible to recognize the contours of a bird in the richly textured pattern of lines. In *Stone* (Plate 114), which dates from 1955, colour, form and nature are far more closely interwoven; rocks and water, space and light, are directly evoked by painterly devices that remind one of Vieira da Silva's *The Overhead Railway* (Plate 112), which was painted in the same year.

MANESSIER

More decisively structured than Bazaine's *Stone*, *Night at Gethsemane* by Alfred Manessier (1952; Plate 115) none the less strives, in its use of colour and line, for maximum pictorial effect. Passion, in

Fig. 317
Paul Klee
Oriental Sweetness
1938

PLATE 115
Alfred Manessier
Night at Gethsemane
1952
Oil on canvas
198 x 148 cm

both the emotional and the religious sense, takes form and colour beyond mere decoration. Yet it is the decorative quality of Manessier's work which allows it to be 'applied' so easily to architectural contexts, a fact exemplified by the large number of stained-glass windows that he has created (see Fig. 316).

In this picture and others of its kind the influence of Klee on French art is clearly apparent. Before the Second World War French painters – especially the Surrealists – had been particularly interested in the pictures of Klee's 'fantastic' period; now it was his late pictures (see Fig. 317), with their stained-glass structure and the covert references to nature in their seemingly abstract signs and forms, which attracted the most attention. Vieira da Silva, Bazaine, Roger Bissière and Manessier were all admirers of Klee, who exerted a considerably greater influence on this section of the Ecole de Paris – an influence which even extended to his great opposite, Dubuffet – than on post-war German art.

Gestural Painting

HARTUNG

In addition to this new, specifically French idea of 'painterly' style, the artists of the post-war era devised a further alternative to geometricism, in the shape of an art based on free graphic gesture, on form as action. All over the world form became 'informal'. One of the pioneers of this new style was the German-born artist Hans Hartung, who moved to Paris in 1935 and lived in France for the rest of his life. His work stands in a line of development which goes back to the early pictures of Kandinsky (see Fig. 328) and to German Expressionism. As early as 1923 Hartung had begun to experiment with free graphic movement (see Fig. 318), at a time when the avant-garde was mainly interested in geometrical form. It was only later that he began to investigate the stylistic possibilities of Cubism, from which his work derived a more marked pictorial character. However,

Fig. 318 Hans Hartung, *E 1923*, 1923

245

he steadfastly adhered to his dynamic, 'psychographic' notion of form. A picture such as *T.38-2* (Plate 116), which was painted in 1938, shows that he, too, was influenced by the highly fruitful Surrealist idea of psychic automatism, particularly as seen in Miró's pictures from the mid-1920s (see Fig. 319), with their freely drawn lines on a monochrome, often blue, ground. Hartung also found a source of inspiration in the work of the Spanish sculptor González, who offered him friendship and encouragement. In *T.38-2* the figure on the plinth, sketched in free, spontaneous lines, is strongly reminiscent of González's iron sculptures (see Fig. 320), which Hartung also drew upon in a sculpture of his own, made in the same year as the painting. Hartung's early pictures clearly anticipate the post-war artistic movement variously known as Abstract Expressionism, *Art Informel*, Gestural Painting, *Tachisme* and Action Painting. Given the emphasis of this movement on expression, it is surely far from coincidental that two of its leading initiators, Hartung and Wols (both of whom lived in France), were Germans.

*

Hartung painted *T.49-9* (Plate 117) in 1949, after the Second World War, in which he had fought on the French side, sustaining serious injuries. It is possible that his wartime experiences led him away from German artistic models and towards a French manner of pictorial thinking. The character of his art changed: he abandoned the spontaneous scribblings of his early work and began to employ a more deliberate, painterly idiom. *T.49-9* is a carefully balanced picture

PLATE 116
Hans Hartung
T. 38-2, 1938
Oil on canvas
100 x 149 cm

Fig. 319 Joan Miró, *Two Personages and a Flame*, 1925

246

Fig. 320
Julio González
The Dream, 1934

Fig. 321
Hans Hartung
Sc. 1938, 1938

which dispenses with expressive pathos: the spontaneous eruption of subjective feeling has been replaced by the rhythmic play of free forms. The expressive graphic language of *T. 38-2* has given way to a pictorial language using neatly executed signs and characters whose function is to make an aesthetically pleasing pictorial statement rather than to draw a form of psychogram. Hartung occasionally referred to this picture as 'Chinese'; like so many other European painters of the post-war era, he was fascinated and influenced by Chinese and Japanese calligraphy.

PLATE 117
Hans Hartung
T. 49-9, 1949
Oil on canvas
89 × 162 cm

PLATE 118
Pierre Soulages, *8 December 59*, 1959
Oil on canvas, 201.5 x 162 cm

Fig. 322
Pierre Soulages
Painting, 1947

Fig. 323
Franz Kline
Diagonal, 1952

SOULAGES

A similar approach to painting can be found in the work of Pierre Soulages, who was fifteen years Hartung's junior. Like Hartung, Soulages is not content with expressive gesture: he, too, strives for order, clarity and beauty. He refuses to neglect painterly values, to sacrifice the aesthetic element for the sake of expression or dynamic pictorial action. His gleaming black canvases combine energy and vitality with a technical refinement which sets his work apart from American Action Painting, from the pictures of such an artist as Kline (see Plate 121 and Fig. 323). Although Kline, who was almost ten years older than Soulages, was interested in the Frenchman's work and visited his studio in Paris, his idea of painting was very different, orientated towards the expressive and the gestural, towards openness, and paying less heed to the boundaries of the canvas, which Soulages continues to respect. Even where the action of a Soulages painting disregards the right-angle, the picture retains its essential integrity; the function of the action is to chant out the rhythm which structures the work. In Soulages's early pictures, from the 1940s (see Fig. 322), the gesture as such is dictated by a stronger expressive urge, but even here the fundamental aim is to achieve pictorial stability. These early works map out a path which was subsequently trodden by Kline, rather than Soulages himself. It is said that Soulages was initially influenced by Hartung. If this was so, then the influence was clearly short-lived: right from the outset, the younger French painter convincingly demonstrated the independence and individuality of his genius. Nevertheless, the progression from free gesture to the ordered, self-contained picture is common to the work of both artists. Like the German Hartung, the Frenchman Soulages consciously adopted a specifically European position which contrasted sharply with American attitudes to painting.

249

In the years immediately following the war Nicolas de Staël was also a member of the small group of artists, based in Paris, who developed a French version of Abstract Expressionism (see Fig. 324). With de Staël, this was tempered by the example of Braque and his dictum of 'la règle qui corrige l'émotion' (the rule which tempers emotion). Despite its expressive vehemence and declamatory tone, the work of de Staël remained true to the French tradition of refined painting. Here, as in the pictures of Hartung and Soulages, one finds a distinctly European approach to painting which was subsequently overshadowed by developments in America. De Staël's *Figure by the Sea* (Plate 119) was painted in 1952, only two years after Pollock's *Number 32* (Plate 120), yet, although both artists fall under the general heading of Abstract Expressionism, the two pictures are worlds apart. In later pictures (see Fig. 325), painted shortly before de Staël committed suicide in 1955, expressive pathos gradually gives way to formal clarity and luminous colour, and finally to traditional figuration. *Figure by the Sea* exemplifies the dynamic character of de Staël's artistic temperament, but the dynamism does not express itself in hurried, emphatic movements; instead, it seems to be stored up, like an electrical charge, in the blocks of colour from which the picture is constructed. Rather than bursting forth in spontaneous gestures, the power is concentrated and collected, though moderated by the sheer beauty of the painted surface and by the brightness of the colours. In grappling with the issue of figuration, the artist has opted for the autonomy of form and colour: the reclining figure on the shore is composed of patches of colour applied with a palette-knife, and the sky and sea are a brilliant red. Soon after he painted *Figure by the Sea* de Staël was to find it increasingly difficult to ignore the voice of the object, and it is quite likely that this conflict between abstraction and figuration was one of the factors which drove him to suicide.

Fig. 324 Nicolas de Staël, *Composition*, 1947

Fig. 325
Nicolas de Staël
Harbour in Sicily
1954

PLATE 119
Nicolas de Staël, *Figure by the Sea*, 1952
Oil on canvas, 161.5 x 129.5 cm

It was from the United States, rather than Paris, that Abstract Expressionism and Action Painting set out to conquer the art world in the 1950s. In the main, America lacked the tradition of fine painting which held European, and especially French, artists in thrall; where the rudiments of such a tradition existed, they came under attack. Unfettered by aesthetic inhibitions, the American artists of this period revelled in a newly discovered freedom, painting on huge canvases and initiating a revolution which soon extended beyond their own continent. Their work reflected the buoyant mood of the times, the renewed vitality and self-confidence of America. For the next three decades the East Coast of America became the world's leading artistic centre. It was not until the end of the 1950s that European artists began to take note of this shift in the focus of artistic activity.

The central figure in this new movement was Jackson Pollock. Born in 1912, Pollock was tragically killed in a car accident in 1956. *Number 32* (Plate 120), painted in 1950, is a truly monumental *chef d'œuvre*; unlike his other large-format pictures, it dispenses with colour in favour of black gloss paint, which lends it a particularly radical quality. 'Painting' is an inappropriate term for Pollock's method of producing pictures. The canvas, which in this case is some thirteen feet wide, was laid flat on the floor, and the artist moved about, dripping and smearing the fluid paint in bold, sweeping movements (see Fig. 326). This 'dripping' method was subsequently used by the European artists associated with the movement known as *Tachisme*.

In these pictures action, movement and speed are paramount. The body is just as involved as the mind, which is hyper-alert, concentrating on every second of the painting process. Pollock paints with the whole of his body and soul. The question of the relationship between mind, body and soul does not arise: in the act of painting, it is impossible to differentiate between them; man becomes a unified whole. Thus, it is entirely logical that the picture lacks a focus or centre: its main pivot is located outside, in the perpetrator of the action, the event, which constitutes it. Uninhibited action means taking risks, enthusiastically accepting the element of chance, and in the 1950s artists often spoke of 'steering' chance, making calculated use of an aleatory principle which categorically opposes traditional notions of composition. Instead of an ordered composition, what we find in *Number 32* is a dynamic network of lines and dots, tracing out a set of movements over the canvas, which Pollock saw as a kind of arena. This network seems to extend beyond the edge of the picture, as if the boundary of the canvas were a purely arbitrary dividing line between internal and external movement. Lacking any sense of hierarchy, the picture has a homogeneous 'all-over' form, albeit of a more structured kind than Tobey's *Plane of Poverty* (Plate 107): the concatenations of lines and dots give it a more rhythmical feel and provide a certain element of stability. Nevertheless, the negation of the principle of form is carried to a radical extreme, underlined by the use of black only, which corresponds to the formal extreme of Malevich's *Black Square* (Fig. 291). This is perhaps the

Fig. 326 Jackson Pollock painting *Number 32* (Plate 120), 1950

PLATE 120
Jackson Pollock
Number 32, 1950
Duco on canvas
269 × 457.5 cm

most daring picture that Pollock ever painted. Like Malevich, he was not content to carry on repeating a single radical gesture. He not only took to using colour, which in itself has a moderating, softening effect; he also placed increasing emphasis on rhythm, introducing an element of formal order and even including figurative motifs in a picture such as *Number 27* (Fig. 327), which was painted shortly after *Number 32* and implicitly calls the radicalism of the latter work

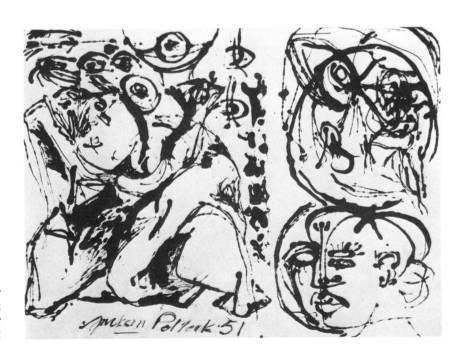

Fig. 327
Jackson Pollock
Number 27
1951

253

into question. Hence, *Number 32* occupies a unique position in Pollock's oeuvre.

In some respects the 'informal' boldness of Pollock harks back to the early work of Kandinsky (see Fig. 328). However, despite the points of comparison between the two artists, there are also obvious differences: even in his pre-1914 pictures Kandinsky was very much concerned with composition and formal structure. At the point when he was liberating himself from figuration, his pictures already had a centre, one or more focal points around which the composition was organized: the idea of 'all-over' structure was completely alien to his way of thinking, as was the principle of chance, whether real or merely apparent. What interested Kandinsky was not 'action' but the 'spiritual'.

A further, more direct source of inspiration for Pollock's art lies in the Surrealist notion of psychic automatism. As early as 1942 Ernst, who was continually on the lookout for new artistic techniques, had experimented with the method of 'dripping', in pictures such as *The Confused Planet* and *Young Man Intrigued by the Flight of a Non-Euclidean Fly* (Fig. 329). Ernst describes this procedure as follows: 'Tie a piece of string, one or two metres long, to an empty tin can, drill a small hole in the bottom and fill the tin with fluid paint. Then lay the canvas flat on the floor and swing the tin backwards and forwards over it, guiding it with movements of your hands, arms, shoulder and your whole body. In this way, surprising lines drip onto the canvas.' Ernst claimed to have drawn Pollock's attention to this technique in 1943. Be that as it may, the two artists used the method with very different results. Whereas Pollock opted for apparent chaos, Ernst painted a clearly defined, semi-geometrical form, even when experimenting with a technique governed by the principle of chance, that element in artistic creation which the Surrealists valued so highly.

Despite his interest in Surrealism and his personal association with Ernst, Pollock does not appear to have been strongly influenced by Surrealist thinking. His early work clearly points to other, more important influences, such as that of Picasso in the 1930s and 1940s and of the Mexican mural painters David Alfaro Siqueiros and José Clemente Orozco, whose pictures enjoyed considerable popularity in America at the time when Pollock's artistic ideas were beginning to take shape.

Fig. 328 Vassily Kandinsky, Drawing for *Black Lilies*, 1913

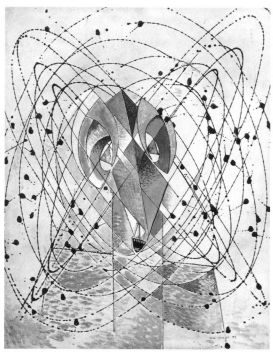

Fig. 329 Max Ernst, *Young Man Intrigued by the Flight of a Non-Euclidean Fly*, 1942/47

KLINE

Compared with Pollock's revolutionary redefinition of the concept 'picture', the large untitled canvas by his friend Franz Kline (Plate 121) appears relatively traditional: despite the violence of the picture's action, the dynamic black brushstrokes constitute a stable pictorial framework. Yet here, too, the artist demonstrates a willingness to take risks: the factor of chance, of random impulse, is accepted as a legitimate ingredient of the picture, although it is corrected here and there by painterly means. Kline deliberately denies

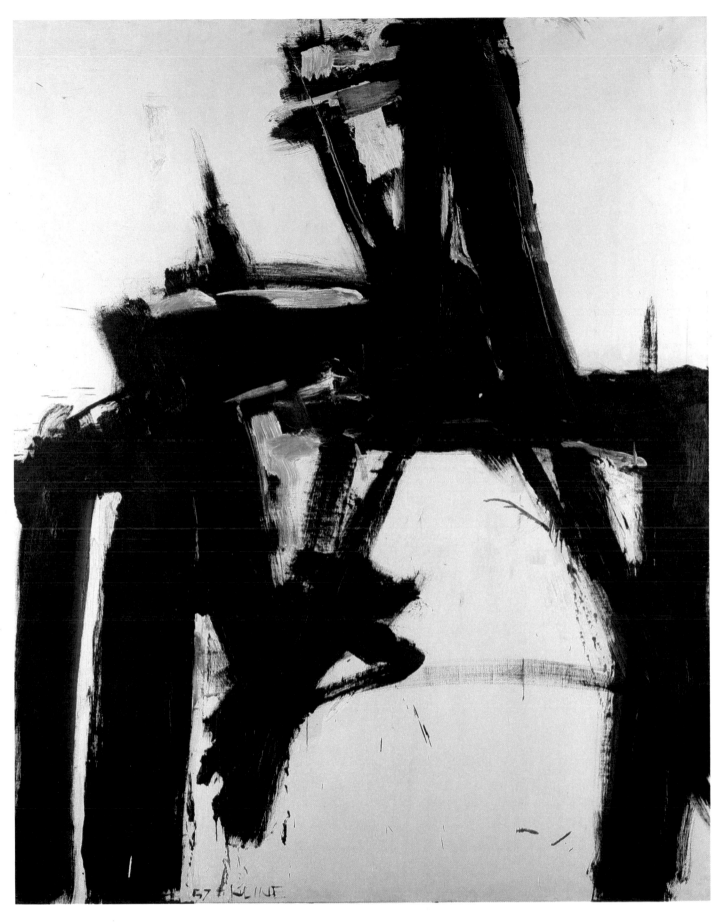

PLATE 121
Franz Kline, *Untitled*, 1957
Oil on canvas, 200 × 158.5 cm

the picture a centre of gravity or a clearly demarcated boundary. In many of his pictures a large form runs horizontally across the entire canvas, from one side to the other: as in the work of Pollock – for example, *Number 32* (Plate 120) – the edge of the picture appears to be a purely arbitrary demarcation, beyond which the action continues. What we see in the picture is merely a detail selected at random from a larger action.

TWOMBLY

The American Cy Twombly, who lives in Italy, was born almost twenty years later than Kline. In 1959 – only two years after Kline painted the picture just discussed – Twombly did a series of pictures on a white ground, including *Untitled* (Plate 122), which at first glance appears to be nothing more than a jumble of hurried lines and marks, lacking any obvious formal or compositional structure. The picture epitomizes the 'informal' or 'gestural' art of the 1950s: it is made up entirely of free, spontaneous gestures of the brush or pencil. Above all, it exemplifies the 'scriptural' approach to painting which gained wide currency in the 1950s. Twombly's work also falls within the category of Lyrical Abstraction, a further term that gained wide currency at the time. His art is considerably more European than that of Pollock and the other exponents of Abstract Expressionism.

Lacking any obvious principle of order, this picture, like much of Twombly's other work, is characterized by an effect of extreme arbitrariness. Although one quickly registers its stylistic homogeneity and its pronounced sense of rhythm, the scribbled signs flatly refuse to accede to any form of definite order. Precisely in its rejection of order, the picture shows a high degree of stylistic consistency. The

Fig. 330 Antoni Tàpies, *Numbers*, 1971

Fig. 331
Cy Twombly
Untitled
1969/71

PLATE 122
Cy Twombly
Untitled, 1959
Oil, pencil and crayon on paper
mounted on canvas
152 x 247 cm

signs are not even uniform: as well as 'pure' lines, one finds words and numbers, together with closed rectangular forms and even figurative elements, such as a heart and a rudimentary drawing of the male genitalia; it is as if the artist had hurriedly noted down things that occurred to him in the course of working on the picture. The work is even less 'composed' than the canvases of Pollock. Its order is entirely open, and the only thing which provides a sense of unity is the spontaneity, the graphic consistency of the fleeting signs, whose sensitive quality is heightened by the use of paper rather than canvas: since the scribbled lines and marks no longer have to overcome the resistance of a primed canvas, they appear more direct, spontaneous and intuitive than might otherwise be the case.

Parallels to this approach to painting can be seen in the drawings of Antoni Tàpies (see Fig. 330), which also have a 'scriptural' character: here, too, one finds a mixture of abstract signs and figurative forms, together with numbers and words. However, Twombly subsequently broke with the principle of open form: in the late 1960s, for example, he painted a series of pictures (see Fig. 331) which have a uniform graphic rhythm, retaining a measure of openness only in so far as the lines of 'writing' appear to run on into the space beyond the borders of the picture. Formal ideas of this kind are largely alien to Tàpies, whose artistic thinking is orientated towards a more traditional notion of the picture.

257

In the early 1950s the young German painter K.R.H. Sonderborg drew attention to himself with a series of pictures whose sole theme is speed. The painting process is timed with a stop-watch, and the titles of the pictures record the exact number of hours and minutes required to paint them. Hence, the time factor takes on decisive importance. However, what really interests Sonderborg is not, of course, the mere passing of chronological time, but the experience of time in the execution of the picture. The stop-watch becomes a symbol of an attitude to painting in which speed is everything. This temporal-spatial emphasis in Sonderborg's work is reminiscent of Pollock, although the American painter oversteps a spatial threshold which the European Sonderborg continues to respect. His pictures also evoke non-pictorial associations – jazz and aeroplanes, rockets

PLATE 123
K.R.H. Sonderborg
Flying Thought,
12.11.1958, 16.53-23.09
1958
Tempera on photographic
paper on canvas
108.7 x 69.7 cm

Fig. 332 Umberto Boccioni, *Running Train*, 1912

and explosions – which lend an air of reality to the breathtakingly fast movements on the canvas. *Flying Thought* (Plate 123) conveys the idea of an aeroplane in flight, stirring up masses of air – masses of paint – in its path. This almost illusionistic representation of speed, which recalls the Futurists' attempts to depict motion (see Fig. 332), was subsequently abandoned by Sonderborg in favour of a more composed manner of painting: in the pictures entitled *Window*, for example, the speed of the act of painting is absorbed into a static pictorial framework with vibrant structures. A major feature in the texture of *Window* (Plate 124) is the inclusion of a set of prints from a shoe with a ridged sole, a device which intensifies the feeling of real experience in the picture by, among other things, pointing to the passage of time. The use of footprints and, more often, of prints from the artist's hand is quite common in the art of the post-war period. It is a gesture of defiance directed at overly puritanical

PLATE 124
K.R.H. Sonderborg
*Window, 27 April 1965,
11.31-12.43*
1965
Tempera on photographic
paper on hardboard
108 x 70.3 cm

notions of autonomous form. In trampling on his picture, Sonder-borg is trampling not on art itself, but on a particular view of art as an elevated, semi-sacred activity.

NAY

In Germany, Abstract Expressionism was able to revive the heritage of the original Expressionist movement, which had been outlawed and vilified during the Third Reich and was hence all the more interesting to artists after 1945. The early work of Ernst Wilhelm Nay is clearly indebted to classic Expressionism; in the course of the 1950s, however, the artist gradually devised an idiom of his own, a personal version of Abstract Expressionism. Nay was a born painter, a highly individual artist whose work stands apart from program-matic notions of Action Painting. In 1955 he painted a series of pictures using circles of colour to, as he himself put it, 'walk over the picture plane choreographically'. In the early 1960s these 'chromatic' pictures show an increasing liveliness and impetuosity (see Plates 125, 126): the floating circles are replaced by vehement swirls of coloured action which relate more directly to the persona of the artist. Although the painter is primarily interested in the 'objective' drama of colour, it is impossible to overlook the expressive urgency, the subjectivity, of these pictures. Since their language is based on formal rhythms and on the spatial effect of colour, form and colour retain their traditional functions.

The circle in these pictures is an event, an action, rather than a form, and has little in common with the circles which had played such a prominent part in the ideology and artistic practice of artists devoted to geometricism. Before the First World War Delaunay had already filled the geometricists' circle with living colour and with a move-ment which turned the static circle into a rotating disc. Although Nay's pictorial language is quite different from that of Delaunay, its historical antecedents are surely to be found in a picture such as *Circular Forms* (Fig. 333), with its chromaticism, its dynamism and its 'cosmic' pathos.

Fig. 333
Robert Delaunay
Circular Forms
1912/30

PLATE 125
Ernst Wilhelm Nay
Circular Signs
1961
Oil on canvas
200 x 120 cm

PLATE 126
Ernst Wilhelm Nay, *Key Signs*, 1962
Oil on canvas, 220 x 160 cm

The Expressiveness of Matter

Action Painting is only one of the various facets of what became known in the 1950s as *Art Informel*. A further aspect of this broad-based movement is 'texture' or 'matter' painting, which, like Action Painting, was practised by artists all over the world, although its beginnings are to be found in Europe rather than America. Its exponents replaced the *belle matière* of the French tradition in painting with deliberately coarse materials and textures, giving rise to a surface relief that scarcely permits individual motifs to emerge from the whole: the distinction between structure and form is dissolved. The way for this style, which was radically opposed to the traditional refinements of French painting, had been prepared by Surrealism. One of its foremost practitioners was a French artist, Jean Dubuffet, who rejected the notion of painting as a craft concerned with the production of beauty and devised a method of creating pictures in which matter is not only the medium but also an essential part of the content. Rather than refining and sublimating raw matter in the interests of the 'spiritual', Dubuffet sees the materiality of the artwork as a spiritual reality in its own right.

In order to translate this conviction into artistic practice, he was forced to go beyond traditional techniques of painting. By 'matter' he meant something more emphatically 'material' than the artist's paints. Paint, in his view, cannot replace matter; it can only colour it. What interested him was not the outer skin of matter, but its flesh, its muscles, nerves, veins and guts. Like the Dadaists, he scorned high culture and the notion of taste, favouring anti-artistic, impoverished materials and techniques – the *moyens pauvres* which, paradoxically, had acquired 'artistic' status through the Dadaists' use of them in their sacrilegious assault on traditional forms of art. Yet instead of staging Dada-like spectacles on the canvas, Dubuffet amalgamates his materials to create a unified, densely textured whole.

In 1944, after the German armies had retreated from France, the Paris art dealer René Drouin organized the first in a series of exhibitions of Dubuffet's work, which attracted a considerable amount of attention. It was here that Dubuffet first exhibited his portraits of painters, poets, musicians and art dealers, including *René Drouin: Open Hands* (Plate 127). There is a certain physiognomic resemblance to the sitter, but this was not the artist's principal concern. The important thing in the picture is the rudimentary appearance of the figure, pressed and scratched into the hard impasto of the painted surface: a head with a shock of hair, a bottle-shaped body, two oddly outstretched hands without arms. The eyes are indicated by pieces of coloured glass, the moustache by a piece of string. The figure and the surrounding space are equally amorphous. There are obvious parallels with the art of children and especially with that of mental patients (see Fig. 335), in which Dubuffet was particularly interested. He built up an extensive collection of pictures done by the inmates of lunatic asylums, referring to them by the term 'art brut' (raw art), and felt happier with these works than with the products of 'high' art. Nevertheless, he was impressed by the work of a painter such as Klee, who had also taken an interest in children's drawings and in the art of mental patients (see Fig. 337).

Fig. 334 Jean Dubuffet, *Man Sitting in an Armchair*, 1945

PLATE 127
Jean Dubuffet, *René Drouin: Open Hands*, 1946
Mixed media on canvas, 110 x 88 cm

Fig. 335
Drawing by
a mental patient

Fig. 336
Jean Dubuffet
*Jean Paulhan
with Small Fins*
1946

Fig. 337
Paul Klee
In the Meadow
1923

Fig. 338
Jean Dubuffet
*Landscape with the
Moon and a Bird*
1946

Fig. 339
Jean Dubuffet
*He is holding
a Flute and a Knife*
1947

In *Sun-drenched Sundays* (Plate 128) Dubuffet has etched a scene from a suburban garden into the dark matter of the ground, again in the manner of children's scribblings. One is also reminded of children's drawings by the clumsy figure of the man walking along the path, drawn as he is with a sovereign disregard for proportion. The scene has a melancholy naivety in its evocation of the atmosphere of a Sunday afternoon in petit-bourgeois suburbia. At this point in his career, between 1945 and 1950, Dubuffet painted a considerable number of landscapes, traversed by roads and paths, which combine front-on view and plan (see Fig. 338). This series of works includes pictures, painted between 1947 and 1949, which reflect the artist's experience of three expeditions into the Sahara (see Fig. 339).

*

Even when Dubuffet's pictures are covered with a homogeneous, albeit modulated, layer of 'matter', they cannot be termed abstract: their structures evoke earth and stones, sand and dust. Dubuffet seeks nature in the raw, prior to the emergence of individual forms. Matter is present in two forms in his art: as the elementary material of nature, pulsating with the forces of life and organic growth, and as a relic of previous existence, marked with the furrows, scratches and scars left by the passage of time. The latter can be seen in *Brazen Landscape* (Plate 129), which was painted in 1952. As in *Sun-drenched Sundays*, the horizon is at the top of the picture, but there is no human figure or reference to urban motifs. The landscape is merely structured matter; the sky is lighter than the brown earth, but the structure is the same. The earth resembles a geological formation of the kind often found in Dubuffet's pictures, frequently incorporating gnome-like human figures. *Brazen Landscape* is part

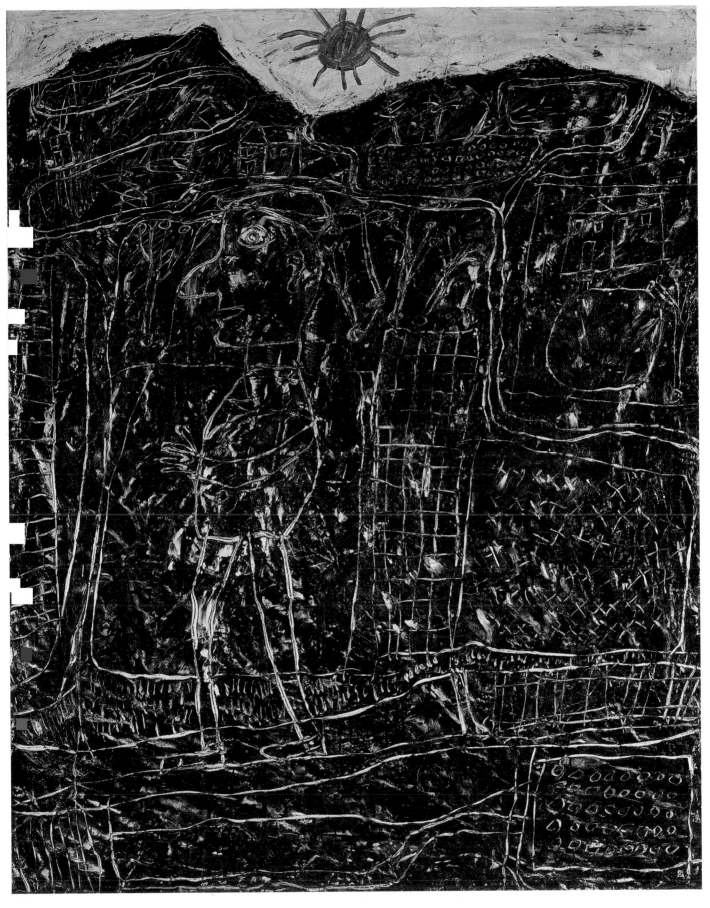

PLATE 128
Jean Dubuffet, *Sun-drenched Sundays*, 1947
Oil on canvas, 146.5 x 115.5 cm

Fig. 340
Jean Dubuffet
Landscape with Figure
1952

of a series of pictures which Dubuffet called 'Landscapes of the Mind' and which, like the 'Philosophical Stones' he painted at the same time, can be seen as 'philosophical' landscapes. There is an obvious affinity between pictures of this kind and the ideas which Ernst was exploring in the mid- to late 1920s: although one hesitates to speak of a direct influence, *Brazen Landscape* immediately reminds one of Ernst's skeletal forests (see Fig. 341).

Fig. 341 Max Ernst, *Sun and Forest*, 1927

TAPIES

The Spanish artist Antoni Tàpies, who was born some twenty years later than Dubuffet, is also an exponent of 'matter' painting. In his youth Tàpies had been influenced by the work of Klee and by Surrealism, painting lyrical pictures with fantastic motifs; subsequently, however, he gravitated towards *Art Informel* and became one of its leading practitioners. Unlike Dubuffet and several other 'matter' painters of the 1950s, Tàpies is neither a 'geologist', ploughing up the earth in search of buried treasure, nor do his pictures conjure up landscape associations. Instead, he takes matter as an accomplished fact, as something whose life consists precisely in dying, in a continuing process of decay and decomposition. To these images of dead matter, he adds occasional signs and marks. Thus, in his *Large Grey Painting* (Plate 130), which dates from 1955, we find lines and notches resembling cuneiform inscriptions scratched into the paint surface, together with a wing-shaped form and, rather surprisingly, a white cross. One is reminded of carvings on ancient stone tablets, with mysterious signs which are indecipherable but nevertheless pregnant with meaning. The later painting *Relief in Brick Colour* (Plate 131) is like a lump of masonry, a large, enigmatic stone. The space of the picture is closed, and the matter is abandoned to its own melancholy. Here, too, one finds occasional lines and marks, notably a number of crosses. The cross plays an important part in Tàpies's art. Although it cannot be interpreted in straightfor-

PLATE 129
Jean Dubuffet
Brazen Landscape, 1952
Mixed media on hardboard
195 x 129.5 cm

269

PLATE 130
Antoni Tàpies
Large Grey Painting, 1955
Mixed media with sand
on canvas, 195 x 169.5 cm

<div align="right">

PLATE 131
Antoni Tàpies
Relief in Brick Colour, 1963
Mixed media with sand
on canvas, 260 x 195 cm

</div>

ward terms as a Christian symbol or a *memento mori*, it plays on atavistic memories of this kind, buried in the depths of the European mind, and it lends the pictures a certain emotional force which is heightened by the expressive character of the sign language. Unlike American art of the 1950s, which reflected the vitality and self-confidence of a new generation, the work of Tàpies draws on the memory of the past, delving into the remote depths of history and reminding one of Altamira rather than of the modern world, to which this artist's pictures nevertheless belong. For many years Tàpies's art was seen as opposing the Franco dictatorship: critics interpreted the mute calm of his pictures as a gesture of resistance, a silent protest against the noisy, slogan-chanting parades which were such a prominent feature of life under Franco. Yet even after Franco's death and the advent of democracy, Tàpies's work retained a political dimension, in so far as it offered an alternative to the rigid, oppressive structures of modern life, dominated by technology and inhumanity. The language of his pictures is modern, but it also voices the fears and doubts to which the modern world gives rise. Using the characteristic idiom of his generation, Tàpies exemplifies the general tendency in European art since the turn of the century to articulate regressive dreams via progressive forms.

SCHUMACHER

In terms of age, the German Emil Schumacher stands exactly half-way between Dubuffet and Tàpies. Yet this age difference is scarcely noticeable in his work, whose development was impeded by historical circumstances. At the time when Schumacher started to think about art, there was no place in Germany for the ideas he was beginning to formulate. In 1933, when the Nazis seized power, he was just over twenty, and by the time the Second World War ended he was thirty-three: it was only then that he could begin to paint, at the same time as Tàpies, but as a mature person rather than a young man barely out of his teens. Like a number of other contemporary German artists, he subsequently found himself attracted to *Art Informel*. It would seem probable that he was influenced to some extent by the tradition of German Expressionism, which was rehabilitated after the war; this is made all the more likely by the fact that Schumacher was a native of Hagen, where the Expressionist painter Christian Rohlfs lived until his death in 1938. However, the borders were now open, and it was possible to see what was happening in Paris. Despite the fascination which the French capital held for European and even American artists in the late 1940s and early 1950s, Schumacher maintained a certain aloofness from what was then known as the Ecole de Paris. He sought a coarser, more powerful and expressive language and found a solution which combined the twin facets of *Art Informel*, the structural and the gestural, by painting in graphic brushstrokes on a coloured ground with a rich material texture. His pictures retained a painterly quality. Although he rejected the cultivation of beautiful painting for its own sake, he found a new form of beauty in the material quality of colour. He clung to traditional pictorial principles to the extent that he continued to see his pictures as closed, unified wholes. Despite the energy

Fig. 342 Emil Schumacher, *Joop*, 1963

PLATE 132
PLATE 132
Emil Schumacher
Large Red Painting, 1965
Mixed media on canvas
150 × 270 cm

and vigour with which they are inscribed on the canvas, the arch-like forms found in many of Schumacher's paintings confer a sense of stasis, of self-contained repose, on the picture: although the graphic action has the character of an event or process, it does not break up the identity of the picture as an image. Fascinated though Schumacher is by the destruction of matter, his pictures exhibit a high degree of subtlety and delicacy in their use of paint. While including a wide variety of anti-aesthetic elements, they have a specific aesthetic interest.

In *Large Red Painting* (1965; Plate 132) the dialogue between the coloured ground and the graphic action is also a dialogue between red and black. Despite the 'informal' character of the picture, neither form nor compositional balance is sacrificed in the interests of expressive vehemence. And at first sight the work appears to contain a further traditional element: one is tempted to read it as a landscape, with red earth and a black sky. However, this figurative reading is contradicted by the overall 'action' of the picture: one realizes that it is not, in fact, a landscape but a pure pictorial event, a prime example of Abstract Expressionism.

In the past, since many of Schumacher's pictures appear to allude to nature and landscape, his work has often been interpreted by reference to his native region, the Ruhr district. A work which readily lends itself to this interpretation is the relatively small painting *Joop* (the title is meaningless), which also derives its power from the stark contrast between black and red (Fig. 342). Here, as in *Large Red Painting*, the red section is animated by graphic marks which can be read at one and the same time as pure expressive gestures and as

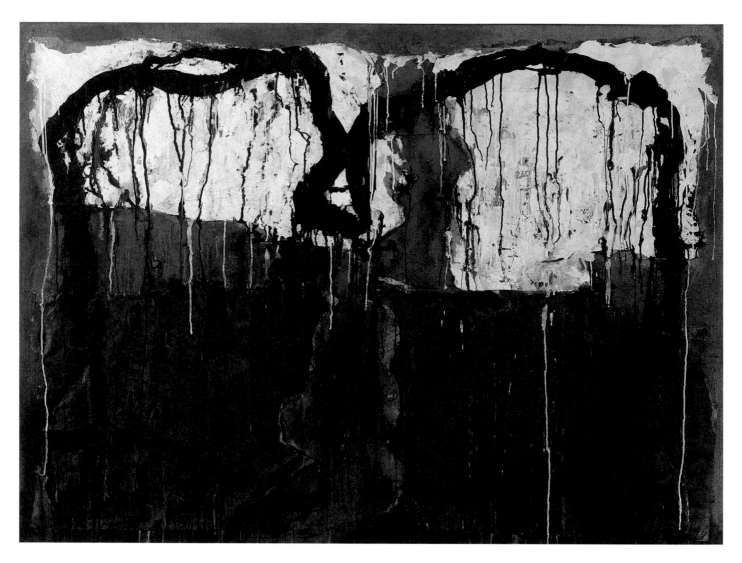

PLATE 133
Emil Schumacher, *Macumba*, 1973/74
Acrylic on paper and jute, 137 x 184.5 cm

veins of mineral deposits in the earth. In other pictures, especially in the gouaches on paper which the artist painted when travelling away from home, one finds direct references to nature and reality. Schumacher is very far from being a dogmatically anti-figurative artist.

Macumba (Plate 133), which was painted in 1973/74, is made of large pieces of packing-paper, with torn edges, which are stuck on to the unprimed canvas and painted in a partly gestural style. Physical destruction is a theme which runs right through Schumacher's oeuvre, but for him destruction does not mean a negation of the aesthetic: form and painting are not liquidated but merely disrupted, and the disruption lends them both a specific expressive force and a specific aesthetic charm. A few years before he painted *Macumba* Schumacher used wrinkled and torn pieces of lead sheeting to make a picture entitled *B-5/1969* (Fig. 343). Here, as in the painting, the tears and gashes suggest an excess of destructive energy against which the black arches have to struggle to hold their own: destruction is offset by form, which restores the balance. Schumacher also uses the element of chance as a challenge to form. Even in the large arches which are such a frequent feature of his work, chance and spontaneity continue to play a prominent part: on the one hand, the arches are

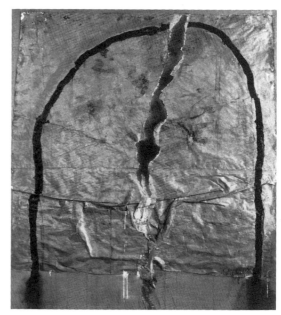

Fig. 343 Emil Schumacher, *B-5/1969*, 1969

274

like static arcades but, on the other, they are linear processes which allow one to sense their innate energy. This constitutive ambiguity in the art of Schumacher shows that, even when the formal motif is one which constantly recurs, the emphasis lies not on the idea but on the execution.

BURRI

The New Banality of Objects

It is only a short step from matter to material. At the beginning of the 1950s, when there was much talk of 'matter' in painting, it was an obvious progression for artists to start using new materials, and the idea of *Art Brut* led to a preference for particularly crude materials of the kind with which Schwitters had experimented in the 1920s. Thus, the Italian artist Alberto Burri made pictures out of old grain sacks, charred wood, battered pieces of tin and sheets of plastic foil. In his sack pictures – for example, *WHEAT* (Plate 134) – he accepted the material as he found it, with tears, seams, patches and stamped inscriptions. Yet all these random imperfections are incorporated into a clear, composed pictorial order. Burri, like Schwitters, is concerned with composition in the traditional sense, although he is also interested in the shock effect of the materials, in the 'live' element which resists artistic sublimation.

Klee was also given to using sackcloth, especially in his late pictures, where the forms, too, are coarser than in his earlier work. His *Imprisoned* (Fig. 344) predates Burri's *WHEAT* by just sixteen years.

PLATE 134
Alberto Burri
WHEAT, 1956
Sacking
150 x 250 cm

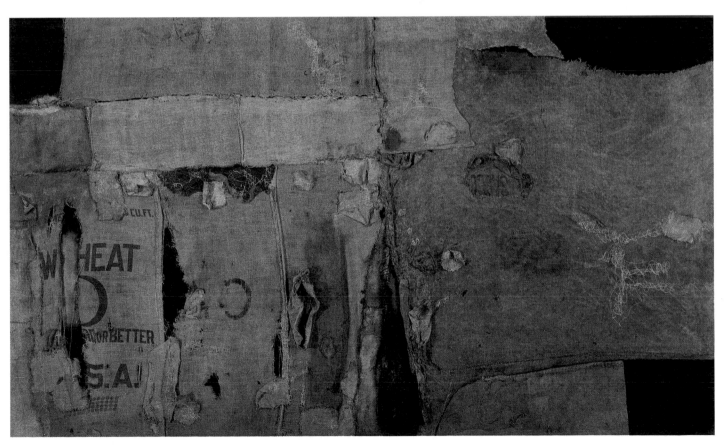

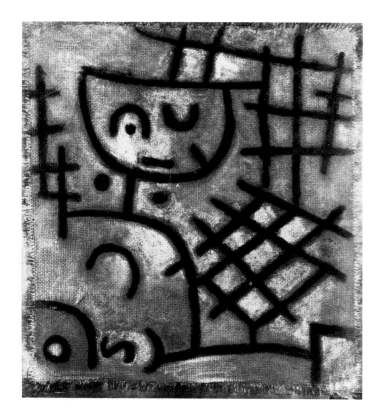

Seven years after Klee painted *Imprisoned* Schwitters produced *ESIR* (Fig. 345), a piece of torn sacking on to which he glued strips of printed paper. The use of typographical elements anticipates Burri's picture, which, as the inscription stamped on the material shows, was made of wheat sacks. The inclusion of printed letters in pictures was by no means a new invention; it had been pioneered before the First World War by the Cubists in their collages. What was novel was the use of company insignia, as in Burri's picture and, somewhat later, in the work of Robert Rauschenberg (see Plate 139). This is a device which points, more clearly than in Schwitters's version of Dada, to the world of industrial production and mass consumption. Its appearance in *WHEAT* is a sign that European artists, as well as their American counterparts, were moving in the direction of what was shortly to become known as Pop Art.

Fig. 344 Paul Klee
Imprisoned, 1940

Fig. 345
Kurt Schwitters
ESIR, 1947

BONTECOU

The generation gap was beginning to narrow. When Schwitters died in 1948, Burri was already over thirty. It was at this point that Rauschenberg, who was ten years younger than Burri, began to draw on the heritage of Dada, paying particular attention to the work of Schwitters, whose use of typography he imitated in his pictures from the late 1950s. The destruction of the pictorial material, symbolizing the breakdown of aesthetic convention, became a popular concern and informs the work of many artists of this period. Like Burri, Lucio Fontana made holes in his canvases before making the clean incisions which are such a characteristic feature of his work (see Plates 147, 149). Schumacher used torn canvases and gashed sheets of metal. The maltreatment of the picture for the sake of pictorial

PLATE 135
Lee Bontecou
Untitled, c. 1959/60
Welded steel and canvas,
175 x 182 x 61.5 cm

effect was one of the formal devices which led, in the post-war years, to the emergence of a new concept of the picture as object. Pictures also became increasingly three-dimensional, a development which had already been seen in the work of Schwitters and which culminated in the 'object art' of the 1950s and 1960s, whose exponents radically questioned traditional notions of painting. This is the case with the American artist Lee Bontecou, who created a considerable number of pictures by stretching pieces of worn canvas over metal structures which extend forward into space – for instance, *Untitled* (Plate 135). The structure is put together in a seemingly functional manner, but it lacks any actual function. Here, as in the work of other artists of the period, one finds an improvisatory element which signifies an implicit criticism of the modern ideal of technical perfection; at the same time, however, the forms of the picture remind one of a machine – a turbine, for example. Paradoxically, the formal analogy with hyper-technical structures articulates an attitude of opposition to technology.

PLATE 136
Kurt Schwitters
Untitled (Wood on Black)
1943/46
Assemblage
on cardboard
54.7 x 43.7 cm

SCHWITTERS

Thus, from 1950 onwards, the abandonment of traditional notions of the picture proceeded apace, indeed, the very concept of 'art' was increasingly called into question. As anti-art slogans gained currency, artists began to seek fresh inspiration in Dada, which experienced something of a revival, centering on the work of Kurt Schwitters. Since the 1920s, when he had experimented with geometrical forms (see Plate 66), Schwitters had once again reformulated his artistic ideas: following his emigration, first to Norway, then to England,

Fig. 346 Kurt Schwitters, *Untitled (Picture with Pieces of Wood)*, 1942/45

PLATE 137
Kurt Schwitters, *Young Earnest*, 1946
Collage on canvas (book cover) on cardboard
19.5 x 16.2 cm

he had abandoned geometry, which was essentially foreign to his temperament, and turned his attention to a modified version of what he called MERZ. In his work of this period one finds signs of a return to nature. In Norway Schwitters was surrounded by the splendours of nature, and he painted a number of landscapes which he himself saw as having little artistic value, although he felt them to be entirely necessary. In England, too, he spent the last years of his life in the depths of the countryside, in close contact with nature. From this point onwards, one finds an increasing number of natural objects in his abstract assemblages, bringing the atmosphere of nature, with its continuous cycle of life and death, into his art.

This interest in nature is clearly apparent in *Untitled (Wood on Black)* (Plate 136), which was made between 1943 and 1946 in England. The gnarled piece of bark, a marvellous natural *trouvaille*, must have particularly delighted Schwitters, the nature lover. The same 'back to nature' mood can be seen in many of Schwitters's works from this period (see Fig. 346), which feature not only pieces of urban junk, but also relics of nature, and reveal that latent Romantic streak in Schwitters's make-up which other Dadaists, especially the members of the Berlin Dada group, had recognized and criticized in the 1920s.

Little remains of the playfulness of Schwitters's early work in the untitled assemblage of 1943/46 or in the collage *Young Earnest* (1946; Plate 137), with its pieces of torn paper on a dark ground. Although his pictures from the 1920s are also glued together from old and shabby materials, they afford a certain aesthetic pleasure and are the product of a conscious formal impulse whose origins clearly lie in 'Cubo-Futurism'. Despite their randomness, they embody a definite set of structural principles, a covert or manifest formal law. This is no longer the case in Schwitters's post-Constructivist works. His untitled assemblage lacks any kind of formal structure; there is no visible principle of order to subdue the chaos. The materials are stuck together in a manner which preserves a certain sense of balance but dispenses with any formal pattern, a manner more random than in Schwitters's early collages, with their cheerful 'law of chance'. Nevertheless, the artist continues to exercise his formal imagination. This is clearly apparent in the two right-angled elements, which emphasize the vertical and echo the style of Schwitters's geometricist phase, and in the red square in the bottom right-hand corner of the inner square of tarred felt. Yet the picture is dominated by other elements, especially by the piece of rough bark, whose naturally bizarre appearance probably inspired Schwitters to make the assemblage, just as the pieces of driftwood which he found on the shore in Holland had led him to make *Little Seamen's Home* (Plate 66) some twenty years previously. The idea of a nature-loving Dadaist sounds paradoxical, but Schwitters was indeed fascinated by nature, particularly during the last ten years of his life, when he was cut off from the international art world and lived in remote areas of northern Europe where he was surrounded by nature rather than modern urban culture. Hence, many of the objects which he included in his later works point to a definite feeling for nature, allied with the mood of resignation which displaced the optimism of the 1920s as his life gradually drew to a close.

As already mentioned, the generation gap was beginning to narrow. The classic Dadaist Schwitters died in 1946, at the relatively early age of sixty-two, when the Neo-Dadaist Robert Rauschenberg, aged twenty-one, was painting his first pictures. In Europe the rediscovery of Schwitters did not get underway until the early 1950s, but in the United States he had never been entirely forgotten. Thanks to the activities of museums and galleries in New York, young American artists of the post-war period were already familiar with his work. Rauschenberg was considerably influenced by Schwitters, although he rejected the German artist's essentially 'harmonic' conception of form: this is the major difference between Neo-Dadaism and the original Dada movement. A picture such as Rauschenberg's *Wager* (Plate 138) is a downright mockery of traditional notions of composition. In his late work, however, Schwitters himself abandoned the formal model of Cubism and experimented with types of pictorial order for which the term 'composition' would be a misnomer, since the pictures lack a unifying formal principle of the kind found in his pictures from the 1920s, despite the latter's Dadaist destructive gusto. For example, the assemblage *Merz Picture with Rainbow* (1939; Fig. 347) clearly anticipates the open compositions of Rauschenberg, right down to such a detail as the rainbow motif, which disrupts the order of the picture and which occurs again in Rauschenberg's *Wager*, where it also appears to be a deliberate 'flaw' in the composition. *Wager*, a large-format picture consisting of four canvases joined together, was painted between 1957 and 1959. While its expressive vehemence reminds one of Action Painting, its Neo-Dadaist elements lend it greater complexity. In the closed central field, painting runs riot, uninhibited by form. Here, we find such everyday articles as socks and ties, which have a certain personal, autobiographical

Fig. 347 Kurt Schwitters, *Merz Picture with Rainbow*, 1939

PLATE 138
Robert Rauschenberg
Wager, 1957/59
Oil and assemblage
on four-part canvas
206 x 376 cm

significance, but which have lost their individuality – their 'individual poison', as Schwitters used to say – in the process of integration into the unruly painting. The central area is surrounded by a calm, light ground with occasional nuances of colour. In the right-hand section Rauschenberg drew a life-sized nude, probably by standing up against the canvas and tracing the outline of his own body in pencil; this, too, is a non-artistic, direct form of reference to reality. Stuck to the bottom left-hand corner is a photograph of the Capitol in Washington, an obvious symbol of America's new-found self-confidence.

<p style="text-align:center">*</p>

Rauschenberg's *Icon* (1962; Plate 139) is a crudely constructed wooden box, later mounted on wheels for a 'happening', which is partly covered with sheets of roughly patterned tin, painted white. A small metal plaque with the address and telephone number of a New York company is nailed to the front right-hand side. The box has a door, and this puts one in mind of a shrine; but one is also reminded of Duchamp's *Door: 11, rue Larrey* (Fig. 349), which is quite simply a door and nothing else. The inside of the box is lit from above and has a mirror at the back which creates an effect of added depth. In the mirror one sees the reflection of several objects: a rusty tin can, hanging down from the top of the box; a wooden wheel built into the right-hand wall; a piece of dusty cloth roughly

PLATE 140
Robert Rauschenberg
Quote, 1964
Oil and silk screen
on canvas, 239 × 183 cm

Fig. 348
Robert Rauschenberg
Icon (rear view)
1962

wrapped round a wooden peg; and a strikingly coloured piece of Abstract Expressionist painting. Nailed to the reverse of the 'shrine' (Fig. 348) is a smaller wooden box with a slit in the back through which one can look into the interior; immediately above the slit is a large metal door-bell. The vertical piece of wood attached to this smaller box – the leg of a chair or table – is reminiscent of Magritte's balustrade posts (see Plate 80). Finally, two rough planks of wood, with letters stencilled on the back, project from the side of the box. The work is a three-dimensional collage or assemblage, made from the widest possible variety of what the Surrealists christened *objets trouvés*. The materials have a life of their own, which Rauschenberg, like Schwitters in the 1920s, deliberately exploits: 'fine' materials would have been wholly unsuitable for a work of this kind. Schwitters himself made a number of Dadaist 'shrines', especially in his *Merz Building*, where they were gradually walled in and thereby obscured; however, some of these 'grottoes', as Schwitters called them, were set behind glass panels and remained visible. A number of other artists associated with Dada and Surrealism also made boxes and 'shrines'. It was not until 1941 that Duchamp produced his *Valise*.

*

In terms of technique, subject-matter and composition, Rauschenberg's large silk-screen pictures mark a radical departure from established pictorial conventions. Instead of painting, the artist silk-screens photographic images – newspaper photographs and reproductions of art-works – directly on to the canvas. He takes elements of unprocessed reality and incorporates them in the picture in a seemingly arbitrary manner, paying no attention whatever to composition, proportion or thematic unity. Within the context of American art these pictures represent a categorical rejection of Action Painting, proclaiming that the business of art is to deal with the brute facts of objective reality, rather than to serve as a medium for the uninhibited expression of subjective emotion.

Fig. 349 Marcel Duchamp, *Door: 11, rue Larrey*, 1927

The large-format picture *Quote* (1964; Plate 140) follows a purely additive principle of order. It comprises four basic images: a photograph of President Kennedy delivering a speech, the double image of a parachutist, a collection of traffic signs on a New York street corner and a schematic drawing of a geometrical form. In addition, there is an area of roughly painted black and a green spot, together with patches of red and black which have no obvious significance.

With its hectic brushstrokes, the area of black which edges its way in between the patches of red on the left of the picture is a hangover from the days of Action Painting. By way of contrast, the greyish-white layer of colour which frames the image of the President is a highly subtle piece of pure painting. In several places the painter's brush intervenes, correcting and pointing up the images, and adding a subjective note which tempers the photographic directness of the motifs. The red of the silk-screen printing alters the character of the photographs in a similar way. In the work as a whole one finds 'brute' reality engaged in a dialogue with the specific forces of the picture: the voice of reality is clearly audible, but the picture insists on maintaining the upper hand. Within the picture, however, there is no dominant structure, no hierarchy or 'composition': the individual images are unrelated and entirely self-sufficient. The work is compiled rather than composed.

Rauschenberg is often seen as one of the initiators of the Pop Art movement of the 1960s, whose exponents borrowed images directly from everyday reality without subjecting them to any kind of artistic interpretation. Yet unlike these artists, Rauschenberg followed the lead given by Schwitters some fifty years previously and contented himself with citing fragments of reality, a technique which has a greater suggestive power than the wholesale importation of reality

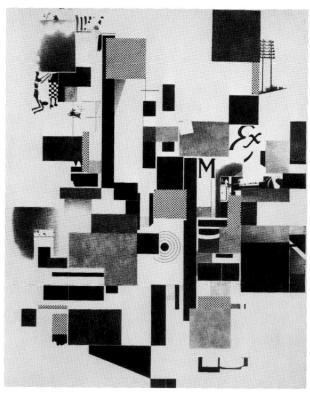

Fig. 350
Kurt Schwitters
Untitled, 1921

Fig. 351
Kurt Schwitters,
Lithograph from
Merz Portfolio
1923

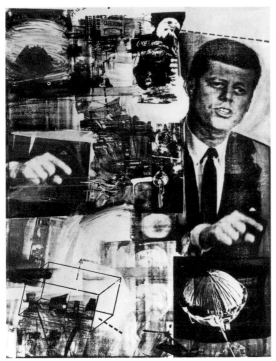

Fig. 352 Robert Rauschenberg, *Buffalo II*, 1964

into the picture. These fragments of reality are disparate and disconnected, but this is precisely what makes the picture interesting: it is more than just a portrait of an American popular idol, a depiction of military action or a reproduction of a set of traffic signs. Through these motifs, and by way of its obvious allusions to the image-making apparatus of the mass media, the picture evokes the reality of the contemporary world.

The motifs found in *Quote* recur in a number of Rauschenberg's other silk-screen pictures (see Fig. 352). The artist repeatedly used the same images of Kennedy, the parachutist and the traffic signs.

There are obvious similarities between *Quote* and the work of Schwitters. One is forcibly reminded of the German artist's late pictures and of a number of his Dadaist collages from the early 1920s (see Fig. 350), where, for once, his principal concern is with content rather than form, as he plays an ironic game with a motley variety of photographs and illustrations. Particularly close to Rauschenberg are the lithographs from *Merz Portfolio* of 1923 (see Fig. 351), which contain fragments of reality, embedded in an overall geometrical structure which indicates the future direction of Schwitters's work.

JOHNS

Jasper Johns stands side by side with Rauschenberg as one of the leading representatives of the Neo Dada movement in American art of the 1950s. His early pictures show that he, too, was influenced by Abstract Expressionism and did not reject it as radically as the Pop artists who came to the fore a few years later. The grey picture *4 The News* (Plate 142) still has a certain expressive verve, but it is more muted, more nuanced and sensitive than the wild 'action' of paintings by Pollock or Kline. Of all the American post-war artists who have set out to turn art upside down, Johns is the one who most deserves to be called a 'painter'; he has cultivated and refined the craft of painting in a way which is generally seen as un-American, as typically European or even specifically French. However, he is not content merely to exercise his technical virtuosity by painting beautiful pictures. His work ceaselessly questions the nature of art and has definite intellectual implications. Moreover, Johns has frequently incorporated everyday, non-artistic objects into his pictures, thereby disavowing pure painting. In his choice of motifs he is given to making bold, radical gestures, covering entire canvases with the image of the American flag or with a map of the United States. Yet he remains a painter through and through, and one is continually impressed by the subtlety and aesthetic elegance of his work.

The aesthetic appeal of Johns's pictures is enhanced by his frequent use of the ancient technique of encaustic, the best-known examples of which can be found in the art of the early Coptic Christians. The technique consists in mixing the pigment with liquid wax, which dries and hardens very quickly, allowing the artist to work faster than with more conventional paints. Johns combines the use of encaustic with a kind of collage technique, covering the ground with

pieces of newspaper which soak up the wax and show through on the surface of the painting. This layer of newspaper gives the picture a relief-like structure, and the liquid wax lends it a particular warmth.

In his early pictures, from 1955 onwards, Johns uses such motifs as flags, targets, numbers and letters – images which are striking precisely because of their banality. The artist himself explains that he chose these motifs because of their ordinariness: one is not used to looking at them closely. Their attraction for him lies in the very fact that they have no intrinsic value. Banal and conventional they may be, but for the painter they are fresh and new. In a television interview Johns explained: 'I'm interested in things which suggest the world rather than suggest the personality. ... The most conventional thing, the most ordinary thing – it seems to me that those things can be dealt with without having to judge them; they seem to me to exist as clear facts, not involving aesthetic hierarchy.'

It is possible that Johns's choice of the US flag as a motif (see Plate 141) was at least partly motivated by the heightened sense of national self-esteem which one finds among American artists of the 1950s: Johns, after all, belonged to a generation which was in the process of liberating itself from European artistic traditions. As well as the flag, he also uses maps of America. However, not all his motifs have this kind of symbolic significance: the letters and numbers, for example, have no patriotic connotations. When asked why he repeatedly used the image of the Stars and Stripes, Johns replied that he had once dreamed of painting a large flag: 'Using the form of the American flag meant a lot to me, because I didn't have to invent it. So I carried on with similar things, like targets, things which had always been familiar. That gave me a chance to work on other levels.'

'Is it a flag, or is it a painting?' Johns once asked. The question is of course purely rhetorical: the main thing is obviously the picture rather than the flag. Yet the artist must also be interested in the

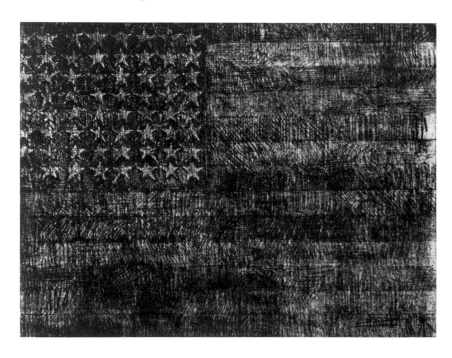

Fig. 353
Jasper Johns
Flag (with 64 stars)
1955

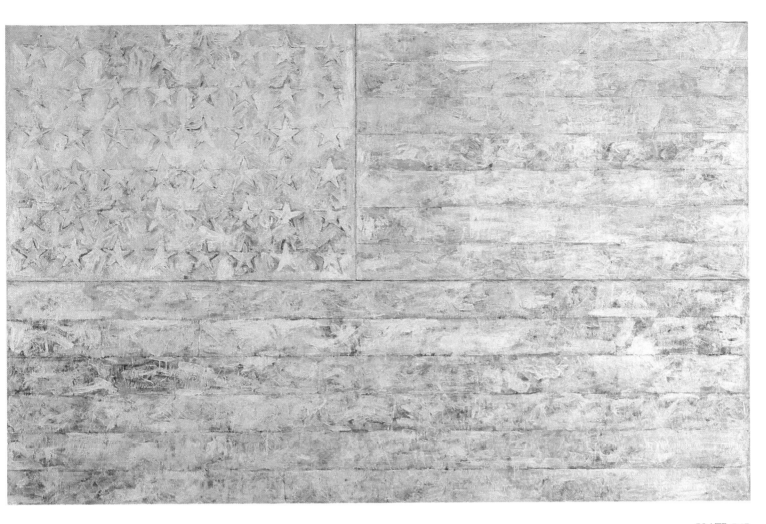

PLATE 141
Jasper Johns
White Flag, 1955
Encaustic and collage
on canvas, 198.9 x 306.7 cm

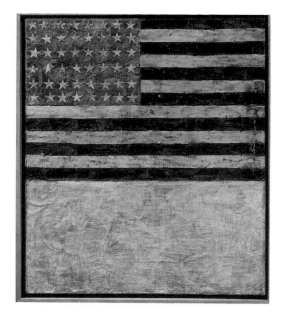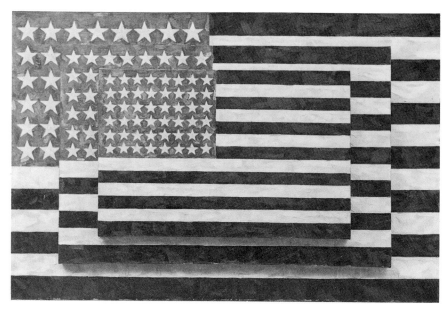

Fig. 354 Jasper Johns
Flag above White with Collage, 1955
Fig. 355 Jasper Johns, *Three Flags*, 1958

presence of everyday reality in the picture; otherwise, he would have opted for abstraction. The dramatic effect of his pictures, which shocked many people when they were first exhibited, derives from the fact that, instead of showing the flag in a clearly defined thematic context, Johns presents the image as a bald fact. The flag becomes a picture and vice versa: thus, the artist establishes an identity of image and object, boldly upsetting conventional notions of both art and reality in a way which reminds one of the pictures of Magritte.

Some of Johns's flag pictures are painted in red, white and blue, the national colours, but in others he uses different colours, or even monochrome white. The flag does not always cover the picture: in some cases it is set in a larger field of colour (see Fig. 354). Where this is so, the identity of object and work which so troubled the contemporary art world is dissolved; however, even in these pictures, the flag is still presented as a non-signifying fact rather than being located in a specific context. In the largest work in this series (Fig. 355) two smaller flags are set on top of the large flag, which fills the entire canvas. As well as the paintings, Johns did a parallel series of flag drawings, in which he plays exceedingly subtle games with shades of grey within the given form of the flag (see Fig. 353).

Measuring over six feet by ten, *White Flag* (1955; Plate 141) is a large and exceptionally impressive painting. One is especially struck by the subtle richness of its colouring against the creamy white background. Johns painted it in 1955, at the age of twenty-five; it is his answer to the art of Pollock and, as such, has a particular historical significance. Five years previously, Pollock had painted *Number 32* (Plate 120); he died in 1956, the year after Johns burst on to the scene with *White Flag*, instantly establishing himself as one of America's foremost artists, and four years before the young Frank Stella began to paint his black pictures (see Plate 165).

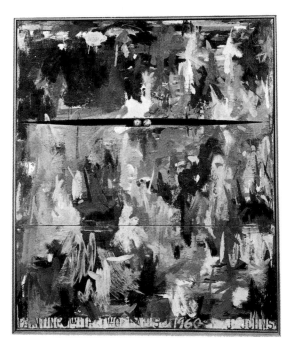

Fig. 356 Jasper Johns, *Painting with Two Balls*, 1960

*

In *4 The News* the new approach to painting is documented by different means. The canvas is divided, in an ostentatiously 'unartis-

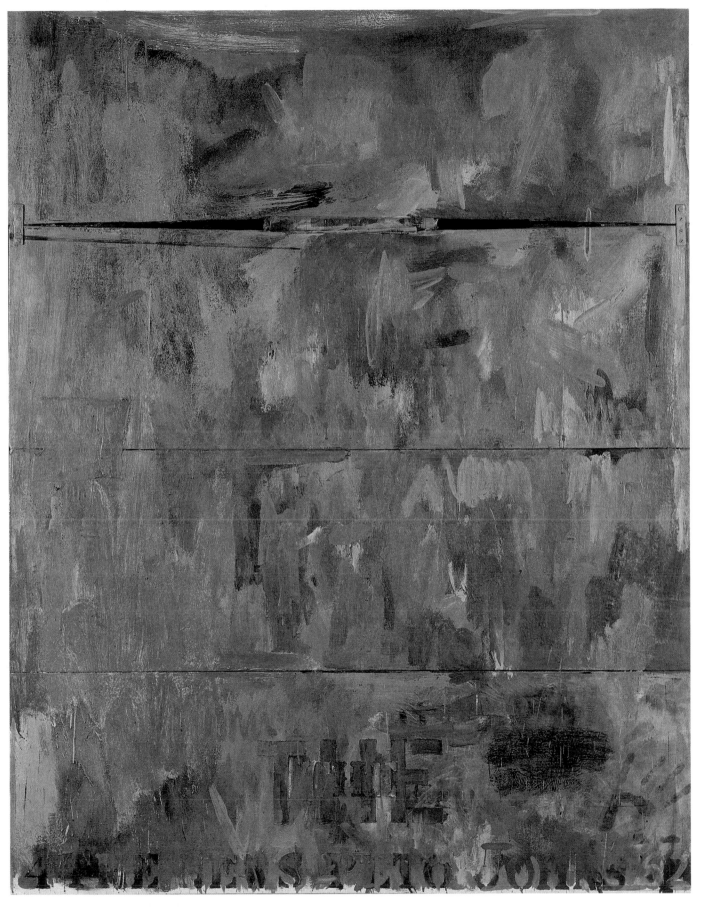

Jasper Johns, 4 *The News*, 1962
Encaustic and collage on canvas, 165.1 x 127.6 cm

289

tic' manner, into four sections, two of which are roughly bracketed together. A folded newspaper, dipped in wax beforehand, is inserted in the gap between the top two sections. At the bottom of the picture there is a carefully stencilled inscription, which is partly painted over. Finally, we find a piece of cloth stuck on to the canvas and, in the bottom right-hand corner, a hand-print. (There are obvious points of similarity between this work and Johns's *Painting with Two Balls* [Fig. 356], in which two wooden balls are wedged between two sections of canvas.) One of the most remarkable features of the picture is the newspaper. Some fifty years beforehand, the Cubists and Futurists had already incorporated newspaper cuttings in their pictures, thereby striking an abrasively modern, topical note. Johns takes this device a step further by stuffing an entire newspaper into his picture, at the bottom of which one also finds the word 'news'. The title contains a pun, the number '4' replacing the word 'for'.

There is a further interesting detail in the inscription at the bottom: the name 'Peto', which is half-concealed between 'news' and 'Johns'. John F. Peto was a late nineteenth-century American artist who enjoys a high reputation in his native country as a painter of still lifes in which the objects are reproduced with exceptional naturalistic verisimilitude. Johns also has a high opinion of Peto's art, which, like his own, admits banal objects into the picture. The new spirit of self-confidence in post-war American art led artists to investigate the historical roots of their own work. It is possible that Johns took the pun '4 = for' from Peto's *The Cup We All Race 4* (Fig. 357). Peto, too, wrote the title of his picture in large letters at the bottom: an avant-garde gesture which is surprising in an American picture painted as early as the turn of the century.

Fig. 357 John F. Peto, *The Cup We All Race 4, c.* 1900

ARMAN

The European counterpart of the American Neo-Dada movement was a group of artists based in Paris who called themselves 'Nouveaux Réalistes'. The members of this circle sought to inject a new sense of reality into art by the simple device of using real objects. Like so many artists of the 1950s, they were fervent admirers of Schwitters, whom they recognized as a great artist rather than as a mere joker. The scope of *Nouveau Réalisme* extends from 'matter' and 'object' artists, such as Arman and Daniel Spoerri, to the mystic Yves Klein.

In the early 1960s Arman produced a series of pictures with dismembered objects, which he called *colère* (anger). A new generation of angry young men was engaged in picking through the remains of an inherited cultural tradition and hurling them in the face of the contemporary public. The act of smashing a violin (see Plate 143) was a symbolic gesture of cultural sacrilege, implying a total rejection of art in all its manifestations. The choice of a musical instrument, a culturally sacrosanct object, was calculated to offend traditional artistic sensibilities: Arman was unperturbed by the accusation that he was brutalizing art. In other works, however, he used more banal objects – for example, a coffee-grinder (Fig. 358).

Fig. 358 Arman, *Cubist Coffee-Grinder*, 1961

PLATE 143
Arman
Anger: Violin, 1963
Assemblage on plywood
94 × 76 cm

 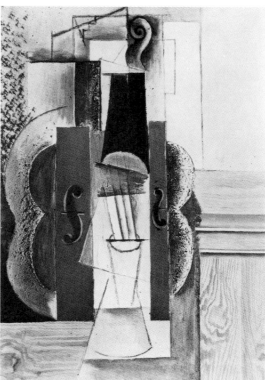

Fig. 359
Arman
Virtuosity
1961

Fig. 360
Pablo Picasso
*Violin Hanging
on the Wall*
1912/13

Schwitters declared that the task of art was to build something new out of the ruins of culture. In his view, construction was just as important as destruction. Hence, although he destroyed objects, he regarded form as an indispensable element in art and left it largely intact. Arman, who once proclaimed, 'it all began with Schwitters', defines the difference between his own work and that of his Dada predecessor thus: 'In the art of Kurt Schwitters we participate in a search for harmonious balance ... for him, the pictorial value of the objects and the way in which they fuse together are more important than the material itself.... I maintain that the expression of junk and objects has an intrinsic value, and I see no need to look for aesthetic forms in them and to adapt them to the colours of the palette.'

In the early 1960s Arman put these principles into practice in a series of boxes filled with odd pieces of assorted junk. Yet although these boxes appear to lack order and form, Arman is unable to disguise the fact that he is seeking to make an artistic point by aestheticizing objects which are inherently non-aesthetic. This intention is clearly apparent in a further series of boxes filled with objects which are all of the same sort, rather than chosen at random: these 'accumulations', as Arman calls them, have a definite formal structure and generate a specific aesthetic effect. While the objects do not undergo the kind of aesthetic transformation found in the work of Schwitters, their arrangement, 'informal' as it may be, still bears the mark of an artistic imagination with a definite sense of structural coherence.

Rather than smashing his violin in a fit of real anger, Arman carefully dismantled it into its component parts. In a number of other works he sawed up violins, cellos or guitars into narrow segments and mounted them in a parallel pattern on the surface of the picture

(see Fig. 359). The effect is one of destruction, but also of formal calculation, mitigated by the impression of randomness in the arrangement of the segments: like so many other artists of his generation, Arman was fascinated by the idea of chance, which offered a radical alternative to the traditional ideology of 'law and order' in art.

The dismembering of musical instruments is a traditional motif in modern art, dating back to the time around 1910 when Picasso (see Fig. 360) and Braque began to fragment the object in order to develop their new, Cubist concept of form. The objects which came in for this treatment included violins, guitars and mandolins, which were dismantled on the canvas in an act of artistic irreverence that, paradoxically, was motivated by a new kind of reverence for the picture: in fragmenting such objects as musical instruments, the Cubists sought to demonstrate the autonomous musicality of form and colour. The same thing can be seen in the work of Arman, with the difference that he attacks the musical instrument itself, rather than allowing the brush to undertake the work of fragmentation. It is a matter for debate whether his pictures, like those of his Cubist predecessors, compensate for the destruction of the object by interpreting it in aesthetic terms, or whether an element of surplus aggression remains which is not fully absorbed by the process of aestheticization.

KLEIN

The Ideal Character of the Picture

The work of Yves Klein exhibits a restless creative energy unparalleled by almost any other artist of his generation. From the beginning of his career until his early death in 1962, he unceasingly leap-frogged from one idea to another: he was one of those artists who extend the boundaries of art by continually overstepping them. His activities were always bathed in a glare of publicity, and there is a hint of the charlatan about him, oddly combined with a touch of religious fanaticism. He was an introverted Utopian who nevertheless hungered for public attention. As the leading figure of the *Nouveau Réalisme* group, he was closely associated with Arman, Spoerri and Jean Tinguely, artists who shared his sense of irony but who were more concerned with physical reality than with metaphysical abstractions. Compared with them, Klein appeared like a kind of saint, albeit one who was not afraid of public spectacle.

In 1960/61 Klein painted three monochrome pictures (Plates 144-46) whose formats are relatively small. To a greater extent than his larger canvases, these paintings convey a sense of the picture as a self-enclosed object, which consequently has no need of a frame, rather than as the scene of some form of event. This is emphasized by the rounded corners and the relief-like surface. The pictures have a physical immediacy which aligns them with the work of other members of the group.

Sponge Relief, RE15, Blue (Plate 144) is one of a series of paintings incorporating sponges. The sponges are painted blue and stuck on

PLATE 144
Yves Klein
Sponge Relief, RE 15, Blue, 1960
Sponges and paint on plywood
107 x 60 cm

Fig. 361 Yves Klein
Sponge Relief, Blue, 1961

the blue ground in a 'calculatedly random' arrangement. If one looks at the work from slightly to one side, some of the sponges appear to stick out over the edge of the plywood support, an effect which heightens the impression of the picture as object.

Klein regarded blue as an inherently spiritual colour, an idea which links his work with a specifically German tradition of aesthetic speculation extending from Romanticism, with its notion of the *Blaue Blume* (blue flower), to the theories of the *Blaue Reiter* group. The idea of blue as the distinctive colour of a remote area of experience far removed from mundane reality is not without a certain empirical foundation, inasmuch as objects seen from a distance – mountains, for example – tend to appear blue. Seeking to escape the confines of physical reality, Klein naturally opted for colours which tend towards the immaterial: gold and, above all, blue. He did not merely choose these colours, he immersed himself in them as in a sea of sheer emotion. Banishing forms and lines from his pictures, he sought to achieve 'pure sensitivity'. He explained that his preference for the monochrome was determined by 'a longing ... to sense the soul and to represent this feeling without words' – that is, without individual forms or lines and using only a single colour. Klein's thinking revolved around such concepts as purity, emptiness and immateriality, which eventually led him to work with wholly immaterial elements, such as fire and air.

In Klein's work one finds a certain conflict between the material and the immaterial. In his efforts to convey the 'spiritual' dimension of the colour blue the artist found himself faced with a technical problem: the binding agent in the pigment tended to detract from the purity of the colour. He eventually devised a solution to this problem in 1960, the year in which he also made his first monochrome picture in gold. Despite his spiritual leanings, he always paid close attention to the technical aspect of art.

*

Planetary Relief, 'Moon' I, RP 22, Red (Plate 145) was created in a manner which at first sight appears wholly unartistic. Klein took a relief map of the moon, threw handfuls of cement at it and then painted or sprayed the layer of cement with carmine colour. However, Klein did not rely solely on mechanical procedures: it is likely that he used either his finger or some kind of tool to make the holes in and between the 'craters'. The picture is part of a series of works done in 1960/61 which Klein called 'planetary reliefs' (see Fig. 362, 363). Most of these pictures are relief maps of France, coloured blue, but some of them are white and possibly unfinished. There are also three reliefs in red: two of the moon and one of the planet Mars. It is surprising that instead of blue – the colour of remoteness and transcendence – Klein chose red – the colour of fire – for these 'planetary' pictures. Red, in general, is a more sensual colour than blue; however, the red in this picture is tinged with violet, which takes away its warmth and lends it a harsh, almost phosphorescent quality.

This red picture is altogether more sensual and physical than the blue and gold monochromes (Plates 144, 146). Above all, it has a

Fig. 362
Yves Klein
Planetary Relief, Blue
1961

marked tactile quality. As one's eye roams through the picture, one finds oneself mentally fingering the bumps and indentations in the relief, the mountains and craters, the solid matter of the planet's surface. Like the convex forms in the sponge pictures, the concave craters and holes introduce a sense of materiality into Klein's declaredly spiritual art. With their 'geological' formations, both the sponge pictures and the 'planetary reliefs' can be seen as exemplifying the world-wide trend in the 1950s towards an art of matter and structure, an art whose foremost exponents in Europe were Dubuffet and Tàpies. It is this interest in matter which links the work of Klein with that of his friends from the *Nouveau Réalisme* group, although his preoccupation with the spiritual marks him out from the other members of the circle. The loose, seemingly random arrangement of the sponges and the craters also follows one of the central principles of the art of the 1950s, in which the element of chance plays such a prominent part: one thinks, for example, of the random distribution of paint in Action Painting or the chance accumulations of broken objects and shoddy materials in 'object' art. Yet chance can also be regarded as a dispensation of providence, as a manifestation of a higher will, a view which Klein, with his esoteric leanings, found attractive. Thus, in manipulating the surface of his reliefs, he limits himself to helping chance along, eschewing any kind of compositional order. One is reminded of the work of another, considerably older artist: Fontana, who in the 1940s had begun to puncture his pictures in a similarly random manner (see Plate 147). Both Klein and Fontana physically attacked the picture and launched a vehement assault on traditional concepts of art with the intention of opening up new aesthetic avenues.

Fig. 363 Yves Klein, *Planetary Relief, Blue* 1961

*

Monogold, MG 11 (Plate 146) is a plain gold surface whose monochrome appearance is broken up by the chessboard pattern of the squares of gold leaf. There are eighty-eight squares in all, measuring seven by seven centimetres and arranged in eleven rows of eight. The gold is loosely stuck on to a piece of plywood covered with a layer of plaster; in places it is peeling away, and the slightest draught

Yves Klein, *Planetary Relief*, *'Moon' I, RP 22, Red*, 1961
Plaster and paint on plywood, 95 x 65 cm

causes it to tremble and shimmer. If one stands in the right place when looking at the picture, one sees a diagonal relief effect which is produced by the ground, whose unevenness breaks up the reflection of the light. It would hardly seem appropriate to speak of a golden 'surface': the edges, too, are wrapped in gold leaf, which gives the work the appearance of a golden object rather than of a picture.

The spell which this object casts on the viewer is undoubtedly influenced by our 'atavistic' attitude to gold, which is both a material and an immaterial substance. Throughout the ages gold has always been a source of fascination; one could write a history of its cultural and artistic significance, from the civilizations of antiquity, via the Middle Ages to the present day. It is traditionally associated with the sacred and the mystical. Klein's gold monochromes are like modern devotional pictures. It therefore comes as no surprise to learn that he was keenly interested in Christianity and Zen Buddhism, in addition to certain rather dubious forms of mysticism.

Fig. 364 Lucio Fontana, *61 O 52: Sun in St Mark's Square*, 1961

Lucio Fontana, an Argentinian of Italian extraction, was born in 1899, which makes him almost thirty years older than Klein. He was the spiritual and intellectual mentor to a whole generation of European artists, from the *Nouveaux Réalistes* to the painters and sculptors who assembled under the banner of Op Art in the 1960s. Fontana overturned the traditional practice of painting by restricting himself to monochrome coatings of the picture support and by attacking and violating it. He began to perforate his pictures in 1948; from 1958 onwards the rough-edged punctures were replaced by sharp, clean cuts. In these activities there was a fundamental principle at stake: Fontana's aim in performing such unusual, unexpected operations was to bring about a renewal of painting, but without abandoning the traditional form of the easel picture. He limited himself to violating the surface and left the picture as such intact. He also refrained from violating form: in his pictures form is merely arrived at in a different way, using alternative means. The distribution of the holes or cuts corresponds to the arrangement of dots and lines in the more traditional paintings of other abstract artists, and it incorporates an element of randomness which reminds one of Action Painting. However, the act of destruction, whose radicalism far outstrips that of an artist such as Burri (see Plate 134), signifies a categorical rejection of painting in all its previous forms: it has the

PLATE 147
Lucio Fontana
Spatial Concept
49 B 3, 1949
Paper on canvas
100 x 100 cm

Fig. 365
Lucio Fontana
Spatial Concept 59 B 2
1959

character of a determined effort to transform art and to make the viewer think about the nature and function of the picture. Fontana's work thus points to the intellectual foundations of art. *Concetto Spatiale* (Spatial Concept), the title which he gave to many of his pictures, not only refers to a particular idea of space, but also indicates that his art is based on a concept, an intellectual idea. Moving away from a purely 'retinal' conception of art, Fontana and other artists emphasized the importance of the intellect, with highly varied results. Duchamp, for example, painted pictures as though they were technological artefacts, and this, too, betokened a rejection of the idea of art as a source of visual pleasure or as a vehicle of self-expression.

Fontana's aesthetic thinking, like that of Klein, is orientated towards the idea of overcoming the physical materiality of the picture. This dematerializing tendency is epitomized by the unstructured white of many of Fontana's pictures, a colour preference which one frequently encounters in modern art from Mondrian onwards, especially in post-war geometricism and in Op Art. However, despite the emptiness of his pictures, signifying pure spirit, they retain an unmistakable tactile quality, a definite physical and material character. The act of destruction itself, while motivated by spiritual considerations, is a drastic material event: it causes the surface of the picture to burst open. In the earlier, perforated works the paper or canvas is lacerated with holes whose edges are ragged and torn. Some of these pictures include fragments of glass which are stuck on to the surface next to the holes (see Fig. 364), and this, too, is a conspicuously tactile feature. The tactile value of the clean cuts in the later pictures is less obvious, but one nevertheless experiences the slashing of the taut canvas as a physical shock.

The three works reproduced here offer an excellent illustration of Fontana's approach. In the early perforated picture (Plate 147), the

PLATE 148
Lucio Fontana, *Spatial Concept, 60 O 48*, 1960
Oil on canvas, 150 x 150 cm

PLATE 149
Lucio Fontana
*Spatial Concept, 65 T 46
(Expectations)*, 1965
Tempera on canvas
118 x 148 cm

holes, which were made partly from behind and partly from the front, have a certain random character but nevertheless form a coherent pattern of lines and configurations; in places they cluster together like metal balls on a magnetic plate. The larger holes in the yellow perforated picture (Plate 148) are more individual and expressive; they are encircled by rigorous, scribbled lines which are etched into the impasto of the painted surface. The slashed picture (Plate 149) finally dispenses with expression. Ten parallel, vertical cuts are made at intervals which once again appear random. The effect of the work is dictated partly by chance and partly by calculation. What is notably lacking is the emotional quality of the more expressive, perforated pictures, where the surface is, as it were, 'vandalized'. The tactile value is reduced to a bare minimum. Instead, the idea of space acquires central significance: the space beyond the cuts is a black, infinite void. The word appended to the title, 'Expectations', indicates the artist's aim of evoking a mood of meditative calm. Fontana was one of the many artists in the 1950s and 1960s who sought to achieve a meditative effect through emptiness and nothingness. In this respect, his pictures were much admired by younger artists – Klein, for instance – and it is in the context of this generation, rather than his own, that Fontana's work has to be seen.

Fig. 366 Günther Uecker, *Chair (1)*, 1963

One of the movements which succeeded *Art Informel* in the 1960s was Op Art, whose practitioners rejected the randomness and expressive 'impurity' of *Tachisme*, Action Painting and 'matter' art. Reviving the geometricist approach of the 1920s and 1930s, they based their work on structural principles derived from optics, emphasizing the importance of order, precision and purity in the use of colour, light, material and movement. These ideas were taken up by the ZERO group, which was founded by Otto Piene and Heinz Mack in the late 1950s. Based in Düsseldorf, the group had a wide following, both within Germany and elsewhere. Its members included Günter Uecker, who joined in 1960. ZERO became a clearing house for a variety of artistic trends: it attracted the support of Tinguely and Spoerri, two of the foremost exponents of *Nouveau Réalisme*. Yet unlike their colleagues from Paris, who were obsessively concerned with matter, the Düsseldorf artists followed the lead of Fontana and Klein in affirming the absolute purity of the artistic idea: Piene even coined the term 'Nouveau Idéalisme' to distinguish his conception of art from that of the 'materialists'. None the less, in the work of the ZERO artists the notion of purity, of immateriality and spirituality, is translated into specific material terms: Piene works with fire, Mack uses reflecting metals, and Uecker's characteristic material is nails.

Uecker's almost exclusive preference for this material demonstrates the latent affinity between *Nouveau Réalisme* and *Nouveau Idéa-*

PLATE 150
Günther Uecker
Table, 1963
Oak, partly sprayed white,
and nails, 80 x 65 x 65 cm

lisme, despite the apparent differences between these two rival notions of art. Nails are essentially mundane, everyday objects; one could hardly hope to find a more 'realistic' – and aggressive – material. The act of hammering in a nail is also an artistic 'action', a drastically material event. Uecker has even staged public 'happenings' which, like those of his friend Klein, purport to preserve the purity of the artistic idea. In addition, the nail dynamically violates the picture, as do the perforations and slashes in the canvases of Fontana. There is a further eminently 'real' aspect which links Uecker's work with that of the *Nouveaux Réalistes*: his practice of covering everyday objects – tables, chairs, pianos and television sets – with forests of nails which defamiliarize the objects and transpose them on to the plane of art but which make no attempt to camouflage their mundane provenance. Notwithstanding Uecker's concern with the spiritual, the objects in such a work as *Table* (1963; Plate 150) are not, in fact, spiritualized but merely reinterpreted: their new aesthetic meaning and interest derive precisely from the tension between the aesthetic action and their original function, which remains plainly apparent.

<p style="text-align:center">*</p>

In his abundant programmatic statements Uecker seldom mentions this material dimension of his activities. He speaks mainly of light, space and spirituality, which in his work, as in that of so many other modern artists, are symbolized by the colour white. Over a period of some twenty years he has produced a continuing succession of nail pictures with white surfaces. In some cases the nails are arranged in uniform structures which cover the entire picture, whereas in others they form clusters, like clumps of poisonous fungi which appear to eat into the surface. One of Uecker's favourite forms is the concentric or spiralling circle (see Fig. 368). The spiral enhances

Fig. 367 Marcel Duchamp, *Rotorelief No. 8*, 1935

Fig. 368 Günther Uecker, *Spiral*, 1958

Fig. 369 Günther Uecker, *Light Spiral*, 1970

the impression of circular movement, which in some pictures is converted into real movement by the addition of an electric motor. The circle occupies a prominent position in the formal vocabulary of twentieth-century art, enjoying especial favour with the exponents of geometricism. In using the circle, Uecker therefore locates his work in this particular historical tradition, although the idea of rotation, combined with flagrant materiality, points above all to the art of Duchamp (see Fig. 367), who also made occasional use of electric motors in his works. In Uecker's *Between Light and Dark* (1983; Plate 151) the nails are arranged on the two unprimed canvases in spiralling circles, one underlaid with white, the other with black paint. The spontaneous structure of the painted surface, which also has a spiralling appearance, complements the rotating movement of the nails and intensifies the sense of pace which characterizes the picture. Both the bare canvas and the casual, informal manner in which the paint is applied make it plain that this work, unlike the dark and light spiral pictures which Uecker created in 1970 (see Fig. 369), has little to do with the idea of purity. However, Uecker demonstrates his continuing concern with the effect of light and space and with the dualism of white and black, a dualism which can be seen as a fundamental spiritual principle.

MANZONI

One of the international followers of ZERO, which was also known as NUL, was the Italian Piero Manzoni. He, too, favoured white, painting monochromes which he preferred to call 'achromes' (see Plate 152). In much the same spirit as the ZERO artists he spoke of 'total space' and 'absolute light'. His aim in his pictures was to create 'a totally white – or rather, totally colourless – surface, removed from all painterly phenomena, from any formal intervention: a white which is in no sense a polar landscape, an evocative or even merely beautiful material, a sensation or a symbol, or anything else of the kind; a white surface which is a white surface and nothing else (a colourless surface which is a colourless surface); indeed, better still, a surface which is, and nothing else: "being".' In spite of his declared intention, Manzoni's pictures retain a certain element of painterliness. He structured the surfaces of his paintings, which are made up of square pieces of corrugated canvas: these were first steeped in kaolin before being covered with a layer of plaster, to which the white paint was applied. The squares are arranged in semi-geometrical, slightly irregular patterns. One notices a certain informality in the randomness of the corrugations and wrinkles from which the pictures derive their sense of animation. With their relief-like effect, the paintings have a pronounced tactile character, which one also finds in Manzoni's works in other materials, such as cotton-wool and glass fibre.

Like many other artists of his generation and intellectual persuasion, Manzoni created his pictures in series, and within individual works he repeated a single basic form, following a 'serial' principle which does away with hierarchical organization and traditional notions of composition. The important thing was that the structures should be

PLATE 152
Piero Manzoni, *Achrome*, 1958
Kaolin and fabric on canvas, 80 x 100 cm

Fig. 370 Piero Manzoni, *Achrome*, 1959/60

regular, while incorporating an element of irregularity which disrupts them but leaves them basically intact. Regularity is offset by irregularity, and vice versa. Manzoni, too, was a believer in pure spirituality, a conceptual rather than a visual principle which confers a Utopian quality on the entire range of artistic activity which lies between Fontana and Klein, between 'neo-geometricism' and Op Art. And like many of the other artists who espoused the principle of spirituality, he had no difficulty in establishing a connection between this experimental idealism and the 'New Realism' being propagated at the time, by making objects of a quite different kind and by staging public happenings which boldly challenged artistic and moral conventions and on numerous occasions offended the sensibilities of the audience. Manzoni died in Madrid in 1963, at the early age of thirty.

The trend towards the monochrome, generally combined with a radical simplification of form, is one of the most characteristic developments in post-war painting from the 1950s onwards. The motives behind this trend are highly varied, and the results, too, are very different, which makes it difficult to use the term 'monochrome' as a collective label: it covers a multitude of heterogeneous intentions and artistic practices. Some monochrome pictures have no ambition to be anything but plain-coloured surfaces. Others are coloured spaces whose spatial quality is suggested by the use of a single colour. There are monochromists whose principal concern is form, but the monochrome can also serve to articulate the idea of pure spirituality, whose significance extends far beyond formal considerations. Finally, the monochrome can also be the product of an expressive passion which wipes out colour and, indeed, everything else. Although the action of the monochrome picture tends to oscillate between the twin poles of form and spirit, the principle of emptiness and nothingness is generally associated with the notion of spiritual fulfilment. One finds several painters of this period striving to transform the empty surface of the picture into a spiritual space in which the viewer's eye finds a form of meditative repose. This is a decidedly Romantic aim which represents the antithesis of those forms of contemporary art which are orientated towards the realm of 'objective' fact: towards the formal facts of geometry; towards physical facts, such as light and movement, in Op Art and kinetic sculpture; and towards the products and the detritus of modern technological civilization in Neo-Dada and Pop Art. In view of the polarity between these two rival conceptions of art, it is remarkable to find them co-existing in the work of such artists as Klein, Uecker and Manzoni.

The medium through which the monochrome principle works is, of course, colour, regardless of the degree of purity with which the principle is applied. Klein invests colour with a lofty metaphysical significance. Arnulf Rainer fills it with existential disquiet. Like Mondrian and Malevich before them, many of the artists associated with *Nouveau Idéalisme* attached particular importance to black and white, the 'absolute' colours: one thinks, for example, of Fontana (see Plate 149), or of the pictures of Manzoni, Uecker, Jan Schoonhoven and Enrico Castellani. At the start of his career, even Rauschenberg painted black and white monochromes. To label Mark

Fig. 371 William Turner
*Seascape with Storm
coming on, c.*1840

Fig. 372 Caspar David Friedrich
Evening, 1824

Fig. 373 Mark Rothko, *No. 1 – 1962,* 1962

PLATE 153
Gotthard Graubner
Colour Space Body I, 1973
Oil on Perlon over synthetic fleece
on canvas, 201 x 131 cm

Rothko (see Plate 158) a monochromist would be quite mistaken, but the general trend towards the use of plain, single colours nevertheless left its mark on his oeuvre, and towards the end of his life he turned to painting all-black pictures. Apart from Klein and Manzoni, none of these artists elevated the monochrome to the level of a programmatic issue; for all of them, what counted was not so much colour itself as the spiritual opportunities which it offers when presented in a pure form.

GRAUBNER

The aesthetic thinking of Gotthard Graubner, who was born in 1930, is dominated by the ideas of colour, light and space. Everything else is deliberately muted in his pictures: for him, silence has a high spiritual value. He uses pure colours whose interior monologue remains undisturbed by form or by other, extraneous colours. Graubner's principal aim is to make colour speak for itself, but he also seeks to convey a sense of space and light, and to communicate a particular spiritual mood to the viewer. To this end, he provides the colour with a 'body', or, as he himself calls it, a *Colour Space Body* (Plate 153), whose immaterial effect is linked to a specific materiality: the cushioning of the canvas and the Perlon cloth which is stretched over the painted surface. The pictures are not straightforward monochromes: the colour is cloudily nuanced and animated; it appears to breathe, to pulsate with a life of its own. Unlike the products of American colour-field painting, Graubner's works have an intensely subjective character. With the utmost sensitivity and subtlety, the artist induces the colours to speak. Since their content is spiritual, their thematic significance goes beyond the tautological idea of colour as colour. Graubner's pictures can best be compared with the vibrant coloured spaces of Rothko's paintings (see Fig. 373). Condensing light and space into silent, spiritual forms, they also call to mind the work of William Turner (see Fig. 371) and Caspar David Friedrich (see Fig. 372), two painters whom Graubner holds in high esteem.

The inappropriateness of using the term 'monochrome' as a catch-all rubric is strikingly illustrated by the case of Arnulf Rainer, whose work stands outside the sphere of influence of such artists as Fontana or Klein. His monochrome pictures have little or nothing in common with those of his contemporaries. Nevertheless, his decision at the end of the 1950s to begin painting pictures dominated by a single colour is typical of the generation to which he belongs. Rainer is not concerned with space or light, nor is he interested in the purity of 'spiritual' principles. His art is non-ideological, entirely free of aesthetic idealism or Utopianism. It is a means, or a continuing process, of self-exploration, a 'passion' in both senses of the word which, over the years, has taken on a wide variety of artistic forms, of which the 'overpaintings' are but one example. Inevitably, the exploration of the self is also an exploration of art, of a particular kind of experience, both in and with the medium of painting: the process takes place within the medium and, at the same time, transforms it. Thus, Rainer's art deals with both human existence and the existence of art: one is tempted to speak of it as existential or even Existentialist. It goes beyond the expressive in the normal sense, and the term Abstract Expressionism seems an inadequate stylistic classification, although Rainer's work has a closer affinity with the products of this movement than with those of other, primarily ideological currents in post-war art.

Rainer himself has explained that his original intention in devising the technique of overpainting was merely to 'disguise the weak points' in his pictures: 'I wanted to create even better works of art; anything else is just rumour.' However, what generally counts in art is precisely the kind of 'rumour' which it provokes. Rainer's account of how he hit upon the technique fails to explain why he accepted the result as a definitive picture and subsequently adopted overpainting as a wholly legitimate method of making pictures, instead of using it for merely corrective purposes. 'Since then,' the artist continues, 'I have noticed that there is no end to the weak points, even when a picture is completely black, because overpainting creates a new visual structure of its own, and there are weak points again, black in black. So I never cease working on my pictures.' Rainer speaks of the 'intoxication' associated with the act of covering the canvas with one layer of paint after another, of the compulsive urge 'to constrict, to strangle, to kill'. Overpainting became a veritable obsession, a continually repeated process and, hence, a style in its own right, in whose conception the idea of death, of the extinction of life, evidently plays a central part, as a deeply pessimistic motive. The result was an extended series of dark and silent pictures, almost invariably monochrome. 'I wanted to spread darkness,' Rainer says: 'I wanted an almost seared up black picture. The principles of my works between 1953 and 1965 are the extinction of expression, permanent covering and contemplative tranquillity.' And he adds: 'My ideal is the completely dark picture, full of some overwhelming silence. Only an "almost", a "nearly", is possible. But I have settled down in this border area; I am trying to find distinct standards of shape, and I long to experience, formulate and evoke this dark, heavy tranquillity.'

Fig. 374 Arnulf Rainer, *Violet Overpainting*, 1961

PLATE 154
Arnulf Rainer
*Overpainting: Red Madder
Lake on White*, 1959/60
Oil on canvas
200 × 130 cm

The meaning of a picture such as *Red Madder Lake on White* (Plate 154) becomes fully clear only when seen in the light of Rainer's own comments: '[Out of] the "overpaintings", which I pursued in the fifties and sixties ... the "total overpaintings" developed ... through incessant reworking. The original motif peeped through the edges. Gradually it vanished completely. Only the four corners of the background remained. It was terribly difficult to fix my eyes on all of them at the same time. My experience was that the most difficult thing of all in art is painting in all four corners at the same time. Sometimes I had to force the overpainting of three corners almost without any feeling for shape, almost without inspiration, only to find my way back, to get out of this hell. Otherwise I would have been stuck in this transparent, unspeakable kind of picture. I could only relax when there was just one tiny white last spot left. I could see more clearly. I could grasp the shape of the picture again.... The pictures are alive because of the white remnant, the almost-concealment.' Rainer himself calls into question this account of his struggle with form and colour: 'Maybe it is all a chimera, merely the imagination of somebody crazy about erasing, the fancy of somebody seeking nothingness, the whim of somebody tired of the world of forms, monstrosities of somebody morose and fed up with the world.'

Fig. 375 Mark Rothko, *Number 118*, 1964

These statements indicate the extreme emotional intensity of Rainer's work, which constantly oscillates between the extremes of hope and utter despair and is the scene of a conflict which can truly be called existential. This may seem a trifle far-fetched, as though one were trying to interpret too much into these empty coloured surfaces. Yet the surfaces are not, in fact, empty: if one looks at them carefully, they reveal themselves to be veritable battlefields, covered with the traces of frenzied action. Instead of eliminating expression, as he claims, Rainer invests his pictures with an expressive power which is reminiscent of Abstract Expressionism, tenuous as the relationship may at first seem. Then there is the colour, a deep, dark violet which, like black, has a psychic implication, unlike the pure, bright colours of colour-field painting, which have no ambition to be anything but straightforward colours. This psychic significance derives not only from the choice of colour, but also from the passion with which the paint is applied to the canvas. Rainer even regards the random traces of colour on the inside of the wooden frame as an intrinsic part of the picture, since they are part of the action of painting. The spiritual intensity of these pictures thus depends on several features at once: on the choice of colours, on the emotionally charged manner in which they are treated and on the renunciation of 'form' in favour of an effect generated almost exclusively by the large areas of colour – the effect of 'dark, heavy tranquillity', which is, in fact, a dark, heavy disquiet.

One need hardly add that Rainer's fascination with emptiness and nothingness is shared by a wide variety of twentieth-century painters, from Malevich onwards (see Fig. 291). Rainer's dark and deeply serious pictures, steeped in existential experience and suffering, can be located somewhere in the triangle formed by the work of Rothko (see Fig. 375) and Ad Reinhardt (see Fig. 376) in America and the art of Tàpies (see Plates 130, 131) in Europe. Yet rather than merely

Fig. 376 Ad Reinhardt, *Abstract Painting*, 1958

indicating their general position in the stylistic cosmos of modern art, it would seem important to note their geographical place of origin. Beset by danger and constantly hovering on the brink of aesthetic suicide, the art of Rainer is clearly indebted to an intellectual and artistic tradition which is characteristic of Austria, his native country: Egon Schiele and Kokoschka (see Plate 36) are but two of the names which automatically spring to mind.

Pop Art

In the twentieth century art has often been mocked and affronted, but the perpetrators of these assaults were invariably artists. Attacking art for artistic purposes is one of the recurrent themes of the art of this period. The anti-art movement was pioneered shortly before the First World War by Duchamp, who transformed mundane objects into works of art by adding his signature and putting them on show in galleries. Outside the institutional framework of art the objects were worthless, but within it their effect was tremendous. However, despite his anti-art activities, there can be no doubt that Duchamp was a true artist and, as *The Chocolate-Grinder* (Plate 40) shows, a first-rate painter.

This first assault on art by Duchamp and the Dadaists, using everyday, banal objects, was followed by a second attack in the late 1950s and early 1960s, with Neo-Dada and Pop Art, both of which were essentially American movements. The motives behind Pop Art were quite different from those which had inspired earlier artists. Anti-art iconoclasm was only one of its constitutive elements; the other was a by no means critical fascination with the reality of modern America. Pop artists discovered the reality of consumer culture, of photography and film, of road accidents and crime – the reality of everyday life from which art had hitherto remained aloof, but which it now found itself obliged to address. Since the artists saw themselves as part of this reality, they could no longer paint it in the traditional manner: in depicting trivial objects – a soup can, for example – their aim was not to translate the object into the terms of conventional still life painting, but to make an image which retained the original character, the crude actuality, of the object, eschewing all forms of aesthetic sublimation. Nevertheless, Andy Warhol, Roy Lichtenstein, Claes Oldenburg and a number of other Pop artists succeeded in discovering specific aesthetic qualities in the world of the supermarket, of advertising, of the mass media, and their pictures are authentic works of art which have an exceptional expressive power.

WARHOL

The life and work of Andy Warhol became shrouded in myth at an early date. Legend has it, for example, that in 1962, when Warhol had reached an impasse in his work, somebody made the casual suggestion that he should paint an object with which every American was so familiar that no one took any notice of it: 'something like a Campbell's soup can'. Warhol bought a whole series of soups in various flavours and set to work. At first he made conventional,

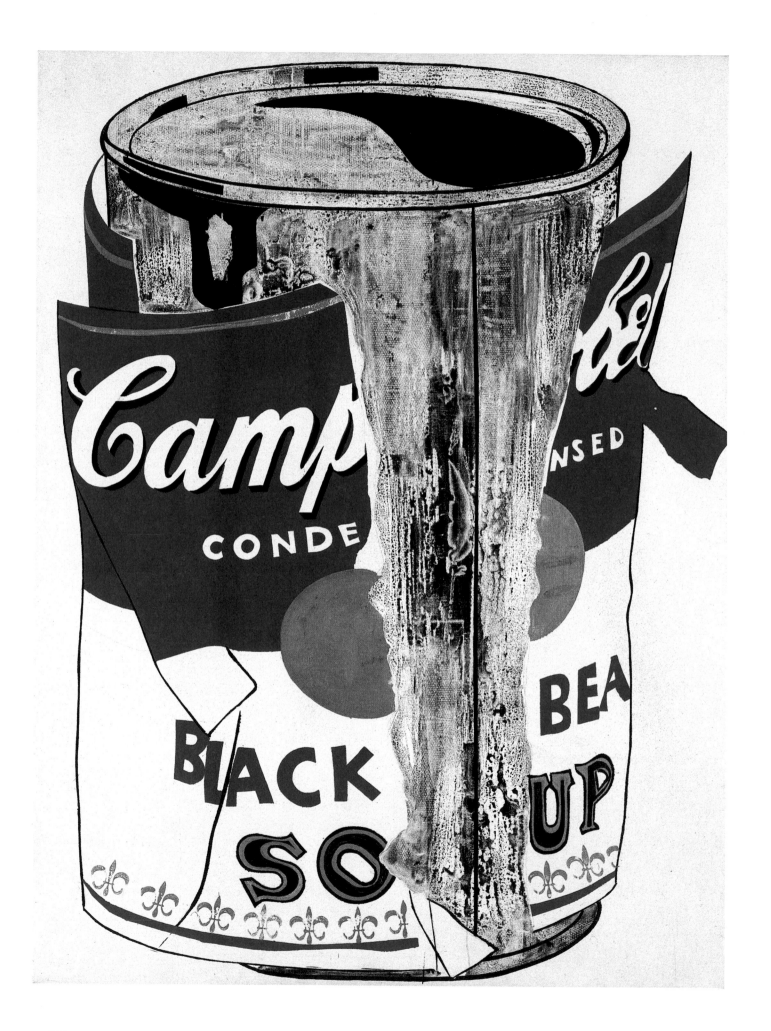

314

Fig. 377 Andy Warhol
Campbell's Soup Can, 1965

Fig. 378 Andy Warhol
*One Hundred Campbell's
Soup Cans*, 1962

PLATE 155
Andy Warhol
*Big Torn Campbell's
Soup Can (Black Bean)*
1962
Acrylic on canvas
183 × 137 cm

Fig. 379 Jasper Johns, *Two Beer Cans*, 1960

large-format paintings of the cans; later that same year, however, he began silk-screening photographs of them on to canvases (see Fig. 377, 378). The silk-screen print subsequently became his preferred medium, until he moved on to film.

Warhol's soup cans have no pretensions to be anything other than banal household objects, identical with millions of other such cans. Nevertheless, certain features of *Big Torn Campbell's Soup Can* (Plate 155) lend it a definite individuality: its isolation, its size and the unique way in which the label is peeling off the tin. The tin and the label are painted with a skilful naturalism – only the pattern at the bottom edge of the label is stencilled – which is purely imitative and lacks any individuality. However, one still finds ample evidence of visual experience and invention: in the lovingly accurate reproduction of the surface of the tin, in the seemingly random way that the lettering is broken up and in the overall directness of the picture, which shows no respect whatever for 'art'.

Klee once remarked that the task of art was to make the invisible visible. Revising this dictum, one could say that Warhol's aim is to make the visible visible. Nobody had ever looked at Campbell's soup cans until Warhol 'discovered' them, just as no one had taken much notice of the Stars and Stripes before Johns drew attention to them (see Plate 141). Some people find this pointless and complain about the banality of the cans, but the obvious rejoinder to such objections is that traditional still lifes are also full of banal objects: why, one asks, should a wine glass be regarded as a more inherently eligible subject for art than a soup can? Warhol does not merely paint banal objects; his real theme is their intrinsic banality, their essential quality of ordinariness, and he points to their mundane significance in everyday life. In his picture the soup can becomes a symbol with sociological and psychological implications, and is thus the subject of an undeniably artistic statement. In the early 1960s pictures like

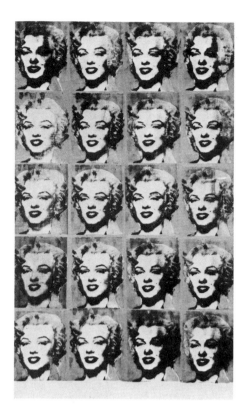

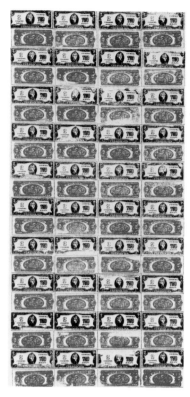

Fig. 380
Andy Warhol
The Twenty Marilyns
1962

Fig. 381
Andy Warhol
*Eighty Two-Dollar Bills
(Front and Rear)*
1962

this and a sculpture such as Johns's *Two Beer Cans* (Fig. 379), a three-dimensional image of almost unsurpassable banality, opened up new horizons of visual experience.

*

Woman Suicide (Plate 156) is part of a series of works based on the principle of repetition, using the same motif, often even the same photograph, over and over again. Like the images in Rauschenberg's *Quote* (Plate 140), the photograph of the woman is silk-screened on

PLATE 156
Andy Warhol
Woman Suicide
1963
Silk-screen print
on canvas
313×211 cm

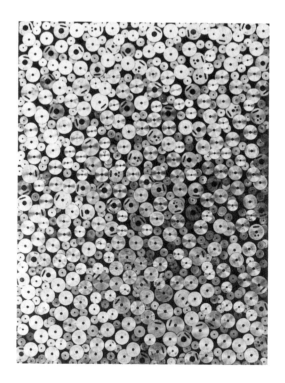

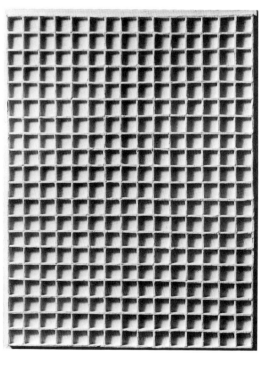

Fig. 382
Arman
Nucléides
1964

Fig. 383
Jan Schoonhoven
R 71-15
1971

317

to the canvas. Yet unlike Rauschenberg, Warhol does not intervene with the brush. He prints the same black-and-white photograph from the files of the New York Police Department in several overlapping rows to create a composite image which conveys, with exceptional directness, both the reality of the suicide, an event as mundane as it is shocking, and the reality of police files and of the mass media. Nevertheless, in this work, as in the picture of the soup can, there is an aesthetic element which modifies and tempers the real. In the course of the printing process the colour alternates between almost black and light grey, and there are intentional, albeit random flaws in the alignment of the individual images, which overlap in places or slant to one side. Although reality is admitted into the picture, in a raw, unprocessed form which excites and disconcerts the viewer, it is at the same time qualified by the serial rhythm of the repetition, the nuancing of the colour and the irregularity in the arrangement of the silk-screened images. Even here, where 'art' in the conventional sense is seemingly abandoned, what we see is, in fact, an artistic appropriation of reality.

Warhol made frequent use of the device of repetition, which is essentially an 'all-over' principle. He employs this technique in his pictures of car accidents and the two-dollar note (see Fig. 381) and in his serial portraits of Marilyn Monroe (see Fig. 380), James Dean, Marlon Brando and Elvis Presley. One encounters the same aesthetic principle in the work of several artists whose ideas, in other respects, run contrary to those of Warhol: for example, in the work of the *Nouveau Réaliste* Arman (see Fig. 382) and in the serial structures of an exponent of Op Art such as the Dutchman Schoonhoven (see Fig. 383).

LICHTENSTEIN

Together with Johns's *White Flag* (1955; Plate 141), Rauschenberg's *Wager* (1957/59; Plate 138) and Warhol's *Woman Suicide* (1963; Plate 156), Roy Lichtenstein's *Big Painting No. 6* (1965; Plate 157) is one of

Fig. 384
Roy Lichtenstein
Red and White Brush Strokes
1965

PLATE 157
Roy Lichtenstein
Big Painting No. 6, 1965
Oil and magna on canvas
233 x 328 cm

the outstanding pictures of the new generation of American painters
which emerged in the late 1950s and challenged the ascendancy of
Abstract Expressionism. Like Rauschenberg and Johns, Lichtenstein
deals with the reality of modern America, the world of consumer
culture, of the supermarket, advertising and comic strips. His pic-
tures epitomize the spirit of Pop Art. In *Big Painting No. 6* he takes the
commonplace image of a collection of brushstrokes and transforms it
into a monumental, ironic pictorial statement. The irony consists in
the fact that the dynamic movement of the brushstrokes is frozen:
the manner of their depiction is meticulous and impersonal, and they
are drained of all expressive energy. Instead of animated brush-
strokes, we find a carefully contrived imitation of animated brush-
strokes, mimicking the painterly style of other artists. By immobiliz-
ing the image of the brushstroke in this way, Lichtenstein implicitly
derides Abstract Expressionism, with its strong emphasis on individ-
uality and its spontaneous, dynamic brushwork, and implies that the
movement is historically obsolete. The impression of dispassionate
objectivity, replacing subjective expression, is heightened by the
mechanical pattern of black dots on the ground. If one examines the
brushstrokes in detail, one finds a pictorial intelligence at work
which reminds one of commercial art, with its simplified, emblematic
images: painting adopts the vocabulary of graphic design. At the

319

Fig. 385
Roy Lichtenstein,
Study for a mural
at the University
of Düsseldorf, 1970

same time, the picture has a remarkable vitality, a celebratory character which recalls the work of Léger, whose influence on Pop artists was greater than that of any other European painter and who was himself particularly receptive to the American reality from which Pop Art took its subject-matter.

Lichtenstein used the brushstroke motif in a whole series of pictures of varying sizes (see Fig. 384), including a mural which he painted for the University of Düsseldorf (Fig. 385). In this work, the motif has a particularly marked monumental character; the ostensibly rapid movement of the brushstrokes is arrested and frozen into an image of stasis.

ROTHKO

Mark Rothko, who was born in 1903, is associated with the American Action painters, but his work lacks the extroverted vehemence of an artist such as Pollock. In his mature pictures the action is directed inwards and conveyed exclusively by the innate energies of the colours. One detects little evidence of an affinity with the work of Pollock, who was nine years younger than Rothko. However, if one looks at Rothko's early work (see Fig. 386), one realizes that he, too, started out as an Expressionist, before discarding the vocabulary of 'gesture' in favour of pure colour. His later pictures, especially his darker canvases, invite the viewer to immerse himself in their tranquillity. They are objects for meditative contemplation: looking at the colours, one inadvertently finds oneself involved in a dialogue with a silent partner. The canvas is generally divided into a small number of large, rectangular fields of colour. In Rothko's pictures, the rectangular form has nothing to do with geometry. The fields of colour are open and ambiguous, and the colours themselves vibrate with a gentle, clearly perceptible rhythm. The silent forms, floating in space, have a quite exceptional spiritual intensity. This distinguishes Rothko's work from that of the colour-field painters of the 1960s, who shared his ideas about colours and energy but refrained from

Colour as Colour

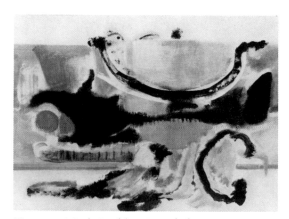

Fig. 386 Mark Rothko, *Untitled*, 1946

PLATE 158
Mark Rothko, *Three Blacks in Dark Blue*, 1960
Oil on canvas, 202 x 193 cm

burdening colour with any kind of expressive meaning: the colour-areas in their pictures have no spatial or spiritual depth. In Europe one encounters this kind of attempt to endow colour with a spatial and spiritual significance in the work of younger artists – Gotthard Graubner, for example (see Plate 153) – whose approach to painting is in other respects quite different from that of Rothko.

Despite the emphasis on colour in Rothko's work, *Three Blacks in Dark Blue* (1960; Plate 158) is almost colourless. The two black rectangular fields and the thin strip of colour at the bottom of the picture are scarcely distinguishable from the blue-black ground. Their spiritual meaning stands out all the more clearly. Around the time when this picture was painted Rothko produced a number of paintings using bright, vivid colours. Towards the close of his career, which ended with his suicide in 1970, his canvases grew ever darker, amplifying the tragic note which is already sounded in this picture from 1960.

FRANCIS

There was more to American art of the 1960s than Pop Art, with its near-exclusive interest in the everyday reality of America. A further movement which flourished at the time was colour-field painting, which was primarily concerned with its own medium, colour. The two leading practitioners of this new style were Morris Louis and Kenneth Noland. However, there were a number of other artists, former adherents of Abstract Expressionism, who also experimented with the effect of 'pure' colour. One thinks, in particular, of Rothko, with his tranquil, meditative pictures (see Plate 158), and of the Californian painter Sam Francis, who was some twenty years Rothko's junior.

From 1950 onwards Francis lived mostly in Paris, where he was exposed to the influence of European artistic trends. He particularly admired Monet's late series of water-lily paintings and the work of Bonnard. In 1957 he made the first of several journeys to Japan, and this marked the beginning of his keen interest in Oriental art and culture. His Californian origins also set him apart from the East Coast painters who dominated the American art scene of the 1950s and 1960s.

St.-Honoré and *Composition in Black and Yellow* (Plates 159, 160), which were painted in 1952 and 1954 respectively, show silent cascades of dense, mollusc-like coloured forms which spread out over the whole surface of the canvas and tend towards the monochrome: white in the earlier picture and black in the later work. There is still an element of 'action', but of a subdued, moderated kind: instead of referring to the subjectivity of the artist, the action has an objective quality, appearing to come from within the picture itself. The forms grow and multiply like organic cells and seem to have a life of their own, an effect which is enhanced by the way that the wet colour is allowed to drip and run. Using their innate natural resources, colour and form seek their own expressive identity.

PLATE 159
Sam Francis
St.-Honoré, 1952
Oil on canvas
201 x 134.5 cm

This is the main point of Francis's pictures. However, Francis also sees colours as having a non-sensual, spiritual dimension, in so far as he uses them to answer the question of the centre of being. Talking about his paintings from this period, Francis later recalled: 'I used to think and talk a lot about my centre, my navel, and was very conscious of my centre.' The consequence of this search for the centre is that the artist, unlike the Action painters, does not act in accordance with the dictates of will, but seeks to apprehend being as such, in its purest, most objective manifestation, independent of individual will and experience. This idea of art, which was influenced by Oriental philosophy, is akin to the thinking of Tobey (see Plates 107, 108), another native of the West Coast who shared Francis's interest in Japan and also questioned the extroverted, expansive pictorial approach of Abstract Expressionism, with its emphasis on individual will.

In addition to their meditative concern with the invisible centre of being, Francis's pictures also speak of the visible world, above all of light, even when their colours are dark. The artist himself explains that what interests him here is 'not just the play of light, but the substance of which light is made'. For him, this 'substance' could only consist in the innate life of colours, and this made him receptive to the influence of such painters as Monet and Bonnard. Since he was aware of the spiritual effect of colours, he had no reservations about exploiting their 'hedonistic' qualities. In the combination of a richly nuanced white or black with marginal touches of bright colour he saw both the materiality of light and the spirituality which was so central to his artistic concerns. Finally, in his work the particles of colour run right up to the boundary of the canvas and, in a sense, beyond it: he himself saw his pictures as randomly selected fragments of an infinite space. The 'all over' structures of other American artists are based on the same idea.

There are obvious similarities between the forms in Francis's pictures from the early 1950s and natural organisms of the kind which can only be seen with the aid of a powerful microscope. While it would be wrong, in this case, to posit any direct connection between art and science, it is entirely legitimate to point out an analogy which is clearly apparent to the modern eye.

Fig. 387 Morris Louis, *Burning Stain*, 1961

LOUIS

Pollock used the technique of dripping; Francis allows the colour to dribble and run down the surface of the picture. In *Gamma Gamma* by Morris Louis (Plate 161) the paint spills in symmetrical, diagonal streaks over the two bottom corners of the canvas. The irregular, yet precise form of these streaks arises spontaneously, as the result of a technical operation in which the artist's imagination plays no active part: the canvas is tilted so that the rivulets of colour run down in the desired manner. Louis refrains from intervening in the painting process and leaves the colours to follow their own autonomous logic. The acrylic paint, heavily diluted with turpentine, is immediately soaked up by the unprimed and unsized canvas;

PLATE 161
Morris Louis
Gamma Gamma, 1959/60
Acrylic on canvas
260 x 386 cm

fabric and colour become one. Hence, the streaks of colour lack all structure: their unrestrained flow determines their form. Between them the artist leaves a large area of unpainted canvas, a blankness which at first has a negative effect but inadvertently creates a positive sense of openness. The language of this picture and others like it is one which requires large formats in order to achieve the intended visual effect. *Gamma Gamma* is part of the series of canvases called 'Unfurleds' which Louis produced in 1960. There are three other series: 'Veils' (1954-60), 'Florals' (1958-60) and 'Stripes' (1961/62; see Fig. 387). Louis died in 1962, at the age of fifty.

NOLAND

Whereas Louis used freely flowing rivulets of colour, the colour in the pictures of Kenneth Noland forms semi-geometric fields and bands. In the work of both these painters colour is defined as an autonomous, entirely self-sufficient quantity, an unadorned objective fact which has no extrinsic meaning. All trace of expression, of individuality, is obliterated: the colours refer only to themselves. Somewhat surprisingly, Noland combines this attitude to colour, rejecting expression and composition, with an interest in geometric

order. Yet he transcends the limits of geometry: in *Bloom* (1960; Plate 162), for example, one finds a marked element of painterliness. Despite the geometric appearance of the concentric circles, the colours are very much 'painted', especially in the irregular outer circles, which completely ignore geometry. This ostensible paradox is somewhat puzzling. Although the inner circles have the exact geometric form of a target, the overall effect of the picture is quite different: the work 'breathes' in a way which clearly distinguishes it from the pictures of, say, Mondrian (see Plates 61-63). Noland's circles are at once concentric and decentralized, centripetal and centrifugal. Despite its absolute flatness, the picture has a certain spatial effect,

PLATE 162
Kenneth Noland
Bloom, 1960
Acrylic on canvas
170 x 171 cm

calling to mind the wide open spaces of America. Closure and openness, secrecy and candour, restriction and freedom: the effect and the spirit of Noland's picture are better described in terms of these oppositions than by the word 'geometry', which is in any case contradicted by the irregular outer circles. Historically, the picture harks back to the coloured circles of Delaunay (see Fig. 389), in which unexpressive bands of colour are also set around a focal point, rather than to the absolute circles of Malevich (see Fig. 388).

*

The same approach can be seen in *Swing* (1964; Plate 163). The bands of colour are geometrically demarcated, but there is a residual element of painterliness, deviating from the geometric order. One is reminded of the teachings of Albers. Like Albers (see Plates 100, 101), Noland leaves colour to follow its own intrinsic logic, albeit within certain clearly defined limits. He, too, paints right-angled bands of colour, although they do not extend over the whole canvas. Yet there is a significant difference between the two painters, inasmuch as Noland omits to establish a proportional relationship between the bands of colour: they are of equal width and lack any sense of rhythm. One scarcely notices that the outer band of white is wider than the others: one tends to see it as part of the 'ground', which is interrupted by the coloured stripes, just as the white square on the right appears to be part of the square surface of the whole. Noland is less obsessively concerned with the square than Albers; indeed, in a sense he neutralizes it. In *Swing* he tilts it to one side in a manner which one occasionally finds in the work of Mondrian (see Fig. 390), and this, together with the effect of the bands of colour, gives it a dynamic appearance: the colours destabilize it and shift the focus of visual attention to the left. Despite the geometric form of the coloured stripes, one finds minimal painterly irregularities in their boundaries: here, too, there is an element of openness and freedom which countermands the hermetic principle of geometry.

Fig. 390 Piet Mondrian, *Composition with Two Lines*, 1931

PLATE 163
Kenneth Noland
Swing, 1964
Acrylic on canvas
251 x 249 cm
(sides 177 cm each)

At first sight, Ellsworth Kelly's *Black/White* (1976; Plate 164) also has a geometric appearance. Reducing action and visual interest to an absolute minimum, the picture consists of a large, flat field of black, rigidly divided from the smaller field of white by a partly diagonal boundary. Here, we see an example of what became known in the 1960s as 'hard-edge' abstraction. The sharpness of the edges in Kelly's picture is emphasized by the fact that the two fields of colour are painted on separate canvases, with a narrow gap in between which only becomes visible on closer inspection.

Although the shapes of the two fields are mathematically regular and sharply defined, they are not, in fact, strictly geometric. Instead of squares, rectangles or triangles, what we see are two irregular five-sided forms. However, we tend to overlook their irregularity: our attention is fully absorbed by the dynamic contrast between the dense black and the harshness of the white. Here, too, as in the pictures of Noland (see Plates 162, 163), one is struck by the openness of the forms, by the power and weight of the black and white fields. The painting has a spaciousness, a severity, a sublime quality which transcends mere formal considerations and carries an emotional, spiritual charge. In this respect, Kelly's picture is reminiscent of the work of Barnett Newman, an artist who belongs to the same generation as the Abstract Expressionists but whose pictures are radically different from those of his immediate contemporaries.

Kelly, who was born in 1923, a year later than Noland, was over fifty when he painted *Black/White*. The picture is thus the work of a mature man, rather than of a callow youth kicking against artistic convention. However, Kelly had embarked on his quest for maximum simplicity and clarity at an early age, long before the emergence of such movements as hard-edge abstraction, Minimal Art and colour-field painting. If one endeavours to trace the development of his art back to its historical roots, then it becomes plainly apparent that he was influenced by the *papiers découpés* – large-format collages using flat fields of bright colour – which Matisse created towards the end of his life (see Fig. 391).

Fig. 391 Henri Matisse, *The Snail*, 1952

STELLA

In 1959/60 Frank Stella, who is some ten years younger than Kelly and Noland, painted a series of black pictures patterned with parallel stripes, including *Delphine and Hippolyte* (Plate 165). The title, with its somewhat surprising mythological ring, is taken from a poem by Baudelaire which Stella happened to come across while he was working on the picture. It has no obvious meaning, unless one takes the two names as referring to the twin lozenge forms.

Stella did a number of sketches which illustrate how the structures of this picture emerged. One finds the lozenge motif, together with several other forms, in a pencil study made in 1959 (Fig. 392). The drawings show that what initially interested the artist was not geo-

metric form but the idea of flatness, embodied in forms which were discovered intuitively rather than by the application of strict geometric principles. In the paintings themselves Stella also takes an improvisational approach, working out the order of the picture in gradual steps. This is clearly apparent in the first works from the series, which are asymmetrical and decentred; one senses that the artist is still hesitantly groping his way forward. Concerning his method of creating pictures, Stella himself explains: 'I wasn't translating an idea. When I'm painting the picture, I'm really painting a picture. I may have a flat-footed technique, or something like that, but still, to me, the thrill, or the meat of the thing, is the actual painting. I don't get any thrill out of laying it out.... I like the painting part, even when it's difficult. It's the thing which seems most worthwhile to address myself to.' The sketches do indeed contain little evidence of excitement at the planning stage; the 'thrill' of which Stella speaks comes later, in the finished painting. As he says, 'the worthwhile qualities of painting are always going to be visual or emotional, and it's got to be a convincing emotional experience. Otherwise it will not be a good – not to say, great – painting.' This emotional quality is especially noticeable in Stella's black paintings. It is conveyed partly by their colour and partly by the gently vibrating lines, which are not 'painted' in the conventional sense, but merely strips of blank canvas between the bands of black.

In formal terms, the action of the picture is extremely simple. The canvas is divided into two halves, each of which contains a series of lozenge shapes radiating outwards from the centre to form a geometric structure which covers the entire surface and appears to extend into infinity beyond the boundaries of the picture. The work departs from the traditional principles of geometricism in so far as the structures are non-relational, unlike the rectangular fields in the

pictures of Mondrian (see Plates 61-64), where one finds a pattern of carefully balanced relationships; in addition, Mondrian scrupulously avoids repeating the same form. Even Albers, who exercised a powerful influence on contemporary American art, paints his coloured squares (see Plates 100, 101) in such a way that they appear to relate to one another in a quantifiable manner. In the work of Stella the 'all-over' principle asserts its predominance over geometric structure.

The methodical character of Stella's thinking and artistic practice is also illustrated by a further version of the same picture, entitled *Tuxedo Park* (Fig. 393), where he modifies the image by the simple expedient of upending the canvas. Although the images in the two pictures are identical, the visual character of the works is quite different.

PLATE 166
Kumi Sugaï
Motorway Festival, 1965
Oil on canvas, 250 × 200 cm

SUGAI

The striving for objectivity and anonymity which characterizes much of the art of the 1920s takes a variety of forms in post-war art. Paradoxically, this denial of individuality, of subjectivity and expression, is allied with an extreme artistic individualism. The Japanese artist Kumi Sugaï, who has lived and worked in Paris for many years, started out as an exponent of *belle peinture*, painting Oriental symbolic forms in a traditional idiom before aligning himself with the hard-edge movement in the 1960s. The ornamental forms in a picture such as *Motorway Festival* (Plate 166) are redolent of Japanese symbolism, but, at the same time, they convey the artist's fascination with motorways and their 'cold', expressionless icons. Unlike other twentieth-century artists who have followed the cult of the automobile, Sugaï does not endeavour to translate the idea of speed into pictorial terms: on the contrary, the picture is entirely static. Sugaï's emblematic paintings are like imaginary traffic signs standing beside the motorway.

People and Objects

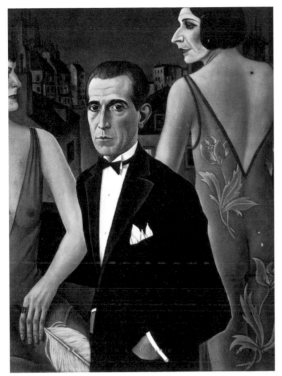

Fig. 394 Christian Schad, *Count St. Genois d'Anneaucourt*, 1927

Fig. 395 Otto Dix, *To Beauty*, 1922

Although art in the 1950s and 1960s was dominated by abstraction, a number of artists still continued to paint in a figurative style, without falling prey to traditionalism or academicism. Some of them were older painters whose roots lay in the art of the inter-war period – for example, in the German *Neue Sachlichkeit* movement – but there were also a number of younger artists who risked critical obloquy by attempting to initiate a revival of figuration. The risk subsequently receded with the general return to representational painting in the 1970s.

Richard Lindner and Bruno Goller were both born in 1901 and witnessed the rise of *Neue Sachlichkeit* at first hand, although they took no active part in the movement. When the Nazis seized power in the 1930s, Goller stayed in Germany, but Lindner went into exile, emigrating first to Paris and then to the United States. It was there, in the early 1950s, that he eventually established himself as a full-time painter, and his work consequently has to be seen in the context of American post-war art. However, like Goller in Germany, he remained something of an outsider, albeit one who took a keen interest in contemporary life, from which Goller remained largely aloof. Whereas Goller was always a peripheral figure, isolated from the rest of the art world, Lindner was regarded as a typical representative of the American scene. His predilection for banal motifs and his interest in the urban subculture of New York led critics to categorize him as a Pop artist. This, however, is quite mistaken, for his work has very little to do with Pop Art.

In Lindner's *The Street* (1963; Plate 167) one finds seven human figures and a large violet dog. First there are five adults: a hurrying pedestrian with a bullet-proof vest and a walking-stick, a sinister-looking man and woman, a gangster brandishing a machine-gun and, on the right-hand side of the picture, a muscleman who looks like an escapee from a comic-strip – an imaginary character set apart from the other figures. Then there are two children: a Lolitaesque girl in a white dress and a small boy laughing in a manner which suggests wickedness rather than childish innocence. A brightly coloured mechanical structure floats in the air above the girl's head; the dog is playing with a ball; and the muscleman clutches a large garish object which may possibly have something to do with automobiles.

Ordinary as they may be, these precisely delineated figures nevertheless tempt one to read a 'literary' meaning into the picture. What we see is not merely a genre scene, a conventional representation of a street, as indicated by the title; indeed, the street itself is invisible. Instead, the picture appears to present a gallery of iconographical stereotypes: the man (possibly a detective), the pimp, the whore, the half-innocent, half-knowing pre-pubescent girl, the neatly dressed boy whose laughter hints at evil, the Charles Atlas figure and the mongrel.

Lindner arrived in New York in 1941 and was immediately seduced by the glamour and excitement of the city. He was particularly

Fig. 396
Richard Lindner
The Meeting
1953

fascinated by the nocturnal bustle of Times Square and 42nd Street, by the whores, the bright lights of the shops and bars, and the neon advertising signs. As a European, he found all this highly exotic, but he gradually learned to see New York through American eyes: he was, after all, part-American by birth. His art contains German, American and Jewish elements in equal proportions.

Although Lindner did not begin to paint until his arrival in America, the sources of his art are clearly European. He was heavily influenced by *Neue Sachlichkeit* – for example, by the pictures of Grosz, Dix (see Fig. 395) and Christian Schad (see Fig. 394) – and, above all, by

Fig. 397
Balthus
The Street
1933-35

PLATE 167
Richard Lindner
The Street, 1963
Oil on canvas, 183 x 183 cm

modern German writers, such as Frank Wedekind and Bertolt Brecht. His work takes up the thread of these traditions but transposes them into an American setting. Lindner was also a great admirer of Léger, who was similarly fascinated by New York and sang its praises with equal fervour. And like Léger, Lindner strove to eliminate all trace of emotion from his art: his pictures are cold, detached, even callous, showing doll-like, unrelated figures in a setting of unrelieved bleakness. The paintings speak of isolation and anomy, of the harshness of everyday life in the concrete jungle, which Lindner nevertheless found exciting and inspiring. This is the message of the images in *The Street*: the pimp and the prostitute, the armed criminal threaten-

ing the innocent child, the overweight cur lethargically snapping at a ball. 'Literary' as these ideas may be, there can be no denying that the artist has succeeded in translating them into pictorial terms.

There is a marked resemblance between *The Street* and a picture with the same title and theme painted by Balthus in 1933/35 (Fig. 397). This work, too, is something of an anachronism, since figurative painting had fallen out of fashion by the mid-1930s. It also shows a group of unrelated, doll-like figures – adults, young people and children – in a street somewhere in France. The picture could almost be an early work by Lindner: the basic spirit is much the same, although the style is more conventional than that of Lindner, who exaggerates and simplifies the features of his figures and divides up the space of the picture like a collage. Balthus's street has an air of tedious normality, but the figures who populate it seem to be under a kind of spell, like players in a game whose rules are determined by some unknown agency.

GOLLER

Unlike Lindner, Bruno Goller began painting early, at the beginning of the 1920s, and he was personally associated with *Neue Sachlichkeit*. He initially joined the Rhineland circle of avant-garde artists, whose members included Dix and Ernst, but subsequently moved away to cultivate his own idiosyncratic style. At a point very late in his life, this style appeared to accord with contemporary artistic concerns, and his work found a wider audience. His pictures deal mainly with simple objects – hats and umbrellas, teacups and clocks, chairs and mirrors, numbers and strange ornaments – but they also feature cats and human figures, as in *Hat and Cat* (Fig. 398). Addressing the world of objects and ornaments, his art is stubbornly individual, making no concessions whatever to the fluctuations of artistic fashion.

Hats, both men's and women's, are a frequent motif in Goller's pictures (see Fig. 404). There is a biographical reason for this: Gol-

PLATE 168
Bruno Goller
Large Shop-Window
1953
Oil on canvas
150×115 cm

Fig. 398
Bruno Goller
Hat and Cat
1953

339

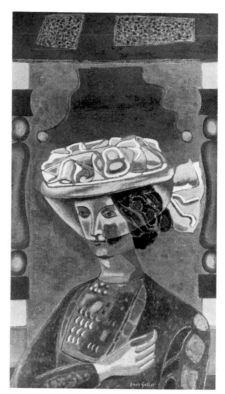

ler's mother was a milliner, and hats thus figured prominently in his childhood experience. It is likely that he continued, throughout his life, to identify hats with his mother and the world which so delighted him as a child, the world which he immortalized in such a picture as *Large Shop-Window* (1953; Plate 168).

Hats also feature in the work of a number of other twentieth-century artists. The motif plays a significant, if enigmatic, role in several pictures by Ernst (see Fig. 401) and Magritte (see Fig. 403), and also in the film entitled *Vormittagsspuk* (Morning Apparition) which

Fig. 401
Max Ernst
*It's the Hat
that Makes
the Man*
1920

340

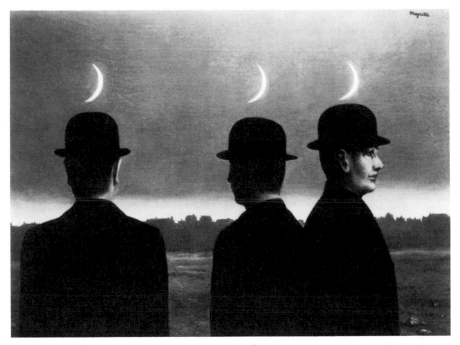

Fig. 402 Hans Richter, *Two stills from the film Morning Apparition, 1927/28*

Fig. 403 René Magritte, *The Masterpiece, or the Mysteries of the Horizon*, 1955

Fig. 404 Bruno Goller, *Two Men's Hats, 1930*

Hans Richter made in 1927, where a whole cavalcade of black stiff-brimmed hats takes off and dances a merry ballet in the air (Fig. 402). One also finds particularly striking hats in the work of Dix (see Fig. 399), whom Goller frequently encountered in Düsseldorf, and in the pre-1914 pictures of Kirchner (see Plates 32, 34), Macke (see Plate 31) and Marie Laurencin.

In Goller's work hats are used to produce a wide variety of effects, ranging from the sublime to the ridiculous. His *Large Shop-Window* is decorated with hats, ribbons, drapery and all manner of strange ornaments. It is more than a mere shop-window; it offers a glimpse into a magic world where nothing is quite as it should be: Goller's artistic language has transformed the entire scene. The space is divided up into abstract fields and surrounded with an ornamental framework; an ornamental spirit has also taken possession of the objects. The large, richly coloured canvas is packed with interest and event. It is far from sad, but does contain a hint of melancholy; the abundance of forms and colours and the sphinx-like smile on the woman's face lend it a considerable expressive vitality. The work is both a salute to the world of women's fashions and a general celebration of womanhood.

*

Twelve years later Goller painted a picture of a large armchair flanked by ornamental pillars (Plate 169). The chair is another of the artist's favourite motifs, one that occurs in his pictures as early as 1924 (see Fig. 407). Compared with this early work, the later painting appears considerably more modern: it isolates and celebrates the object and ornamentalizes the surroundings. Here, Goller follows his general practice of combining the traditional with the modern, the academic with the contemporary; he also blends serious-ness with humour, solemnity with vulgarity, sophistication with naivety. From the very beginning Goller showed a sublime disregard for the contemporary art scene: his style is entirely individual, to a

PLATE 169
Bruno Goller, *The Armchair*, 1965
Oil on canvas, 170 x 140 cm

Fig. 405
Vincent van Gogh
Vincent's Chair
1888

Fig. 406
Henri Matisse
The Lorrain Chair
1919

Fig. 407 Bruno Goller, *The Armchair*, 1924

degree which makes it almost impossible to identify the place of his work in the history of twentieth-century painting. The relationship of these pictures to contemporary movements in art varied over the years, according to the shifts of fashion which occurred within the art world. Goller himself ignored these, steadfastly maintaining the same position.

One encounters the motif of the chair, standing alone in the middle of a room, in the pictures of several other modern artists, including van Gogh (see Fig. 405) and Matisse (see Fig. 406). Tàpies, Beuys and Uecker have made artistic use of chairs as objects (see Fig. 409, 408, 366). In the 1960s, when Goller painted *The Armchair*, such a choice of motif was in itself hardly surprising. What was surprising was the discovery of Goller as a forerunner of the new figurative trend in painting; younger artists, in particular, held him in high esteem as a figurative painter who had unerringly stood his ground at the time when 'informal' abstraction was the order of the day. With the advent of Pop Art it at last became possible to recognize the virtues of his work and to pay due tribute to an artist from an older generation who still refused to ally himself with recent movements in painting.

Fig. 408
Joseph Beuys
Fat Chair
1964

Fig. 409
Antoni Tàpies
Draped Chair
1970

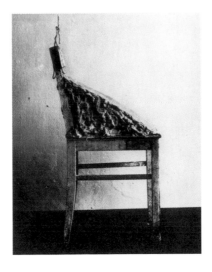

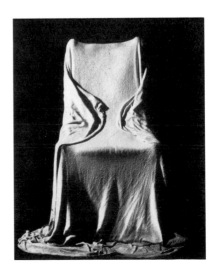

Goller's pupil Konrad Klapheck was still a young student at the Düsseldorf Academy when he painted his first picture of a typewriter. It was an astonishing work: at a time when contemporary art was still in thrall to 'informal' abstraction Klapheck flouted avant-garde convention by making a straightforward figurative painting of an everyday piece of office machinery. In the course of the next few years he painted a series of pictures featuring both typewriters and other mechanical motifs whose crude actuality invariably conceals a further dimension. While retaining their technological character, the objects undergo a pictorial transformation and take on a kind of heroic pathos. To a far greater extent than the objects in the pictures of Goller (see Plates 168, 169), who ignored the modern world of technology, Klapheck's precisely delineated and carefully arranged objects have an aura of magic: as he himself once remarked, they transform themselves into monsters. From an early age Klapheck was particularly interested in Surrealism: he frequently travelled to Paris and was personally associated with Breton.

Forgotten Heroes (Plate 170), a relatively small picture painted in 1965, reminds us that we live in a rigidly organized technical world, a world in which the individual has to struggle to maintain his identity. The niches in the ordered architectonic-technical structure contain five small elements which have a certain independent life of their own, minimally disturbing the dominance of the mechanical over the organic. One thinks of the façade of a modern office block or apartment building with its rows of identical windows. One is also reminded of the cemeteries of southern Europe in which the graves are set into the walls: Klapheck himself speaks of this picture as 'a pantheon with the busts of dead celebrities', which invites one to see the boxes in the niches as coffins, whose anonymity is relieved by the objects resting on the lids. These objects turn out to be bicycle bells, another machine-made motif which frequently occurs in Klapheck's pictures; in this case he has used it to 'sign' the coffin lids. The object on the far right is a humble screw. As the title of the work indicates, the wall is a monument to the heroes of the past, who are immortalized and yet forgotten: a memorial to the Unknown Soldier. The names of these heroes are missing or are indicated by inappropriate signs. However, it would be wrong to set too much store by the title: Klapheck is primarily concerned with painting a picture rather than telling a story, albeit a picture which touches on fundamental human feelings, despite its technological coldness. The viewer is forcibly led into a realm of unsentimental emotion which is at once oppressive and attractive: its colours and rhythms have an irresistible beauty. This is an exceptionally clever aesthetic trick, like the song of the Sirens, using beauty to entice one into a world from which there is no escape. Herein lies the power of Klapheck's paintings, which are characterized by a constitutive ambivalence: beneath their aesthetic appeal there is an underlying sense of danger.

Klapheck himself offers the following comments on *Forgotten Heroes*: 'Originally I wanted to paint a new version of the pictures with bicycle bells, arranging the bells in a neat row, but with a foreshortened effect, as if they were mounted on a sloping wall.

Fig. 410 Konrad Klapheck, *The Generations*, 1966

Fig. 411 Konrad Klapheck, *Genealogy*, 1960

PLATE 170
Konrad Klapheck
Forgotten Heroes
1965
Oil on canvas
72 x 80 cm

While I was working on the preliminary drawing I hit on the idea of putting each bell in a recess, and this led to the serial structure of niches which seems to continue beyond the edges of the picture. In order to fill the niches in a satisfying way I had to give the bells compact casings. The result was that, instead of bicycle bells, I had forms which looked like some kind of container with a flat lid. I had no intention of giving up my plan of painting bicycle bells, but I had to reduce the original motif and put it in at the end of the painting process. A trace of the motif remained, in the shape of the little propellers from the bell mechanism on two of the five forms. The other forms are divided up into fields of colour, in a way which, to me, describes a landscape with sky and earth, as if one were looking through a keyhole from a small room into a wide-open space of wistful longing. The whole thing puts me in mind of a Mediterranean cemetery or a pantheon with the busts of dead celebrities. A friend pointed out the phallic character of the forms and interpreted the picture as a mausoleum for the impotent heroes of the past. In this dead world life has withdrawn into the bell elements. They are the only signs of hope, assisted by the vivid green of the architecture – the colour of nature and organic growth.'

The small picture is constructed with mathematical precision: Klapheck makes highly skilful use of perspective, with vanishing lines

and foreshortening effects, and plays a sophisticated game with top and bottom views. These techniques serve to enliven the picture, while maintaining its constructed character. This effect is reinforced by the way that the pattern of the wall seems potentially to extend into infinity, although it is painted in a specifically finite language: the repetition of uniform elements does not detract from the idea of boundless space. The ironic title of the painting also suggests animation and humanity. In 1966 Klapheck painted a similar picture entitled *The Generations* (Fig. 410).

The five stylized drills standing out against the blood-red sky in *War* (Plate 171) are like dangerous monsters. The way that they march across the picture makes one think of generals or captains of industry, of the 'ruling class', or, remembering the title, of war. There is a biographical reference here to the red sky over Leipzig during the 1943 air raids, a traumatic episode in Klapheck's childhood. However, the idea for the central motif came from a set of illustrations

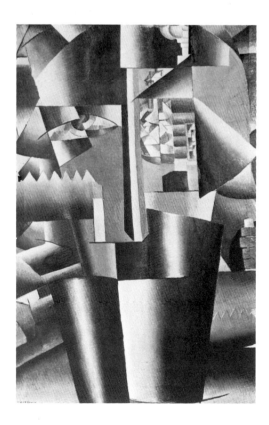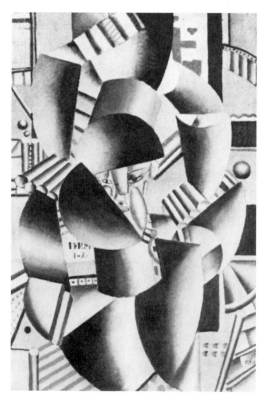

Fig. 414
Kasimir Malevich
Portrait of Ivan Klyun
1911

Fig. 415
Fernand Léger
The Two Acrobats
1918

346

of drills in a manufacturer's brochure (Fig. 412, 413). This reminds one of Duchamp, who was inspired to paint *The Chocolate-Grinder* (Plate 40) by a machine which he chanced to see in a shop-window. Similarly, Ernst took the motif for his *The Wavering Woman* (Plate 73) from a magazine illustration of a ship's engine. Instead of merely copying the machine-made model, Klapheck transforms it – while retaining its technological character – into an entirely different, almost anthropomorphic form which is at once both real and unreal. One thinks of the tubular forms which Léger painted at the beginning of the 1920s (see Fig. 415) and of the early work of Malevich (see Fig. 414), prior to his Suprematist phase. The art of Klapheck can thus be located in the general tradition of modernism, whose most important strand, for him, is Surrealism.

Klapheck once remarked that he sought to sustain his passion by covering it with a layer of ice, to make it glow with a cold fire. Looking at such pictures as *Forgotten Heroes* and *War*, one immediately realizes what he means. One feels the coldness of their construction and their epidermis, the frigid precision with which they are made. At the same time, however, one senses the passion with which Klapheck addresses his theme, a theme which is not simply one of a number of readily available options, waiting to be taken up and used, but which has to be created by the artist's vision.

Horst Antes, who was born in 1936, started out as an exponent of *Art Informel* but showed figurative leanings at an early stage in his career. The outlines of his figures rapidly grew crisper and clearer, and he soon abandoned informalism in favour of a style which shows the influence of hard-edge painting, using large, flat areas of colour and precisely delineated, emblematic images, as in *Figure in Black and White* (Plate 172). His iconographical repertoire is narrow in the extreme, limited almost exclusively to the motif of the 'head-foot', depicted in profile and invested with a ceremonial, ritual quality which is reminiscent of the pre-Columbian art of Central America (see Fig. 416). Antes himself refers to these strange creatures, which populate his entire oeuvre, as *Kunstfiguren* (art-ificial figures), emphasizing that they belong to the sphere of art and artifice, rather than to the realm of mythology or, indeed, to the real world. Contrary to appearances, the motif in *Figure in Black and White* is neither a human being nor an idol: it is quite simply a figure. Although its gestures and expression are enigmatic, hinting at some hidden, possibly nefarious intention, it is an essentially friendly, good-humoured creature. The technique of the picture is simple and straight-forward, with plain colours, an elementary compositional structure and forms which look like paper cut-outs. The expressive, individual manner of Antes's early pictures has been replaced by a largely anonymous style, albeit with occasional painterly touches which relieve the cold flatness of the colours.

It goes without saying that this domesticated monster is a creature of Antes's own imagination. He invented it himself, rather than copying it from Mexican codices (see Fig. 416) or the Kachina dolls of the Hopi and Zuento Indians, although he owns an extensive collection of these figures (see Fig. 418), which also fascinated Ernst and, to a lesser extent, Lindner. Antes has frequently visited the

Fig. 416
Illustration in
an Aztec codex

Fig. 417
Horst Antes
*Figure with Red
P-Hat and Flag*
1967

PLATE 172
Horst Antes, *Figure in Black and White*, 1967
Aquatec on canvas, 150 x 120 cm

Fig. 418
Kachina figures of
the Pueblo Indians, Arizona
Collection of Horst Antes

Indian reservations in North-East Arizona. His interest in Indian art and culture has an obsessive quality which also manifests itself in his continuing preoccupation with the 'head-foot' figure which is his artistic trademark. In an age when there is much talk of 'serial' principles in art, it is hardly surprising to find a painter such as Antes endlessly repeating a single motif. Although the motif itself remains the same, it is treated in a large number of ways: Antes's oeuvre shows considerable variety within a limited range of subject-matter.

*

Antes's pictures occasionally take on a semi-religious character which reflects the obsessive nature of his interest in the art of the Hopi Indians. In *Large Graphite Picture: Seated Female Figure* (Plate 173), which dates from 1983, one sees, on the right, a seated figure resembling a kind of goddess and, on the left, facing her, a hermaphrodite. The two figures are separated by an oval form which Antes copied from the drum of a Siberian shaman. The white spoon which sails through the air, casting a dark shadow on the background, obviously has some kind of deeper, mysterious meaning. It can be seen as symbolizing the elementary human activity of eating, especially as the artist informs us that, for the West African Lobi tribe, the spoon has a ritual function. There is an obvious visual alliteration between the spoon and the white form of the sperm behind the hermaphrodite's back. In the vast majority of the world's religions the image of the snake has a symbolic significance; with its ancillary white outline, the flying snake in the middle of Antes's picture echoes the motif of the spoon, while the snake on the ground adds an important touch of colour. Antes sees the horse drawn inside the hermaphrodite's head as an image of masculinity, and the woman, surrounded by five small figures, as a symbol of motherhood. In the background of the scene, which can be seen as either an indoor or an outdoor space, there is a ring-shaped, glittering red sun which reminds one of the suns in pictures by Ernst; the cheapness of the glitter mixed into the colour demythologizes the picture and undermines its ritual character. In looking at this work, the important thing is not to decipher the meaning of the individual images, which

Fig. 419 Horst Antes, *Grey Figure, Wooden Spoon, Wooden Chair,* 1982

PLATE 173
Horst Antes
Large Graphite Picture:
Seated Female Figure, 1983
Aquatec, graphite, pastel
and isinglass on three-part
plywood panel, 180 x 360 cm

for the artist himself have a purely associative significance, but rather to recognize the general symbolic resonance of the picture as a whole. The same set of motifs can be found in a number of Antes's other works from the early 1980s (see Fig. 419), including a series of twenty-five objects made of gold foil and acrylic glass, which he calls 'votives'.

*

Over the past two decades art has followed a variety of different paths. Some artists have withdrawn from reality altogether, while others have cultivated a near-photographic form of realism. Artistic form has been stripped down to a bare minimum, and painting has been reduced to a set of pure 'spiritual' concepts. Latterly, however, we have seen a revival of painterly values, with a renewed emphasis on sensuality and expression. The very diversity of the available stylistic options would appear to be the distinctive hall-mark of our time. Yet stylistic pluralism has a long and venerable history, beginning with the Renaissance and the emergence of the idea of individuality as the basis of artistic activity. As the ties which bound art to society became looser, so traditional stylistic conventions lost their authority. The artist was empowered to choose his own style at will, but in return he incurred an obligation to think about and to justify intellectually his choice. It is true that, from time to time, styles emerged which dominated the art of an entire period, but the quality of an artist's work increasingly came to be judged by its individuality and originality, by the extent to which it stood out from the other art of its time. The freedom of the artist, his intellectual and creative independence, was reflected in his personal style, bearing his own unmistakable signature. However, there eventually came a time – in our own century – when even this personal style was seen as a straitjacket, from which the truly independent artist must seek

to free himself. Instead of maturing in a gradual organic process, the work of a number of artists developed in a series of abrupt, short-lived phases, taking style as an interchangeable method, rather than as the necessary expression of an individual creative impulse. This tendency is strikingly exemplified by the work of Picasso, with its constant dramatic shifts of style. Those critics who complain about the stylistic pluralism of present-day art would do well to remember the art of the 1920s, when, in addition to the competition between the avant-garde and the traditionalists, the avant-garde itself was split into several opposing factions – geometricism, Constructivism, Surrealism and *Neue Sachlichkeit* – and within these different currents – 'current', in this case, is a more appropriate term than 'style' – there were individual stylistic approaches by each of their various exponents. In the 1960s Pop Art, colour-field painting and Op Art flourished simultaneously, together with forms of realism which were by no means traditionalist. A similar situation obtains at present. Part of the price which the artist pays for freedom is the absence of a stylistic model, an authoritative set of guidelines for his work. Certainly, the freedom of the artist remains limited by the opportunities which society offers or withholds; and despite the diversity of art, there are certain characteristic features, certain historical hallmarks which indicate that a work belongs to a particular period. Yet although styles, movements and groups continue to emerge, it is always the individual artist who has the last word: art is essentially a matter for individual decision. What lies in store for art in the future? The contemporary art scene poses a number of disturbing questions. One's hopes for the future rest on the fact that unrest, rather than calm, has always been a spur to creativity, especially in periods when there was no single canonical style to serve as a focus of orientation for the work of the individual artist.

Index of Names

Numerals in bold type refer to pages with colour plates of works in the collection of the Kunstsammlung Nordrhein-Westfalen, those in italics to pages with black and white illustrations.